The New Museum Community

The New Museum Community

Audiences, Challenges, Benefits

A Collection of Essays

MUSEUMSETC | EDINBURGH

Contents

Learning to Look/Looking to Learn: A Visual Thinking Strategies Survey

NICOLA ABERY

Creative Director

www.looktolearn.co.uk

Using this survey I will explain what Visual Thinking Strategies (VTS) is, how it is used in museums and through school partnerships and the academic research that supports it. I will then discuss how VTS has resulted in some amazing academic improvements in the USA and how it could support the *Creative Partnerships* programme here in the UK.

What is Visual Thinking Strategies?
VTS is an education programme that develops critical thinking skills through the observation of visual art; the answering of a series of open-ended questions and facilitator-led group image discussions. This is underpinned by many years of study on how aesthetic thought[1] develops, based on the research of cognitive psychologist Abigail Housen and renowned museum educator Phillip Yenawine. This collaboration led to the creation of an innovative programme known as *Visual Thinking Strategies*. The cognitive and communication skills nurtured through VTS have been proven to transfer to other areas of the curriculum and I will focus on a number of case studies where this has been evident.

Currently used in schools across the USA and Spain, VTS is a student-centred curriculum, consisting of nine class-based lessons and one museum-based session, facilitated by classroom teachers over an academic year. During each lesson, students look at a series of carefully selected visual art images and engage in guided conversations. Students are encouraged and invited to scrutinise the images, comment and explain their interpretations using evidence, while

the teacher ensures each comment is heard, respected and points in the pieces of art to what is being mentioned. As the conversation progresses, the teacher connects students' concepts together, creating links and establishing a depth to the meaning-making process.

A VTS conversation

I have used VTS in both a school and museum context. Most recently I have started using it in schools where I already teach art. I chose to start VTS' second grade curriculum for a year 3 class as they have not had the opportunity to discuss art in depth before. Each hour-long lesson consists of specific developmentally sequenced images which are viewed and discussed by the class.

Here is an extract from the first VTS lesson of a year 3 class at a London primary school. I teach art on a weekly basis and we were working on *Relationships in Portraiture* as our half term's unit. VTS was introduced to them at the beginning of the unit as an additional aspect to their visual arts learning. This discussion took place prior to an outing to the National Portrait Gallery where I was going to run a VTS programme. This was their initial session and they were enthusiastic and interested.

The first image in the curriculum is *Child and a Dove* by Pablo Picasso, 1912.[2] I presented it to the students on an interactive white board and asked them to look at it for about twenty seconds. Each comment is paraphrased back to the class before another student is invited to respond. The full

discussion lasted fifteen minutes and we then moved on to the next image.

Nicola Abery (NA) OK, so what's going on in the picture?
Millie: I see a girl and she is holding a toy bird.
NA: What do you see that makes you say that?
Millie: I think she is holding a toy because there is a ball on the ground and it's also a toy.
NA: Millie sees a girl holding a toy bird. She thinks that it is a toy because there is a toy ball on the floor. What more can you find?
Ben: I think it's a girl and she is going to a party. She has a bird in her hand and there's a ball on the ground.
NA: What do you see that makes you say that?
Ben: She's a girl and she has a dress on. Girls like to wear dresses for parties and there is a bow on the back of the dress so it's obviously a fancy one. She is holding her bird.
NA: Ben agrees with Millie that it is a girl because she is wearing a dress and girls usually wear dresses for parties. He has noticed that it has a bow at the back so he thinks it might be a special dress. She is holding her bird. What more can you find?
Alison: I think that she has just found the bird and it is hurt. She wants to protect and help it?
NA: What do you see that makes you say that?
Alison: She is holding the bird close to her and telling it that it will be OK.
NA: What do you see that makes you say that?
Alison: She looks like she is talking because her mouth is close to it and she is whispering to the bird. I think she loves it.

NA: Alison thinks that the bird in the girl's hand is hurt and she wants to protect it. So she is holding it close to her and telling it that it will be OK. What more can you find?

Noe: I think that she is sitting down in a room with toys and she has picked up the bird to play with it. Her dress is a normal one and the ball is there too.

NA: What do you see that makes you say that?

Noe: I think that she is sitting because your feet don't do that when you are standing. Look, when I stand you can't see all my foot (he stands to demonstrate) but when I sit down on a chair, you can see more of it. I'm not sure it's a room now because the blue background looks like water. Maybe she is outside on a bridge but she is still sitting down.

NA: Noe agrees with Millie and Ben about the bird being a toy but he thinks that the girl is sitting down because her feet are visible. Noe is not sure if the girl is in a room or outside because he thinks the blue background could be water. What more can you find?

Eve: I don't agree with Noe, I think that she is inside and standing. The bird is real and it's her pet.

NA: What do you see that makes you say that?

Eve: The room is bare but there is a ball on the floor. If she was outside she would have a different outfit on or even a coat. Her dress is pretty. It's got a big bow at the back and that is what you can see.

NA: Eve disagrees with Noe and she thinks that because that if the girl was outside she would be wearing a different outfit or even a coat. What more can you find?

Joel: I think that she has just come home and she has gone straight to say hello to her bird. The ball on the floor was left there from earlier

on and she is still wearing her party clothes. I'm not sure about the bow though. I think the dark blue bit on her middle, is like a belt and maybe the bow is at the back. She has very short hair.

NA: What do you see that makes you say that?

Joel: She looks like she has been out and I think that she is wearing fancy dress. There is a bit in the middle that is the same colour as the back bit of the dress.

NA: Joel thinks that the reason that she is wearing a pretty dress is because she was at a party but now she is home. The dress has a belt and bow which is why it is a party dress. What more can you find?

James: It's from a long time ago

NA: What do you see that makes you say that?

James: We don't wear clothes like that any more. Even the girls, they wear different dresses and we don't usually have birds.

NA: James thinks that this picture is from a long time ago because we don't usually wear clothes like that and he thinks that we don't really have birds of our own. Thank you for your fantastic comments and for listening so well to each other.

How VTS works

As demonstrated in the transcript, first the image was presented to the students and they were invited to look at it without commenting for about 15-20 seconds. I then used three questions which are the key components in instigating a VTS discussion[3]. These carefully crafted questions were formulated by Housen and Yenawine based on their evidential findings on aesthetic thought development.[4]

The first question is *What's going on in the picture?*

This invites the viewer to look at the image and say what they see. For my students, they start creating a story and as the discussion gets underway, the viewing becomes more focused on the image.

I then ask them to provide some evidential indication of the observations by enquiring: *What do you see that makes you say that?*

Here the students have to pinpoint how they have come to a particular answer. The second question invites closer inspection and offers a chance to consider their original ideas. For example, the comments Joel made about the sash on the dress. During the answering of these questions, I point out the areas or objects in the picture using my finger, so that the students' eyes are engaged with the picture. In addition, at the end of each comment, it is paraphrased, acknowledging its validity, encouraging greater understanding and demonstrating that I am able to see their point of view.

Finally I ask the third question: *What more can you find?*

This encourages the viewers to delve deeper and search for more. All responses are acknowledged, even when the explanation is difficult to decipher. Remaining neutral to the pupils' comments enables me to continue the flow of the conversation and, if possible, assists clarification by returning back to question two or three. After fifteen to twenty minutes, I end the conversation by thanking the students for their contributions and complimenting them.

In the VTS discussions I had with this particular class,

a number of keen individuals engaged in commenting immediately. The enthusiasm they exhibited for viewing and discussing art is encouraging and, as can be seen from the transcript, their comments were thoughtful and applicable. By the end of the conversation all students were actively engaged in viewing and commenting.

One challenging aspect of the process is that, throughout the conversation, the teacher acts purely as a facilitator and doesn't impart facts about the piece of art. In *As Theory becomes Practice: The Happy Tale of a School/Museum Partnership*, Housen sums up her goal: "I want people to feel that they can respond to a work of art in their own voice. I want them to feel excitement from asking their own questions and engaged as they discover their own answers." [5] This student-centred learning approach is the theoretical underpinning of VTS.

VTS theory

Abigail Housen explains: "VTS looks deceptively simple, but the sequencing of questions and images is based on the developmental analysis of thousands of examples of viewers' reasoning about art, collected over a period of two decades. The VTS process accesses the power of art by focusing attention at a level that is accessible and provocative to the learner in an appropriate sequence over time." [6]

This description of developmental levels is based on the evidence that Housen completed twenty years ago on aesthetic development. This work underpins the philosophy of VTS and its practice. Housen collected data based on the observations

of people's behaviour while visiting art museums. She decided that, although their outward behaviour was interesting, she could find out far more about their responses to the art by collecting "non-directive, stream-of-consciousness interviews, called aesthetic development interviews (ADI)." [7] These interviews were recorded, analysed and then categorised with other ADIs with similar patterns of aesthetic development. On studying these categories, Housen noticed "five patterns of aesthetic development that correlate to the amount of exposure subjects have had to art." [8]

Accountive viewers are storytellers. Using their senses, memories and personal associations, they make concrete observations about the work of art which get woven into a narrative. Here, judgments are based on what is known and what is liked. Emotions colour their comments, as viewers seem to enter the work of art and become part of the unfolding narrative.

Constructive viewers set about building a framework for looking at works of art, using the most logical and accessible tools: their own perceptions, their knowledge of the natural world, and the values of their social, moral and conventional world. If the work does not look the way it is "supposed to" – if craft, skill, technique, hard work, utility and function are not evident, or if the subjects seem inappropriate – then this viewer judges the work to be "weird", lacking and of no value. The viewer's sense of what is realistic is a standard often applied to determine value. As emotions begin to go underground, this viewer begins to distance him or herself

from the work of art.

Classifying viewers adopt the analytical and critical stance of the art historian. They want to identify the work as to place, school, style, time and provenance. They decode the work using their library of facts and figures that they are ready and eager to expand. This viewer believes that, properly categorized, the work of art's meaning and message can be explained and rationalized.

Interpretive viewers seek a personal encounter with a work of art. Exploring the canvas, letting the meaning of the work slowly unfold, they appreciate the subtleties of line and shape and colour. Now, critical skills are put in the service of feelings and intuitions as these viewers let underlying meanings of the work – what it symbolizes – emerge. Each new encounter with a work of art presents a chance for new comparisons, insights and experiences. Knowing that the work of art's identity and value are subject to reinterpretation, these viewers see their own processes subject to chance and change.

Re-creative viewers, having established a long history of viewing and reflecting about works of art, now "willingly suspend disbelief". A familiar painting is like an old friend who is known intimately, yet full of surprise, deserving attention on a daily level but also existing on an elevated plane. As in all important friendships, time is a key ingredient, allowing Stage 5 viewers to know the ecology of a work – its time, its history, its questions, its travels, its intricacies. Drawing on his/her own history with one work in particular, and with viewing in general, this viewer combines

personal contemplation with views that broadly encompass universal concerns. Here, memory infuses the landscape of the painting, intricately combining the personal and the universal.

Housen then worked in collaboration with Phillip Yenawine to create a programme that would encourage aesthetic development in an accountable way. The VTS questions: *What's going on in the picture? What do you see that makes you say that? And what more can you find?* were developed to activate the beginning learner into thinking and talking about art. As viewers become more sophisticated in their aesthetic development, the tasks and images increase in complexity. Throughout the entire curriculum, the teacher acts as the facilitator enabling the student to lead the learning process.

Over the past ten years, studies have been carried out that have quantified the progress made and its impact on the learning community. An understanding of how the methodology works has led to studies in skill transfer beyond art. As Housen explains in *Aesthetic Thought, Critical Thinking and Transfer*:

> *In 1993, we had the opportunity to design and implement a longitudinal study to test not only for the effect of our curriculum in stimulating aesthetic growth, but also to look for evidence that it develops critical thinking, and its transfer... The results of our five-year study supported our hypothesis that our curriculum accelerates aesthetic growth. Moreover, we found evidence that VTS causes the growth of critical thinking and enables its transfer to other contexts and content.*

Ultimately, our results serve not only as a window into the kinds of thinking and learning that occur when elementary age students respond to works of art over an extended period, but also how learning in the arts can enable students to move beyond the interpretation of images.[9]

There are a number of ways VTS works in schools. Firstly it can become part of the art curriculum, taught alongside practical skills over the period of several years. The ten VTS lessons are taught by the class teacher (who will have undergone training by VTS) with the final session taking place a museum or gallery. Another programme example is a school/museum partnership, whereby VTS lessons are taught in the classroom but the students visit the museum regularly over the course of a year and museum educators visit the school. This partnership would usually continue for a number of years. Each of these examples exists today in communities across the USA. The more in-depth partnerships lasting five years or more have seen amazing results with the transfer of critical thinking skills across the entire curriculum. The next section of this survey will address some of these examples and how they have impacted the students' overall performance.

Case studies and their academic successes

These examples of VTS's work come from the USA. I will focus my attention on examples of its use in schools and school/museum partnerships. VTS has carried out a number of studies to measure the impact of the programme and how the

skills developed through the programme can be transferred to other areas. These case studies will reveal how successful the programmes are across different ethnic, socio-economic and linguistic backgrounds and in particular how children who are considered to be underachieving benefited.

My first example took place in San Antonio Texas between the San Antonio Independent School District, ArtPace (a non-profit contemporary visual art centre) and the San Antonio Museum of Art. The study set out to focus on novice viewing (stage 1) students in Key Stage 2 (US grades 3-5). The programme took place over two academic years. As a result of using VTS, the students were able to transfer critical thinking skills, such as supported observations and speculations, to independent art and non-art viewing experiences. In addition, the students were assessed to have moved to Stage II of aesthetic development.

Interestingly, many of the students did not speak English as their first language; nevertheless, this did not impede their aesthetic development. In fact they too made progress in their critical thinking capacities.

The second example comes from a four year school/ museum partnership between The Minnesota Institute of Arts (MIA) and the Byron Schools District (local authority) starting in 1993. Interestingly the results in this project demonstrated that the students transferred the skills learnt through VTS to other curriculum subjects.

One of the class teachers from the Byron School District described her observations: "The students' reasoning has

come along very well this fall. They have been able to apply the scientific method more effectively than I can ever remember... We've always had to promote active listening and active learning. But this gives students a license that means we don't have to push. The VTS lets them express themselves, share things that go beyond what we teach them, and even to be wrong – which to me is okay because they are thinking, and that is what is important."

Another teacher felt that his students' approach their history text differently: "There is a whole chapter in our social studies text on the history of the United States, with photographs of scenes which compare the past with today. Before, I used to have to work any comments out of the students and ask them all kinds of questions. Now, they go on and on and on without anything from me. This is definitely not a capacity that the kids had before we started teaching the curriculum." [10]

Positive results were also seen at the MIA. This is how one of the museum educators described the impact VTS had: "I feel very differently about the role of information in museum teaching than I did, and I want to see more and more looking and thinking result from the encounters we facilitate as museum educators." [11]

This transition of opinion towards museum education has developed across the USA since this study was carried out. Museums are continually aligning themselves with VTS and creating lasting partnerships with schools.

My next two examples involved collaborations between

museums, VTS and schools funded by government education agencies but researched and evaluated by independent bodies. The first study involved the Isabella Stewart Gardner Museum in Boston, the Institute for Learning Innovation and three inner city state schools. Completed in 2007, the study looked at multiple visit programmes over a three year period. At the end of the study, the three participating schools saw dramatic improvements in their students' responses to art and, interestingly, the museum shifted its entire educational philosophy to using VTS which continues today as a direct response to the results.

The second study in Miami, Florida,[12] was an arts-integrated social studies curriculum project designed to provide British School years 4-6 (US grades 3rd-5th) students and teachers with the tools necessary to develop visual literacy skills; implement social science content across academic content areas; and create opportunities for integrated artistic response.

The programme was evaluated by independent education researchers and funded by the US Department of Education. As a result of the three year project, the researchers concluded that the participating students had significantly higher growth rates in visual literacy, reading and mathematics than comparison group students – but most noteworthy was the fact that VTS promoted good citizenship skills, cooperation, respect and tolerance for the views of others.

These four case studies demonstrate the different ways schools and museums can use VTS. Intrinsic in every example

is their desire to use art as a means to improve aesthetic development and critical thinking in students. For some schools the commitment level is just for one year. The classes involved buy the curriculum packs, teachers are trained by VTS staff at a partnered museum in their locality and an evaluation debriefing takes place at the end of the academic year. The final session takes place at the partnered museum, enabling the students to consolidate their skills. Many schools start off at this level of commitment as it is relatively cheap and easy to achieve for a school and museum faculty. As the case studies demonstrated, teachers begin to see an improvement in their students' approach and conversation towards art but the skill development is likely to be limited.

On a grander scale, some schools embark on a five year school/museum partnership with VTS where every class is involved in the programme. Students visit the museum multiple times during the year and the curriculum builds a stronger foundation for developing critical thinking skills year upon year. With such an investment, students' thinking skills are transferred beyond the art lesson and teachers see an adoption of VTS terminology and methodology. With this arrangement, the school would select a lead teacher to train directly with VTS and become the local VTS representative. This investment will enable the school to develop the programme and enable the students to flourish. In some cases it has prompted other local schools and museums to participate in the programme.

Creative learning in the UK

So far in this survey we have addressed the theory of VTS and its practical implications for school and museum communities in the USA. Unlike the UK, most museums are independently financed and managed. Does the UK have the capability to take part in a programme like VTS? I would like to say that given the evidential research proving its success, we should try to embrace the opportunities of developing a generation of deeper level thinkers and art lovers – and using VTS seems to provide a very solid structure. Even with financial constraints for our publicly funded schools and museums, there is enough evidence that VTS works to justify the initial investment.

In its recent report, *Learning: Creative Approaches That Raise Standards*[13], Ofsted made the following key findings:

- Pupils who were supported by good teaching that encouraged questioning, debate, experimentation, presentation and critical reflection enjoyed the challenge and had a sense of personal achievement. The confidence they gained encouraged them to develop and present their own ideas with greater imagination and fluency. Approaches developed successfully in traditionally creative subjects, such as the arts and English, were often incorporated into other areas, such as science and mathematics.

- Teachers were seen to promote creative learning most purposefully and effectively when encouraging pupils to question and challenge, make connections and see

relationships, speculate, keep options open while pursuing a line of enquiry, and reflect critically on ideas, actions and results.

• Good professional development within the school was a key factor in helping teachers to encourage and assess creative approaches to learning and improve their subject knowledge. Externally produced resources and short training courses had limited impact without local training and continuing in-school support.

• Partnerships that were planned to complement schools mainstream curriculum made a positive contribution to pupils learning and personal development.

Ofsted's short survey in 2006 of the *Creative Partnerships* programme had a significant and positive impact on the way in which schools are now selected and their participation managed and evaluated.

These observations highlight the benefits of programmes such as VTS and that enquiry-based learning produces confident and resourceful learners. Also noteworthy is the benefit of partnering schools and cultural institutions which has been most recently assisted by the project, *Creative Partnerships*, run by the organisation Creativity, Culture and Education (CCE).

Therefore all the evidence supports using a programme such as VTS to improve critical thinking skills and student

performance in the UK. Here in the UK, the potential to implement VTS may lie with organisations such as CCE who can provide the initial funding. CCE describes itself as the new national organisation created to generate transformational cultural and creative programmes for children and young people across England to enhance their aspirations, achievements, skills and life chances.[14] Their *Creative Partnerships* scheme has been praised highly by Ofsted and it supports thousands of innovative, long-term partnerships between schools and creative professionals. If VTS was to align with an organisation like CCE, schools and museums would be supported in creating a long-term meaningful programme.

I hope that this survey provides a strong case for the inclusion of VTS in the UK and I look forward to assisting in the creation of a new generation of deeper level thinkers.

Notes

1 Housen, A. 1979

2 Pablo Picasso. Child with a Dove. 1901. Oil on canvas, 28 3/4 x 21 1/4 in. On loan to the National Gallery, London.

3 Art Viewing and Aesthetic Development: Designing for the Viewer by Abigail Housen. Originally appearing in: From Periphery to Center: Art Museum Education in the 21st Century, edited by Pat Villenueve. Reprinted with permission from The National Art Education Association, Reston, VA. Copyright 2007.

4 Housen, A 1979

5 As Theory Becomes Practice: The Happy Tale of a School/Museum Partnership by Catherine Egenberger and Philip Yenawine

6 Aesthetic Thought, Critical Thinking and Transfer by Abigail Housen originally published: Arts and Learning Journal, Vol. 18, No. 1, May 2002

7 A Brief Guide to Developmental Theory and Aesthetic Development by Karin DeSantis and Abigail Housen 2009

8 Ibid p10

9 Aesthetic Thought, Critical Thinking and Transfer by Abigail Housen originally published: Arts and Learning Journal, Vol. 18, No. 1, May 2002

10 As Theory Becomes Practice: The Happy Tale of a School/Museum Partnership by Catherine Egenberger and Philip Yenawine p10

11 Ibid p12

12 Artful Citizenship Project: Three-Year Project Report Miami, FL; 2005

13 http://www.ofsted.gov.uk/Ofsted-home/Publications-and-research/Browse-all-by/Documents-by-type/Thematic-reports/Learning-creative-approaches-that-raise-standards :15 Jan 2010 HMI: 080266

14 http://www.creativitycultureeducation.org/who-we-are/

Learning from Autism

LENORE ADLER

Program Outreach Specialist

Carnegie Museum of Natural History

Pittsburgh

The inclusion and engagement of audiences is an equity issue at its core and, as such, is a fundamental one for Education and Public Program staff at museums. As Education has been seeking parity with Research and Collections over the past decades, so too, the Disability Community has been seeking equal treatment and accommodation in society.

Background

Prior to the 1800s many viewed people with disabilities as being punished for their or their parents' misdeeds; disabilities were seen as a form of divine retribution for sins. By casting disability as a moral or religious issue, society at large was able to ignore rather than confront that population.

With the mid-1800's the precursors to museums, early cabinets of curiosity, came in fashion. However, these private collections did not engage any public including the Disability Community. Early in the 1900s "enlightened" western society began to view disability as a medical issue. People who were "sick" and unable to be cured by doctors were excused from school, work and society as a whole. For the most part, this separation kept people with disabilities from interacting with museums.

By the mid-20th century things were changing in the United States. Taking a page from the civil rights movement of African Americans, the Disability Community organized and made their voices heard. The US government responded with a variety of Education and Rehabilitation legislation.

Special education classes were formed. "Mainstreaming" and "least restrictive environments" were the rallying calls by parents for the education of their children with special needs. Children with disabilities were coming to museums on school field trips. Special programs or special days for people with disabilities were created at museums. However well-intentioned these types of programs were, they necessarily were separate from and hence not quite equal to standard museum programs.

The *Social Model* of the late 20th century promoted inclusion of the person with a disability. Following the enactment of the Americans with Disability Act in 1990, activists in the United States have been able to successfully remedy many accessibility issues through lawsuits and the threat of lawsuits. People with disabilities were now out in the community and that included visiting museums.

The *Activist Model* is the current social paradigm. Disability is seen as natural. Society is seen as needing to change, not the person with the disability. The environment is viewed as flawed not the person. It is society's attitude that is handicapped. This new paradigm has had a significant impact on the museum community. Persons with disabilities strive for equality in all areas of life, including museum visitorship and participation in all that museums have to offer. That is where museums find themselves today – including and engaging the Disability Community. A museum has to be open to possibilities and be willing to work on inclusion. Although the challenges are considerable, as educators we

learn from the experiences. Persevere we must to reach a goal of living in a more democratic society where all its members are valued and accommodated.

It is from this model of welcoming and striving for equality that the case study I am presenting is taken. The Disability Community wants to do more than just visit museums, it wants also to participate as volunteers and staff. Carnegie Museum of Natural History (CMNH) in cooperation with the Pennsylvania State Bureau of Autism is building a pilot program focusing on a particular subset of people who are differently abled, teenagers with Autism Spectrum Disorders (ASD). Together we are working to modify existing teen volunteer programs and opportunities to better serve this audience. We wanted to start small in order to maximize the chances for success. By putting a structure in place and providing supervision and mentoring opportunities we hope to have a program template that other museums may use to create their own viable programs.

Who we are

Carnegie Museum of Natural History, one of the four Carnegie Museums of Pittsburgh, was founded in 1895 by industrialist and philanthropist, Andrew Carnegie, for the people of Pittsburgh. Carnegie Museum of Natural History maintains, preserves, and interprets an extraordinary collection of 21 million objects and scientific specimens. Today, the museum is ranked among the top five natural history museums in the United States. Its renowned dinosaur collection includes

the largest collection of Jurassic dinosaurs anywhere in the world and the third largest collection of mounted, displayed dinosaurs in the US.

Museum on the Move, the outreach program at Carnegie Museum of Natural History that serves children with special needs, was formed in 1983 to bring the museum to hospitalized children. It soon grew to include children in special education, learning support, and life skills classes at public schools, at residential treatment facilities, "special" camps, and early intervention preschools. Program presenters are given training to work with a variety of children with special needs and orientation to each site's requirements.

We have had previous experience working with children on the spectrum at autism learning support classes in public schools, early intervention preschool classes for children on the spectrum, Wesley Spectrum Services (www.wesleyspectrum.org), Spectrum Charter School (www.spectrumcharterschool.org), and Watson Institute and its satellite community classes (www.thewatsoninstitute.org).

The museum also has a goal that all its programs be aligned with its mission. This program supports our mission: "through public engagement, we share the joy of discovery about the processes that shape the diversity of our world and its inhabitants."

What is autism?

The National Institute on Neurological Disorders and Stroke (NINDS) of the US National Institutes of Health (NIH)

defines Autism spectrum disorder as "a range of complex neurodevelopment disorders, characterized by social impairments, communication difficulties, and restricted, repetitive, and stereotyped patterns of behavior."

There are levels of severity along the spectrum, from the milder, to the moderate and severe. Related diseases that some include on the spectrum are Childhood Disintegrative Disorder, Asperger syndrome, Rett syndrome and Fragile X syndrome. The spectrum also includes groups of pervasive developmental disorders not otherwise specified (usually referred to as PDD-NOS).

NINDS further states: "Although ASD varies significantly in character and severity, it occurs in all ethnic and socioeconomic groups and affects every age group."

The Autism Speaks organizational website reports:

Today it is estimated that one in every 110 children is diagnosed with autism, making it more common than childhood cancer, juvenile diabetes and pediatric AIDS combined. An estimated 1.5 million individuals in the U.S. and tens of millions worldwide are affected by autism. Government statistics suggest the prevalence rate of autism is increasing 10-17 percent annually. There is not established explanation for this increase, although improved diagnosis and environmental influences are two reasons often considered. Studies suggest boys are more likely than girls to develop autism and receive the diagnosis three to four times more frequently. Current estimates are that in the United States alone, one out of 70 boys is diagnosed with autism.

What happened

A therapist from the regional office the State Bureau of Autism approached the museum with the idea that we might be able to partner with them to provide learning and work (volunteer) opportunities for their clients in the Venture Group (a group of 22 teens, ages 12-19 from four area counties). The State Bureau of Autism is under the Department of Public Welfare (DPW). Its mission is "to develop and mange services to enhance the quality of life and independence of Pennsylvanians living with Autism Spectrum Disorders and to support their families and caregivers. The Bureau will carry out its mission either by development and direct management of services within the Bureau or providing mentoring and training to other divisions in DPW."

After our initial meeting, we decided to have a three pronged approach: training of staff, identifying possible programs and engaging the teens in the museum. The Bureau provided training for Public Program (Education and Exhibition), Customer Service, and Group Visits staff. A morning session was set up and thirty people attended. We were also given two resource DVDs (produced by the state) on autism. The *Teen Docent* program, *Discovery Room, Bone Hunters Quarry, Overnights* and summer camp programs were identified as potential areas in which the teens could volunteer. Museum staff from these programs met and brainstormed on how to best integrate the teens into these programs and what "jobs" they might be able to do. We engaged the teens and their parents. The teens selected a group

overnight to attend. We set up a group tour for the teens and their families to visit the museum the week before, during which time the teens could observe some of these programs in action and have a chance to talk with the current volunteers prior to the overnight. The overnight is structured so that the 120 participants are assigned to four groups of 30 as they rotate through the different activity stations in the evening. It was determined that the teens with autism and their families would constitute one of the four groups. That was in keeping with the comfort level expressed by the group. Due to record-breaking snowfall in the Pittsburgh region, the overnight has twice been cancelled. Currently, the group has not yet chosen an alternate overnight to join. In that time the staff person in charge of overnights left her position and an interim person has taken charge.

Some of the Venture teens were interested in photography. We invited them to submit images they had taken from their tour for our internal monthly newsletter. We also created a digital survey to capture the teens' feelings about and impressions of the museum; where they saw their place in the museum; and some basic demographic information. We are in the process of collecting the data.

Applications for the *Teen Docent* program were sent to all members of the Venture Group. The interviewing process is underway for the new class and training begins in March. The staff person for the Venture Group is now on the list to receive notices for the *Teen Docent* Program. The museum staff person in charge of the *Teen Docent* Program, the *Discovery Room* and

Bone Hunters Quarry has incorporated new materials into the trainings for teen volunteers to adapt to the unique issues presented by members of the Venture Group. Some of the rules for volunteering were amended.

What we learned

Autism affects a person's cognitive development. People with autism might have trouble recognizing people, understanding facial expressions, and learning the difference between object categories. There may be difficulty in reading social cues. These are all important for program staff to know and use in our training and interactions. For instance, when the public says, *Thank you* to a Teen Docent, it really means, *I'm finished*. Translation for the museum volunteer: Stop talking; the people want to move on.

Working with this population, it is important to know that impairments in the areas of communication, restrictive/repetitive behaviors, and social skills do not manifest themselves all at the same level (mild, moderate, and/or severe). It is essential to recognize each individual's differences and needs.

People on the spectrum may react to or process sensory experiences differently than other children; the lack of eye contact does not necessarily indicate lack of interest or of understanding. It might be that there is too much stimulation for the person to listen and watch at the same time.

A therapeutic tool we found to be very helpful is the traffic light-with a single red, yellow, or green circle on a card. By

gentle and discreet prompting, the teens try to change the light from red to yellow or green: give opinion instead of a lecture, mention shared interests and experiences instead of an interrogation, point out caring, sharing, and exchanging instead of a delivering a monologue.

Program goals for the teens as volunteers are to learn, observe and practice appropriate social skills, in addition to learning content for the job; to connect teens in conversation, cooperation, friendship and increased experiences working with the public which would eventually lead to employment opportunities. Possible side benefits or outcomes for the program experience might be more emotional regulation and decreased self-stimming behaviors. A side benefit for the museum is having additional volunteers in the various programs. The main idea was that the Venture kids could learn and practice appropriate social skills by observing the neuro-typical teens' acceptable behaviors.

Some of the teens on the spectrum had communication issues. One such issue is *echolalia*, when a person repeats what is said. It may be immediate or delayed. Staff had to take into consideration that if they asked a question, all or part of it might be repeated, sometimes followed by the answer. As in: *What kind of dinosaur bone is that? What kind of bone is that – femur.*

Persons on the spectrum often have auditory processing deficits. They experience some difficulty in understanding what is said. Sometimes there is a lag time or a problem in understanding multiple steps of directions (or only the last

step). The solution? Simplify – offer one step at a time when describing the process for a task. Be sure to give enough time between asking a question and waiting for the answer.

Many people diagnosed with autism have prosody issues, that is, with the intonation of words. Their speech frequently has a flat or robotic tone. Reminding people to smile and have a friendly face often positively impacts speech tone. Of course, make sure that your tone is a good model for others to copy.

Persons on the spectrum often display what is called pragmatic language – they are "experts" in a particular field. Some children with autism tend to get stuck on a topic of interest, having it become an obsessive or all-absorbing interest. For those volunteering at the museum, we hope to capitalize on their interest when it coincides with an area of the museum and help the teens use their topic of interest in a positive, functional setting. Training in that topic area may be boring or exciting to them. We also try using that interest area to link to other areas of the museum that they might not think of as exciting. For example, dinosaur interest to other fossil animals; dinosaurs to birds. While the Teen Docent program has, in the past, had the condition that participants take all the trainings (based on the different exhibition halls in the museum), we are now making exceptions when necessary. We are also permitting teens to sign up for only one session an afternoon instead of the previous requirement of two if the teen feels s/he is only able to handle one session at this time.

Repetitive behaviors and self stimulating (flapping arms or hands; flipping fingers in front of eyes; making repetitive

sounds; jumping up and down; clenching muscles; and turning in circles) are characteristics of people with autism. We try to mitigate them using the traffic light cues, by controlling the environment, so that it doesn't become too stimulating or knowing when to step away for a break before things become overwhelming.

Conversational skills covered in the training include: taking turns, making some eye contact, non-verbal behaviors, stop/start cues, tone, content (what is acceptable to say), physical distance (between you and the public), topic volume (when the public asks a question make sure the answer is more like a water fountain than a fire hose), gestures (some are friendlier than others), expressions (put on a friendly face) and other ways to get a message across. Basics are also covered, such as how to act interested – use a friendly face and voice; look; ask questions/make comments: what is the other person doing, feeling, interested in?

Other issues are being addressed by the training. What is a friend? What does it mean to be a friend? Teens on the spectrum often have limited opportunities to practice friendship skills. Many have inadequate social skills because of issues with receptivity (what are others trying to communicate to them – reading others) and/or expressively (what they are trying to communicate to others – reaching others).

Some of the teens have difficulty with change/transition, down time, organizational skills, ambiguity/unpredictability, and overstimulation. Many of these issues are of concern to

all teens who will be working with the public. Time-tested suggestions to compensate are goal setting, practicing, and modeling desired behaviors. Rehearsing positive behaviors helps in breaking less appropriate behavioral routines. Make sure you devote lots of time to role playing and practice interacting with public. It is also important to identify a person the teen can go to to process events, a debriefing if you will, after their shift and any time if an incident should occur. As for all teens, actions should have clearly identified consequences determined in advance.

Modeling cooperation is another component of the training. How to ask someone to participate (join you). How about this idea? Have you considered? There might be more than one way... How one maintains a conversation of interest to others is another important lesson to be learned.

Many people on the spectrum process sensory input differently. The humming of florescent lights or a computer screen that isn't noticeable to the general public can be a distraction or stimulation, the smell of food, cleaning products, building materials, visitors' perfume can all be an assault on the sense of smell. Taste, textures (clothing, foods, materials to be handled), and sight (overly bright lights) can all affect an individual in various ways. It is important to be aware of the environment's potential to impact the person with autism. The museum environment includes granite or marble (different feel from walking on carpeting, tile or wood and associated echoes), the smell of old (musty or wood), smell of plastic, metal or wooden cabinetry, the feel and sound of

air moving between entry areas and halls, the noise of other visitors, from audio equipment, and the presence of crowds.

The more coordination with parents and mental health professionals the better. Locally we consult with a person from ABOARD (Advisory Board on Autism and Related Disorders) http://aboard.web.officelive.com in addition to the Venture family and the Bureau of Autism. Keeping lines of communication open is vital for success. As with many disabilities, there are a myriad of internet resources available for information on autism. These sites (see *Resources* section below) may provide some guidance, but we recommend working with local people for the best outcomes. If a museum is being proactive and doesn't have a local contact person, finding an organization online is a good start. Be aware that different organizations have differing agendas and foci.

Next steps

Because of the hurdles with actually having the overnights and getting the teens into the building observing different volunteer opportunities, our next step is continuing contact with the group and scheduling their next visit, encouraging the teens to apply for positions, and working with the Volunteer Office on placements.

Given the individuality of how ASD affects each person, there must be room for the individuality of the response. Sometimes it may work better to meet a group's needs by separating them. A private tour instead of a public one, a class with just children on the spectrum rather than open

enrollment or opening the museum early for families with children on the spectrum with readily available return passes if they have to leave. Having digital images of the museum (including stairs, elevator, water fountain, bathroom, halls, ramps, doors) available on your website, to acclimate the child or adult to the space prior to visit is very helpful. They can also be used by families of preschoolers and others prior to visitation. Make sure the images are downloadable. Families are empowered to make pre-visit choices at home and even create a book of their visit either before or after they come in. They can plan to follow a predetermined path based on the map of features they create. As a large museum we have experiences with other groups and could model a program on our successful *No Big Kids Allowed Day* (when the museum opens on an otherwise closed to the public day for preschoolers and has special activities and events planned) or our *Senior Citizen Days*. It is hoped that as people with autism get more familiar with the museum, they will self-select to participate in all the programs and opportunities that the museum offers. By encouraging teens and their families to participate and getting their feedback on programs, it is hoped that the museum's programs will be more universally inclusive.

Another issue for the Disability Community is how people with disabilities are portrayed in museums. Is their voice heard in history museums? Is their art displayed in art museums? This is another area for museums and the disability community to address.

Conclusion

While we haven't had total success yet in implementing our nascent program with teens on the spectrum, we are working with an identified group toward a goal. Museums and Disability Groups can partner together to improve programs and opportunities. Best practices in the museum community today are those that are inclusive and integrate people with disabilities into all museum programs and exhibits. This article is written in the spirit of moving toward a more fully inclusionary and democratic society; of bridging the gap of where we, the museum community, are today and where we would like to be. The author hopes that the road will be well-traveled.

Resources

Association for Science in Autism Treatment

http://www.asatonline.org/

ASAT is a not-for-profit organization of parents and professionals committed to improving the education, treatment, and care of people with autism. Our mission is to disseminate accurate, scientifically sound information about autism and treatments for autism and to improve access to effective, science-based treatments for all people with autism, regardless of age, severity of condition, income or place of residence. Since ASAT was established in 1998, it has been our goal to work toward adopting higher standards of accountability for the care, education and treatment of all individuals with autism.

Autism and PDD Support Network

http://www.autism-pdd.net/

Autism-PDD.Net is an information and resource site for parents of children and caregivers coping with Autism. We provide an online support community forum for you and parents to express your thoughts, ideas and seek help. We will continue to provide the most current information to help you as we have been for the past 7 years.

Autism Collaboration

http://www.autism.org

We lead a parent-driven collaboration dedicated to advancing autism research in the interest of all individuals living with autism today. We believe that the perception of autism as a lifelong incurable psychiatric disease needs to be abandoned to embrace one that views autism as a medical disorder that is preventable and treatable. We are here to fund effective research – we are not the researchers. Our grantees are treated as partners for the cause.

Autism Consortium

http://www.autismconsortium.org/

The mission of the Autism Consortium is to catalyze rapid advances in understanding, diagnosis and treatment of autism by engaging, supporting and fostering collaboration among a community of clinicians, researchers, donors and families in order to improve the care of children and families affected by autism and other neurological disorders. They founded the Autism Consortium, assembling an unprecedented team of imaginative, bold researchers dedicated to changing the way we understand and treat autism. Bold and creative donors fostering bold and creative science: a potent combination for revolutionizing science and treating a complex disorder now.

Autism Education Network

http://www.autismeducation.net/

Our primary purpose is to provide information and training to families and professionals regarding best practices in autism treatment. The Autism Education Network also works with professional organizations to develop community-based programs and we coordinate clinical outreach services so that local families can access treatment options not generally available in the Silicon Valley.

Goals & Objectives 1. Help families identify appropriate educational interventions in their community. 2. Provide conferences and training supporting best practices. 3. Develop community-based programs and services. 4. Raise funds for scholarship programs for community-based inclusion programs. 5. Establish volunteer committees to address current issues.

Autism National Committee

http://www.autcom.org/

AUTCOM is the only autism advocacy organization dedicated to "Social Justice for All Citizens with Autism" through a shared vision and a commitment to positive

approaches. Our organization was founded in 1990 to protect and advance the human rights and civil rights of all persons with autism, Pervasive Developmental Disorder, and related differences of communication and behavior. The Committee further believes that the principles of social justice can only be upheld through organizational methods which reflect those principles. Just as we envision communities based on the cultivation and support rather than the control of their members, the Committee encourages its individual members and organizational partners toward self-direction and self-empowerment.

Autism One Network

http://www.autismone.org/

Autism One is a nonprofit, charity organization 501(c)(3) started by a small group of parents of children with autism. Parents are and must remain the driving force of our community, the stakes are too high and the issues too sacred to delegate to outside interests. Autism is a preventable/treatable biomedical condition. Autism is the result of environmental triggers. The key is education: The Autism One Conference, Autism One Radio, Autism One Outreach and Autism in Action initiatives educate more than 100,000 families every year about prevention, recovery, safety, and change.

Autism Research Institute

http://www.defeatautismnow.com/

The Autism Research Institute (ARI) is a non-profit organization founded in 1967 by Bernard Rimland, Ph.D. ARI conducts and sponsors "research that makes a difference, "focusing on studies that translate into immediate benefits for today's generation of children and adults with autism. Over the past three decades ARI has pioneered a number of successful treatments supported by experimental and clinical evidence. Defeat Autism Now! is a project of ARI dedicated to the exploration, evaluation, and dissemination of scientifically documented biomedical interventions for individuals

within the autism spectrum.

Autism Society of America

http://www.autism-society.org

The Autism Society, the nation's leading grassroots autism organization, exists to improve the lives of all affected by autism. We do this by increasing public awareness about the day-to-day issues faced by people on the spectrum, advocating for appropriate services for individuals across the lifespan, and providing the latest information regarding treatment, education, research and advocacy.

Founded in 1965 by Dr. Bernard Rimland, Dr. Ruth Sullivan and many other parents of children with autism, the Autism Society is the leading source of trusted and reliable information about autism. The Autism Society is a member and chapter organization who's national Board of Directors is composed of democratically elected members and appointed members. We are proud to be one of the few organizations to have members with autism serving as active board directors.

Autism Speaks

http://www.autismspeaks.org

Mission: At Autism Speaks, our goal is to change the future for all who struggle with autism spectrum disorders. We are dedicated to funding global biomedical research into the causes, prevention, treatments, and cure for autism; to raising public awareness about autism and its effects on individuals, families, and society; and to bringing hope to all who deal with the hardships of this disorder. We are committed to raising the funds necessary to support these goals. Autism Speaks aims to bring the autism community together as one strong voice to urge the government and private sector to listen to our concerns and take action to address this urgent global health crisis. It is our firm belief that, working together, we will find the missing pieces of the puzzle.

Autism Speaks was founded in February 2005 by Bob and Suzanne Wright, grandparents of a child with autism. Since then, Autism Speaks has grown into the nation's largest autism science and advocacy organization, dedicated to funding research into the causes, prevention, treatments and a cure for autism; increasing awareness of autism spectrum disorders; and advocating for the needs of individuals with autism and their families.

Autism Treatment Center of America

http://www.autismtreatmentcenter.org/

Since 1983, the Autism Treatment Center of America™ has provided innovative training programs for parents and professionals caring for children challenged by Autism, Autism Spectrum Disorders, Pervasive Developmental Disorder (PDD) and other developmental difficulties. The Son-Rise Program® teaches a specific and comprehensive system of treatment and education designed to help families and caregivers enable their children to dramatically improve in all areas of learning, development, communication and skill acquisition. All programs are designed especially for parents to teach parents how to effectively help and work with their children.

Autism United

http://www.autismunited.org/

Autism United is an alliance of families and individuals affected by autism spectrum disorders working with professionals and organizations who serve the autism community. Our effort begins with families working together to build community support, services and resources. Autism United will forge our collective strength to improve the welfare of individuals and families affected by ASD.

We join together to support professionals who pursue treatment-based research that can help improve the quality of life for people affected by ASD, find the causes of the

autism epidemic, and ultimately recover people affected by ASD.

We will build community strength and practical assistance so that a caring and united community can protect the interests of all individuals affected by ASD throughout their lifespan.

Autistic Society

http://www.autisticsociety.org/

Our mission is to unite parents, families, friends, people with Autism and professionals by creating a strong, supportive community worldwide. Sharing first hand knowledge, information, news and research about Autistic Spectrum Disorders. Together we can build a better understanding and awareness of autism around the globe and help each other in need. If you have a question post it in our forum, somebody in our community may know the answer.

Exploring Autism

http://www.exploringautism.org

The Exploring Autism website is the result of a collaboration between researchers, non-profit groups, and families who are living with autism. Organizations that make this site possible range from major universities and medical centers to the National Alliance for Autism Research. Researchers from these institutions are members of Autism Genetics Cooperative

This website is dedicated to helping families who are living with the challenges of autism stay informed about the exciting breakthroughs involving the genetics of autism. As new genetic research findings are reported for autistic disorder we will report and explain these findings. We will explain genetic principles as they relate to autism, provide you with the latest research news, and seek your input as together we work to increase the body of knowledge about autism. The Exploring Autism website is the collaborative effort of Autism Genetics Cooperative, a group of researchers and

clinicians working with the help of families with children affected by autism to find the genetic causes of autism.

Families for Early Autism Treatment

http://www.feat.org/

Education: We educate families about best-outcome treatment and increase public awareness by providing information about autism prevalence, incidence and variance. Advocacy: We advocate for children with autism while training their parents to become their best advocate. Support: We provide bridge funding for treatment, resource groups and social activities for children with autism and their families. FEAT supports children, young adults and adults who are living with autism.

FEAT is a non-profit volunteer driven organization of parents, educators and treatment professionals dedicated to providing Education, Advocacy, and Support for the Northern California Autism Community. FEAT was founded in 1993 by parents and professionals to bring best outcome treatment to the Greater Sacramento area.

First Signs

http://www.firstsigns.org/

First Signs, Inc. is a national non-profit organization dedicated to educating parents and professionals about the early warning signs of autism and related disorders. Our mission is to ensure the best developmental outcome for every child by promoting awareness regarding the most important and often overlooked aspects of development: social, emotional, and communication. Our goals are to improve screening and referral practices and to lower the age at which young children are identified with autism and related disorders.

The organization was founded in 1998 by a parent of a child with autism. First Signs, Inc. has 501(c)(3) tax-exempt status as a non-profit organization, and is based in Merrimac, Massachusetts. First Signs has created a statewide model program for disseminating

key information about early warning signs, the need for routine screening, and the treatment options available to parents of children diagnosed. The First Signs program provides professionals with tools and training, and parents with education and support, to help young children stay on a healthy developmental path.

Interactive Autism Network

http://www.ianproject.org/

The Interactive Autism Network (IAN) is an innovative online project bringing together tens of thousands of people nationwide affected by autism spectrum disorders (ASDs) and hundreds of researchers in a search for answers. Individuals with an ASD and their families can share information in a secure setting to become part of the largest online autism research effort in the United States. The data collected by IAN both facilitates scientific research and empowers autism community leaders to advocate for improved services and resources. In addition, anyone impacted by an ASD can become part of IAN's online community to stay informed about autism research and make their voices heard.

IAN, the Interactive Autism Network, was established in January 2006 at Kennedy Krieger Institute and is funded by a grant from Autism Speaks. IAN's goal is to facilitate research that will lead to advancements in understanding and treating autism spectrum disorders (ASDs). To accomplish this goal, we created the IAN Community and IAN Research.

International Society for Autism Research

http://www.autism-insar.org/

The International Society for Autism Research (INSAR) is a scientific and professional organization devoted to advancing knowledge about autism spectrum disorders.

The International Meeting for Autism Research (IMFAR) is an annual scientific meeting, convened each spring, to exchange and disseminate new scientific progress

among ASD scientists and their trainees from around the world. The first and primary aim of the meeting is to promote exchange and dissemination of the latest scientific findings and to stimulate research progress in understanding the nature, causes, and treatments for ASD.

National Autism Association

http://www.nationalautismassociation.org/

The mission of the National Autism Association is to educate and empower families affected by autism and other neurological disorders, while advocating on behalf of those who cannot fight for their own rights. We will educate society that autism is not a lifelong incurable genetic disorder but one that is biomedically definable and treatable. We will raise public and professional awareness of environmental toxins as causative factors in neurological damage that often results in an autism or related diagnosis. We will encourage those in the autism community to never give up in their search to help their loved ones reach their full potential, funding efforts toward this end through appropriate research for finding a cure for the neurological damage from which so many affected by autism suffer.

National Autism Center

http://www.nationalautismcenter.org/

The National Autism Center is dedicated to serving children and adolescents with Autism Spectrum Disorders (ASD) by providing reliable information, promoting best practices, and offering comprehensive resources for families, practitioners, and communities.

An advocate for evidence-based treatment approaches, the National Autism Center identifies effective programming and shares practical information with families about how to respond to the challenges they face. The Center also conducts applied research and develops training and service models for practitioners. Finally, the Center works to

shape public policy concerning ASD and its treatment through the development and dissemination of national standards of practice. Guided by a Professional Advisory Board, the Center brings concerned constituents together to help individuals with ASD and their families pursue a better quality of life.

Online Asperger Syndrome Information and Support and MAAP Services for Autism and Asperger Syndrome

http://www.aspergersyndrome.org/

The Online Asperger Syndrome Information and Support (OASIS) center has joined with MAAP Services for Autism and Asperger Syndrome to create a single resource for families, individuals, and medical professionals who deal with the challenges of Asperger Syndrome, Autism, and Pervasive Developmental Disorder / Not Otherwise Specified (PDD/NOS). This web site provides articles, educational resources, links to local, national and international support groups, sources of professional help, lists of camps and schools, conference information, recommended reading, and moderated support message boards. The web site resources are an addition to the annual conference, newsletter email and phone support provided by MAAP Services.

MAAP Services was started in 1984 by Susan Moreno. Susan had met with 24 other parents of more advanced individuals with autism, Asperger's Syndrome, or pervasive developmental disorder. At that time, all 25 parents agreed to share their names, addresses, phone numbers and information about their challenged loved ones with one another in hopes of corresponding about their common problems, advice, etc. MAAP Services is currently funded by the individual contributions of parents, professionals, private foundations and philanthropic organizations.

Organization for Autism Research

http://www.researchautism.org/

The Organization for Autism Research (OAR) was created in December 2001–the

product of the shared vision and unique life experiences of OAR's seven founders. Led by these parents and grandparents of children and adults on the autism spectrum, OAR set out to use applied science to answer questions that parents, families, individuals with autism, teachers and caregivers confront daily. No other autism organization has this singular focus.

OAR's mission is to apply research to the challenges of autism. The mission of "applying" research to answer questions of daily concern for those living with autism drives each of the goals and objectives that define OAR's programs and determine its budget. OAR defines applied research as research that directly impacts the day-to-day quality of life of learners with autism. It entails the systematic investigation of variables associated with positive outcomes in such areas as education, communication, self care, social skills, employment, behavior, and adult and community living. In this context, it extends to issues related to family support, the efficacy of service delivery systems, and demographic analyses of the autism community. In simplest terms, applied autism research is "practical research that examines issues and challenges that children and adults with autism and their families face everyday."

Pathfinders for Autism

http://www.pathfindersforautism.org/

Pathfinders for Autism is a parent sponsored, non-profit organization dedicated to improving the lives of individuals with autism and their families. In 2000, Pathfinders for Autism was founded by a group of parents of children with autism to support and develop lifespan services and provide information and resources for families of children with autism. Goal is early detection. Pathfinders for Autism is a 501(c)3 nonprofit, charitable organization. "Our mission is to find a path for our children."

Safe Minds (Sensible Action For Ending Mercury-Induced Neurological Disorders)

http://www.safeminds.org/

The Coalition for SafeMinds is a non-profit organization founded to scientifically investigate, support research, raise awareness, change policy and focus national attention on the growing evidence of a link between mercury and neurological disorders such as autism, attention deficit disorder, language delay and learning difficulties. Our mission is to end the health and personal devastations caused by the needless exposure to mercury, one of the most neurotoxic substances on earth.

We envision that through the accomplishment of our mission we will assist in creating optimal health in pregnant women, infants and children through the elimination of unnecessary exposure to mercury in its many forms.

Southwest Autism Research and Resource Center

http://www.autisticsociety.org/

Established in 1997, the Southwest Autism Research & Resource Center's (SARRC) mission is to advance research and provide a lifetime of support for individuals with autism and their families. SARRC undertakes self-directed research, serves as a satellite site for national and international projects and provides up-to-date information, training and assistance to families and professionals about autism.

This history of SARRC begins with two dedicated mothers of children with autism and a doctor who cared for their children. SARRC had developed a series of educational workshops for parents, educators and students; began worldwide collaborations; established a database of families; and participated in the first clinical trial of secretin in the treatment of autism.

Talking About Curing Autism

http://www.talkaboutcuringautism.org

Our Mission: Talk About Curing Autism (TACA) provides information, resources, and support to families affected by autism. For families who have just received the autism diagnosis, TACA aims to speed up the cycle time from the autism diagnosis to

effective treatments. TACA helps to strengthen the autism community by connecting families and the professionals who can help them, allowing them to share stories and information to help people with autism be the best they can be.

Since 2000 Talk About Curing Autism (TACA) has been providing support services to Californians. Beginning in 2007, TACA expanded its services throughout the United States. Ninety-five percent of what TACA provides to families affected by autism is free. TACA provides support and education for families affected by autism through outreach and parental education.

The Autism Hub

http://www.autism-hub.co.uk

The Autism Hub is a central point for blogs about autism from autistic people, family members, and students/professionals. The Autism Hub promotes diversity and human rights, with ethics and reality as the core guiding principles; aspects include: empowerment/advocacy, acceptance, and a positive outlook.

The Autistic Self Advocacy Network

http://www.autisticadvocacy.org/

Mission Statement: The Autistic Self Advocacy Network seeks to advance the principles of the disability rights movement in the world of autism. Drawing on the principles of the cross-disability community on issues such as inclusive education, community living supports and others, ASAN seeks to organize the community of Autistic adults and youth to have our voices heard in the national conversation about us. In addition, ASAN seeks to advance the idea of neurological diversity, putting forward the concept that the goal of autism advocacy should not be a world without Autistic people. Instead, it should be a world in which Autistic people enjoy the same access, rights and opportunities as all other citizens. Working in fields such as public policy, media representation, research and systems change, ASAN hopes to empower Autistic

people across the world to take control of their own lives and the future of our common community. Nothing About Us, Without Us!

Who are we? The Autistic Self-Advocacy Network (ASAN) is a non-profit organization run by and for Autistic people. ASAN's supporters include Autistic adults and youth, cross-disability advocates, family members, professionals, educators and friends. ASAN was created to provide support and services to individuals on the autism spectrum while working to change public perception and combat misinformation by educating communities about persons on the autism spectrum.

The Doug Flutie Jr. Foundation for Autism

http://www.dougflutiejrfoundation.org

Our mission is to support families affected by Autism Spectrum Disorder. We are committed to increasing awareness of the challenges of living with autism and helping families find resources to help address those challenges. We provide individuals with autism and their families an opportunity to improve their quality of life by funding educational, therapeutic, recreational and advocacy programs

In 2000, they established the Doug Flutie, Jr. Foundation for Autism, Inc. as an independent foundation to continue this work. Since 1998, the Fluties have helped raise over 10 million dollars for autism through corporate and individual donations, fundraisers, endorsement promotions featuring Doug and Doug Jr. as well as sales of Flutie Flakes and other related items.

The Real Autism

http://www.autistics.org/

The purpose of the autistics.org project is to connect autistic people with the services we need to live whole and happy lives. The immediate goal of autistics.org is to build a global database of information and resources by and for persons on the autistic spectrum. The autistics.org project is by and for autistics, not parents of autistic

children, though family members and professionals may find this website helpful.

Tin Snips

http://www.tinsnips.org/

Tinsnips is a special education resource that strives to share a variety of specialized teaching tools, techniques, worksheets, and activities with teachers of students who have autistic spectrum disorders and related developmental disabilities.

Unlocking Autism at http://www.unlockingautism.org

Our mission: To bring the issues of autism from individual homes to the forefront of national dialogue. To join parents and professionals in one concerted effort to fight for these children who cannot lift their voices to the nation for help. To educate parents about pending legislation and existing laws. To educate parents about biomedical treatments and behavioral therapies. To assist parents of newly diagnosed children by providing direction through a parent-to-parent support hotline in an effort to network families across the country. To raise funds for biomedical research, behavioral research, and projects. To work to increase society's ability to work with and understand people with autism. To help those on the autism spectrum reach their greatest potential in leading fulfilling and productive lives in relationships, society and employment. To educate parents to the danger of mercury to the developing brain of children both born and unborn. To work to preserve every parent's choice of conscientious belief and religious exemptions for vaccinations.

Unlocking Autism was founded in February of 1999 by two mothers and a grandmother. Our organization is based on 100% volunteer efforts. No one receives monetary compensation for the work that they do. Our over 250 state representatives are present in nearly every state in America and operating in nine other countries around the world to date. We educate parents of children of all ages about biomedical, behavioral and sensorial intervention options that can make a difference in their child's lives. We educate parents on the importance of grassroots political involvement.

US Autism and Asperger Association

http://www.usautism.org/

US Autism & Asperger Association (USAAA) is a 501(c)(3) nonprofit organization for Autism and Asperger education, support, and solutions. Our goal is to provide the Opportunity for individuals with autism spectrum disorders to achieve their fullest potential. Providing immediate solutions through expert guidance and compassionate support. Consolidating the overwhelming amount of information and resources to simplify the lives of all associated with autism. Individualizing education on treatments and services for the diverse population of those affected. Providing networking opportunities for parents, professionals, students, educators, and individuals.

World Autism Awareness Day

http://www.worldautismawarenessday.org

World Autism Awareness Day shines a bright light on autism as a growing global health crisis. WAAD activities help to increase and develop world knowledge of the autism epidemic and impart information regarding the importance of early diagnosis and early intervention. Additionally, WAAD celebrates the unique talents and skills of persons with autism and is a day when individuals with autism are warmly welcomed and embraced in community events around the globe.

By bringing together autism organizations all around the world, we will give a voice to the millions of individuals worldwide who are undiagnosed, misunderstood and looking for help. Please join us in our effort to inspire compassion, inclusion and hope.

Making the Most of Museum Field Trips

ANURADHA BHATIA & CAROLE J MAKELA

Colorado State University

Field trips to museums are the most popular school outings many adults remember from their elementary school days.[1] Today, museums offer age- and grade-appropriate programs and invite teachers and their students for half- or full-day excursions and guided tours. Field trip programs which meet curriculum standards attract teachers and students to museums. Through interactive programming, museum educators expect to impact affective aspects of children's learning such as curiosity, amazement, and interest to learn more, and impart an experience to last a lifetime.[2]

To justify their museum field trips, teachers focus on conceptual learning as the primary purpose and outcome. They schedule annual field trips to supplement classroom curriculum, yet many do not fully optimize the informal learning experiences gained at the museum.[3] This paper suggests ways to optimize student learning experiences on field trips, the purpose of which should not be limited to curriculum supplementation. While supplementing curriculum is an important aspect of making school outings meaningful, museum field trips are meant to impart long lasting learning experiences. Organizing museum (art, science, or natural/local history) field trips for exploration and discovery in addition to supplementing classroom teaching may result in learning applicable to a variety of subjects and fields.

A meaningful field trip requires more from a teacher than scheduling and reserving transport. Planning museum field trips that are well-connected needs activities, before and after

the trip, to solidify museum experiences and complete the learning cycle (see Fig. 1). Collaboration between museums and schools to organize pre-and post-trip lessons and activities in school is necessary to enhance informal museum learning and to make the field trip a meaningful experience for children. Preparation before the field trip, orients children for a novel milieu and learning experience outside their classrooms. After the field trip, experiences gained at the museum are reinforced through children's discussions, presentations, and writing and drawing activities in classrooms. The social aspect of post-field trip learning, thus, solidifies experiences gained at the museum.[3] Museum educators bear part of the responsibility to help teachers plan field trips. Museums can implement initiatives such as offering pre- and post-field trip activities and guides, organizing teacher trainings and museum previews, or providing opportunities for web scheduling and support, which may help teachers to integrate museum programs in classroom seamlessly.

The purpose of this paper is to propose recommendations to educators and teachers for optimizing students' learning experiences on field trips. A checklist is included for teachers based on the learning cycle (Fig. 1) to enable planning and facilitating students' experiences on museum field trips while supporting the educational objectives of museum educators and teachers. The framework suggests pre-field trip classroom activities to set the trip context and then reinforcing the museum experiences in the classroom with post-field trip activities.

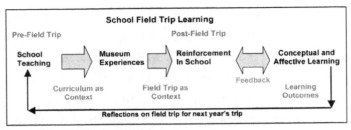

Figure 1: School Field Trip Learning Cycle

Museum programming for schools

School children and young people constitute the largest visitor group for museums. Inviting schools to museums for field trips is one common strategy to fulfil museums' educational missions and to support classroom teaching. By offering object-based programming that supplements (or enriches) school curricula, museums strive to achieve their mission of providing education. Many museums offer classroom visits when schools are unable to bring children to museums. Alternatively, there are trunk programs available free or for a small fee to supplement classroom teaching whether or not a field trip is part of the plan.

Museum programming for schools has changed in the past decades from being walk-and-talk tours to interactive and hands-on teaching to engage children and young people. Partnerships between museums and schools to teach and learn science, art, history, geography, and other subjects have evolved from being a day-out-of-school excursion to building curriculum-related experiences influenced by educational reforms and policies. According to an Institute of Museum and Library Services (IMLS) survey conducted in 2000-01,

the number of school programs offered through museums steadily increased since 1995. The majority of programs were offered to upper elementary school children (3^{rd}–5^{th} grades). Until 2000-01, social studies was the most targeted curriculum by museum educators followed by art, science, and language arts.[4] The legislation *No Child Left Behind* (NCLB), enacted in 2001, pressured U.S. teachers and schools to be accountable for reading and writing curriculum through high stakes state-level testing. A decline in school field trips since the implementation of NCLB has been observed by museum professionals.[5] School budget cuts have further taken a toll on field trips in the United States.[6]

Museums form partnerships with schools and school districts as both institutions want to impart education using teaching and learning methodologies appropriate for their environments. Museum teaching is object-based, relatively less structured, and non-evaluative, and thus, considered informal.[7-10] Museums' exploratory environments provide a novel physical context for children outside the school's settings.[11] In museums, object-based teaching and informal learning create sensory experiences to encourage curiosity, motivation, and interest leading to active student participation that results in affective experiences and learning.[12-13] Free choice and informal learning, when used effectively and efficiently by museum educators and school teachers, can help develop lifelong learning skills among children.[14] Museums' programming with hands-on, minds-on, interactive, and playful activities connects formal to

informal education. In contrast, teaching and learning in schools is formal, sequential, and evaluative, guided by national and state curriculum standards.[15]

School and museum partnership

Researchers in the past decade have examined the learning purposes and outcomes of school field trips from teachers' and educators' perspectives.[16-18] Differences between teachers' and educators' field trip purposes and outcome expectations prompted this study to explore a partnership for student learning between elementary schools and a local history museum in an urban town in Northern Colorado.

The museum's field trips are designed to supplement a second grade local history unit taught as part of the social studies curriculum. The field trip program choices include docent-led presentations and activities at historic cabins located in a courtyard and a tour of the museum's gallery. Teachers may combine cabin and gallery visits or choose to have historic cabin tours of 90–120 minutes. The gallery tour includes a scavenger hunt to allow free exploration by children. Depending on the time available, teachers and students are encouraged to visit the seasonal exhibition in the museum gallery.

Teachers' and educators' perceptions of field trip experiences provided insights into the partnership between the district's schools and the local history museum. In-depth interviews of educators (n = 7) and a questionnaire administered to 2nd grade teachers (n = 72) were the primary data sources. A post field

trip activity (n = 3 schools [6 classrooms, and 125 children]) provided insights on students' learning and validated the questionnaire and interview data.

The museum educators indicated their expectation of teachers to conduct pre-field trip classroom activities and prepare students to learn local history and build long-lasting experiences on museum field trips. For educators, conceptual learning is one of the underlying outcomes of museum programs. The museum programs-based school curriculum standards provide a common ground to initiate dialogue with students. Staying true to the museum's mission, educators provide informal education through object-centered teaching. With a field trip program that supplements the second grade classroom teaching, educators want children to experience the museum and get excited about history. Accepting the challenges of short (90-120 minute) one-time trips and students' ages (7-9 years), educators strive to impart exploratory experiences and curiosity among children, encouraging return visits with family and friends to learn more. They expect (and hope) that teachers will integrate field trips into their classrooms using post-visit activities to reinforce the museum experiences. They believe field trips, planned during the curriculum unit in the classroom, benefit student learning the most compared to at the end of the unit which does not leave time to reinforce museum experiences or assess children's gains.

In response to survey questions, the teachers' indicated that their field trip objectives and learning outcomes were geared

toward students' curricular experiences at the museum. Teachers think field trips supplement school curriculum well and a fun-filled field trip suggests success. They credit their in-class teaching and museum educators' informal teaching styles for successful field trips. Most teachers are not trained to capitalize on learning from informal environments and they are willing to implement pre- and post-field trip activities with educators' help. However, they have not approached the museum educators to provide help with classroom activities. The teachers do not acknowledge children's experiences beyond the curriculum; nor do they use the field trip experiences to build further learning.

Based on the communicated purposes and interactions between museum educators and teachers, the partnership between the two institutions for field trips appeared coordinated. As educators offer a once-a-year field trip to impart lifelong learning experiences to second graders, teachers take students to the museum for a curricular experience and conceptual gains. The inherent difference in each institution's educational philosophy impacts educators' and teachers' outlooks of field trips. Minimal communication between the institutions to schedule field trips impedes an advancement to higher levels (coordinated or integrated) of partnership.[19]

A connected field trip and sustained partnership between museums and schools demands the consistent communication and exchange of expectations, ideas, and resources and a unified purpose among partners to achieve

targeted learning outcomes benefiting students. Educators can provide educational resources and information for use in the classroom to connect field trips better with classroom teaching. Similarly, teachers' feedback on museum programs, as well as children's learning experiences, can help museum educators evaluate their programs and docent presentations.

To take this partnership to collaboration or integration levels, educators and teachers need to make a unified commitment to student learning. This can be achieved through enhanced communication, shared resources to train teachers to capitalize on museum resources, and most of all, giving teachers an opportunity to understand the museum's educational mission.

Recommendations to museum educators
Here are the recommendations for museum educators to advance their partnership with teachers to collaboration (and integration) with the goal of enhancing student learning.

1. Direct and improved communication with teachers
To have an effective partnership, educators need to proactively inform teachers of the museum's purpose of imparting experiences through field trips. This can be achieved by inviting teachers to serve on museum advisory boards, offering museum preview days, and providing teacher training to bridge formal and informal learning.

Invite teachers on to the Advisory Board: On a nationwide education listserv discussion in Dec. 2008, museum

professionals suggested having teacher advisory boards comprised of 15-20 elementary grade teachers or more representing schools to plan and process field trip programs. These boards should be invited for three or four meetings a year to discuss program goals and agendas, brainstorm new program ideas, and review progress of the current programs. This direct communication between partners is necessary to set a course of museum programming supporting a unified purpose and coordinated efforts for shared learning outcomes. Teachers on the board may enjoy incentives such as free/discounted memberships, preference for attending lectures, classes, and educational seminars, and discounts at museums' gift stores (Based on museum professionals' postings on a MER listserv in Dec. 2008).

Offer Teacher Preview Days: Teachers can be invited to preview programs and resources (e.g. pre-and post-activities, trunks, etc.) available at the museum to support classroom teaching. A preview organized at the beginning of the school year will give teachers a head start for planning and preparation of the field trips to optimize learning gains. It is important for teachers to understand the museum as a novel place and the roles objects, exhibits, and displays play in the dynamics of learning. Teacher previews can present opportunities to share field trip implementation strategies with their colleagues.

Alternatively, attending teachers' professional organization meetings may give educators a venue to initiate dialogue with teachers. This will give educators a chance to network and

have multiple contacts in the teacher community. Relying on a Curriculum Coordinator as the conduit may not be enough to enhance the visibility of the museum. These sessions would provide educators with opportunities to directly answer teachers' questions and promote museums' programs.

Train teachers to bridge formal and informal education: Museum educators need to proactively promote the museum's experiential and informal methods of learning by training teachers to optimize student learning on field trips. Educators can organize training sessions for teachers and trainee teachers about museums' informal learning and teaching methods and resources available through the museum. Research shows training about museum resources helps teachers with professional development and classroom teaching.[20] During these sessions, teachers are made aware of research to extend museum experiences in schools. They can earn professional development credits for attending the sessions.

Invest in an informational website: An informational and interactive website, which supports lessons and program guide downloads, aids scheduling of field trips, and offers an array of activities related to field trips, will promote communication between museums and schools. Teachers can access the website to download classroom activities as well as use it as a venue to provide constructive feedback to the museum. A web interface between educators and teachers is essential when both have time limitations.

Visit classrooms: Educators can build rapport and field trip contexts with teachers and students with pre-and/or

post- visit(s) to classrooms. Setting the context before the field trip helps children have focused interactions with objects and exhibits which further impacts learning.[21-24] Pre-visits establish a common knowledge base among children which educators can use to build museum presentations. Museum educators' post-field trip visits can help extend and reinforce the museum experiences for teachers and students. Time constraints may limit educators making such visits a reality. In the absence of these, educators may provide pre- and post-field trip classroom activities, which may have the same impact as school visits. Museum educators should post pre-and post-field trip activities online so that teachers can download at their convenience for use in classrooms.

2. Provide learning opportunities to children
Children's work created as a post field-trip activity suggested that educators' enthusiasm influenced students' experiences in addition to the hands-on activities. Engagement with exhibits and objects, which is generally measured in time spent, does not necessarily translate into learning, whereas "short periods of time under the right conditions" are enough for high quality learning.[24] Learning and experiences result from young visitors' constructive interpretations and interests.[25] Educators and teachers are responsible for providing the conditions to optimize children's learning by giving them an experience of the museum as a place. Children learn best by social interactions. They should have opportunities to express in writing, drawing, and/or through discussions with

peers, what they experienced at the museum. During the field trip programs, educators must allow time with the children to review their field trip experiences and information before they return to school. The discussion can be used to answer queries and provide clarifications. This may also provide an opportunity to reinforce the vocabulary used during the presentations as children may be hearing new words and phrases.

3. Investment in docent training

Our research shows that educators' enthusiasm to share information influenced students' interest and learning. The museum should invest in ongoing docent training as the educators' role is crucial on field trips to enhance students' motivation to learn. Docents should have opportunities to learn from museum, education, and psychology experts the methods best suited to impart learning to young children in informal settings. Educators may identify teachers who are enthusiastic about museums and experiential learning and use their help to train docents. Video-taping presentations to train docents on teaching and learning methods for children can also be explored.

4. Teachers' assessment of field trips

To serve teachers and students better and to understand the worth of school field trip programs, educators need to have a comprehensive program feedback instrument and assessment plan. Appropriate action and reactions to feedback

are necessary to complete the evaluation cycle. Educators must find a system to inform teachers of actions taken on feedback. A quarterly/semi-annual newsletter mailed directly to teachers or website postings are suggestions for reporting actions on feedback.

5. Periodic program assessments
It is important to periodically assess museum programs and evaluate their effectiveness in terms of implementation and outcomes. Updating programs to incorporate research-based theories and methodologies can foster audience engagement and learning skills.

In the museum and school partnership, teachers are as much a part as educators. The following recommendations, which educators should help teachers implement, are intended to strengthen partnerships and enhance student learning.

Recommendations to teachers
Using the learning cycle to optimize learning and reinforce children's museum experiences, teachers should prepare and implement activities in the classroom before and after field trips. The following recommendations are made to help them in planning and implementing meaningful museum field trips.

1. Direct and consistent communication with educators
Have direct communication with educators via phone or email to convey your purposes and desired outcomes from field

trips. Field trip outcomes should not be limited to cognitive and curricular connections and should include affective outcomes as well, to impart longer-lasting experiences.

Recognize the importance of a shared purpose in student experiences and learning: If educators know the students' contexts from the classroom, it helps prepare an individualized field trip for them. Teachers may ask parents or a staff person to help organize the field trip by conveying specific information such as students' background knowledge (e.g. books and texts used), classroom activities (e.g. use of trunk, or role playing), and specific curricular standards to museum educators.

Collaborate with educators to improve pre-and post-field trip activities and help design and test new ones to enhance children's learning.

Provide constructive and candid feedback including strengths and weaknesses to help educators assess their field trip programs.

Take part in museum-organized events and activities such as serving on advisory boards and attending seminars, lectures, and museum previews to understand the museums' education missions and philosophies and to find out about the available resources to incorporate in teaching.

2. Better learning opportunities for children
Children benefit from the informal learning experiences museums offer, which are greater than conceptual learning and encompass affective domains. For example, in the note

cards collected as a post-field trip activity, children wrote about and/or drew objects that piqued their interest. They shared their feelings and depicted themselves as happy visitors to the museum. These experiences can be enhanced by implementing the following:

Plan field trips during the unit as it helps children to learn and relate. Conduct pre-field trip activities as they provide a context, prepare children for a novel learning environment, and help them build new experiences.

Help children experience the museum as a place in addition to what is displayed at the museum. As informal learning places, museums are designed to impart experiences through exploration, discovery, and fun activities. These experiences may provide lasting memories.

Give children time to learn and absorb while at the museum. Recognize the multiple intelligences in students.[26] Work with educators to develop strategies so all students benefit from field trips. Allow time for exploration as no one knows what object or experience might capture a student's attention!

Re-visit museum experiences using post-field trip activities in class. To build long-lasting memories, museum experiences should not end with the field trip but should continue at school. Promote a culture for critical thinking by asking children to share their museum experiences using writing/drawing/discussion exercises in classrooms. Use field trip experiences to facilitate discussions and to complete the learning cycle for the students (see Fig. 1).

3. Connect the field trip to other subjects
Children's post-field trip activity suggested they learned new vocabulary at the museum with or without the conscious intent of the educators.

Develop classroom writing activities to explain the meanings and usage of new words introduced on field trips. As this is the age when children learn and strengthen language skills, make new vocabulary part of science, English, and language arts.

4. Use the Field Trip Checklist
A checklist is included below to help plan pre-, during, and post-field trip agendas to make learning experiences meaningful for students. This checklist includes actions to plan and implement field trips with longer-lasting learning gains, encompassing cognitive and affective domains. These actions also help build a sustained partnership with an area museum and its educators by helping them meet their educational goals.

Summary
To enhance students' learning experiences (or experiential learning), it is important for teachers to integrate field trips into the school curriculum, just as educators integrate the school curriculum into museum programming. Educators can proactively initiate efforts to inform and involve teachers in integrating field trip experiences in the classroom. Emphasizing curricular learning on field trips impedes children's connections with the place. Informal places like

museums are great venues for discovery and exploration, where learning is constructive and individualized. Museum educators impart the real value of museums through "wonder and discovery" that may be lost if the sole focus of field trips remains curriculum supplementation.[27] Partnerships between museums and schools will be strong, sustained, and synergetic through consistent and candid communication and the sharing of ideas and resources. Sustained and integrated field trip museum programming enhances both students' learning (the teachers' objective) and their experiences (the museums' missions).

Notes

1. Falk, John H., and John D. Balling. "The Field Trip Milieu: Learning and Behavior of a Function of Contextual Events." Journal of Educational Research 76, no. 1 (1982): 22-28.

2. Bhatia, Anuradha. "Museum and School Partnership for Learning on Field Trips." Dissertation, Colorado State University, 2009.

3. Kisiel, James F. "More Than Lions and Tigers and Bears: Creating Meaningful Field Trip Lessons." Science Activities 43, no. 2 (2006): 7-10.

4. Hirzy, Ellen. "True Partners, True Needs." Washington, DC: IMLS, 2002.

5. Jennings, Jack, and Diane Stark Rentner. "Ten Big Effects of the No Child Left Behind Act on Public Schools." Review of Reviewed Item. Phi Delta Kappan, no. 2 (2006), http://www.pdkintl.org/kappan/k_v88/k0610jen.htm.

6. Nassauer, Sarah. "Bad Trips: School Outings Getting Downgraded." Wall Street Journal, Oct. 28 2009.

7. Griffin, Janette, and David Symington. "Moving from Task-Oriented to Learning-Oriented Strategies on School Excursions to Museums." Science Education 81, no. 6 (1997): 763-79.

8. Kisiel, James F. "Revealing Teacher Agendas: An Examination of Teacher Motivations and Strategies for Conducting Museum Fieldtrips." Dissertation, University of Southern California, 2003.

9. Sheppard, Beverly, ed. Building Museum & School Partnerships. Harrisburg, PA: Pennsylvania Federation of Museums and Historical Organizations, 2000.

10. Tran, Lynn Uyen. "Teaching Science in Museums." Dissertation, North Carolina State University, 2004.

11. Hooper-Greenhill, Eilean. Museums and the Interpretation of Visual Culture. New York: Routledge, 2000.

12. Falk, John H., and Lynn D. Dierking. "School Field Trips." Curator 40 (1997): 211-18.

13. Wolins, Inez S. "Learning Theories in the Museum Setting." In Building Museum

and School Partnerships, edited by Beverly Sheppard, 33-42. Washington, DC: American Association of Museums, Pennsylvania Federation of Museums and Historical Organizations, 2000.

14. Vallance, Elizabeth. "The Public Curriculum of Orderly Images." Educational Researcher 24, no. 2 (1995): 4-13.

15. Berry, Nancy W. "A Focus on Art Museum/School Collaborations." Art Education 51, no. 2 (1998): 8-14.

16. Xanthoudaki, Maria. "Is It Always Worth the Trip: The Contribution of Museum and Gallery Educational Programmes to Classroom Art Education." Cambridge Journal of Education 28, no. 2 (1998): 181-95.

17. Kisiel, James F. "Understanding Elementary Teacher Motivations for Science Fieldtrips." Science Education 89, no. 6 (2005): 936-55.

18. Cox-Peterson, A. M., D.D. Marsh, J. Kisiel, and L.M. Melber. "Investigation of Guided School Tours, Student Learning, and Science Reform Recommendations at a Museum of Natural History." Journal of Research in Science and Teaching 40, no. 2 (2003): 200-18.

19. Wilkinson, Vida D. "Workforce Investment Act of 1998: One State's Approach to a Workforce Development Partnership." Dissertation, Colorado State University, 2008.

20. Penna, Stacy L. "Beyond Planning a Field Trip: A Case Study of the Effect a Historical Site's Educational Resources Have on the Practices of Four Urban Eighth Grade Social Studies Teachers." Dissertation, University of Massachusetts, 2007.

21. Anderson, David, James Kisiel, and Martin Storksdieck. "Understanding Teachers' Perspectives on Field Trips: Discovering Common Grounds in Three Countries." Curator 49, no. 3 (2006): 365-86.

22. Falk, John H., and Lynn D. Dierking. Learning from Museum: Visitor Experiences and the Making of Meaning. Edited by C. G. Screven, American Association for State and Local History Book Series. Walnut Creek, CA: AltaMira Press, 2000.

23. Piscitelli, Barbara, and David Anderson. "Young Children's Perspectives of Museum Settings and Experiences." Museum Management & Curatorship 19, no. 3 (2001): 269-82.

24. Puchner, Laurel, Robyn Rapoport, and Suzanne Gaskins. "Learning in Children's Museums: Is It Really Happening?" Curator 44, no. 3 (2001): 237-60.

25. Packer, Jan. "Learning for Fun: The Unique Contribution of Educational Leisure Experiences." Curator 49, no. 3 (2006): 329-44.

26. Gardner, Howard. "Making Schools More Like Museums." Education Week Oct. 9 (1991): 40.

27. Blair, Elizabeth. Museum Field Trips Tailored to Teach to the Test: National Public Radio, 2008. Audio recording.

Field Trip Checklist

Use the following checklist to enhance children's *learning experiences* (or *experiential learning*) on a museum field trip. **Check all statements that apply. Complete the sentences as they apply to your teaching.**

Part A: Before the Field Trip Actions

Part A: The teacher should fill out this part, if a student teacher, parent, or staff person is responsible for arranging the museum field trip. The purpose and preparation for the visit must be informed to the museum educators.

1. Schedule a field trip during studying unit in school□

2. Communicate/discuss purpose of field trip with museum educators□

a. My purpose(s) of the field trip is (are):

 ○ Curriculum supplementation/enrichment ...□

 ○ Positive experience ..□

 ○ Learning curriculum with enjoyment ...□

 ○ Novel place for experiential learning ...□

 ○ Other ...□

 Specific purposes are ...

 ..

b. Expected learning outcomes for children□

 I expect ...

 ...for my students.

c. Teach curriculum unit and do related activities in preparation for field trip□

 I have been teaching/doing ...

 ..

3. Conduct (or ask museum educators) for pre-field trip activities to

 do in classroom to prepare students for the museum visit□

 I conducted ..

 ..in the classroom before the field trip.

 I introduced the museum, its history, and functioning with students......................□

4. Prepare students to look for specific objects and artifacts while on

 the field trip? ...□

Part B: Field Trip Action

Part B: You can encourage students' interactions to build experiences listed in Part B.

5. **At the museum, I encourage children's interactions** ☐

 Encouraged children to:

 ⊃ Explore .. ☐

 ⊖ Listen ... ☐

 ⊃ See ... ☐

 ⊖ Touch ... ☐

 ⊙ Ask questions ... ☐

 ⊖ Reflect/Explain ... ☐

 ⊖ Discuss .. ☐

 ⊖ All the above ... ☐

Part C: After the Field Trip Actions

Part C: As a facilitator of learning, you can do a number of activities in your classroom to reinforce field trip learning experiences. Document your experiences and reflections of the museum field trip as a guide to plan the next field trip.

6. **Do post-field trip follow-ups with students:**

 ⊃ Discussion .. ☐

 ⊖ Writing activity ... ☐

 ⊙ Drawing activity ... ☐

 ⊙ Skit .. ☐

 ⊙ Presentation ... ☐

 ⊃ Question-answer session .. ☐

 I reinforced the museum experience after the field trip by ...

 ..

7. **Ask children what they liked at the museum and why** ☐

 Children liked ..

 ..

 Children asked about ..

 ..

8. **Field trip was planned to help children gain/learn** ...☐

 Children gained/learned..

 ...from the museum field trip.

9. **Provide constructive and candid feedback to the museum educators**..............☐

 Filled out the museum's feedback/survey ..☐

 Sent email/personal letter ...☐

 I commented on/about...

 ...

 *Notes for self for next field trip ..

 ..

 ..

 ..

Growing Up in the Borderlands

KATE BONANSINGA

Director

Stanlee and Gerald Rubin Center for the Visual Arts

The University of Texas at El Paso

This is a story about growing up in the borderlands.

El Paso is on the edge of the USA, and at its heart is the University of Texas at El Paso (UTEP). Its sister city, Ciudad Juarez, Mexico, is less than a half mile away, and shares its Chihuahuan Desert setting.

UTEP is committed to the education of first-generation college students, about 80% of whom are Mexican or Mexican-American, many of them economically underprivileged. It goes without saying that this demographic is not well known for art museum support and attendance. But this is our audience, and it is devoted, growing and energized.

The Stanlee and Gerald Rubin Center for the Visual Arts at UTEP opened in 2004, under the watchful eye of its strong-willed parent, with the mission of making our location on the periphery central to the national conversation about contemporary art. We do this by creating exhibition opportunities for some of the most innovative artists of our time.

The challenge was then, and still is, to engage the El Paso populace while also maintaining the standards expected of a research university and its faculty and students, and to do this with limited resources. Questions from the public range from "Why is this art?" to "My 90-year old Tia could paint better than this." Inquiries from the faculty sound more like, "How does this extend the Duchampian model?" We balance these two worlds through exhibitions and related programs that stretch the thinking of those who appreciate contemporary art as well as those who are new to the game.

For example, in planning for the inaugural show, when

the Rubin Center staff was an army of one, I drew upon an *Artforum* exhibition review that I had read about New York-based artist Paul Henry Ramirez, who was born, raised and educated in El Paso, where he began exhibiting his work in the 1980s. I was attracted to the sumptuousness of his paintings, where colorful biomorphic forms and sinuous black lines dominate. They have immediate appeal, while also emitting enduring formal and conceptual complexity.

On one of my trips to New York I met with the artist and told him about the plans for the Rubin Center. "My mom combed wigs for Gerry Rubin," he reminisced. Ramirez was the son of a former employee of our benefactor, Gerald Rubin. Rubin's business, Helen of Troy, has become a multi-national personal products marketing giant, but it began as a shampoo manufacturer and wig shop, and Ramirez's mother had worked there for many years. Ramirez would go there after school to keep her company. While she combed wigs, he would sit at her feet and draw, the beginnings of the hair-like imagery and cosmetic palette that currently define his mid-career oeuvre.

Plus, Ramirez had attended UTEP for two years before moving to New York. The hometown boy who had earned acclaim in the City was the perfect artist for the inaugural show. Planning time was short, however, (about a year) and he had already scheduled a show at Mary Boone Gallery in New York during the same month that the Rubin Center was to open. I persuaded him to agree to a mini-retrospective that he designed to hang in loosely chronological order. Ramirez painted

directly onto the gallery walls to connect the autonomous canvases and to create a holistic expression, complete with an audio component. The room and its contents became an extension of the human form. It was an explosion of color; the accompanying sound track consisted of chirps, yelps, and buzzes that suggested the frenetic pace of contemporary life.

"It's good to be back," claimed Ramirez. He thrust himself wholeheartedly into the creation of the show. The uninitiated relished Ramirez's connection to El Paso and the joyfulness of the imagery. One visitor heralded from behind a big grin, "My granddaughter told me this was not to be missed," referring to one of the music majors who had visited the day before. More experienced viewers discussed the immersive environment and its strategies for referencing bodily fluids in both sound and image, and how the site-specific painted components expanded the picture plane. Ramirez marked the beginning of our commitment to exhibiting artists of Mexican heritage to serve as examples to UTEP students, who were, and still are, our primary audience.

The Rubin Center also has a track record for researching, documenting and responding to the fragility and mystery of the Chihuahuan desert. During Spring 2007, we hosted *Hydromancy* by SIMPARCH with Steve Rowell. SIMPARCH is an invented word that conflates two others: simple and architecture. It is a flexible collection of individuals. Its two principals, Steven Badgett and Matt Lynch, met in 1996 in Las Cruces, New Mexico, forty miles west of El Paso; they have an intimate understanding of the environmental concerns of

the area. SIMPARCH had achieved international recognition through participation in Documenta XI in Kassel, Germany, in the 2004 Whitney Biennial and in a solo show in 2005 at Tate Modern in London.

For UTEP they explored, in Badgett's words, "the critical and contentious subject of water and its politicized place defining the U.S./Mexico border." The Rio Grande River divides El Paso from Juarez, and the U.S. from Mexico. This once mighty river is now usually still and almost dry in El Paso, yet it continues to function as a geographic and political marker.

For *Hydromancy*, Rio Grande River water was stored in a 300-gallon tank at the top of the rocky hillside outside of the Rubin Center. Gravity moved the water through three passive solar distillation units arranged in a descending formation on the hill, which is dry, brown, and lunar in character. The stills used the energy of the sun to heat the water to the point of vaporization and through this process the once dirty water was made drinkable. This condensation dripped via a steel pipe supported by an elaborate armature into the building.

Inside, visitors were offered cups to gather and drink the water. The left-over water was left to pool on the concrete floor in an empty and dimly lit gallery. A spotlight illuminated the puddle; its reflection shimmered on the opposite wall. At least daily Rubin Center staff mopped the puddle, which was bigger when the sun was shining. SIMPARCH collaborator Steve Rowell walked the Rio Grande recording the sounds of both sides of the border and these provided an audio overlay to the installation.

Together with UTEP's Center for Environmental Resource Management (CERM), the Rubin Center hosted a panel discussion in conjunction with *Hydromancy*. Panelists included residents of the Negev and Wadi Rum Deserts in the Middle East who are active in Friends of the Earth-Middle East (FoEME), along with urban planners, environmentalists, architects and water specialists. Bob Curry, the then-director of CERM, described the installation as at "the forefront of the exploration of environmentally sensitive landscapes."

This collaboration was a truly interdisciplinary blend of art installation and science experiment that drew upon the intellectual resources inherent in a university. After the exhibition closed, the stills were relocated to residences in Juarez, where they continue to be used today. Badgett explains that SIMPARCH has carried this desire to "experiment with fully operational systems... into subsequent projects... where we pursue... more rational existence on the planet."

The Rubin Center has also developed a secondary curatorial focus on idea-driven contemporary craft that complements our primary focus on art which responds to the desert or to the U.S./Mexico border. This builds upon my background: before beginning work at UTEP, I had been director of the Hoffman Gallery at the Oregon College of Art and Craft in Portland. Then, for four years prior to the Rubin Center's opening in 2004, I served as the gallery director in UTEP's department of art, an art faculty-driven enterprise for which the exhibitions were usually medium-specific. I helped faculty implement exhibitions that they thought would enhance their students' education.

Two of the faculty members who were, and still are, the most enthusiastic about exhibition planning were the Professor of Ceramics and the Professor of Jewelry. In the past few years the Rubin Center has hosted group exhibitions that explore those disciplines and expand our understanding of them. I am committed to engaging faculty from many areas, within the field of art and beyond, because faculty engagement fosters student engagement and our audience expands.

One of our most successful craft-based exhibitions focused on textiles. *Unknitting: Challenging Textile Traditions* was the premier exhibition of the spring/summer season in 2008, but it developed as a complement to *In the Weave: Bhutanese Culture and National Identity*, a concurrent exhibition in an adjacent gallery at the Rubin Center. I discovered in 2005 that the Smithsonian Institution planned to highlight the arts of the state of Texas and the country of Bhutan for its 2008 Folklife Festival. The UTEP campus is defined by its unique Bhutanese architecture that began in 1914 when the university dean was inspired by photographs of the central Asian country that his wife had seen in National Geographic. He based the construction of the campus on that inspiration.

UTEP bridges the two locales that the Smithsonian had randomly paired. It was a great opportunity for the Rubin Center to emphasize this convergence and to create another one, between our mission – to bring innovative contemporary art to the UTEP and El Paso communities – and the aesthetic of the exterior of our building. Bhutanese textile design and technique are similar to those of other cultures, including

Mexican and Native American, which predated the European influence in American Southwest.

These local connections, in addition to the beauty and intricacy of the textiles, steered me to focusing on organizing an exhibition of traditional Bhutanese fabrics that would take place during summer 2008, at the same time as the Smithsonian Folklife Festival, which put UTEP in conversation with this national entity. In fact, UTEP's President invited the Prince of Bhutan and an entourage of dancers to visit El Paso and the exhibition on their return trip to Bhutan from Washington, D.C. This supported her initiative of outreach to Bhutan, including scholarships for Bhutanese students. More than seven thousand members of the El Paso community came out to meet the Prince and see the dancers perform.

This is all well and good, but the Rubin Center is not in the business of exhibiting traditional art forms. Instead, we exhibit some of the most innovative art of our time created by internationally recognized artists. Fortunately, Dr. Stephanie Taylor, Assistant Professor of Art at neighboring New Mexico State University, brought to my attention knitting as a newly popular method for renegade art making.

It would be a perfect pairing. The weavings looked back to the past, and the knitting looked to the future, but both were rooted in the present, and together explored the capabilities of textiles. With this in mind, Taylor and I co-curated a group exhibition about knitting and textile practice in the creation of fine art. We wanted the show to incorporate new media and

to draw from a talent pool that reached beyond the U.S. and to, in Taylor's words, "present a thoroughly contemporary take on the centuries-old practice of knitting."

During the next few months, each of us brought several artists to the table for discussion before we narrowed our list to four (one is Mexican, another is Mexican-American, the third is British and the fourth is an American who teaches at Cranbrook Academy of Art) who knit or unknit and use photography to document that act or its results. "Placing my performance-based work in a gallery setting raised some interesting challenges for me, and has led to explorations of performance vs. object," muses one of the artists, London-based Rachel Gomme, who not only performed in El Paso, but also in Houston when the exhibition travelled to the Houston Center for Contemporary Craft. The curator there, Gwynne Rukenbrod, reflects, "The exhibit challenged our audience's perception of contemporary textiles."

By this time the university had supported the hire of Rubin Center assistant director Kerry Doyle to focus on education and community outreach. (Up until September 2007 we had operated with a preparator, several part-time student interns, and me as director.) Doyle's outreach for *Unknitting* included public performances by two of the artists and hands-on family programs where participants created a cardboard loom.

Since that time Doyle, who lived in Juarez in the 1990s, has incubated several cross-border programs that involve the creation of new work by artists that addresses the recent escalation of violence in Juarez. "We are bringing international

artists... to engage with the border... and to inspire genuine dialogue," states Doyle.

For example, Tijuana-born, Mexico City-based artist Tania Candiani came to the border for a week to mentor students at both UTEP and at Universidad Autonoma de Ciudad Juarez (UACJ) in the creation of "weapons" from domestic tools. The students staged performances at their respective institutions where they wore or held the sculptures they created during the workshops, statements about political uncertainty and death. We streamed video footage of the performances in real time so that audiences at each university could experience both performances simultaneously: one on a cinema-sized screen and the other in person. The performances took place on the night of the opening at the Rubin Center of the exhibition *Battleground: Tania Candiani and Regina Jose Galindo.*

Doyle has also developed high school programs led by UTEP students that have been a resounding success: the high school students respond to instruction and guidance by near-peers, and the university students, who are mostly art education and studio art majors, acquire valued museum experience.

After five years in the making, the Rubin Center is still growing up. But we have diversified our audience and our supporters and grown our staff, still small but mighty. We have inspired administrative and financial support from the university, the El Paso community, and beyond through programming and outreach to other UTEP departments, as well as to area high schools, and like-institutions in both

Mexico and the U.S. Meanwhile, the Rubins have supported other initiatives at UTEP, where there is now a Helen of Troy Softball Field.

I recognize that we are fortunate to be in the politically charged locale of the U.S./Mexico border; it provides artists with fertile territory to respond to and it provides us with an international local audience. On the flip side, the Rubin Center serves as an emerging example of how any museum, anywhere, has the ability to tap into what makes it unique, to shape exhibitions and programming around those distinctive qualities and to grow and mature in a manner that best serves its audience.

It is the winning combination of most successful institutions: an understanding of its history and strengths, and of the needs and interests of its constituents, interpreted through the passions of the people at its helm.

Seriously Playful: Paul Henry Ramirez 1995-2004, Fall 2004, Stanlee and Gerald Rubin Center for the Visual Arts at The University of Texas at El Paso. Photo: Marty Snortum.

Steve Badgett of SIMPARCH with *Hydromancy* (exterior view), January 2007, Stanlee and Gerald Rubin Center for the Visual Arts at The University of Texas at El Paso. Photo: Marty Snortum.

Planning for Young Children and Families in Museums

VICKY CAVE

Exhibition Consultant

Brighton, UK

This essay is based on my experiences of developing galleries for young children in museums, science centres and discovery centres since 1991. It builds on my thoughts around how the process by which a gallery is developed affects its communication potential – an area which I explored in my PhD, *The Process of Developing Hands-on Educational Exhibits for Children* (UCL, 1999). I followed the development processes of four exhibitions for young children. I became interested in the idea while working at Eureka! The Museum for Children (1991-94) during the development of its inaugural exhibitions – *Me and My Body, Living and Working Together* and *Invent Create Communicate*, and the subsequent evaluation of those exhibitions.

The findings presented here are from a range of organisations, and although the majority of these are discovery centres or science centres, the methodologies and ideas can be applied to many types of museums.

Playful learning experiences

Hands-on exhibitions provide places for children and adults to play and learn together. They can cater for the whole family, providing a range of learning opportunities targeted at a variety of learning styles. Interaction between children and their carers helps to embed experience as memories, and these memories form a crucial part in learning. Hands-on exhibitions can allow children to "scaffold" their learning through their own experiences and their experiences with other people. Hands-on exhibitions can be emotionally

meaningful to children and resonate with what is happening in their lives.

Museums, galleries, discovery and science centres create the social space and time for families to play and communicate in a range of ways. In the informal learning spaces of exhibitions, families learn new things and explore new aspects of each other. Role-play allows families to explore topics and issues in a risk-free environment. Visitors comment that they have found their family members engage in different activities and display new skills because they have seen them in new situations. Visitors can be prompted to explore new concepts and ideas together and learn about each other.

Building on children's ideas

Discover is a hands-on story-building centre for young children which opened in East London in 2003. During its development, the team explored how exhibition development can include local people in the creative process. We did this through developing an outreach programme, a children's forum and a series of Exhibition Workshops (see the chapter: *What We Did at Discover*). There are examples of how we involved the target audience in the development process throughout this essay.

For the development of an outdoor learning environment at Greensted Primary School and Nursery in Basildon (Fig. 1), funded by Creative Partnerships, artists and storytellers were commissioned to develop characters and stories with the children and teachers. These ideas were then developed

Suddenly, Flipperty Wopper ordered: 'Time to go below!' and jumped overboard and started to pull the ship down... down... down under the sea.
As he pulled the ship down it changed from a ship to an amazing submarine with huge great headlamps like huge great eyes and windows of every shape and size.

Figure 1: A page from the storybook which was created as part of the outdoor learning space development at Greensted Primary School and Nursery.

into a 3D environment which is supported by a storybook of the children's story and activity cards developed in collaboration with the teachers. By using innovative and creative techniques with all ages, exhibitions offer layered and content-rich experiences for a range of learning styles and abilities. Exploring ideas and concepts for exhibition content tends to open up the potential for meaning, which can lead to greater depth in an exhibit.

Making children the experts

Eureka! The Museum for Children, Halifax opened in 1992.
A key character called Scoot was developed as part of the *Me
and My Body* exhibition where children can find out about
their bodies and how they work. The character aims to offer
children the opportunity to act as experts in the exhibition.
The back-story, which is presented to groups at the beginning
of the exhibition, tells of how Scoot was made from old parts
in an shed and cannot understand what children are, how
they are made and how they work. Children are tasked with
finding out about themselves, such as how their heart works,
and reporting back to Scoot with their discoveries. This
character was developed based on findings from Health for
Life research, which identified how much children love to find
out about their bodies. It built on the notion that children like
to feel that they are being listened to and that what they say
is valid. The character, Scoot, continues to be a massive hit,
with children motivated in the exhibition to find out more
and tell Scoot, and also to write to Scoot after their visit. Scoot
is so popular and effective in prompting enquiry, exploration
and reporting that the proposal for a new gallery around
health and well-being centres around a similar character. It
provides an emotional identity on which they can hang their
emotions about their visit so much more easily than around
a building and an experience. It personalises their visit and
makes it special.

Scoot was so successful at Eureka! that we used the idea at
Discover. We wanted to find a similar tool to encourage and

motivate children to engage with literacy. There were several stages to this character. Firstly, at a very early stage the design company, Pentagram, had provide *pro-bono* work which consisted of a set of characters. We took these characters and asked children what they thought of them. From their responses we found their favourite: the children were excited by the idea that it was a creature from outer space and were intrigued by the trumpet-like feature that is like a cross between a trumpet and a trunk. Children suggested different names for the character, and we selected the name Hootah. Secondly, the Discover Children's Forum created a song about this alien, called *Hey Hootah!* and recorded it with simple backing track. We then made a 3D version of the character and developed the outreach programme, *Space to Imagine*. In it we were able to explore and develop the story about Hootah. From our pilots, we developed the idea that Hootah had come to Earth looking for stories because his planet was running out of them, and could the children help? Through *Space to Imagine* we learnt that the Hootah was hugely successful in motivating children to use their imaginations and to develop new story ideas. The Children's Forum became very attached to, and proud of, Hootah and the character became a key part of their activities associated with the development of Discover. Children remembered him, wrote letters to him and talked to their parents about him. The third stage in Hootah's development was to develop a character that would work as both a graphic identity and a physical reality in the exhibition (Figs. 2-5).

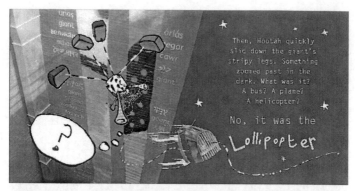

ABOVE Figure 2: A page from Hootah's Story. BELOW Figure 3: Hootah as made by one of the children in the workshops with the designers.

ABOVE Figure 4: The graphic version of Hootah, shown sucking up words.
BELOW Figure 5: Hootah in its final form being welcomed by the children.

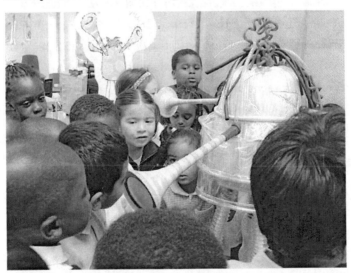

We had found through *Space to Imagine* that the original three-dimensional version of Hootah was cumbersome and would be impractical as part of the exhibitions. We asked children to help us re-design Hootah. The exhibition designers, Bremner and Orr, ran workshops with classes of children to explore what Hootah could look like. Bremner and Orr selected versions which would work both as a graphic and as a 3D version, and developed the designs from there. We involved the Children's Forum again at this stage, asking them to develop ideas around how Hootah collected stories, transported them around and would take them back to his planet. This workshop was so rich in ideas that the graphic designers developed them into a back-story which tells of Hootah's journey from his planet, Squiggly Diggly to Earth and Discover. This was then made into an introductory video to help visitors at the start of their visit. The design of the graphics and the 3D Hootah for the final exhibition grew out of these stories, with the designers being inspired by the children's work. The success of this character lies in the development process being flexible – adapting to meet children's needs, interests and wishes.

For the Children's Project in Syria (Massar), Science Museum Solutions was asked to develop a touring programme for children aged 5-15 years old, which could tour around Syria, using local Cultural Centres. We used the device of asking children to become experts and developed activities around a mock archaeological dig where children acted as History Detectives and were given booklets in which they could record

their findings. The children used a range of different tools to observe, measure and record the objects that they found (which represented Syrian culture and history). One parent told us that their child had said the following day: "Oh I wish I had my magnifying glass so I could look at that more closely", talking about something she found of interest while out and about. The touring programme has run from 2005 to the present and informed the development of the new Children's City which is being built in Damascus.

Creating a museum without walls

Discover's outreach programme, *Space to Imagine*, toured local schools for three years prior to Discover opening. It was an excellent way to test ideas and establish the ethos and nature of what we were doing, and meant that schools understood the concept of Discover when it opened. *Space to Imagine* was a story-building programme that took place in an inflatable structure. The structure was brilliant at exciting schools about Discover. It was emblematic and having a physical structure which was so big (it was about 8 metres in diameter and 2-3 metres high) created a stir and excitement at the school while it was there. *Space to Imagine* allowed us to test our ideas and incorporate children's ideas into the development of the programme and also the exhibitions. We were able to see how the activities met the aims and objectives that we had developed and this informed the content development of the exhibition. We gained knowledge about schools in six target boroughs and found out more about the diverse

local population, as well as discovering what children found exciting and what teachers responded to and what they needed.

The structure created a magical environment – it changed the quality and colour of the light and was an interesting form. And being a blow-up structure it was really effective and amazing – one minute it's there and the next it's not. Having such a structure meant that we could use it for local events, and the structure reinforced our identity – children and teachers who had experienced it in their school strongly connected with it.

Testing out ideas

Using an iterative process allows an exhibition to be refined and adjusted as it develops. Defining clear aims and objectives which link to curricula and other relevant schema allows ideas and content to be evaluated and amendments made. The development of such aims and objectives can allow for the development of exhibits which are intuitive and multi-level, so they can be used in a range of ways, from self-directed exploration, where visitors can find their own starting points, to more facilitated experiences.

At Eureka! at the outset of the development of the *Living* and *Working Together* exhibitions, which consist of role-play spaces clustered around a Town Square, we talked to children to find out what they would like to do in different spaces. In the Bank, they wanted to be the boss and crack the code to the safe. In the Shop we found that they thought that if you

bought an orange as a shopkeeper and sold it on, you should sell it cheaper as it was second hand! In this way we were able to grasp where children were in their thinking and to find ways to develop content and exhibits to explore these concepts. We used the children's ideas as inspiration for the content development of the exhibits.

At Discover, during the development of one of the role-play spaces – the *Secret Cave*, we were concerned about how parents would respond to having to crawl inside a space. We created a cardboard cave in the nursery next door to Discover and ran sessions with children and parents there to explore their responses. Because it was cardboard, we were able to experiment with the height of the entrance to the cave and with what worked best. As well as exploring how parents reacted, we discovered other aspects which we had not anticipated, which we incorporated into the final designs. For example, we saw how much children enjoyed peep-holes and smaller spaces to squeeze through; as a consequence we developed different sized entrances and windows for the final cave. We also gained an insight into how exciting communication from inside to outside was, and developed further opportunities for children and adults to do this in the final version (Fig. 6.)

At Discover, we used the building before it was open to the public. In 2002, we opened the *Story Garden*, a playspace which encourages physical and imaginative play around stories. This was a year before the exhibitions opened, and it was free. People loved the *Story Garden*, because it was like

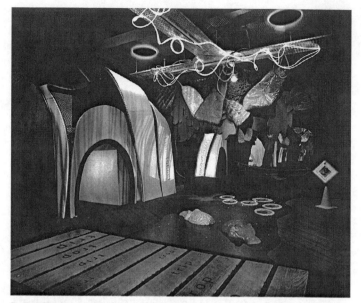

Figure 6: The Secret Cave at Discover where children can crawl inside, climb on top and round. They can create their own atmosphere using sound and light and communicate from inside to outside.

an "oasis for children" in the middle of the city, and provided a place for children and their families to spend time together playing and learning. Visitors to the *Story Garden* became interested and involved in the development of Discover, and were strong supporters of it when it opened. Additionally, we used the building in various stages of dilapidation and renovation for workshops with the children's forum. Also, as we had funding delays, we built three exhibits and then ran sessions and workshops and invited groups to come, and we used these workshops to develop and refine ideas for graphics and details of exhibits. It was a constantly evolving process

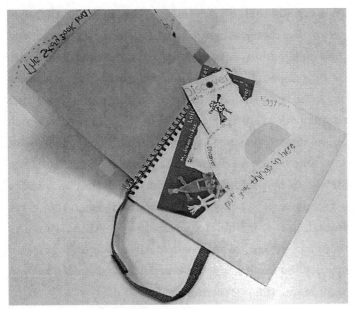

Figure 7: Hootah's Story and Story Book Bag.

and we invited people to be part of it as much as we could.

Embedding exhibition experiences in children's lives

Things to take away, pre- and post-visit activities: At Discover, the associated resources used in the exhibitions and pre- and post-visit take-away activities, aim to make very clear links between activities at home and school and in the exhibitions. We developed a *Story Book-Bag* (Fig. 7) which provides opportunities for visitors to create a souvenir of their visit. They can draw and write story snippets in the exhibitions and collect items around the exhibition which they put into a back pocket, such as tickets, menus, and maps.

They can add their own details to these items, so that they personalise their memento with the details of their visit and their imaginations. Materials for pre- and post-visit activities were developed around the character Hootah. There is a poster of a letter from Hootah, which tells of his plight (his planet running out of stories); a storybook (Hootah's Story) which tells of Hootah's journey around the exhibitions and photos of what the children will find there; a copy of the song *Hey Hootah* (developed by the Children's Forum) which the children can play and learn in school and they sing it when they meet Hootah in the introductory session at Discover. Hootah's Story can be used in follow-up activities and provides an opportunity to talk about the experiences at Discover, helping to make them shared memories.

Welcoming visitors to your museum

This essay also refers to research carried out for The Potteries Museum and Art Gallery, Stoke on Trent who, in partnership with Peterborough Museum and Art Gallery and The New Art Gallery Walsall, commissioned research into the communication potential for families with young children within galleries and museums, supported by NESTA in 2006. The findings from this study can be found in the publication: *How to create communication-friendly museums* which can be downloaded at www.stokemuseums.co.uk.

This research revealed the need to reach out and welcome the whole family. Children depend on their parents to come; parents will be the decision-makers of whether to visit or not,

and it was found that they appear to feel more confident and interact better with their children if they are welcomed.

Orientation, identity and role

The research showed that parents and carers like to feel prepared before they engage with the displays, exhibitions and activities. Offering materials and information for carers helped them to feel more confident to communicate with their children. The research showed that providing information at the front desk, briefing reception staff, leaflets, trails or activity packs were effective. This idea can be extended to publicity material; flyers announcing special events/times for young children or a section of the website dedicated to *What you can do in the museum with your young children.*

Mental orientation is incredibly important. At Discover, we asked people with English as a second language what would help them, thinking that they might like a translator in the exhibition. What they wanted more than anything were images of what they would experience, so that they had a mental map of what would be there; they wanted very clear images of what there was, what they could do with their children and for someone that they knew to brief them before they came. They wanted to be mentally prepared for a visit so that they could make the most of it of it.

Support for parents and carers in museums and exhibitions can include:

- Signposting and signalling activities for families with young children.

- Providing clear indications of the roles carers can take.
- Supporting and encouraging parents and carers to engage with their children and the exhibits and activities by means of instructions, suggestions and prompts, such as *See if your child is interested in …; Try …; Some suggestions …*

Making people laugh at themselves!

At Explore@Bristol, a wobbly mirror which distorted people's reflections was installed in the lift up to the floor on which we held a Preview exhibition. By the time people reached the floor, they had lost some of their inhibitions, as they experimented with playing with their reflection (Fig. 8).

Something that makes people laugh or surprises them can help adults to relax and start to play. The Story-builders' introduction at Discover for groups targets the adults as well as the children, describing their role in a playful manner. One of the first exhibits at Discover is a blue screen exhibit where visitors can see themselves on screen in a video using children's drawings and ideas. The fun environment makes them feel safe and they relax and then when they go out of the exhibit they realise that their images have been projected onto the outside on a huge screen. This makes them laugh, especially the adults. At Eureka! Archimedes is suspended high up above a bath of water, into which he is plunged every half hour. This creates a visual stir, a talking point and an event.

Figure 8: A child explores their reflection in the mirror.

Making space for families

Creating spaces which are inviting to both carers and children were seen to promote, support and extend opportunities to play, communicate and imagine together.

Getting close to one another: Creating opportunities for parents and carers to sit down and get down to their child's level, means they are likely to stay longer, and to communicate better with their child. Providing opportunities and incentives (seating, exciting things to look at or through, creating interesting spaces for carers and children) were seen to encourage carers and their children to get closer to each other and to communicate.

Seating

Something seemingly so simple as seating can have a huge impact on the interaction between children and their parents and carers. Seating can separate or unite a family; it can put parents/carers at the heart of the action, or on the sidelines.

Parents and carers tend to find places to sit wherever they can find a space; they will sit on workbenches, lean against objects and walls, perch on small chairs. Acknowledging that carers tend to stay longer if they can rest their legs, developers can start to identify places where carers can perch, sit or lean. This may take the form of formalised seating, or could be ranges of surfaces which could be used as a perch, bench and can be fully integrated into the activity. The key element is to create chances for parents and carers to get close to the activity and down to the same level as their children.

Design issues

The NESTA research revealed some design aspects which can impact on how families interact with one another:

- Group similar concepts together with few distractions, possibly in clusters.
- Minimise the level of noise. Noisy environments are tiring and prevent adults and children communicating. Consider using soft flooring, sound baffles, minimising hard surfaces off which sound can bounce, directional sounds to avoid sound pollution and limiting musical instruments.
- Use lighting levels to signal areas of relaxation and

activity, using contrast to attract and invite carers.

- Ensure that activities and displays are free from finger-traps or sharp edges at head height for children of all ages. Consider the ergonomics for a range of ages, especially remembering younger children who are typically less steady on their feet.
- Ensure that displays are clear in what they are communicating and that links between objects, displays and activities are very clear.

Types of exhibits

In 1987 Regnier (Cohen in Durbin, 2000) developed a series of criteria which he believed should be included in exhibitions for families with children up to primary school age. These included elements such as: gross motor activities; multi-sensory activities; sand and water; collections with classifications; role-play; dressing up; places to hide; objects to assemble and disassemble; activities which can provide choice and diversity; no school-related activities; no non-interactive exhibitions; small amounts of reading; no confusing, unclear outcomes for an exhibition; no need for advanced comprehension or using ideas which are not child-centred; and no exhibitions which require a long time to be spent at them.

However, these criteria do not consider the holistic needs of a family audience, and neither it is it clear whether these criteria are indeed what families would require.

When families come to museums, studies have shown

that different members of the family learn differently. For example, children have been found to learn by asking, doing and looking, while adults tend more generally to learn by examining, discussing and reading (Borun and Dritsas, 1997). If displays, exhibitions and activities are to cater for the needs of all family members, they should include a wide range of experiences for different learning styles, interests and abilities, taking into consideration the different generations within the families.

Within the context of a museum visit, communication between family members has been found to be an important part of the family learning experience. Different types of displays and exhibits have been shown to provide stimulus for conversation between family members. Falk (2004), in an experiment where he interviewed visitors four to eight months after their visit, found that interactives promoted talking, communication and doing things together. Objects, as well as interactives, have been found to elicit positive responses from children. In an internal study carried out by the Science Museum (1996) children were shown to be affected by the impact of the significant, the beautiful and the old, and that this is part of which makes museums stand out from other experiences.

As well as the interaction between exhibits and visitors, the interaction between visitors themselves has been found to be as important (Blud, 1990). In order to make the experience satisfying and rewarding for all, exhibitions need to create opportunities for families to communicate with each other,

and cater for all members of the group in both a hands-on and minds-on way. Borun and Dritsas (1997, p180) propose seven characteristics to improve family learning within the museum. The exhibit should be:

1. Multi-sided so the family can cluster around the exhibit.
2. Multi-user to allow interaction between several sets of hands (or bodies).
3. Accessible – so comfortable for both children and adults.
4. Multi-outcome – to foster group discussion.
5. Multi-modal – so that it appeals to different learning styles.
6. Readable – the text is arranged so that it is easy to understand segments.
7. Relevant – so that it provides cognitive links to visitors' existing knowledge and experience.

Ways of looking

Maximise opportunities to look at things in different ways. Highlight this as an activity, make it fun and celebrate it. Have things to look through, things to look for, a variety of ways of seeing (peepholes, reveals, binoculars, periscopes, different lenses such as Fresnel, magnifying glasses, looking through cases, looking at things from different angles (from below, from above), moving to look at things in different ways (lying down on your front/back/side; looking down under your feet); a range of scales and perspectives, part images. Include

activities which encourage observation skills such as:

- Spot the difference.
- Matching activities.
- Naming.
- Matching noises to objects (especially with animals!)

Acting it out, getting in role: Of the activities observed, children relished opportunities to take on a range of different roles by putting on costumes, hats, masks or using puppets. This encouraged them to see themselves in a new light and to express themselves in different ways. These activities were seen to provide a clear incentive and motivation to communicate:

- Puppets and theatre.
- Finger puppets.
- Dressing up – ways to encourage role-play outside of gender specific groups. During trials at Discover, we found that positioning a throne which appealed to girls (a chair with a back made from a board in soft peaks) next to a throne which appealed to boys (a chair with a back which was more spiky) encouraged girls and boys to sit next to each other and role play across genders which they tended not to do in the nursery where we testing the ideas. Finding aspects which will appeal to both genders and placing them side-by-side may encourage boys and girls to role-play more with each other and extend the nature of their play.

- Masks, hats and headpieces.
- Props and furniture.

Personalising spaces

A range of props in different places, targeting a range of ages, could engender child-initiated play with carers in a range of ways. Props out of context (such as kitchen tools like sieves and strainers) led to the imaginative use of these objects, encouraging symbolic play and prompting children to use the objects in creative ways. Props which could be easily attached to babies' feet or arms (using Velcro and elastic), so that babies could activate them, created a positive interaction between the carer and the babies. Consideration should be given to finding ways in which babies can select materials from a choice, such as materials hanging down from a frame.

Drawing benches and making tables

Opportunities for children to make a mark, draw and write are all important ways for them to develop their literacy skills. Creating places which shows these skills in novel ways can encourage and stimulate children in their activities. At Discover, children can write on glowing sail-shaped panels, as well as add details to tickets, maps, menus and invitations which they can collect in their *Story Book Bag* and take home.

Programming and events

An evaluation of one of the Skills for Families Programmes found that activities focusing on creativity and oracy were

very helpful for parents with little or no experience of formal learning (DfES/HM Treasury, 2005). Encouraging parents to take part in activities with children helped to develop speaking and listening skills and to build confidence in both adults and children. That is, for parents who may themselves have poor communication skills, providing activities such as art and crafts, gardening and sports, can encourage communication between parents and carers.

Additionally, parents who have low levels of confidence, or those with the greatest learning needs, are more likely to take part in practical activities that do not need reading and writing. Another suggestion is to hold sessions for parents on topics in which they have expressed interest, such as child-health information (91% of parents expressed interest in this); information on childcare (86%) and child development (80%) (Nicholas and Marden, 1998).

Summary
The range of ways in which children and families can be catered for is wide-ranging. By involving them creatively in the earlier stages of exhibition development, and by responding to them, you can help to ensure that your exhibition will:
- Meet their needs and interests.
- Engage with them in a variety of ways and at a range of levels.
- Engender a sense of pride and ownership in those who have been involved in the process.

Involving a range of staff members in the development process, including those who will be in day-to-day contact with young children and their families, will help them to understand the target audience and be more able to meet their needs.

References

L.M Blud (1990) Social Interaction and Learning in Family Groups Visiting a Museum. *Museum Management and Curatorship*, 9 (1), March, pp. 43-51

M. Borun and J. Dritsas (1997) Developing family-friendly exhibits. *Curator: The Museum Journal*, 40(3) September, pp. 178-196.

DfES/HM Treasury Joint Policy review on *Children and Young People, Response from the National Literacy Trust* (2006) http://www.hm-treasury.gov.uk/media/F32/CC/cypreview2006_nationalliteracytrust.pdf

J.H. Falk (1997) Testing a Museum Exhibition Design Assumption: Effect of Explicit Labelling if Exhibit Clusters on Visitor Concept Development. *Science Education*, 81 (6), pp. 679 – 688.

G. Durbin (2000) *Developing Museum Exhibitions for Lifelong Learning*. London, The Stationary Office.

G.E. Hein (1998) *Learning in the museum*. London, Routledge.

C. Howell (2005) *Meeting the needs for all. Designing a model to inform the future production of exhibitions for informal learning*. Unpublished MA dissertation, MA Museum and Gallery Management, City University, London.

MLA (2004) *Visitors to Museums and Galleries*. Museums, Libraries and Archives Commission; London

A. Titus and P.Clyne (1995) *Riches Beyond Price: Making the most of family learning*. UK, National Institute of Adult Continuing Education.

Organisations

Eureka! The Museum for Children
www.eureka.org.uk

Discover
www.discover.org.uk

The Potteries Museum and Art Gallery, Stoke
www.stokemuseums.org.uk/pmag

Peterborough Museum and Art Gallery
www.peterborough.gov.uk/leisure_and_culture/museum_
and_galleries.aspx

The New Art Gallery Walsall
www.thenewartgallerywalsall.org.uk/

Creating Exhibitions
With and For Children

VICKY CAVE

Creative Director,

Discover (2000-2003)

Discover is a hands-on learning centre for children under eight years old based in Stratford, East London, which opened to the public in June 2003. Its focus is *story-building*, a term coined by Discover whereby children and their accompanying adults are encouraged, motivated and inspired to use their imaginations, to express themselves in a variety of ways, and to make stories together. Children and their adults can explore a series of story settings, where they can pretend to fly to fantastical places, dress up as monsters and invite friends to a party, make puppets and act out their own plays, wriggle through the Lion Tunnel to the Secret Cave, cross a Sparkly River on the Spider Trolley and draw or write postcards, secret recipes, wishes, poems and stories. Each child can make their own story in a story-book-bag with words, pictures, ideas and items collected from different story settings in the Story Trail.

Discover came to life after a study commissioned by the Gulbenkian Foundation identified the scarcity of informal learning provision in the UK as opposed to USA (with their children's museums) and Europe (with programmes for children run within museums and galleries). Director Peter Eatherley started with the task of establishing what Discover was going to be, and what better place to start than with the people who were going to use the place. The opinions of parents, carers and teachers informed the theme of Discover, which started as "words, language, and imagination", which developed into "making stories together".

With this idea in mind but with nowhere to go, Discover turned to the London Borough of Newham. They came to

the rescue with the donation of a five-storey Edwardian building and a plot of land off the High Street in Stratford, on a peppercorn lease. And so began the next step of raising the money and developing the exhibitions, all of which took a while.

The development time of Discover is longer than most projects, which may be no bad thing, as it afforded the opportunity for Discover to work with many different people. Being inspired by children's ideas, working closely and collaboratively with Bremner and Orr designers, and adding and refining throughout the development has made Discover the unique place that it is. It means that Discover has been made by children for children.

During the early stages of development of Discover, the team identified a strong commitment to developing the exhibitions by involving local people of the target age range. It was of paramount importance that there was local ownership for the project.

The question was, how should we go about communicating our ideas to an audience when there was little in the area that we could refer to? And how could we convey what it might be like when the building was still a building site and the garden a rubbish tip (literally)? And how could we involve very young children?

The answer was a three-pronged approach:

1. *Outreach*: Discover launched three outreach programmes targeting Key Stage 1 pupils, nurseries and people in public spaces such as libraries, museums and community centres.

In these sessions, children and adults travelled into a world of fantasy and imagination with trained story-builders. During the sessions, participants shaped and built their own stories. Through these outreach programmes, local schools became familiar with the concepts that Discover was promoting, and in turn, we were able to test out these key concepts.

2. *Testing out ideas:* Discover started an Exhibition Workshop Programme in January 2001, and the aim of this was to involve the community in the exhibition design and to provide opportunities for local people to develop a sense of ownership of Discover.

3. *Setting up a Children's Forum:* Discover developed a Children's Forum, which comprised 35 children aged between 4 and 11, who met regularly to contribute ideas and views on the development of Discover.

Through this range of different activities, we were able to achieve different goals:

- We made contact with our audience and communicated the different concepts we were planning for Discover.
- We were able to test out ideas and engage with people in creative ways that fed into the development of Discover.
- We built up a core team of advocates for Discover, who felt passionate about the place and who had a definite sense of ownership.

During the three years of development of Discover, through

the outreach programmes, the exhibition workshops and the Children's Forum, over 20,000 adults and children became involved and had a Discover experience. This meant that before it opened, local people and schools had some idea of what it was about and felt they had been involved with it in its early stages, giving them a sense of ownership and pride. Word-of-mouth is one of the most effective publicity tools and with 20,000 people as advocates of the project, word-of-mouth publicity spread like wildfire!

The Exhibitions Workshops Programme
Having decided that Discover's commitment during the development phase was to involve children and adults in its development, I felt it was really important for the process to be as creative as possible and to offer all the target age range the opportunity to contribute. The Outreach and Community Officer and I worked together to develop an Exhibition Workshops Programme, with the idea that the workshops would provide the raw material – the ideas and inspiration – for the design of the exhibits.

The Exhibition Workshops Programme aimed:

- To create opportunities for local people to become actively and creatively involved in the development of Discover.
- To engender a sense of local ownership and pride for Discover.
- To raise the profile of Discover within the local community.

- To provide a means to ensure that, when Discover opened, the exhibitions would be of interest to, and engage, the public.
- To provide opportunities for the Discover Children's Forum to become involved in co-ordinating the development of Discover's permanent experiences.
- To develop new audiences with a broad range of cultural diversity and to ensure that this would be reflected in Discover's exhibitions.
- To make links with community groups which would not necessarily visit Discover.

Further objectives were:
- To enlist and involve local artists in the development of Discover.
- To provide a bigger physical presence within the community when Discover opened.
- To act as a model example of community participation in the development of visitor attractions.
- To promote literacy through our theme of stories and creative learning.

The process

We developed a pool of artists, from a variety of different backgrounds, by placing advertisements in local arts shops and venues and in the *Artist's Newsletter*. Artists sent in their CVs and examples of work, expressing their interest and we filed them according to different criteria, such as experience

of working with young children, location (we wanted to work with local artists if possible), levels of creativity, ability to work as part of the wider project of the development of Discover.

We identified times in the exhibition development process that would benefit from an influx of creativity and developed workshop ideas to explore concepts and ideas which could be used in the exhibition.

We identified key audiences with whom we wanted to work. The criteria for selecting groups was based on representing the diverse population in Newham.

We drew up a programme of workshops, with around one workshop a month. This programme identified what artform we were intending to use, what area of the exhibition we were aiming to creatively explore and what target group we thought would benefit. We knew this programme would change as we took on the ideas from the children and the artists, but we needed a framework within which to work. This programme also allowed us to seek funding for the each of the workshops, and we had a good degree of success – it seemed that there were a number of charities who were willing to fund smaller projects which came in bite-size chunks (of around £5,000).

We interviewed and selected artists and visited the groups with whom we intended to work. We redefined the details of the sets of workshops according to the ideas of the artists and the needs of the groups.

The artists ran the workshops in schools, and with community groups. The artists were supported by the

Community and Outreach Officer and myself.

We wanted to use volunteers to watch and observe the workshops and to make notes of the stories that the children told. However, these volunteers found it hard not to get involved and became assistants to the artists much of the time. We sought other volunteers who could perform a more evaluative role, but we were not successful, simply through lack of time, now that the programme was in full swing. Often I would visit the sessions and carry out this role, and this was really effective, as it was a direct link to the exhibition development process. I was able to listen directly to the children, see their work and engage with them and further explore their ideas. I think that this was vital to the success of this project.

After the workshops in the schools or community groups, each of the artists provided us with an illustrated diary or report, which included photos of the children during the workshops and examples of their work. Some of the reports were in the form of a story and one of the artists produced a CD, animating the children's work to illustrate the narrative they had created.

We held meetings with the artists and the exhibition designers so that they could feed back the children's ideas to them.

Much of the artwork from the workshops was used by the designers as part of the exhibition decoration, and was incorporated into the identity of Discover. All materials produced in the workshops were saved and became a huge resource in the latter stages of the design process.

We adapted and amended the overall programme according to what had happened and we interviewed artists on a regular basis for the next set of workshops that were about to come up.

We used the records from the workshops (photographs, quotes, artwork) as a means to show funders what Discover was about and to show how much people were enjoying and gaining from the workshops.

The process provided us with ideas and showed us where we were going wrong, but most importantly where we were going right. The things that went well, we built on, experimented with and extended. By running the workshops we were able to take a good idea and develop it further with the children and make it into something even better.

As far as I know, this process is unique. We found that the programme of workshops meant that the children's ideas and work led our ideas in terms of the content and design, rather than being reactive. The work created in the workshops was the basis for the design ideas. It was the process of the workshops, and the ideas and concepts that they generated, which was of interest rather than the final product. For me, the snippets of narrative gleaned from children involved in their intense creations, were inspirational. We became absorbed in what interested the children, the ideas they developed and the characters and narratives they created. These were the things which we used as inspiration for the design of the exhibits. Many parents told me how much they loved Discover when it opened, but my favourite comment was from one mother:

"It's like stepping into the imagination of a child."

Examples of the kinds of workshops we run included:

- Exploring a 3D sensory path with 2-4 year-olds.
- Exploring the character of our organisation's mascot with the Children's Forum.
- Designing garden play structures – these ideas formed the basis of the brief for the sculptor we chose. In fact he ran the workshops.
- Exploring picnics: which is the theme of one of the exhibit areas – we explored the characters, the furniture, types of invitations and menus that would be at an animal picnic.
- Developing a story and images which would feed into the development of a chromakey exhibit called *Flying Pages* – the images children developed were integrated into a fly-through based on the stories that they developed.
- Designing the patterns for a giant's trousers.
- Developing the patterns for a responsive sensory exhibit.
- Developing ideas and prototypes for costumes.
- Exploring ways of transforming everyday objects into make-believe wonders using imagination (wooden spoon to puppet).

Top tips

- It is a time-consuming process – allow yourself enough time and adequate staff support.

- Invite members of the Board/Trustees/Senior Management to the workshop sessions. If they are at all sceptical they won't be if they get involved in a session.
- Don't underestimate young children. They have definite views, likes and dislikes. It's about creating an environment where they can choose different things and you can observe them.
- Get involved! Go to the workshops, support the artists and talk and play with the children. This will give you a real feel for what they are into.
- Involve the exhibition designers in the planning of the sessions, and invite them to take part. They will be much more receptive to taking on the ideas if they feel that they have ownership.
- If you can, publish the results of the workshops on your website or hold a series of exhibitions to display the work. Invite the participants to bring their family and friends.

Language Learning for Migrants, Refugees and Asylum Seekers

SHERICE CLARKE

Visiting Researcher

Learning Research and Development Center

University of Pittsburgh

The last few decades have seen the emergence of an increasingly reflexive museum, critical about their social and educational role as institutions situated within communities. This paradigm shift has highlighted the visitor as central to what museums do, how they communicate and educate, generating a wave of research focused on answering the question: just who is the visitor and why do they visit museums (Falk and Dierking 1992, 119; Hooper-Greenhill 1994, 1994).

Visitor research has been largely illuminative in this respect, bringing to light the commonalities of museum visitors (socio-economic status, ethnicity) as well as identifying groups of individuals that are under-represented visitors to museums. Visitor studies have also identified some of the barriers to attendance for under-represented groups, such as linguistic, geographical, attitudinal, financial and physical (Dodd and Sandell 2001). Awareness of barriers to attendance, coupled with the sector's inclusive agenda (see e.g. DCMS 2000; Sandell 1998), has generated some innovative programming in museums endeavouring to eliminate these barriers.

English for Speakers of Other Languages (ESOL) in museums is an example of this type of inclusive provision targeted towards eliminating linguistic barriers that might exist for migrants, refugees and asylum seekers by using museums and their collections for English language instruction. While archival research indicates that these types of programs are not exclusively a contemporary phenomenon, as practitioners have had a long history of making use of

museums' cultural, historical and educational resources to engage learners (Abram 2002; Lauritzen 2000; Gill 2007), there are a growing number of institutions developing this type of provision. These programs are becoming a more permanent aspect of their educational programming under the remit of inclusion, by way of partnerships between museum educators and ESOL practitioners.[1] While these programs differ in their approaches and implementation, the fundamental principle has been the same: to provide linguistic access to museums, their collections and educational resources to engage migrants, refugees and asylum seekers.

Museums for language learning?

After situating this type of provision within its socio-political and historical context, a few questions immediately emerge: (a) why language learning in museums? (b) what do museums and their collections have to offer as contexts for language learning? (c) how can language learning in museums be better understood in relation to the concept of inclusion? The answers to these questions could be helpful for informing policy and practice in museums, providing an evidence base for the this type of work.

To date, significant empirical research has not addressed the above concerns. This paper reports on doctoral research that investigates language learning in the City of Edinburgh Council's Museums and Galleries with a cohort of adult migrants, refugees and asylum seekers.

Figure 1: Research participants, City Art Centre, Unseen China Exhibition.

Background of the study

Theoretical Framework: Grounded in a socio-cultural theory of learning, this research takes the position that learning is mediated by physical and symbolic tools (Vygotsky and Cole 1978; Appel and Lantolf 1994). By physical tools, I refer to objects such as museum artefacts, while symbolic tools refer to tools such as language. Thus discourse and interaction are conceptualized in this study as sites in which learning can be advanced.

Museums and Galleries: This study was conducted with the participation of the City of Edinburgh Council Museums and Galleries service, whose main remit is to collect, preserve and provide educational resources about the culture, history, people and art of Edinburgh. The museums and galleries used as learning contexts for this study included the City Art Centre, an art museum and exhibition space; the Museum of Edinburgh, a history museum displaying aspects of the city of Edinburgh from prehistoric times to the present; the People's Story Museum, an oral and social history museum

of Edinburgh people; the Museum of Childhood, a history museum displaying aspects of childhood past and present; and lastly, the Writer's Museum, whose central focus is Scotland's literary history. (Fig. 1)

Data collection: Data collection was conducted in three phases carried out between December 2007 and September 2008. The first phase helped to map substantive issues with respect to adult ESOL provision and learners in Edinburgh. The second phase trialed the use of museums for adult ESOL instruction and the third phase sought to understand participants' experiences of adult ESOL in museums in depth.

For the first phase of the study, two community-based ESOL classes were observed, which provide part-time instruction for the target community of learners. Ten adult learners from these classes participated in two separate focus groups. The focus groups explored the participants' experiences in Edinburgh, in particular, their experiences engaging in English language and perceived learning needs.

Since no singular archetype of ESOL in museums exists, the aims of the second phase of the study were to consider how museums and their collections could be used for adult ESOL and how this type of provision could be made relevant to adult ESOL learners. Six adult ESOL learners participated in five ESOL sessions in all of the five museums and galleries. These sessions trialed and evaluated approaches to teaching English through the use of museums and their collections. The cohort participated in critical evaluative discussions held at the end of each session to examine their experiences

and perspectives during the sessions. Each session revolved through a development cycle of design, implementation, evaluation and refinement so that subsequent iterations were both informed and increasingly clarified. In addition, pre- and post-interviews were conducted with each participant to explore their biographies, reflections and evaluations of ESOL in museum sessions collectively.

The third phase of the study aimed to understand adult ESOL in museums in depth. It built upon findings from the first and second phases to implement eleven visits to City of Edinburgh Museums and Galleries over the course of three months. An ESOL teacher and a volunteer with extensive experience of the museums and a knowledge of their collections who assumed the role of docent, facilitated these sessions. A new cohort of 13 adult ESOL learners was selected to participate in the sessions over this three month period. The sessions were audio and video recorded and time-series interviews were conducted with participants at three stages: prior to the sessions, after the seventh session and one month after the sessions had concluded.

Participants: At the time of the study, Scotland had recently experienced rather rapid demographic changes in light of EU enlargement and labour migration encouraged by the Scottish Government (Scottish Executive 2001), as well as having been impacted by changes in the UK's asylum dispersal policy that has settled asylum seekers in Scotland's cities since 2000 (Institute for Public Policy Research 2005). These changes have contributed to emerging new communities in Edinburgh, a

term that I use to refer to economic migrants, refugees and asylum seekers inclusively.

In order to gain access to the target population for the study, partnerships were fostered with gatekeepers within these communities such as community centres, ESOL providers and practitioners. Partnerships with community centres in Edinburgh proved particularly fruitful, many of whom hired volunteers that were newly settled migrants themselves, who worked as liaisons to organize social programs and outreach for newly settled migrant families. These volunteers served as network hubs within these communities, which enabled me use snowball sampling to gain access to these hard-to-reach groups though family and friendship networks.

Participants in the study comprised a range of ethnic and linguistic backgrounds that are representative of the diversity of community-based ESOL in Edinburgh. The study included settled migrants, refugees, asylum seekers and economic migrants from Poland, Algeria, Pakistan, Ukraine, China, Japan, India, Sudan, Sri Lanka, Bhutan, Columbia and Iraq. Participants also ranged, with respect to their levels of formal English language education, from those that had no prior knowledge of English on arrival, to those that had years of formal language education. They also ranged in levels of ability from emergent/beginner to upper intermediate level.

Tasks: The eleven sessions were organized around a tripartite pre-, during- and post-session structure. The pre-gallery visit was used to activate participants' schematic and

lexical knowledge of the thematic content of the exhibitions or permanent display collections. During the visit, participants explored the collections, performing tasks that ranged from structured at the beginning of the study to increasingly open towards the end. The post-gallery visit tasks enabled participants to respond to the museum collections in a variety of ways, again moving from structured tasks at the beginning to increasingly open discussion tasks towards the end of the study. The pre- and post-stages were used to provide input and feedback on grammar and lexis. Sessions focused on developing and using speaking and listening skills. Communication gap tasks were used to facilitate authentic communicative gaps and encourage real-world listening and speaking.

Resources: A range of museum resources were used to facilitate these sessions in the galleries in addition to the objects (artefacts), sculpture, paintings, photographs and wall texts. These included the museums' handling collections, used during the pre- and post-phases; slides and audio recordings that accompanied collections on display; and materials developed by the ESOL practitioner and researcher specifically for learning tasks.

The following section will discuss data analysis and consider the implications for using museums for adult ESOL with this population. In doing so, this discussion will take as its central focus the data generated from the third phase of data collection, which investigated ESOL in museums in depth.

Understanding ESOL in museums

In order to understand ESOL in museums, this analysis focuses on two sources of data: talk in museums and narratives of experience.

Firstly, the goal of the research was to gain in-depth understanding of this type of learning in action. Through conversation analysis of naturally-occurring talk in interaction (Markee 2000), it is possible to understand the type of talk that is occurring within these contexts; how that talk is being constructed collaboratively and contingently through this interaction; and how talk constructed through interaction functions as an immediate resource for language learning and development. Analysis of transcriptions take a bird's eye perspective of discourse in museums, asking questions of the data such as what are participants doing in English, and examining how participants are drawing on one another's linguistic input during the interaction. Thus the discussion tasks, at the more open end of the spectrum, enabled me to analyze how participants were engaging with museum objects, and were making meaning from collections through talk and interaction.

In order to connect experience of this type of provision with the concept of social exclusion, it was necessary to understand participants' experiences of exclusion and inclusion prior to the study and analyse the trajectory of these narratives over the course of the study. Narrative analysis has helped to make the connection between ESOL in museums and the world that participants experienced outside the

Figure 2: People's Story Museum.

museums. Using this analytic approach, I examined how stories were constructed within an interview, or across a series of interviews, and analyzed how "storying" can elucidate the meanings that participants ascribe to their experiences (Labov and Waletzky 1967; Riessman 1993; Bell 1988).

Critical spaces for language learning

Following is an excerpt from the first visit to the People's Story Museum (session 4). This excerpt occurs just after participants' self-guided survey of the collection, during which the teacher opens up a discussion about what they observed in the galleries.

Excerpt 1: The People's Story: [2]

1 T1: -open discussion about ehm (++) what you (++) thought?

2 (3)

3 L2: nice building

4 L3: //((laughs))//

5 6 T1: nice building ((chuckles))

7 L2: yeah very historical (++) I think

8 T1: I liked the stairs and different places to go °and° (3) anything else? Did you learn anything //from=//

9 L2: //((inaudible))//

10 (3)

11 L1: because PEOPLE is very very intéressant I'm look is BIG CHANGE no this year is very very big change life people twenty (++) uh two hundred years ago (+) people LIVE °to° different to live (+) this moment (++) is uh, this moment is life is GO up is uh (2) no very very (+) long time ago? (+) people have money, >have work<, have ((inaudible)) to life, have time is (+) maybe no very diff- diffi- diff- life is difficult old time, °this moment is° maybe late late life is (++) nice?

12 L7: but is different no in compare yeah, I don't know, what ((word searching))

13 L8: ((to L7)) how is life? ((inaudible)) (++)

14 L2: I saw a picture when some women put labels (+) on whiskey bottle it was (+) I think (+) fifteen years ago? uh now polish staff put labels on this bottle ((grins)) (2) so? uh everything are changing (++) but we do some jobs=

15 T1: =same? Yeah they do similar jobs

16 L2: ((nods head)) yeah

Here we have a simple yet quite complex conversation, which helps to highlight the three dimensions of talk in museums that analysis of this case study has identified: linguistic, epistemic, and dialogic. By linguistic, I am referring to the functions of language produced. Language functions such as elaboration, refutation, repair requests (e.g. word searching) and providing a repair suggestion, are considered part of this linguistic dimension. In the above example, L1 responds to the teacher's request with an elaboration of her observations in the museum. L7's communication breakdown (line 11) beckons a repair suggestion, which is provided in this case by L8. However, L7 does not continue to elaborate on his point, so it is not clear if L8's suggestion was the expression he was looking for. Finally, L2's interjection at the end of the excerpt both responds contingently to L7's refutation as well as serves to elaborate on and support L1's perspective several conversational turns earlier. In this sense, the linguistic dimension highlights what participants are doing in English in these discussions and how that talk creates spaces for the co-construction of knowledge.

The epistemic dimension, a recurrent dimension in dialogic models of classroom talk (e.g. see Lefstein and Snell in press) relates to those aspects of talk that pertain to what counts as knowledge, the sharing of knowledge and who possesses knowledge. With respect to the above example, the teacher opens up a broad discussion, which functions to shift

institutional roles. In this respect, the teacher does not position herself as the sole possessor or transmitter of knowledge, but instead the question prompt functions to position participants as possessors of knowledge, who could potentially share their knowledge with participants, if they so choose.

There are two aspects of this role shift that need to be considered. Firstly, in terms of expertise, focus is on the expression of personal meanings, in which participants are the expert. Shortly, I will expand on the significance of this aspect in the context of studies that have illuminated the leitmotiv of discourse structure in second language teaching and learning. The second aspect is that by shifting the roles in this manner, the teacher does not objectify knowledge of the museum, collections and its objects. Instead, the teacher opens up space for participants' meaning making, which may be mediated by the museum's message about their collections, the participants' own experiences, prior knowledge, and beliefs, as well as interaction with other participants (aspects of Falk and Dierking 's (1992) interactive experience model).

Finally, the third dimension of talk during these sessions is their dialogism. This refers to the interactional aspects of talk including contingency, collaborative construction of meaning, negotiation for meaning, and intersubjective dynamics. In the above excerpt, contingency is a particularly salient aspect of the discussion, as turn sequences proceed swiftly and the discussion involves multiple speakers. Contingency entails both comprehension of other speakers and relevant responses that indicate that both display

understanding (negotiation for meaning), as well as keeping the conversation going (Silverman 2001, 168). In this respect, L7's refutation (line 11), displays his attention to L1's contribution (line 10), understanding and display of disagreement. Similarly, L8's repair suggestion (line 12) demonstrates that she was both attending to L8's meaning, his repair request and based on her understanding of his utterance within this context, hypothesizes his intended statement and offers that suggestion to him (L7). Likewise, L2's contribution (line 13) responds contingently to L7's refutation, ultimately showing disagreement, and elaborates on L1's interpretation in line 10. By doing so, he displays management of talk across a series of turns, with attention to meaning. This aspect of contingency is an especially important aspect of the talk that occurred in these museums, in the context of the common thread in second language classroom discourse, which I will discuss shortly.

In addition to contingency, participants are collaboratively constructing meanings, and generating discourse in this setting that is responsive, purposive and collective. By way of illustration, in the above excerpt L2's elaboration of L1's interpretation of the dominant theme in the collection helps to both clarify her perspective, but also ground it in the group's shared experience in the museum by referring back to a display in the gallery and how that display illustrates L1's point. This contribution might also act as language input and support for L1, who possesses a lower level of English proficiency than L2.

In explicating the dimensions of talk of ESOL in museums, my discussion so far has been limited to what has occurred during this visit to the People's Story Museum, through the interaction. However, this data alone does not provide enough insight into how this type of learning experience connects with learners' experiences of the world outside of museums, especially with respect to their use of English language. The narratives that I will discuss in the following section, help to make this connection, highlighting participants' experiences over the period of time of the study and how increased agency helped to bridge interaction outside of the museums.

Unpacking social exclusion

Firstly, it is important to note that definitions of social exclusion are numerous and debated. It has been conceptualized in psychological as well as sociological terms (see e.g. Abrams, Hogg, and Marques 2005; Paugam 1996; Levitas 2005). The (UK) Department for Culture, Media and Sport (DCMS) has urged the sector that inclusive initiatives should "promote the involvement in culture and leisure activities of those at risk of social disadvantage or marginalisation, particularly by virtue of the area they live in, their disability, poverty, age, racial or ethnic origin. To improve the quality of people's lives by these means" (DCMS 2000, 7).

While a lack of clarity exists within the sector with respect to a definition of exclusion (Hooper-Greenhill et al. 2000), what is characteristic of many approaches has been this emphasis on increasing participation of marginalized groups.

In this current study, in order to understand experiences of participation in ESOL in museums, it was necessary to understand experiences of marginalization and exclusion, and then make connections between these experiences and what the museum might offer that helps to address these complex issues. Interviews were conducted with participants before, during, and after participation in the museum program, exploring participants day-to-day experiences in Scotland, with particular emphasis on their experiences using English.

It was found that participants in the study experienced isolation that was mediated by both their opportunities (or lack thereof) to use and engage speakers of English and their perceptions of self as English language speakers. For example, while economic migrants that participated in the study had higher degree levels of education, they were only able to secure employment in low-skilled positions, such as slaughter houses, factories, and shipping facilities. These jobs did not require much engagement in any language, let alone English. Of those jobs that included some degree of interaction with colleagues, many were able to use their mother tongue as their colleagues came from the same ethnic or linguistic background. Similarly, participants that were stay-at-home parents, suffered from isolation, not having developed social networks in Scotland.

Another aspect of marginalization is that identities shaped engagement in English, or perceived access to that engagement. One of the findings of this study was that participants experienced a shift in self-perception through the

migration process (see also Norton 2000). Many participants perceived themselves as having a deficit of linguistic abilities in English and of what they could accomplish in English. For example, two of the participants had been doctors prior to migration, but were not able to secure employment as doctors in Scotland. It should be noted here that this might be attributed to a number of factors, such as medical qualification issues. However, what is significant is that participants perceived that the obstacle was language.

Fig. 3 (facing and following page) provides a glance at some of the narratives of three case studies, in light of this issue of social exclusion, as well as expressions of their desire to engage with people in English in Scotland and finally, excerpts from narratives after having participated in ESOL in museums, all of which help to unpack the experience of inclusion.

Unpacking inclusion

What is most salient form the excerpts from the last column of Table 1 is empowerment (the sense of being able to engage), agency (taking action), and engagement (the effect of agency). By way of example, L3's first excerpt in this column describes her impressions of engaging in museum discussions. At first she felt nervous, but after discussions were underway she felt more comfortable, or empowered to participate. Then by exercising this agency, she participated, after which she was amazed by what she said and her ability speak for a long period of time in English. In the second and third story, she describes noticing the statue of Greyfriar's Bobby[3], offering to retell

Case	Self-perception	Desire to engage	Unpacking inclusion
L1	I'm afraid is people good speak English, maybe listen my speak, maybe think oh this no good speak. Is a moment, I'm maybe to go to… inside? (Interview 1: 212-216) My nature is big talk normal to Poland [chuckles], normal big talk [chuckles], I like talk… (Interview 2: 414-416)	I here muss learn, muss talk… Maybe no I am no good, talk is barrier to me talk, very big barrier to me, no no I don't know maybe no good… This moment I maybe not [talk] very much. I go-ed to school, muss open- openly (Interview 1: 128-147) My nature is big talk normal to Poland chuckles]. Normal big talk [chuckles]. I like talk… To no talk English, to me, this is very big problem. (Interview 2: 414-419)	Go here, I'm talk my opinion, I… here talk is to me… helping to normal life. (Interview 2: 480-483) My colleague to factory to Scottish is… this… she… this is big women, she "woah you talk? You, what is this? You learn? You talk?" Yes eh…- woman know I no talk English… is moment she talk me, I answer, she's woah, you talk English? [chuckles] (Interview 2: 490-500) This moment is to me possible to me small contact to my colleague at work (Interview 2: 501-502) This moment I go here… is possible I'm open… (Interview 2: 533-534)
L6	First I want to improve my English level and then later I have confidence enough and then I will look for job. (Interview 1: 78-80)	You live in the foreign country and you must go into the sociality, how do you say? S: Society? L6: OK society, you must go into the… otherwise you will feel… feel mmm lonely. So if you want have friends, want something more, you must go into the society and you must to have confident to communicate with others, so the conversation is very important. (Interview 1: 142-153)	I think this is really a very good chance for me, come here, out of house… now I can be - I can have my own time, and I can talk about with others- about something with others and then I can get in touch… (Interview 2: 201-208) I'm looking for a job. But at first I get an interview for part-time base, but at last I got an offer is full-time offer. (Interview 3: 541-543) It's [job offer] just care assistant in care home, I don't think it's very good - very good opportunity, but anyway it's first job and I hope I can play a very - play a positive role in this country. (Interview 3: 549-554)

Case	Self-perception	Desire to engage	Unpacking inclusion
L3	OK with my speaking, I'm not happy with my speaking, OK?... I don't like myself when I say "sorry, sorry". I want to, if you ask me question, understand without say "sorry, sorry, sorry". So, because sometimes difficult for me go to uh... doctor, if I have got serious problem (Interview 1: 140-156)	I need to speak with other people, and understand me, and understand them. So maybe if I speak ok and understand them OK so. Now if feel homesick, yes. So after that - I don't know how to call in English, but if I can speak and understand, so maybe I feel little bit homesick. (Interview 2: 173-181)	At the first discussion I'm maybe a little bit panic for me, but after we start I feel more rest ok?... and I'm getting start to speak to speak to speak. And sometimes I speak English and after I go back home and say "oh that's what I said? Oh, ok ok" I don't believe myself when I speak for a long time. (Interview 2: 424-430) Sometimes I ask my husband, "do you know something like, do you know Bobby? Oh I will tell you" you know ((chuckles)) "so I will tell you about that" oh aye... yes. It's very nice. (Interview 2: 348-354) And uh... ok, sometimes when I was walking the street, I find Bobby, yes ((chuckles)). Tell my husband, "Bobby, do you want me to tell you about Bobby's story?" Yeah something like this (Interview 3: 751-756) Because if I want to call the doctor, I say my husband "call the doctor". And he say "no, you can do it, no, you can". No, I can call myself and I can speak in telephone... I can do anything by telephone. (Interview 3: 940-947)

Figure 3: The narratives of three case studies.

this story. Here the same narrative is repeated approximately two months after the first telling. Repeated narratives might indicate that this experience was particularly salient to this individual. Later in her narrative, she tells how knowing about some aspect of history that she could share with others felt rewarding.

L1's narrative describes her participation in ESOL in museums as helping her to lead a normal life. The desire for normalcy was a recurrent theme throughout her narrative, suggesting that her life lacked a sense of normalcy in this new circumstance. She describes participating in ESOL in museums as the beginning of her opening up process. She also describes the moment when a Scottish colleague expressed amazement when she noticed that L1 began speaking English. The teacher and teaching assistant in the study observed the same transformation as L1 went from silent to active participant in these sessions. The fourth session (excerpt 1 above) was the first session in which L1 participated voluntarily. Finally, she comments on how she felt she was now able to interact with her colleagues. This highlights a critical aspect of these sessions, which is their ability to bridge interaction outside of museums.

Finally, in the third case study, L6 expresses her desire to increase her confidence before she engages with the public, such as by seeking employment. She expresses a strong desire to "enter society" and reasons that confidence in one's ability to communicate is key in order to become a member of society, have friends and not experience loneliness. After participating

in ESOL in museums, she comments on being able to talk with other people and "get in touch", which suggests that this type of engagement also helps her make connections with people. This type of engagement can be contrasted with more transactional forms of interaction. Finally, she describes looking for and being offered a job, which is meaningful in the light of her earlier expressed desire to increase confidence in order to be able to find work.

As previously mentioned, the participants were engaged in tasks that created authentic communication gaps in order to facilitate active listening and speaking.

Engagement in active listening and speaking is significant – I would argue critical – with respect to language learning and adult ESOL learners, as it can lessen the gap between classroom discourse and real-world interaction. Van Lier notes that one of the qualities of discourse in the language classroom is its unnaturalness, and argues that practitioners should be striving for authenticity (van Lier 1996). In this respect, active listening models real-world listening and entails negotiation for meaning, which uses one's grammatical, lexical and pragmatic knowledge to decode and encode talk between interlocutors. Likewise, authentic speaking produces relevant yet unpredictable talk, expresses identities and conveys personal meaning. Because this particular group of learners might have limited opportunities to engage in English outside of the classroom, opportunities for authentic discourse within the classroom are crucial.

Research on classroom discussion has helped to

illuminate the forms of institutional talk that exist in educational settings, such as those that are pedagogically aligned to evaluate uptake of learning content[4], but also has sought to explain what happens when participants are engaged in discussion. Various taxonomies of classroom talk have subsequently emerged, with the aim of explaining the conditions in which learning through discourse could take place (Michaels, O'Connor, and Resnick 2008; Lefstein and Snell in press). What these taxonomies highlight is the co-constituted nature of discussion, in which participants build upon each other's contributions, and how this assists interlocutors to construct meaning and reasoning within these discussions. Similarly, Baynham et al's (2007) survey of best practice in adult ESOL provision found that when students were given opportunities to "speak from within", that is, about things that mattered to them such as lived experiences, the language that learners produced was far more lexically dense than the more structured and controlled language learning tasks. While these studies have focused on formal learning settings, it is possible to see what they offer for the informal learning setting, in conjunction with the dimensions I have outlined above.

Conclusion

"...it is in learning and using language that we enter into and participate in the ongoing dialogue of meaning making in the communities to which we belong". (Wells 1999, 119) It is hoped that this chapter has provided some insights into how

this type of provision can create critical spaces for language learning and inclusion. Talk is at the heart of language learning. However, lack of opportunities to engage in English with speakers of English is one aspect of social exclusion that adult migrants, refugees and asylum seekers face. The other aspect is their identities as speakers of English. Museums can provide learning environments in which learners engage with collections and make meaning of these collections through language. Museum-based language learning can give voice to learners' perceptions, experiences and meanings and engage them in authentic discourse that moves beyond the functional to idea-driven intellectual engagement, opening up space for learning about language, art, culture and history inclusively.

This study constituted a semi long-term partnership (11 museum visits, 3 interviews) with a cohort of participants from a range of ethnic, cultural and linguistic backgrounds. I have taken a single session as the unit of analysis for the purposes of this discussion, in order to illustrate the possibilities and opportunities museums as language learning contexts offer adult migrants, refugees and asylum seekers.

References

Abram, Ruth J. 2002. Harnessing the power of history. In *Museums, society, inequality*, edited by R. Sandell. London: Routledge.

Abrams, Dominic, Michael A. Hogg, and Jose M. Marques. 2005. A Social Psychological Framework for Understanding Social Inclusion and Exclusion. In *The Social Psychology of Inclusion and Exclusion*, edited by D. Abrams, M. A. Hogg and J. M. Marques. New York: Psychology Press.

Appel, Gabriela, and James P. Lantolf. 1994. Speaking as Mediation: A Study of L1 and L2 Text Recall Tasks. *The Modern Language Journal* 78 (4):437-452.

Baynham, Mike. 2007. *Effective teaching and learning*. ESOL. London: National Research and Development Centre for Adult Literacy and Numeracy.

Bell, Susan E. 1988. Becoming a Political Woman: The Reconstruction and Interpretation of Experience Through Stories. In *Gender and discourse: the power of talk*, edited by A. D. Todd and S. Fisher. Norwood, N.J.: Ablex Publishing Corporation.

Cazden, Courtney B. 2001. *Classroom Discourse: the Language of Teaching and Learning*. Portsmouth: Heinemann.

DCMS. 2000. *Centres for Change: museums, galleries and archives for all*. London: Department of Culture, Media and Sport.

Dodd, Jocelyn, and Richard Sandell. 2001. *Including museums: perspectives on museums, galleries and social inclusion*. Leicester: RCGM.

Falk, John H., and Lynn D. Dierking. 1992. *The museum*

experience. Washington, D.C.: Whalesback Books.

Gill, Kate Bowen. 2007. *Toward authentic communication: Analyzing discourse in adult ESOL instruction in an art museum*. Unpublished PhD Dissertation. Graduate School of Education, Harvard University, Boston.

Hooper-Greenhill, E, Richard Sandell, T Moussouri, and H O'Riain. 2000. *Museums and Social Inclusion: The GLLAM Report*. Leicester: University of Leicester.

Hooper-Greenhill, Eilean. 1994. *Museums and their visitors*, The heritage: care - preservation - management. London: Routledge.

―――. 1994. Who goes to museums? In *The educational role of the museum*, edited by E. Hooper-Greenhill. London: Routledge.

Institute for Public Policy Research. 2005. *Asylum in the UK*. London: Institute for Public Policy Reseach.

Labov, William, and Joshua Waletzky. 1967. *Narrative Analysis: Oral Versions of Personal Experience*. Paper read at Essays on the Verbal and Visual Arts: Proceedings of the 1966 Annual Spring Meeting of the American Ethnological Society, at Philadelphia.

Lauritzen, Eva Maehre. 2000. Norway. In *Museums and adults learning : perspectives from Europe*, edited by A. F. Chadwick, A. Stannett and National Institute of Adult Continuing Education (England and Wales). Leicester: NIACE.

Lefstein, Adam, and Julia Snell. in press. Classroom Discourse: The Promise and Complexity of Dialogic Practice. In *Insight and Impact: Applied Linguistics and the Primary School*,

edited by S. Ellis, E. McCartney and J. Bourne. Cambridge: Cambridge University Press.

Levitas, Ruth. 2005. *The inclusive society? : social exclusion and New Labour*. 2nd ed. Basingstoke: Palgrave Macmillan.

Markee, Numa. 2000. *Conversation analysis, Second language acquisition research*. Mahwah, N.J.: L. Erlbaum Associates.

Michaels, S., C. O'Connor, and L.B. Resnick. 2008. *Deliberative discourse idealized and realized: Accountable talk in the classroom and in civic life*. Studies in Philosophy and Education 27 (4):283-297.

Norton, Bonny. 2000. *Identity and language learning : gender, ethnicity and educational change*, Language in social life series. Harlow, England: Longman.

Paugam, Serge. 1996. *A New Social Contract? Poverty and Social Exclusion: A Sociological View*. In EUI Working Papers: European University Institute.

Riessman, Catherine Kohler. 1993. *Narrative Analysis. Vol. 30, Qualitative Research Methods*. London: Sage Publications.

Sandell, Richard. 1998. Museums as agents of social inclusion. *Museum Mangagement and Curatorship* 17 (4).

Scottish Executive. *Promoting Scotland's interests in Europe - McConnell speaks at Poland Conference*. [Press Release], 10 June 2007 2001 [cited. Available from http://www.scotland. gov.uk/News/Releases/2001/04/24d7b9ab-1f69-4700-8609-1f65f330cafa.

Silverman, David. 2001. *Interpreting qualitative data : methods for analyzing talk, text and interaction*. 2nd ed. London: Sage.

van Lier, Leo. 1996. *Interaction in the Language Curriculum.* New York: Longman Publishing.

Vygotsky, L. S., and Michael Cole. 1978. *Mind in society : the development of higher psychological processes.* Cambridge: Harvard University Press.

Wells, Gordon. 1999. *Dialogic Inquiry: towards a sociocultural practice and theory of education.* Cambridge: Cambridge University Press.

Notes

1 Following is a list of some of the museums and galleries that have incorporated ESOL material into their educational provision. In the UK: the British Museum, London, Geffrye Museum, London, National Gallery, London, National Museums Liverpool, Liverpool, Open Museum, Glasgow; Salford Museum and Art Gallery, Salford, Tate Britain, London, Tate Liverpool, Liverpool, Tate Modern, London, National Museums of Scotland, Edinburgh, Victoria & Albert Museum, London; in the US: Getty Museum, Los Angeles, Lower Eastside Tenement Museum, New York, Museum of Modern Art, New York, National Postal Museum, Washington D.C., Philadelphia Museum of Art, Philadelphia; In Australia: Immigration Museum, Melbourne, Melbourne Museum, Carlton, Museum of Contemporary Art, Sydney, Science Works, Spotswoods, Chinese Museum, Melbourne; In Canada: the Vancouver Police Museum, Vancouver; in New Zealand: Te Papa Museum, Wellington.

2 Transcription Conventions (adapted from Markee, 2000 p. 167-8)
Simultaneous overlapping talk by two or more speakers:

 L1: //yes//

 L2: //uh huh//

Intervals within and between utterances:

 (+) a pause of between .1 and .5 of a second

 (1)(2) a pause of between 1 or 2 seconds

Characteristics of speech delivery:

 ? rising intonation, not necessarily a question

 ! strong emphasis, with a falling intonation

 . indicates falling (final) intonation

 , indicates low-rising intonation suggesting continuation

 go::d colon indicates lengthening of the preceding sound

 - indicates an abrupt cut-off

HABIT	capitals indicate increased volume
°cannot°	degree symbol indicates decreased volume

Commentary in transcript:

((laughs))	comments about actions noted in transcript; including non-verbal action.

3 The original plaster cast and other artefacts from the legend of Greyfriar's Bobby are housed in the Museum of Edinburgh permanent collection.

4 Referred to as IRF (initiation-response-feedback) or IRE (initiation-response-evaluation) cycles (see e.g. (Cazden 2001; van Lier 1996; Lefstein and Snell in press).

Keep up the Good Work? The Long-term Impact of Social Inclusion Initiatives

LUCIE FITTON

Inclusion Officer

Museum of London

This essay is based on a dissertation study which explored the long-term impact on individuals who participated in museum-led social inclusion initiatives. There is extensive debate regarding social inclusion and exclusion as the sector still seeks to understand and define its role in relation to these concepts. This debate will not be entered into deeply here, but, because this study focuses on the impact experienced by people at risk of exclusion, an understanding of what that means is vital. For clarification, the Social Exclusion Taskforce[1] takes the term social exclusion to mean people who "suffer from a combination of linked problems such as unemployment, poor skills, low incomes, poor housing, high crime, bad health and family breakdown." In this study all forms of engagement are referred to as "social inclusion initiatives", whether this takes the form of workshops, projects or larger programmes and regardless of the title of the actual programme delivered. This study has sought to explore the impact experienced a significant time after the end of an initiative, so "long-term" is deemed to be at least six months after participants' involvement with a museum. In this study the range was six months – four years with an average of two years.

The first part of the study explored existing research in this area, or more so the reason for the lack of research, but for the scope of this essay this section is only referred to in the conclusion. The second part of this study, and the key focus here, takes the form of a pilot research study into the level and nature of the long-term impact on fifteen individuals deemed at

risk of exclusion who participated in social inclusion initiatives at the Museum of London[2] (MOL). From this pilot research, this study aims to ascertain whether assessment of the long-term impact on people at risk of exclusion is a possibility, whether participation does result in long-term impact and to gauge what the nature of the potential impact is.

Methodology

This is a very brief overview of the study's methodology. The author's position as Inclusion Officer at MOL strongly affected the decision to undertake this work. The author has worked at MOL for over five years (three at the time of the study) and therefore has access to an extensive contact list of participants who have participated in a wide variety of programmes that have engaged audiences at risk of exclusion. The reason to interview participants from just one museum was deliberate because the dedication and time needed to track and organise individuals whose lives are typically transient is considerable. The success of arranging interviews depended on the relationships between staff members and individuals, and seeking this dedication of time and energy from staff at other museums was beyond the scope of this study. Participants from eight different initiatives across four different programmes[3] at MOL were interviewed. Fifteen people were interviewed, all in the form of in-depth interviews.

The questionnaire used the Generic Learning Outcomes (GLOs) framework[4] as a structure for assessing their

perceptions of the levels and types of long-term impact resulting from engagement with the MOL. This framework is employed by the MOL in its approach to evaluation, so many of the participants would be familiar with GLO terminology; however, it was important to adapt the phrasing or language when necessary so that questions were natural. All interviews were transcribed and then the qualitative data was analysed for any positive references. Comments were counted once and coded to one of the five GLOs. In this way a body of rich qualitative and quantitative data was formed.

Was long term impact evident?
All fifteen participants interviewed said their involvement with the museum had a long-term impact on their lives. This has been broken down into the five specific Generic Learning Outcomes. This table shows how many of each fifteen interviewees stated at least one positive reference to long term impact of that particular outcome.

Attitudes & values		Skills		Activity, behaviour & progression		Enjoyment, inspiration & creativity		Knowledge & under- standing	
Yes	No	Yes	No	Yes	No	Yes	No	Yes	No
15 100%	0	13 87%	2	12 80%	3	12 80%	3	11 73%	4

Number of participants who said their museum experience had had a long term impact by outcome.

Type of impact

From fifteen interviews, 144 references were made to the long-term impact on their lives as a result of taking part in initiatives at the MOL. The number of references has been counted to provide a good overview as to which of the outcomes were perceived as having the most impact. Comments could be categorized into a number of outcomes depending upon how they were interpreted, but for this research any statements made by participants have been categorised into just one outcome.

Learning outcome	Number of references	Percentage of total
Knowledge and understanding	16	11.1
Skills	35	25
Enjoyment, inpiration and creativity	48	33.3
Activity, behaviour and progression	22	15.3
Total	144	100

Number of positive references to each GLO, and the % of total comments

Comments were further explored to understand the kind of impacts within each outcome. Illustrative quotes are used for the main sub-themes analysed.

Attitudes and values

Six sub-themes were recognised within the broader theme of attitudes and values.

Theme	Number of references	Percentage of total
More positive attitude towards self	15	31.25
More positive attitude towards others	13	27.1
More positive attitude towards museums	8	16.7
Increased tolerance	5	10.4
Increased self-awareness	4	8.3

Sub-themes analysed within *attitudes and values* outcome

More positive attitude towards self

Fifteen comments referred to a variety of factors that contributed to a more positive attitude towards self. This included feeling proud of achievements, having more confidence, increased self-esteem and more self respect. Paul (M, 41, 42 first number relates to age during engagement, second to age at interview) felt a lasting sense of pride after others, including staff took an interest in his artwork. "I felt proud. I'd have loved to have seen the exhibition. Since, others here have asked about my painting and I can share. Even prison officers, they are interested." Others commented that people in their lives noticed an increased in confidence, such as Nathan (M, 21, 24): "My advisors (employment agency) said you've become a lot more confident. I think yes, I am. Before, well, I didn't take myself serious, I used to just sit back and agree with everything, but now I think, yes this is right, or no that is wrong." Others such as Arthur (M, 53, 55) felt that this positive attitude stemmed from being in a more positive environment;

"My attitude, it's more positive. You can get involved with groups of people who are highly negative with their attitudes, it's so important to rise above that, and you can only do that with help from organisations like yourself and Crisis."[5]

More positive attitude towards others

The majority of these comments related to being able to understand others' different viewpoints, such as Clint (M, 38, 39) who said, "now when others show me their work I start to understand their lives," and Sophearn (M, 28, 29) who commented, "During the project I meet a lot of different people, different colours and even though they are old or young they are your colleagues, I understand more different people." Ghulam's (M, 79, 83) experience left him with a more positive perception of young people: "I enjoyed working with the kids in the project. It did change the way I think about them, they are alright now." Increased respect for difference was a common theme. Andrew (M, 26, 29) commented that "some people totally surprised me with views I wouldn't expect. Now I don't stereotype." In addition, participants also cited being more interested in others, being friendlier towards others, recognising they can learn from others and believing everyone is talented.

More positive attitude towards museums

A change in attitude towards museums was also evident. All eight of these comments were positive and the majority felt they were more interesting. Andrew (M, 26, 29) said the project "made

me want to take more of an interest in going to museums. Since the projects I have gone to Science Museum and Natural History Museum with friends." Ghulam (M, 79, 83) discovered museums for the first time: "Before, I didn't know what was in museums but now I think they are different and interesting." Change in the opinion of others was more profound, such as Arthur (M, 53, 55) who said museums are now part of his lifestyle: "The museum has become part of my lifestyle," and David (M 53, 55) "If I hadn't done the projects I think I might have gone to the occasional one but I didn't feel at home until I done workshops here."

Skills

Six sub-themes were recognised within the broader theme of 'skills'. References to improved social, verbal communication, group working and listening skills as well as confidence, were referred to as being connected, so have been categorized together.

Theme	Number of references	Percentage of total
Increased social, group working, verbal communication, listening skills and confidence	20	55.6
Creative skills	8	22.2
Intellectual skills	4	11.1
Written skills	2	5.5
ICT skills	1	2.8
Teaching	1	2.8
Total	36	100

Sub-themes analysed within *skills* outcome

Increased social, group working, verbal communication, listening skills and confidence

In relation to skills, over 50% of comments referred to soft skills such as social skills and group working, and participants explained how they had applied these new skills. Simon (M 48, 51) felt the project helped increase social skills: "My problem before I came into prison was lack of social skills. Inside I started becoming proactive at socialising, the project was an added impetus and I've gone on to use those skills to be an elected committee member." Andrew's (M, 26, 29) new social skills were used in interview situations: "I picked up social skills from working with people I didn't know, it's helped with interviews. For one job I got we had to be in a room full of other interviewees and I could act confident." Making friends and contacts was commented on. David (M, 53, 55) said, "I've met a lot of interesting people at the galleries and made new friends. I've made a lot of contacts." Some of the new skills were acquired through the experience of working with different staff: Ade (M, 56, 57) comments "I learnt for the first time to work in a group and with lots of tutors; I've been able to apply the skills in my other classes." Some, such as Clint (M, 38, 39) felt that social skills aided self-reflection, "It gave me an insight; I lacked a bit of people skills, I was able to reflect how I communicated with people, I have adjusted. I used to make comments and be a bit of a clown but I since stopped."

Creative skills

Many of the initiatives' interviewees participated in art forms,

such as photography and painting, so it is not surprising many cited that there had been a long-term impact on their creative skills. Brian (M, 53, 34) said, "I got better painting and drawing skills; I was in an exhibition and now I can draw buildings," and Simon (M, 48, 51) also cited ability to do new art forms: "I did carry on doing some screen printing after the project." Some have continued with new creative skills, such as David (M, 53, 55): "I've taken an interest in abstract (art) more than figurative and sort of adding words and pictures to express feelings to the picture."

Enjoyment, inspiration and creativity
It was difficult to divide the enjoyment, inspiration and creativity outcome into categories as such concepts are rather ambiguous; however four sub-themes were recognised. Note, creativity here has been deemed separate from creative skills as referred to in the 'skills' outcome results. The latter relates to the long-term impact of gaining specific skills such as printing or painting.

Theme	Number of references	Percentage of total
Willingness to try new things/have new and innovative thoughts	11	50
More inspired to be creative	5	22.7
Increased enjoyment	3	13.65
More inspired to explore	3	13.65
Total	22	100

Sub-themes analysed within *enjoyment, inspiration and creativity* outcome

Willingness to try new things/have new and innovative thoughts

Over half of all comments for this outcome related to a willingness to try new things, although as mentioned there is overlap in these themes, for example, *wanting to explore* could be the same as *trying something new – a place*. Endi (M, 37, 38) was inspired to put his artwork on the internet: "It (project) made me think of doing a MySpace[6] and I could put my art work on it." Some participants were inspired to try new creative pursuits, such as Ade (M, 57, 60): "I read more poetry and write more. I joined a creative writing group in prison as lots enjoyed my poem."

More inspired to be creative

Participants made five references to being more inspired to be creative since their participation with the project, such as Paul (M, 41, 42): "I'd love to be able to do art and writing, the project helped," and Endi (M, 37, 38): "I never considered doing artwork but I may do some in the future. I liked the end result; it broadened my things I could achieve."

Activity, behaviour and progression

The six key sub-themes identified in this outcome are shown in the following table. Long-term impact on employment activity and involvement in the arts were most frequently cited.

Theme	Number of references	Percentage of total
Employment-related activity	7	31.8
Involvement in the arts	7	31.8
Becoming more active generally	4	18.2
Making new friends	2	9.1
More interest in the local area	1	4.55
Becoming more settled	1	4.55
Total	22	100

Sub-themes analysed within *activity, behaviour and progression* outcome

Employment-related activity

Almost a third of comments relating to long-term impact on participants' activity and behaviour relate to employment, most citing increased time devoted to looking for work or actually getting work. Wanting to do more volunteering was also mentioned. Arthur (M, 53, 55) comments, "These types of things give us impetus to improve, it has for me, and now I'm getting more interviews." Nathan (M, 21, 24) is more active in job searching: "Before the project I just used to walk to the shop, get the paper, look through it and say I haven't found anything (jobs) but after the project I do look in the paper; I go to TNG (employment agency) and other job agencies and I go there every other day looking for jobs." Some cited an impact on their career choice, such as Sophearn (M, 28, 29): "It's made me want to be a tour guide or work in a museum, I have more experience."

Involvement in the arts

An equal number of references were made to becoming more involved in the arts. Ade (M, 57, 60) said. "My personal business is totally destructed after 3 years in here (prison), but whatever I do after here I intend to paint and do an exhibition. That's my motivation from the project." Both Arthur and David joined art groups after their MOL experience. Arthur (M, 53, 55) explains, "I did the Art Works (project) and thought I like learning about art, and then I went to the Mary Ward Centre[7] and did the access arts course. Because I'd been out of education for a lot of time, and being in the circumstances I was, it was very important for me as an individual to socialise and be with people and keep myself active in mind, body and spirit." David (M, 53, 55) explains how he joined an art group as a result of the friends he made from the museum project, "I made friends with people doing the project here (MOL) and they told me about Crisis and I went down there. They (Capital Arts group)[8] go in to do an arts forum at Crisis. I practice art and about every three months we have an art exhibition and I show my work there."

Becoming more active generally

Some of the comments related to wanting to be more active generally; Pushpa (F, 70, 73) said, "When we sit and think about what we done it makes us realise we need to find more new things to do." Andrew (M, 26, 29) believed the experience helped him change his routine: "I was getting in a rut, same routine, it took me out of that."

Knowledge and understanding

Seven sub-themes were identified within the broader theme of increased knowledge and understanding, the most common being new links made between the past, present and their own lives (37.5% of references in this theme), as well as linking art and history to wider issues (31.25%).

Theme	Number of references	Percentage of total
Connections made between the past and the present and links made to own lives	6	37.5
Link made between art or history to wider issues such as politics, employability and multiculturalism	5	31.25
Greater understanding of art and/or history	3	18.25
Greater understanding of life	1	6.25
Greater understanding of self	1	6.25
Total	16	100

Sub-themes analysed within *knowledge and understanding* outcome

Connections made between past, present and their lives

Jill (F, 28, 28) had learnt her family history was linked to Docklands, and this has encouraged her to want to find out more: "The docks, my dad used to work on the docks, yeah, so I can go and learn more about them now." Brian (M, 34, 34) also learnt to relate elements of his life to the past: "Well I like it (Museum in Docklands). It's old things; old and new things have changed a lot ain't they – like pubs where I live."

Links made between art and history, to wider issues

A long-term effect of participating in MOL initiatives was a change in views on the connections between art and history and wider issues. Learning about the history of his local area caused Nathan (M, 21, 24) to recognise London's multiculturalism: "I learnt about different people coming into the country, instead of there just being white people, different nationalities have all come in, it's a multicultural country, I see London as a more diverse place." Paul (M, 41, 42) now views art as political: "I saw the link between Myra Hindley's thumb picture and public opposition. I can see the link between art and politics." Sophearn (M, 28, 29) related a painting in the MOL collection to politics in his own country: "When I see that painting of the Brixton Riots it just, like remind me about my country, what was happening with the monks and the government. Now I just want to paint more things or draw some things to explain and show to the world you shouldn't hurt someone because they are people."

Discussion of results

In summary, 100% of participants interviewed in this study indicated their engagement with the MOL had a long-term impact. 144 comments relating to such impact were recorded, with an average of 9.6 comments per interviewee. Impact on attitudes and values was referred to the most (33.3% of total comments), followed by skills (25% of total comments). Enjoyment, inspiration and creativity, and activity, behaviour and progression were equal next (both with 15.3% of total

comments), followed by knowledge and understanding (11.1% of total comments). To summarize each outcome, 15 out of 15 (100%) participants said their engagement had an impact on their attitudes and values; 13 out of 15 (87%) participants said the skills they had gained had been used; 12 out of 15 (80%) participants felt there had been an impact on their levels or experience of enjoyment, inspiration and creativity. The same number felt their museum experience had an impact upon the way they behaved, what they did or intended to do (activity, behaviour and progression). 11 out of 15 (73%) felt knowledge and understanding gained during their museum experience had an impact. The findings demonstrate that significant impact was experienced across all outcomes, even those which received the least references. Relating these results to the GSOs, it is argued that the outcomes cited had significant impact on participants' quality of life, which related most strongly to outcomes for individuals.

A summary of key themes, which illustrate the areas where impact was most felt by participants, follows. The long-term impact upon participants' attitudes and values related most strongly to a positive change in attitude to self and towards others. There were also a high number of comments referring to a more positive attitude towards museums. Over half of all comments relating to skills that participants have applied in their lives since their time engagement with the MOL link to social, verbal communication, group working, listening skills and confidence. This suggests that museums can play a strong role in helping users develop "softer" skills[9].

Almost a quarter of references in the skills outcome were made to creative skills; however, many of the initiatives the interviewees participated in involved the arts as a method for engaging users in their heritage[10] so the results could be biased due to this.

Impact on levels of enjoyment, inspiration and creativity was often interlinked, so it was more difficult to analyse into sub-themes; however, many cited that since engagement with the MOL they had tried new things and had new ideas. Results of activity, behaviour and progression recorded in summative evaluation can be seen to have direct relevance to intended long-term impact as they aim to gauge what will happen. In this research, participants were asked about tangible things that had happened, as well as long-term changes in behaviour. Most comments related to changes in work-related activity, mainly looking for jobs and getting interviews, as well as increased involvement in the arts, including visiting museums. Policy makers and funders may not attribute so much importance to changes in attitude or softer skills, but hard evidence such as entry to education or employment is harder to deny. With regard to knowledge and understanding, it was observed that knowledge gained during participants' MOL experiences had impacted in the long-term by enabling links to be made between the past and present, and relating this to their own lives or wider issues such as politics and multiculturalism.

It is impossible to know whether the same impact would be the most prevalent across all museums, as outcomes are

tied heavily to the very personal circumstances of museum, initiative and individual. Although the data collected was primarily qualitative, presenting the findings in quantitative form as well aimed to provide a more balanced view of the level at which impact was experienced and what form it took. What the quantitative data fails to show is the depth to which impact is felt. For example, the least number of references were made to knowledge and understanding, but those impacts may have been more profound. It is accepted that this research can only provide a perception of impact, but in line with the widely accepted constructivist[11] view of learning (by which it is understood that users create their own meaning and construct their own knowledge), perception, as Hooper-Greenhill[12] argues, is what visitor research should be assessing: "More people realise that people use museums because of how they perceive them, understanding of visitors must include what perceptions are."

Referring to the concept of "capital", the different impacts experienced by individuals can be seen across all the forms in this research. Involvement in the arts and increased creativity, for example, demonstrates accrual of cultural capital, but the social and identity capital acquired by participants in this research seems to have had greatest long-term impact. Although the analysis of data collected has focused on GLOs and individual impact, the development of the GSOs illustrates the link between individuals, communities and society. Social capital is a key element of the GSOs framework, linked to the outcome Creating Cohesive Communities.[13]

"The basic premise is that interaction enables people to build communities, to commit themselves to each other and to knit the social fabric," London Museums Hub.[14] The report goes on to explain three types of social capital, bonding, bridging and linking.

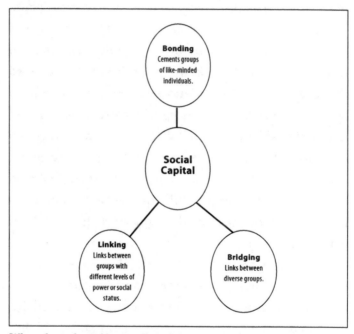

Different forms of capital (not an exclusive list)

Making friends and understanding people different from themselves was cited by many interviewees, which could particularly be described as "bridging social capital". Many in the sector, such as Dodd and Sandell[15], and Scott[16], have discussed the unique contribution of museums to social inclusion. Objects are often recognised as the element that

makes museums unique, and although they are important, the actual environment of the museum is central to their ability to contribute, as Newman[17] suggests, "the museum can assist in the development of social capital because they are comfortable, accessible, enjoyable and trusted places." Museums have a long way to go before they are comfortable places for all, particularly audiences who feel they are irrelevant to their lives, but this study suggests that this is perhaps one of the most important ways museums can contribute towards creating social capital.

Many of the difficulties in assessing long-term impact which are cited in the literature, such as tracking participants, subjectivity in interviewing, and the ability to relate long-term impact to a specific activity that happened a significant time ago, were all evident in the interviewing process. It was not difficult to track sufficient numbers of participants for this small-scale research, but it would have been impossible to contact all participants from suitable programmes at the MOL. The difficulties of linking direct outcomes to museum initiative participation, as Peacock[18] highlights, are because there could be so many intervening factors in an individual's life which could have had an effect since. Such obstacles were tackled by encouraging participants to comment only on outcomes that were direct results of their museum experience. Some participants felt that the museum involvement was a contributing factor towards a particular outcome, and when this was the case the comment has been included. Some, such as Goodlad et al[19], argue that museums can only ever

hope to be part of a bigger process that contributes toward impacts that fashion social inclusion: "theory suggests that, at best, social inclusion might be supported by participation in the arts, but it is unlikely to be the only factor in securing inclusion in more than a few distinctive cases." The value of being a contributing factor should not be underestimated. Many of the outcomes cited in this research were found to be directly related to museum engagement. More research is needed to explore how long-term impacts of involvement in museum initiatives can relate to impact on the indicators of social exclusion such as crime, poverty, unemployment and health, although research which is informed by the GSOs framework has the ability to consider health, wellbeing, civic engagement and make more direct links.

Another challenge in analysing the data was in relation to categorising impacts according to the various outcomes of the framework. It has been mentioned that much of the impact cited by participants was considered interlinked. London Museums Hub[20] describes the challenge, "The need to make choices is a common feature of all evaluation frameworks, the key point is to assign evidence to the outcomes with the best 'fit'." It was felt that this was successfully managed, and although the use of frameworks implies the need for categorization, the very process of doing this allows the results to be understood comparatively from an external viewpoint. The processes, language, terminology and theory behind a standardised framework are vital for practitioner, policy maker and funder alike.

Conclusion

In the study of existing research and relevant literature, this paper found that there are limited existing examples of research into the long-term impact of museum social inclusion initiatives. However, the possible social impact of the museum is a subject of heated debate. An inconsistent approach to evaluation and visitor research has been a key reason for the lack of research. This encompasses a variety of factors including a perceived lack of skills in the sector and confusion as to what impact is, what form it takes, and how to define and assess it. In particular, long-term impact was felt to be especially complex to assess due to the difficulty of relating outcomes to particular activities, as well as tracking participants. Such problems are more apparent when trying to track people who are at risk of exclusion. Up until fairly recently a lack of standardised frameworks with which to approach evaluation and visitor research limited the ability of the results to be understood across museums, regions, and even countries. More importantly, it meant those outside the sector such as policy-makers and funders were less able to understand and compare data. The development of the Generic Learning and Social Outcomes frameworks, which were used in this research, means there is a more universal language for understanding results. This can only be good news for those who believe that the museum has a powerful social role to play.

The political context of museums in the 21st century has particular resonance for the need into research of the long-

term impact of museum inclusion initiatives. The sector has proved that social inclusion practice was not driven solely by the cultural policy of the last decade, but it does accept that it had a massive influence on the extent to which work was undertaken. Government focus on museums' social role has led to increased funding. Whilst the future of funding is not fully secure, more research into the impact of initiatives that receive this funding is part of the ever-increasing professionalization of the sector. Wherever museums seek funding in the future, the need to prove their worth and understand how they impact will only increase.

Aside from the political debate, some argue that increased recognition of the social role of the museum signifies a paradigm shift towards a new understanding of what museums are. It is argued that research which assesses long-term social impact and how this relates to the building of capital can help the museum understand and establish this social role. Although this study has focused on the impact on individuals' lives, this cannot be seen as independent from the impact on communities and society. In addition, in understanding the kind of effects it can have, organisations can experience organisational change. They can become more outward looking, create and sustain new constituencies, develop new ways of working, rethink their values and change their reputation for the better, even if such change is not easy for all museums or staff.

This study aimed to find out if it was possible to assess long-term impact with people at risk of exclusion who have

engaged with targeted initiatives. This proved possible and whilst there were a number of challenges which echoed those highlighted in the literature, these were surmountable. Museums have increasingly accepted the importance and value of engaging hard-to-reach audiences. It was a challenge for the sector, but they are finding new ways to work. Visitor research into these audiences needs to incorporate the long-term benefits of their involvement with the museum. The profession can rise to the challenge and develop standardised approaches for this research. Principally it needs to recognise the value of sustaining the funding and programmes of staff involved in such work – the value of human relationships in this work is key to the success of these programmes' achieving their aims and examining their impact.

The results of this research suggest there is a definite long-term impact on the lives of individuals who engage in museum inclusion initiatives. A positive response was observed across all five GLOs, with the greatest impact felt on participants' attitudes and values. Confidence and social skills and a more positive attitude towards themselves and others were the greatest long-term impact felt by participants.

Museum engagement can have a lasting impact for people at risk of exclusion. It is particularly successful in providing the means for these individuals to improve their lives through the accrual of various forms of capital, most notably 'social capital'. Museums are now in a position to have more confidence in the way in which they assess this impact; the tools to undertake this research are in place,

and comparative frameworks to interpret the findings exist. Proving the social value of museums in this way is not only important to museum staff, it is vital to the funders and policy-makers and most importantly the users themselves – all of which museums need to survive as they navigate the social and political challenges of this century.

Notes

1 Social Exclusion Taskforce website, http://www.cabinetoffice.gov.uk/social_
exclusion_task_force/context.aspx 12/08/08.

2 Museum of London website, www.museumoflondon.org.uk. 15/08/08.

3 Participants interviewed had taken part in projects that were part of a Heritage Lottery Fund Social Inclusion Programme which aimed to engage long-term unemployed adults, offenders and young adults with heritage; the Plant Cultures project which was part of the Community Access programme; a project with adults with learning disabilities; and the Archive Volunteer Learning Programme which engaged Hackney residents with the MOL London Archaeological Archive Research Centre.

4 Museum, Libraries and Archives Council website, http://www.inspiringlearningforall. gov.uk/measuring_learning/learning outcomes/why do we need_glos/_217/default. aspx?flash=true. 20/08/08.

5 Crisis website, http://www.crisis.org.uk/ 20/08/08.

6 Myspace website, a social networking site, http://uk.myspace.com/ 20/08/08.

7 Mary Ward centre website, http://www.marywardcentre.ac.uk/Welcome/Welcome. asp 20/08/08.

8 'Capital A' art group do not have a website; they are an art group for people at risk of exclusion, or experiencing homelessness; they run workshops at Crisis and many galleries and museums across London.

9 Department for Innovation, Universities and Skills website, David Lammy MP argues the importance of soft skills http://www.dius.gov.uk/speeches/lammy_ softskills_290408.html; 20/08/08.

10 Information about the Museum of London Heritage Lottery Fund funded Social Inclusion Programme; Six of the fifteen participants interviews took part in projects from this initiative; http://www.museumoflondon.org.uk/English/Learning/ Community/Inclusion/Inclusion.htm 19/08/08; in addition the majority of other initiatives involved the arts.

11 George E. Hein, 'The Constructivist Museum', Learning in the Museum, ed. George E. Hein, (London, Routledge, 1998) p. 164.

12 Eilean Hooper-Greenhill, 'Studying Visitors', unpublished draft, Reprinted in University of Leicester PG Dip/Masters degree in Museum Studies by Distance Learning 'Museum Communities and Contexts' Module 1 Version October 2005, p, 13.

13 London Museums Hub, Refugee Heritage Project Evaluation Report (London, 2008) accessed from http://www.mlalondon.org.uk/uploads/documents/Refugee_heritage_report_24_Feb_08.doc 13/8/08, p.19.

14 London Museums Hub, Ibid, p. 17.

15 Jocelyn Dodd and Richard Sandell, Including Museums: Perspectives on Museums, Galleries and Social Inclusion, (Research Centre for Museums and Galleries, Leicester 2001) p, 26.

16 Scott, C. 'Measuring Social Value', in Museums, Society, Inequality, ed. Richard Sandell, (London, Routledge, 2002), p 47.

17 Andrew Newman, 'Understanding the Social Impact of Museums, Galleries and Heritage Through the Concept of Capital', in Heritage, Museums and Galleries: An Introductory Reader, ed. Gerard Corsane (Abingdon, Routledge, 2005) p, 231.

18 Peacock, A. 'Changing Minds: The Lasting impact of school trips', (The Innovation Centre, University of Exeter, 2006), on www.nationaltrust.org.uk/main/w-schools-guardianships-changings-minds.pdf 20/08/08, p 12.

19 Goodlad, R., Hamilton, C. and Taylor, P. ''Not Just a Treat': Issues in Evaluating Arts Programmes to Secure Social Inclusion', UK Evaluation Society Conference, The Art of Evaluation: Artistry, Discipline and Delivery, London 12-13 December 2002, http://www.evaluation.org.uk/conference/Conf%20presentations%202002/Goodlad%20Hamilton%20&%20Taylor.pdf. p 14.

20 London Museums Hub, Ibid., p, 21.

Inclusive Arts Practice: Using Collections to Maximise Inclusivity

ALICE FOX

Course Leader, Inclusive Arts Practice

School of Arts & Media

University of Brighton

Although this chapter offers an introduction to inclusive arts practice in museums and galleries for artists working with people with learning disabilities, the majority of thoughts and ideas explored within it are readily transferable to the concerns of other marginalised or excluded groups. Drawing on the experiences gained during building the inclusive *Smudged* performance at Tate Modern (May 2008) it seeks to answer two main questions: firstly, how can museum and gallery collections be used to enable effective artistic collaboration between artists and performers with a wide variety of communication needs? And, secondly, when working in partnerships with museums and galleries, how can inclusive practices realize their fullest potential in the quest to bring about maximum inclusivity?

This chapter is written from the perspective of someone wearing two very different hats, one that reflects my role as the co-ordinator of a community partner organisation – the learning-disabled Rocket Artists group – and the other that signals my course leadership of the Inclusive Arts Practice Masters degree at the University of Brighton. As somebody working outside the museum sector I hope that these "outside" perspectives add to our understanding of this type of partnership working and the most effective ways of going about it, as well as the potential benefits to be gained from it.

Smudged Performance: a case study

In order to pin down a number of lessons learnt, I will focus on our recent inclusive *Smudged* performance as a case study.

A 30 minute-long vibrant mix of movement, live projection, drawing, installation, words, sound and live music, it was an inclusive performance that fused the visual art skills of the Rocket Artists and the performance skills of Corali Dance Company, which works collaboratively with artists and dancers with and without learning disabilities. The piece was devised by the performers under the creative direction of Alice Fox, Ella Ritchie, Sarah Archdeacon and Jacobus Flynn. Other project partners were the University of Brighton which supported staff and students to take part and Tate Modern which made its collections available to the performers whilst hosting the rehearsals and performance space. Smudged was funded by Arts Council South East and the Henry Smith Charity.

The collaboration took place over six full days of workshops at Tate Modern, where the artists responded to artworks from the *Idea and Object* collection (now replaced by other display themes). The resulting performance explored these ideas through movement, live projections, drawings, installation, words and sound. A short clip of the performance can be viewed at www.rocketartists.co.uk/smudged

This artistic partnership was intentionally inclusive: we brought together professional artists and performers, with and without learning disabilities, in order that they could work together through the Tate collection. They could be inspired by each other's different perceptions of the collection, the rich diversity of outlooks stemming from their radically divergent life experiences and artistic approaches. The whole experience provided opportunity to

be creative, exchange skills and share practices. Furthermore, by embedding the performers' relationships in artistic practice through the collection, it offered the members of a very diverse group, some of whom had severe communication difficulties, an important mechanism within which to build new commonalities. This was not brought about through predominantly verbal understandings of the collection but through the act of making work together. As a direct consequence, this practice then promoted equality within the group by focusing on peoples' skills rather than any perceived deficits. All members were artistically skilled and self-identified as artists/performers. *Smudged* also provided an opportunity to exemplify good practice in inclusive arts, whilst raising the level of debate about the significance of the presence of learning disabled artists and audiences in national galleries.

Visual engagement for inclusion

The *Smudged* performance was underpinned by a series of developmental workshops that, through arts practice, researched inclusive activities that were both accessible and appropriate to performers with and without learning disabilities.

"Arts-based inquiry is uniquely positioned as a methodology for radical, ethical and revolutionary research that is futuristic, socially responsible, and useful in addressing social inequities." (Finley, 2009, 71)

By bringing together such a diverse group of people

through their common interest in the Tate Collection we were able to devise visual mechanisms for responding to gallery themes and subsequently use them to foster the collaborative artistic process within an inclusive group of people with a wide variety of communication needs. This enabled all the performers to devise the creative content of the show.

The immediate proximity of the collection to the performance development space at Tate Modern provided an important accessible and physical link for the performers. As a result, they were able to shape their initial responses into movement and drawings very quickly, in context, before they were forgotten. Importantly, the performers had the opportunity to position themselves next to the original pieces of work, thereby giving them a deeper insight into the physicality of the pieces in comparison with themselves and their bodies. This opportunity enabled immediate, physical creative responses that were very different from those which would have been generated from smaller reproductions of the works. The following comments on the experience underline the significance of this method of working: "Sharing our ideas and working together creatively was exciting and inspiring; I have learned more than I could have imagined," Craig Halliday, performer. "I liked looking in the gallery, the escalators and dancing; I want to do more," Louella Forrest, learning disabled performer.

The workshop plan (Fig. 1) describes a typical session with activities and notes on the ideas behind them.

Time	Activity	Lead
10.30	**Welcome, ground rules, housekeeping**	Alice Fox
	Meeting each other and warm up exercise: Name introduction with movement. All participants say their name (or choose to have it said for them) and make a movement in turn, others copy. This is also an introduction into taking turns to lead and having your ideas respected and repeated by others.	Corali
	Photo wall : Participants photograph each other (head and shoulders), print out and make a photo wall chart providing a visual prompt for who's in the group, what their names are and what they look like. The photos are attached to be easily re-arranged during the day as, for example, sorted into groups of those working together, remembering who is away.	Rockets
11.00 -12.00	**In the Gallery Space: Collecting responses to the collection** Looking at Level 5 – *Ideas and Objects* Quarta-feira de cinzas (Ash Wednesday) film by Cao Guimaraes of a parade of ants carrying colourful circles of confetti; sculptures by Robert Morris, Sol LeWitt and Donald Judd; paintings by Ellsworth Kelly; and the use of words and text in Pawel Kwiek's films Video A and Video P. Working in groups to develop responses to works on this floor each group is given a pack of postcards and drawing materials. A series of facilitated drawing activities working on blank postcards to collect responses from experiencing artworks and building - these may be colours, shapes, patterns, sounds or words.	Alice/Ella Participants working in three groups of four.
12.00 12.45	**Sharing postcards responses:** Place the postcards on floor in middle of group. Sort postcards into groups of ideas, using a combination of moving cards around and talking. All look at card groups and choose ones to explore further through movement. **Create movement** from responses to images/words on postcards. In pairs create movements, practice and show to group.	Alice/Ella Ideas shared from each group Sarah/Jacobus
13.30 -14.50	**Movement session** (creating images on blank canvas). Devise further movements from ideas collected in the gallery and extend these to duets and group work. Group select successful ones and start to build a movement vocabulary for the performance.	Sarah/Jacobus
14.50 -15.15	**Visual conversations:** In pairs on large paper with pastels and rubbers participants make marks in response to each others'.	Alice
15.15 -15.30	**Visual recap** of today's session and relaxation exercise to embed experiences and ideas.	Alice

Figure 1: Workshop plan for Tate Project – Day 1.

During one session we asked performers to respond to the collection by using words that came to mind in the galleries. Some of these were chosen by the group to make a poem. This was spoken out during the performance and used as trigger words, each with a corresponding movement. This process allowed for improvisation during the performance.

Smudged poem
smooth red
a bit like a square but different
moving fast ants
relief
reflected feet
seeing round corners
slanted square
traffic lights chess board
about 30 words
staying still
you moved
I can't see you
you're there
smudged words
looking from far away
hiding and showing
block

By continuing to gather new ideas, build a visual and movement vocabulary and layer these with sound, a site-

specific performance can be constructed.

When developing new ideas, it is important that participants feel comfortable to take risks. To encourage this you must value the performers' creative ideas, as well as making sure that all performers' ideas are given time to flourish and be considered. It is also important to work with good quality art materials. Remember how difficult it is to make a tasty satisfying meal with poor ingredients – art is the same. It is fairly common for museums to use typical school or nursery art materials for community workshops. On the one hand this gives off a negative, devaluing message whilst, on the other, it makes it difficult to create good artworks.

We carefully considered how to use these processes of collaboration (as described in Fig.1) to create a space for equality of expression and the development of creative ideas, thereby ensuring that everyone's ideas were *heard* in the broadest sense of the word. Workshop methods were also developed, including supported skills and knowledge sharing sessions, led by the learning disabled performers using visual instructions and creative practices.

By keeping our responses to the collection in a predominately visual language, we kept the ideas in the language of their original making. We did not attempt to translate thoughts and responses from a visual language into words and back again, as is so often the case. In this way we were able to maintain the essence and subtleties of our responses to the Tate Modern collection and have the capacity to communicate these to an audience. We also usefully kept our practice in a

visual language as a means of supporting those performance collaborators with verbal communication difficulties. As a diverse group of performers we now have a common language and experience to draw upon for future collaborations.

These workshop methods, together with their underpinning philosophy, propose a shift in the ways in which museum visitors can gather, reflect upon and reveal their thoughts and responses to the collections. By so doing, we have developed an innovative and transferable model of inclusive interaction, which is of use to both mainstream visitors and excluded groups alike.

Valuing inclusion

Museums and galleries undoubtedly have much to offer their visitors. However, people with learning disabilities are among the most isolated, vulnerable and least mobile groups as they require more support to access both the buildings and the collections within them. Motivation for adopting a more proactive approach to this can be gained by addressing the potential benefits.

Inclusion can provide:
- High quality learning experiences that begin with the interests of the group;
- A vibrant resource for informed inspiration and creative experiments;
- Opportunities for creative flow through immediate response to artefacts;
- Enhanced opportunities for reflection, practical

experience and active experimentation;

- Opportunity to work in response to actual scale of objects, a very different experience to working with reproductions;
- Opportunity to make art in new ways in the gallery space, not restricted to studio;
- Opportunity to challenge perceptions of marginalised people and the values placed on them and their creativity.

Mutual benefits of inclusion

Our core philosophy during this project and others is that community-museum engagement is mutually beneficial, supporting knowledge exchange rather than the idea of knowledge transfer. Such a way of working places value on different forms of knowledge. By understanding that all people have knowledge both of themselves and their ideas, we challenge the notion of the institution being the provider and keeper of expertise. Tim Rollins talks of this with his work with K.O.S arts group for young people with learning difficulties: "We used art as a means to knowledge, that's how we became the Arts and Knowledge Workshop... I love the notion of art as a means to survive. To affirm you have a voice, you have something to say." (Rollins, 2010, 242)

Mutual benefits include:

- A platform for people and their ideas;
- New ways of seeing. Artefacts can inspire different responses which, in turn, enhance perceptions of

collections and challenge dominant social narratives;

· Fresh opportunities to reconfigure, reconstruct, describe and reinterpret objects and ideas;

· Exploration of new forms of non-verbal communication through encountering artefacts;

· New resultant creative output that enlighten and inspire audiences;

· The capacity for positive affirmation of identity for the participants;

· A meeting point for diverse groups mediated through collections;

· Opportunities to develop new ways of working with collections that are beneficial and transferable;

· Diverse audience knowledge, both verbal and sensory, that can interrogate history and meanings;

· Improved partnership working that, in turn, promotes further development of new partnerships and networks;

· Educational benefits, including, for example, the research findings and inclusive arts practice methods developed during the performance that will be fed back into the curriculum within, and beyond, the new MA Inclusive Arts Practices at the University of Brighton.

Challenges for inclusion

The major challenges of inclusive arts projects and research deserve further consideration – if we can see where the hurdles are, we are more likely to be able to jump them. A brave, open

and flexible approach is advisable as Bruce McFarlane points out: "Research is an emotionally demanding process of 'letting go' of our own assumptions about the world." (McFarlane, 2009, 60) "Rational answers to questions and problems are not always available this means sometimes we must have the courage to live with being in a state of uncertainty." (McFarlane, 2009, 57).

However, one of the strengths of partnership working in this area is that projects can draw on a wide range of skills, knowledge, resources and funds within the various stakeholders when faced with challenges.

Common challenges and tips for overcoming them:

- Adequate time in the museum to develop, absorb, incubate and create ideas. This is a particular access issue for people with learning disabilities. More often it is not that results can't be achieved, only that more time is required to do so. Build in enough time in the early stages of project development and ensure the budget reflects this.

- Access to space at the museum where groups can build creative responses to work over a period of time and possibly store the artwork and materials. Negotiate in advance any possible spaces and, if necessary, wait for the space you prefer.

- Adequate funding to support projects: Artists fees, materials, transport, publicity etc. Alongside applications to funders think carefully about resources you can already access within the partnership. Be

suitably opportunistic and enlist any support 'in kind'.

· Showing the artwork on a high visibility platform. The work of marginalised artists can be displayed in low kudos areas, devaluing the work and making it difficult to display/watch properly. Negotiate spaces.

· Developing mutually beneficial aims. These are crucial for a successful project. Agree these at the start and ensure they fit the funding agendas of the different partners.

· Creating a shared language: Words can have different meanings to different partners. Avoid jargon and agree on terminology during initial development of the shared project aims.

· Difficult to build sustainable partnerships beyond projects. Wherever possible, build the project and staffing resources into already existing structures within the museum.

A wider structural challenge can result from the ways in which museums sometimes consider their provision for the inclusion of marginalised groups as part of their local community engagement strategies. This creates a problem when marginalised groups want to work in partnership with the large national museums and are unable to do so because they don't live within the local community catchment area. This can result in exclusion from any relevant local

community budgets. In this instance the resources can not be made available to support partnership working.

Defining and extending inclusion

Inclusion is defined by the Oxford English Dictionary as "the action or state of including or of being included within a group or structure".The full implications of the importance of groups and structures in terms of building inclusion as a key element within any arts project and museum partnership require careful consideration if inclusion is to seen as fundamental, meaningful and sustainable.

It is with these in mind that we devised the *Smudged* performance, as seen in the following description of the various forms of inclusion that we embedded in the project and which we recommend others to consider adopting.

1. *Inclusion through partnership:* "The way forward lies in partnership and alliance between disabled people and non-disabled people and their organisations." (Shakespeare, 2009,197)

Smudged was set up as a partnership between The Rocket Artists, Corali Dance Company, Tate Modern and the University of Brighton. Here we have community groups working with statutory and educational organisations. The key is to find an approach that "ticks boxes" for all the partners and their various funding and educational criteria. By focussing on an approach with mutual benefits a way forward is much more likely to present itself. The stakeholders in each organisation can then become champions for the project and

find places to situate it in already existing structures.

2. Inclusion into museums and galleries though collections: Inclusive Arts Practice may be defined as follows: Supporting creative opportunities between marginalised and non-marginalised people through artistic facilitation and collaboration as a means of challenging existing barriers and promoting social change.

Inclusive arts practice offers possibilities for inclusion into the museum and gallery collections not as discrete groups identified by disability, cultural or ethnic terms as is often the case, but ways that these groups of marginalised people can access such collections alongside other non-marginalised groups. The passion and self-direction of people sharing their experiences and knowledge in free-flowing creative ways fosters new approaches to problems and is a central feature in the development of groundbreaking work through inclusive arts practices. In this way inclusion is embedded not only within the museum itself but within the heart of the group experience, thereby enabling participants to use collections to fuse ideas, and interact and build relationships with each other, the artifacts and the museum.

3. Inclusion through audiences: "Any public institution has an absolutely crucial role in reflecting diversity. Seeing the Rockets artists response to artworks on show and their resulting performance is brilliant because a wider audience gets the chance to see the collection and the performance, so it's a great way of working together". Liz Ellis Curator Community Programme Learning, Tate Modern.

Smudged was presented at Tate Modern to an invited audience of artists, performers, curators, educationalists, journalists, arts funders, people with learning disabilities, carers and friends. The performance publicity was fully accessible and used visual images of the performance, so enabling people to make an informed decision to attend by showing what the audience might expect. Audience development is an extensive job, carefully nurtured, developed and considered by museums and galleries. We took a pro-active approach to this, contacting the most excluded groups and discussing transport, refreshments and individual requirements. Posting an invite to organisations or individuals is often, in itself, not enough and a follow up-call can help in the understanding of any potential barriers to attendance, providing the opportunity to address them wherever possible. We scheduled the performance during the daytime in order to maximise attendance from community groups whose transport provision often finishes by mid afternoon. Most importantly, the placement of the performance in the Tate Modern enabled the audience to view *Smudged* in a gallery setting adjacent to the artworks that inspired it.

4. Inclusion through dissemination: The dissemination process offers many opportunities for the work of marginalised groups to reach wider audiences. In this way the impact of the project can be extended to incorporate more beneficiaries in the learning process. In the case of *Smudged* we were supported by Tate Modern to make a short

video (the Corali Rocket video) about our working processes for the Creative Spaces educational site (http://tate.nmolp. org/creativespaces). This is intended for use by statutory or voluntary groups wishing to work with museum collections in creative ways.

By including university lecturers in the creative and performing arts in the partnership we have been able to ensure academic credibility to the project and associated research. Furthermore, the resultant thoughts and ideas have been disseminated to the students on the MA Inclusive Arts Practice at the University of Brighton. Most importantly, by hosting the performance in a highly valued public gallery, we have included these artists and their performance work into the mainstream art world debate.

An effective way to develop your international audience for such outcomes is to make a website of your work. To do this good quality pictures and film are ideal. In this instance we made a short QuickTime movie for the web (http://www. rocketartists.co.uk/smudged)

Conclusion: Beyond Smudged
This chapter has described the ways in which we can use museum and gallery collections to enable artistic collaboration between artists and performers with a wide variety of communication needs. It also offers a broader understanding of the full panorama of inclusion opportunities when working in partnership with museums and galleries. It has suggested strategies for working alongside institutional structures in

a mutually beneficial way to both compliment and influence them.

Inclusive arts partnership projects such as the *Smudged* performance can generate many benefits to the immediate participants and project partners. The learning experiences can then have a ripple effect through dissemination to other educational, voluntary and statutory organisations.

We live in a society of stereotypes that reduce the richness and variety of the world around us and promote a hostile reaction to difference by trivializing its complexity. In his book *Conversation Pieces* Grant Kester notes that "inclusive dialogical arts" projects can challenge stereotypes and fixed models of identity by cultivating an openness to difference (Kester, 2004, 153). I propose that by shifting our understanding about ways to respond creatively to artefacts through a visual language we can start to use museum and gallery collections to break down stereotypes and meet the needs of the most vulnerable and excluded groups.

References

Berry, I. (ed. 2010) Tim Rollins and *K.O.S. A History*, 242

Finley, S. (2009) Handbook of the Arts in *Qualitative Research*, 71

Kester, G (2004) Conversation Pieces: Community and Communication in *Modern Art*, 153

McFarlane, B. (2009) *Researching with Integrity: the ethics of academic enquiry*, 57, 60.

Shakespeare, T. (2009) *Disability Rights and Wrongs*, 197

Websites

Smudged performance Quicktime: http://www.rocketartists. co.uk/smudged_With_Film.html

Rocket Artists: http://www.rocketartists.co.uk

Corali Dance Company www.corali.org.uk/

Creative Spaces: http://tate.nmolp.org/creativespaces/

Participation and Personalisation: Working with Adults with Learning Difficulties

HELEN GRAHAM

Research Associate

International Centre for Cultural and Heritage Studies

Newcastle University

Museums have new users. Whether on group trips to big London nationals or as regular visitors to see favourite objects or to use the café, museums are increasingly being used by adults with learning difficulties, both on their own and with support.

The increasing use of museums by adults with learning difficulties reflects substantial shifts in the organisation, approaches and funding of social support and personal care, specifically the shift from segregated services such as day centres and residential homes to increasingly personalised support. This encapsulates both a conceptual shift, with policy now emphasising specific values such as independence, choice, control, rights and inclusion (DoH 2001; DoH 2007) and a practical shift with services being modernised and transformed and money for support increasingly sitting with the individual via personal budgets.

This essay sketches these policy shifts and then takes a look at the museum sector from the outside by taking the perspective both of people with learning difficulties and the services which are currently attempting to breathe life into personalisation as a policy. To put it another way, the broad aim of this essay is about turning access logics on their head. Rather than asking how people with learning difficulties might be included in museums, I ask instead how museums might become included in, and become an enriching part of, people with learning difficulties' lives.

Changing lives: from services to self-directed support

Major shifts are happening in adult social care, linking a

conceptual re-imagining of people with learning difficulties' lives with practical shifts in how people's support is funded. The 'values guiding learning disability policy and services have been slowly developing over the past 30 years to increasingly include supporting people to live "an ordinary life" (O'Brien 1982) or "a life like any other" (Joint Committee of Human Rights 2007-8). While the desire to reinvent services across the country certainly preceded 1997 and the election of the Labour Government in the UK, a number of policy documents in England, Wales and Scotland have pulled together and given coherence to the conceptual drivers affecting services. In England, the *Valuing People* vision was for "new opportunities for children and adults with learning difficulties and their families to live full and independent lives as part of their local communities" (2001, p. 2). This vision was underpinned by four key principles: Rights, Independence, Choice and Inclusion (2001, p. 3). In 2009, *Valuing People Now: A new 3-year strategy for people with learning disabilities* was published which updated the *Valuing People* values to more explicitly reflect a human rights agenda, as advocated by Joint Committee of Human Rights (2007-8), and evokes: Rights, Independent Living, Control and Inclusion (2009, p. 29). Such values are also reflected in Scotland's *The Same as You? A review of services for people with learning disabilities* (SE 2000) and Wales' *Statement on Policy and Practice for Adults with a Learning Disability* (2007). A key ethos across nations – and explicitly articulated in England's *Putting People First: A shared vision and commitment to the transformation of adult*

social care – is that these values can only be achieved by setting up a "community-based support system" and through local partnerships and "working together" (2007, p. 2).

In practice the policy aspiration for inclusion has meant a concerted modernisation programme. The long-stay hospitals which housed people with learning difficulties in the mid-twentieth century (and whose populations' peaked in the late 1960s (Walmsley 2006, p. 80)), have all been or are, as I write, in the final phases of closure. Building on substantial research and advocacy in this area, *Valuing People*, for example specifically mentions the need to reconsider the day centre model, as a place where people with learning difficulties spend most of their days: "Day Services frequently fail to provide sufficiently flexible and individual support. Some day centres do little more than warehousing and do not help people with learning disabilities undertake a wider range of individually-tailored activities." (DoH 2001, p. 19)

Also in line with the logic of inclusion, the two major ways in which people with learning difficulties have lived outside of family homes – residential homes and adult placement as lodgers with families – are being phased out through a new focus on *supported living*, which means people hold their own tenancies and can therefore change their support without moving house.

The specific character of service change is often evoked as coming from "person-centred planning" – that is, from the interests and priorities of the individual using the service themselves. The focus of person-centred planning is to learn

"how a person wants to live" and then to describe "what needs to be done to help a person move towards that life" (Smull, Sanderson with Allen 2001, p. 12). These aims have been given a financial focus through individualised funding, now often referred to as *self-directed support* – via direct payments and personal budgets.[1] The means that rather than services being funded centrally, the individual will hold the money which can be used to meet their assessed and increasingly self-assessed needs.

Before moving on to what these changes in policy and funding affecting the lives of adults with learning difficulties might mean for the museum sector, it is worth briefly noting the conceptual tensions within current policy and practice in this area: specifically between an emphasis on the person themselves and an emphasis on inclusion. This tension is sometimes fully visible in policy statements. For example the contemporary Good Life is defined by UK Social Care Institute for Excellence in the following way: "doing things which have a purpose and are meaningful for the individual" and "doing things uniquely right for the individual". Yet these person-centred aspirations are imagined as automatically tending towards "doing things in ordinary places, that most members of the community would be doing" and "meeting local people and developing a sense of belonging" (SCIE 2007, p. 10). Similarly, *Valuing People* guidelines describe person-centre practice in the following terms: "When we use the term 'person centred' we mean activities which are based upon what is important to a person from their own perspective and which

contribute to their full inclusion in society" (DoH n.d. p. 2 emphasis original). In both these statements, person-centred identification of aspirations and dreams are hoped to tend towards inclusion – and the potential tension between what might be characterised as the two ethical poles of person-centred planning are not acknowledged. This has practical implications for museum practice in considering the balance between specialist tailored provision and mainstreamed approaches.

One helpful way of thinking about the navigation between these two ethical poles is explored by Michael W. Smull in his article titled *Revisiting Choice Part 1 and Part 2* (1995). Smull has suggested that choice is helpfully broken down into three aspects, preferences, opportunities and control: "preferences reflect what people want while opportunities reflect what is available. Control is the authority to make use of an opportunity to satisfy a preference" (1995, p. 1). Smull's vision of choice connects to inclusion through the idea that "many people need to have a life of their own before they can have a dream of their own. [. . .] Unless they have already experienced it they will not know whether or not they like it or not" (1995, pp. 2, 6). Smull, therefore, relates choice to inclusion – or at least a kind of moving into the world beyond segregated services – as a means of legitimising control. In Smull's view, what comes to legitimise an individual's control over their preferences is the extent of their freedom, the range of opportunities from which they are choosing and the breadth of their sense of what is possible.

In practical terms from a person-centred planning perspective, this means that there are some things people already know they like and some things they might like to try to see if they like them. The role of museums in this conceptual landscape, therefore, points both to the need for opportunities for people to expand their interests in things they are already interested in and to meet other people who like the same things (via exhibitions, learning programmes, workshops, volunteering opportunities, employment). But it also requires the opportunities to explore a range of ideas, subjects and activities. Both exploring what you know you like and exploring what you might like requires both broad mainstreaming of intellectual access provision, but also specialist provision which is targeted at people with learning difficulties – possibly commissioned via self-directed support by individuals or by groups formed specifically for this purpose – a possibility opened up by the shifts in funding described above.

Contributing to a community-based support system
Putting People First makes it very clear that personalisation cannot work without a community infrastructure. No doubt what is most immediately meant by this is access to mainstream housing, good, effective and accessible transport links, the possibility for employment and high quality volunteer opportunities and accessible and affordable leisure and learning opportunities. However, such any such community infrastructure also includes a role for libraries,

archives, heritage sites and museums.

What follows is not a comprehensive guide to make a venue accessible, not least because there are a number of guides which make suggestions in this area (e.g. The Forum of the Heritage Project Merseyside 2007; Mencap 2008, MLA online), rather it outlines from the perspective of people with learning disabilities and the services which currently support them some of the conceptual shifts which would need to be in place for museum to become an effective part of a "community-based support system".

Visitor experience: Perhaps the biggest conceptual shift in enabling museum to be a community resource is for museums themselves to see themselves or to want to see themselves playing such a role. No question some museums already see themselves in this mode and such a re-imagining of the museum was the focus of Diane Lees' contribution to the Museums Association Conference in 2009. When viewed from the perspective of people with learning difficulties, clearly museums have much to offer in terms of exhibitions, collections and activities, and these are key areas I will move on to. However, a key potential role for museums lies in acting as a kind of community hub, a role which is underpinned by high quality facilities, and can therefore act as a springboard both to engagement with the museum itself but also other activities in the community.

As suggested by the *Changing Places* campaign (online) and recent reports by Mencap (2008) and The Forum of the Heritage Project Merseyside (2008), the core facilities which

enable the values set out in *Valuing People* and *Putting People First* include access to toilets (including toilets which have hoists and changing bays). Some museums already have Changing Places toilets (e.g. Tate Modern) and building such toilets into new developments should be considered a priority, especially if there is no other such toilet in the local area. The other key service which would enable museums to act as a community hub is an affordable and flexible café. One which might include illustrated menus to help people make choices, a carefully considered menu and price structure and discounts for local residents. Another key service that a café could provide is heating up pureed food for those who need it – an issue which actively prevents trips out for some people.

A final widely recognised issue is staff training and the importance of ensuring that access for people with learning disabilities is built into standard Disability Awareness training, which includes the different ways people with learning difficulties might communicate (e.g. signing using Makaton or using a communication book). As recommended by The Forum of the Heritage Project Merseyside, it is also ideal to involve people with learning disabilities in training front-of-house staff (2008, p. 5) and – as discussed below under volunteering – either employing or setting up volunteer opportunities with people with learning difficulties in front of house roles.

Mainstreaming access to exhibitions: People with learning disabilities, like all visitors, will both be looking for exhibitions about things in which they have a passionate

interest, as well as things of more general interest that they might visit with friends and family. Perhaps the key conceptual shift that has to made here is to move away from the notion that there are interpretative key messages which have to be communicated to every visitor. The problematisation of a "communication model" reading of intellectual access is an issue specifically addressed in Kevin Hetherington's research on the way the British Museum supported intellectual access for blind and partially-sighted people to the Parthenon Frieze and sculptures via a tactile model. Hetherington argues that the tactile model offered blind and partially-sighted people a direct substitute for their not being able to see the Frieze, via what he describes as a *distal* form of knowing: "ways of knowing that we tend to associate with representation and sight" (2003, p. 105). Hetherington argues that such a tendency to try and communicate the same knowledge treats not being able to see as a deficit that has to be made up for rather than, for example, allowing blind and partially-sighted people to touch the Frieze itself which might offer, what he characterises as, a *proximal*, embodied and experiential form of knowledge (2003, p. 105).

Using Hetherington's research as a pointer is useful because it suggests that knowing through touch, taste or smell are not necessarily subsidiaries of a broader articulated knowledge or ideas-based (interpretative) message but are ways of knowing the world in their own right (see also Chatterjee 2008). With this in mind, a person with very high support needs, for whom changes in light across their face is

a meaningful and exciting experience, might get this sensory engagement with an exhibit which for others communicates something else. This of course means considering a multisensory approach to exhibition development, but also an asymmetrical interpretative approach, where it is accepted that different approaches can be used to engage different visitors. Crucial here is not seeing low-tech interactives as only being for children and making interactives on a universal design model so that they might be big enough to also be used by adults.

Co-production of exhibitions: There are a number of recent examples of both working to get learning disability history into a mainstream social history context and working with people with learning difficulties to explore and display their own history (e.g. Museum of Croydon/History of Day Centres project; Tullie House/Carlisle People First). Not only does this clearly sit within long-standing trajectories of museum practice (from social history curatorship and work beyond the UK led by First Nation peoples), but also the current emphasis on participation and co-production in heritage policy and theory. However, when viewed from a people with learning difficulties' and the perspective of the services which currently support them, it also fulfils some very important goals. The co-production of history resonates with person-centred planning processes which often include a life history section as well as enabling public preconceptions about people with learning difficulties to be challenged (Duffy 2002).

Mainstreaming access to events and learning programmes:

Museums may not know this but it is more than likely that their current exhibition and events programmes are being directly advertised to people with learning difficulties through local forums/sites and newsletters specifically set up to facilitate people with learning difficulties using of a broad range of leisure opportunities. For example, the *Croydon Council Leisure Link* newsletter advertises museum and libraries events and also includes write-ups of people's experiences of visiting museums.

Because of this, museums need to be prepared for, and to encourage, people with learning difficulties attending events aimed at mainstream adult or intergenerational audiences. Some of the things to do here are simply good practice, including considering multiple learning styles and using multisensory means of communication.

However, it is also possible that people with learning difficulties might come to more conventional adult learning events because they have a particular interest and if so they may bring a support worker. The key thing here is that the speaker/facilitator can actively facilitate contributions from all members of the audiences and feel unembarrassed about this. This includes confidence at asking again if you haven't understood something someone said. Again, this is a skill set to be explored in basic Disability Awareness Training.

Re-imagining volunteering: Person-centred planning aims to work with what people already like and expand it and extend it in ways which facilitate inclusion. Currently, and as a direct result of Day Centre closure, support workers and care

managers are looking for unique opportunities to meet the drive towards inclusion in a way which connects in some way with a person's interest. This might mean in a straightforward way that if someone likes film, maybe they could work or volunteer for a cinema. However, it raises challenges for conventional approaches to volunteer placements. For example, a museum might be looking for someone who has the soft skills of greeting and making people feel welcome – as well as being able to learn, retain and share specific information about, for example, stream trains. However, it might be that different people with different kinds of learning disability might really enjoy and value different parts of that job. For example, those on the autistic spectrum might be brilliant at remembering and talking about specific knowledge – especially if they already love trains – but not be interested in, or able to make, visitors feel welcome. Another person, who loves meeting people, might be great at this and, for example, enjoy giving directions to the toilets and café but might not be interested in retaining specific collections-based knowledge. This suggests the need for tailored and responsive volunteer placements and volunteer job carving. The radical shift here is away from a preset volunteer job that has to be pursued through an equal opportunities logic and instead building volunteer placements around skills, interests and abilities.

Tailored provision – museum-led to self-/collective-led commissioning: In recent years, a number of museums have developed specialist programming or off-the-peg workshops

that can be booked by community groups, including people with learning difficulties. However, from a museum perspective this causes capacity issues as there is the potential for increased demand and no additional resources. Clearly, one factor which has affected these programmes is specialist funding via, for example, the Arts Council and Heritage Lottery Fund – strands of funding which are likely to be drying up. It is being hoped that new sources of funding might come through Local Authority commissioning of a museum's services (e.g. for older people or young people). However – and to take us back to the specific significance of the policy context with which I began – the notion of central commissioning of services is not in keeping with the ethos of personalisation or self-directed support. A potentially more exciting option now exists in the current adult social care funding context which might including individual and collective commissioning of courses/workshops.

The possibility of collective commissioning is of specific practical and daily importance to people with learning difficulties' lives because in changes to day services people have gone from having a large number of hours with high support-to-person ratio to possibly, though depending on need, very small hours of support but on a one-to-one basis.[2] This leaves a huge potential for people to team up with others to employ support to pursue a shared interest. So, for example, if there's a group of people with a passionate interest in local history they might club together and pay for a freelance tutor to run the course with the local museum and local studies

library. Museums could facilitate this by working with people with learning difficulties to generate ideas through co-organised themed events – e.g. History / Films / Painting – where people might meet other like-minded people. It is this latter trajectory which might be the most fruitful avenue for museums wanting to be commissioned to pursue with adult services departments.

Conclusions: becoming a community resource

The current policy context shaping people with learning difficulties' lives is generating exciting possibilities and responsibilities to which museums should respond. Some of what needs to happen can happen under existing access logics – where museum have products (their exhibitions and collections) and adjustments are made in order to make them available to more people. However, for the museum to truly play a meaningful role in people with learning difficulties' lives – and when seen from their perspective – more radical conceptual shifts need to take place. Becoming a "community-based support system" – as *Valuing People Now* puts it – requires a different approach to exhibition interpretation which is not focused only on a communication model and it requires the co-production of knowledges, exhibitions and events with people with learning difficulties. However, it also means high quality facilities – toilets and cafés – developed with an attention to detail (How much is a cup of tea? Will the café be flexible and welcoming to request to bring in food for certain people?) The exciting next step in responding to person-

centred approaches to work and to personalisation of services via self-directed support lie both in a creative rethinking of volunteer placements to be individually-tailored to people's interests and abilities and – and here's where the financial motivation for museums in making these changes lies – in opening up a new source of revenue via self- and collective-commissioning of activities. The latter is only likely to happen if many aspects of the former are in place. The true benefit for museums of making these conceptual shifts will be a renewed and meaningful role in changing policy contexts – and becoming beloved and, crucially, useful places in the lives of people with learning difficulties.

Notes

1 The differences between 'direct payments' and 'personalised budgets' lie in the extent to which the individual commissions all services themselves, with 'direct payments' focused on self-commissioning while 'personalised budgets' holds open the possibility that the individual may not manage the budget themselves. 'Individual budgets' is a term used to refer to budgets which pull in multiple and varied funding streams. It is 'personal budgets' which are being rolled out now, with the aim that all people drawing on social monies will have one by 2011. For a useful full account of the differences see Mithran Samuel (2009).

2 How this has been approached has varied between local authorities. In some a needs assessment has driven shifts in funding, others have simply converted the cost of, for example, five days in a day centre into an amount of money which has now become a 'personal budget'.

Acknowledgements

I would like to especially thank Naomi Blackwell and Katie Graham for our discussions linking the current social care context and the arts and heritage sectors. Thanks too to the Open University-based Social History of Learning Disability group and everyone I worked with as part of the Heritage Lottery Funded History of Day Centres project which ran between 2006-2008.

Bibliography

Chatterjee, H. (2008) *Touch in Museums: Policy and Practice in Object Handling*. London: Berg.

Changing Places (online) Available at: http://www.changing-places.org/ (accessed 1 March 2010).

Department of Health (2001) *Valuing People: A New Strategy for Learning Disability for the 21st Century*. London, HMSO.

Department of Health (n.d.) *Valuing People: Person Centred approaches. Guidance for partnership boards*. Available from www.valuingpeople.gov.uk/echo/filedownload.jsp?action=dFile

Department of Health (2007) *Putting People First: A shared vision and commitment to the transformation of adult social care*.

Department of Health (2009) *Valuing People Now: a new 3-year strategy for people with learning disabilities*. London, HMSO.

Duffy, S. (2002) *Keys to Citizenship: A Guide to Getting Good Support Services for People with Learning Difficulties*. Paradigm: Birkenhead.

The Forum of the Heritage Project Merseyside (2008) *Access to Heritage: Making it Work for Everyone*. Available at: http://www.mencapliverpool.org.uk/wp-content/uploads/2009/08/easy-read-gidance-for-heritage-sites-081007.pdf

Hetherington, K. (2003) Accountability and Disposal: Visual Impairment and the Museum, *Museum and Society*, Vol. 1(2): 104-115

Joint Committee of Human Rights (2007-8) *A Life Like Any*

Other?: *Human Rights of Adults with Learning Disabilities*. Seventh Report of Session 2007–08. Volume I. London, HMSO.

Lees, D. (2009) *Out of the ashes... post-recession museums*, Available at: http://www.museumsassociation.org/about/37272 (accessed 1 March 2010).

Mencap (2008) *Arts for All*. Available at: http://www.mencap.org.uk/document.asp?id=1658&audGroup=&subjectLeve l2=&subjectId=&sorter=1&origin=pageType&pageType=1 12&pageno=5&searchPhrase=

Museum, Libraries and Archives Council (online) *Libraries and Disabilities*, http://www.mla.gov.uk/what/support/ toolkits/libraries_disability (accessed 1 March 2010).

O'Brien, J. (1982) *An Ordinary Life*. London: King's Fund.

Samuel, M (2009) *Direct payments, personal budgets and individual budgets*, http://www.communitycare.co.uk/ Articles/2009/04/08/102669/direct-payments-personal-budgets-and-individual-budgets.htm (accessed 1 March 2010)

Scottish Executive (2000) *The Same as You? A review of services for people with learning disabilities*. Available at: http:// www.scotland.gov.uk/Resource/Doc/159140/0043285.pdf (accessed 1st March 2010).

Smull, M. W. (1995) *Revisiting Choice Part 1 and Part 2*. www. allenshea.com/choice.html (accessed 1 March 2010).

Smull, M. W. & Sanderson, H with Allen, B. (2004) *~Essential Lifestyle Planning: A handbook for Facilitators*. North West Training and Development team Accrington.

Walmsley, J (2006) Organisations, Structures and Community Care, 1971-2001: From Care to Citzenship? In: Welshman, J and Walmsley, J. editors. *Community Care in Perspective: Care, Control and Citizenship 17-37*, Basingstoke: Palgrave.

Welsh Assembly Government (2007) *Statement on Policy and Practice for Adults with a Learning Disability*. Available at: http://www.adjudicationpanelwales.org.uk/topics/health/publications/socialcare/guidance1/statementdisability;jsessionid=FLmRLMTJxdhhomybhyMnBzyJjchcZJQW7fzTwvsczsnBS5YMYj1c!200562741?cr=7&lang=en&ts=1 (accessed 1 March 2010).

Mainstreaming Outreach: Taking Audiences to the Core

HEATHER HOLLINS

Associate Tutor

School of Museum Studies

University of Leicester

Museums across the sector show diverse approaches to the ways that they engage with communities. For individual museums, the factors behind their choices can be influenced by their financial make-up, staffing capacity, staff expertise, collections, museum spaces, strategic priorities, organisational culture or ethos. External factors such as priorities for stakeholders, community partners and key funders can all have a strong influence on decision making. Indeed as Kotler and Kotler (2000) describe, there are a multitude of drivers, motivations and priorities that affect the way that museums are managed, and it is the approach to the strategic planning of audience development work that this paper will seek to explore. It will also aim to uncover how the instigation of a strategic audience development planning methodology can influence the way that community work is delivered in the museum. It will, therefore, explore how policy and a clear strategic rationale can have a positive developmental influence on museum practice.

First, it is worth considering what we mean by the term "community". The on-line Oxford English Dictionary defines community as: *a group of people living together in one place, the people of an area or country considered collectively as a society, a group of people with a common religion, race, or profession, or as a group of people holding certain attitudes and interests in common.*

The implication being that community is a multi-faceted term with its members holding geographical, cultural or religious associations, or sharing common ideas, interests,

practices or professions. As Watson (2007, 3) explains, "museums in the twenty-first century often find it difficult to identify communities and their representatives. In what way does the community differ from the public, or a target audience?" This is an interesting question. Belonging to a community is a personal issue, with people identifying themselves with ethnic, religious, gender, age, disability, sexuality, socio-economic, cultural or special interest groupings. As Kavanagh (1990, 68) discusses, the defining characteristic of a community is that someone feels that they belong to it, feels part of the group. To add an extra layer of complexity, people hold multiple identities and can consider themselves members of several communities.

This leaves museums with a fundamental predicament. With limited staff and financial resources, how do museums choose who to work with and how can they justify working with, or programming for, one community over another? This paper aims to explore how an audience development methodology can support museums to make strategic decisions about their approach to working with local communities. As Reussner (2003, 95) states "strategic management is a familiar concept in for-profit organisations but is relatively new to museums." Although some museums have communities with a national or international reach, this paper will focus on museums who seek to attract and reach out to communities on their doorstep.

To illustrate this rationale a case study from Museums Luton will be presented which will explore this service's

endeavours to understand the complex nature of the community landscape within which it operates. It will describe the work in progress, not as an unobtainable exemplar, but as a series of practical steps that museums can take that are underpinned by a strategic rationale which ultimately strives to offer improved support for local communities.

Museums Luton – an overview

Luton is a large town of over 180,000 people surrounded by the rural county of Bedfordshire, "Famous for its hat industry in the 1800s and early 1900s (and still a world centre for the trade), then for the production of Vauxhall cars, the main employer in the town is now the expanding London Luton Airport" (Museums Luton 2009, 7). As Museum Luton's Forward Plan outlines:

> [T]he local picture for Luton reflects many positive conditions such as its vibrant diverse community, diverse job sectors, a history of cultural celebrations, and a strong sense of belonging to the town felt by residents. However, we cannot be complacent or underestimate the challenges that also exist such as the levels of deprivation in parts of the town and unemployment. (Museums Luton 2009, 13)

There are many positive aspects to life in the town but, as outlined above, there are some significant issues that affect residents, which are issues for the museum to consider when working with local communities.

Luton Museums Service was established by Luton Borough

Council in 1927. As Museums Luton's website explains, in March 2008 the Service became part of the Luton Cultural Services Trust (LCST). At this time it also rebranded to become Museums Luton. The Trust is an independent charity and delivers cultural services on behalf of Luton Borough Council, which remains its principle funding source. In the Trust's first visioning document the Chair of the Board of Trustees, Nick Gibson, describes the transfer over to Trust status:

> [T]he Trust is privileged, because on the day of transfer, three services – the libraries, the museums and the arts – came together. These three services have a long and successful history of service to the people and communities of Luton. Our task then, having been given this opportunity, is to take the Trust forward, with foresight, hard work and by listening to the people and communities of Luton (LCST 2009, 5).

This gives a commitment from the highest level that the needs of Luton's communities are central to the newly formed Trust.

To give an overview of the service, as Museums Luton's website explains, it is a partner in the East of England Renaissance in the Regions programme which is "an initiative set up by central government in 2002 to address years of underfunding in the museum sector. Renaissance aims to transform England's regional museums; making them world class and fit for the 21st century."

The service employs 54 staff[1] and in 2008-9 190,692 adults and children visited its sites[2]. "It operates through three

public sites and... actively works... to advance and promote the cultural life of Luton and beyond" (Museums Luton 2009, 3). This mandate is reflected in the service's mission statement which is "to care for and make accessible to all the heritage of Luton, its people and environment, for everyone's learning and enjoyment" (Museums Luton 2009, 4). In its Forward Plan, one of the key objectives for the next five years is to improve the sustainability of its relationships with communities (Museums Luton 2009, 15). The service has an emphasis on caring for, and making its collections accessible, on inclusion and learning, and believes in placing the people squarely at the centre of service developments.

Before exploring how it has developed, it is first worth introducing its three sites to give a flavour of the service. Wardown Park Museum is a mid-Victorian Grade II listed building. Its displays include a social history of the town and its people, an exhibition about the Bedfordshire and Hertfordshire Regiment and a temporary exhibition space (Museums Luton 2009, 8). Redeveloped in 2008, Stockwood Discovery Centre[3] includes a display on the changing landscape and archaeological history of the Luton area, a transport collection which includes the nationally recognised Mossman collection of carriages and a temporary exhibition space. On-site there is a wide variety of attractions for visitors including world, medicinal, sensory, sculpture and period gardens, an outdoor children's play area and café facilities (Museums Luton 2009, 9). The final site, the John Dony Field Centre, is a focus for environmental education with pre-

school through to adult groups due to its proximity to chalk downland and wetland habitats (Museums Luton 2009, 10). With a wealth of resources, Museums Luton has a lot to offer local communities and next section will look at some of the challenges it faces to fulfilling its potential.

Outreach: peripheral, beneficial or a stepping stone?
Before exploring the development of Museums Luton's community-based activities, it is worth stepping back and looking at the wider context which has influenced developments. In 1992 Dodd explored the changing nature of museums and the work they were undertaking to connect more closely with communities. She described a changing landscape with museum education services, which at that time were mainly focused around schools services, expanding to meet the needs of the wider community. Museums were beginning to recruit community outreach staff to focus on engagement with communities who had not traditionally been visitors (Dodd 1992). Bennett argues that this is a long-held aim for museums, since from their origins one of the founding aims was the intermingling of people from different social strata (Bennett 1995).

Significantly for modern museums, from the late 1990s the rise of the social inclusion agenda was a direct result of governmental priorities. In 1997 post-election, New Labour created the Social Exclusion Unit that aimed to tackle deep-seated disadvantage within society. It defines social exclusion as: "a shorthand term for what can happen when people or

Wardown Park Museum (© Museums Luton)

areas that face a combination of linked problems such as unemployment, discrimination, poor skills, low incomes, poor housing, high crime, bad health and family breakdown. These problems are linked and mutually reinforcing so that they can create a vicious cycle in people's lives" (Social Exclusion Unit 2004, 7).

This policy area aimed to tackle inequalities in society by addressing the root causes of exclusion through the implementation of strategies that promoted social inclusion. As described by Lang, Reeves and Wollard (2006, 21-23) this political backdrop influenced policy and funding from bodies such as Local Authority councils, the Arts Council, the Heritage Lottery Fund (HLF), the Museums, Libraries and Archives Council (MLA) and Renaissance in the Regions, which in turn influenced priorities for core funding in

Stockwood Discovery Centre carriage collections (© Museums Luton)

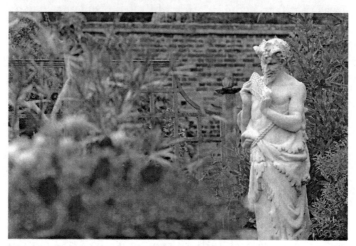

Stockwood Discovery Centre gardens (© Museums Luton)

museums and grant-aided projects.

For Museums Luton, Renaissance in the Regions enabled the service to expand the range of work that it undertook with communities. Renaissance programmes gave specific targets to increasing participation in communities who found museums harder to access (Renaissance East of England 2006). From 2004, this funding allowed Museums Luton to create community outreach posts which focused on making contact with excluded communities, on examining barriers which affected their ability to engage with services, and on creating projects to increase access (Luton Museums Service 2003). Many of these projects focused on taking museum resources out into the community, and between 2005 and early 2010, Museums Luton completed eleven in-depth community outreach projects with marginalised communities, with two further projects in their final stages.[4] These have included:

Travelling people: In 2005-6 the service worked with the local Travellers community to create a temporary exhibition and schools programme that aimed to raise awareness of the culture and lifestyle of people who travel as a way of life, and challenge perceptions and attitudes about them (Luton Museums Service 2007).

Sensory Garden project: In 2007-8 adults with learning disabilities worked with an artist and landscape architects to create part of the Sensory Garden during the redevelopment of the Stockwood Discovery Centre.

Luton Voices: Currently in the completion phase, between 2006-2010 this project trained young people as volunteers to

collect migration histories about the diverse range of people who have moved to Luton from other parts of the UK and abroad. The culmination of this project was a temporary exhibition and the creation of an oral history archive (Museums Luton 2008).

Other projects focused on working with people with mental health difficulties and people with learning impairments. For older people, Museums Luton also developed and launched a long-term reminiscence programme.

From the creation of community outreach posts at Museums Luton the aim to reach out to diverse communities who do not normally visit museums was a success. Significantly some of the groups had an input into the development of the Stockwood Discovery Centre which had an impact on increasing the accessibility of the spaces. However, many of these projects were short-term and separate from the mainstream work of the museum. This echoes what Black has to say about project work with communities: "[P]roject-based work has led to many individual successes. However, projects by their very nature are both short term and peripheral to the core activities of the museum" (Black 2005, 62). Cited in Black, Matarasso (2000, 5) states that "it seems illogical to believe that a response to social marginalization, which is itself marginal to the service promoting it, can have a serious or sustainable impact on the problems it has identified." This shows that the situation at Museums Luton was not unusual within the museum sector.

This is not to say that funding such as Renaissance in

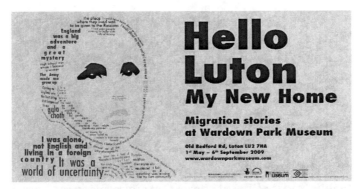

Exhibition poster for *Hello Luton My New Home* Exhibition. Logo created by community partners. (© Museums Luton)

Hello Luton, My New Home: Luton Voices temporary exhibition. (© Museums Luton)

the Regions has not had a hugely beneficial effect on the museum sector and local communities. The recent review of the Renaissance programme highlighted the achievements of the programme in targeting Black and Minority Ethnic (BME), disability and other marginalised audiences (Renaissance Review Advisory Group, 2009). As Black discusses, the role of project work should be acknowledged as

one of the museum's tools for connection with communities: "[T]he opportunity for individuals and groups to engage with museum collections and staff in a sustained manner over a period of time should be a fundamental aspect of the service museums provide" (Black 2005, 62-4). However, the 2009 review I undertook as Learning and Access Manager for Museums Luton identified a separation between community outreach work, core programming and site access issues. It highlighted the limited impact that project work was having on tackling barriers to access, to enable the communities who were now in contact to fully gain access into the museum's spaces. It was also not obvious in strategic terms why certain communities had worked with the museum on outreach projects and why others had not. There was no underpinning rationale behind the choices for community projects other than that these groups could be described as excluded. As Reussner (2003) emphasises this is not an uncommon position within the museum sector. In the Luton area there are hundreds of different community groups on the doorstep of the museum. In this sea of opportunity, how could Museums Luton make choices about who to approach?

Luton had made significant steps forward by engaging with culturally and socially excluded groups. Staff had actively worked to involve them in improving access to its new Stockwood Discovery Centre in the 2008 redevelopment. However, the approach that was being used was not able to fundamentally challenge practices across the whole museum, in order to ensure that the needs of different communities

were consistently prioritised within developments. The physical, sensory, language and perceptual barriers that prevented some communities from visiting the museums were not being systematically dismantled as a result of the community outreach projects.

There was a clear commitment to listening to communities at Trustee and senior management level. On a practical level, however, community issues were not always at the heart of decision making. As Kirton and Greene (2006) discuss, this separation between policy and practice is commonplace in many sectors. The 2009 review at Museums Luton identified that a more strategic approach was needed and that community outreach needed to be integrated with core programming and access development on-site to create an audience development approach. The review called for changes to the way that community issues were prioritised within different work areas of the museum through the development of a strategic Audience Development Plan. Rather than a specialist team of two staff members working on community outreach, the service needed community issues to be embedded in all work areas through a more holistic organisation-wide approach. As part of this, the benefits communities received from their involvement with the museum and the impact on their lives also needed to be considered.

There are strong arguments for forging closer, longer-term relationships with communities as Audience London (2009, 2) describes: "[C]ultural organisations that have strong relationships with their local communities are more

sustainable; attracting more audiences and visitors, more partners and more resources." They also outline the benefits for the communities involved: "[C]ultural organisations can play a vital role in their local communities, providing inspiring opportunities for community cohesion, empowerment, learning and skills development, employment and regeneration" (2009, 2). A more strategic approach to the management of audience-centred services has been called for by Reussner who states that "[S]trategic management is expected to support museums in bringing their mission into action, and thus proving that museums make a difference" (Reussner 2003, 96).

Therefore, a holistic audience-centred rationale was needed rather than a sole focus on community activities with excluded audiences. On an organisational level, the management decisions which created community outreach posts and gave them the mandate to work with excluded audiences can be seen as an important stepping stone towards a more integrated approach.

Audience development: a strategic approach
What is audience development? Much has been written about the process and benefits of audience development for museums (Black 2005, Connolly and Hinand-Cady 2001, HLF 2009, MLA East Midlands 2006b, Renaissance East Midlands 2008, Waltl 2006), so it is worthwhile taking a moment to consider what is meant by this term. HLF (2009, 3) state that "[A]udience development is about taking action

to put people centre-stage." Waltl (2006, 3) describes it as: "a powerful process of improving services to existing visitors and reaching out to new audiences. It is not a simple course of action but a planned and targeted management process which involves almost all areas of a museum working together to deliver the organisation's overall aims and objectives to high quality standards."

For MLA East Midlands (2006b, 4) it "is about knowing who your users are, or aren't, and developing your service to appeal to them so that they become active, satisfied users of your service."

Clearly, audience development is a multi-faceted process which involves exploring provision for visitors and why non-visitors are absent. Crucially, it involves taking action and implementing issues that have been identified during the process. It is not an isolated strategy which is solely carried out by staff whose job titles include the term *community* or *audience*. It engages the whole museum in a coordinated management-endorsed process to mainstream community issues. As HLF explains: "Some organisations might describe this sort of activity as marketing: that is researching market needs, matching the product to markets, segmenting the market, and identifying ways to reach and satisfy consumers. Others might see it as education, outreach or community development. It doesn't matter what you call it: it is the process of engaging with people which is important" (HLF 2009, 6).

An important step in this process is the need to deepen the relationship with existing visitors. Museums can presume

that they offer what is wanted by visitors, whereas services may be out-of-step with their current interests or needs. Without active consultation with communities, museums can make assumptions on their behalf. MLA East Midlands emphasises the importance of not being complacent about current visitors: "In commercial terms, it's approximately ten times more expensive to attract a new user than it is to retain an existing one. This has a significant impact on resources such as staff time, budgets and use of staff skills and facilities. Loyal users are also more likely to recommend your service to others and are more likely to make repeat visits" (MLA East Midlands 2006b, 4).

So clearly there are sound financial and staffing arguments for seeking to ensure existing users are well catered for, as well as expanding core audiences through outreach work. For Museums Luton this highlighted the need to create a coordinated understanding of the key audiences for core on-site programming, for development work or marketing aimed at drawing non-visitors into the museum, and for outreach programmes that aimed to work with excluded groups.

The process of audience development planning

There are various frameworks available which give guidance to museums on how to undertake the process of audience development planning (Connolly and Hinand-Cady 2001, HLF, 2009, MLA East Midlands 2006b, Renaissance East Midlands, 2008). Museums Luton employed a hybrid version of all four frameworks, as each had individual strengths. Museums

Luton is currently working its way through these stages and has not yet completed the full process, due to the time needed. Audiences London has estimated that it can take up to seven years to create an effective audience development programme, depending on staff capacity, funding and the baseline level of engagement with local communities.[5]

The stages that Museums Luton plans to follow are:

Stage 1 - Knowing your audiences: This stage is particularly highlighted by guidance from HLF (2009), MLA East Midlands (2006a and 2006b) and Renaissance East Midlands (2008) and involves profiling the communities around the museum. As Waltl (2006, 3) discusses, "[T]he basis of all audience development initiatives should be research – market research – knowing your audience is key to identify different needs but also to develop niche markets and convince more visitors to become regular museum goers."

The methodology for understanding the nature of local communities involved the production of a Community Profile. This approach was informed by MLA East Midlands' (2006a) *How to...Develop a Community Profile* and Nottingham Museums Service (2006) *Community Audit.* The profile created by Museums Luton focuses on the demographic make-up of Luton and includes information on population, age, gender, ethnicity, religion, lifestyle choices and disability (Museums Luton 2010). This information was gathered through desk-based research from 23 separate sources. Much of the initial time spent on this new audience development process has involved completing the initial research needed to inform

decisions. A large amount of data was gathered from Luton Borough Council's website on its interpretation of the Office of National Statistics 2001 Census for Luton. However, this source is nine years out-of-date and therefore needed to be cross-referenced with more up-to-date sources on its website such as the Luton Borough Council, Research & Intelligence Team statistical estimates on Luton's population.

However, the National Census does not include data about a large range of communities such as the Traveller community, homeless people, Lesbian, Gay, Bisexual and Transgender (LGBT) community, Refugee and Asylum Seekers, recent economic migrants, and only includes data about disabled people in relation to health issues. Therefore, some of the most marginalised groups in society are not adequately explored through the census data. To fill in these gaps sources such as the Luton LGBT Steering Group's report on the needs of the LGBT community in Luton (Luton LGBT Steering Group 2004) and statistics supplied by the Disability Resource Centre in nearby Dunstable (whose remit covers Luton) were used. NHS Luton and Luton Borough Council's Children and Learning Department were also good sources of up-to-date statistics and demographic information.[6]

The Community Profile highlighted a series of key issues:

Luton's people come from a wide range of ethnic backgrounds. Approximately 35% per cent are of Black and Minority Ethnic origin, with significant Pakistani/ Kashmiri, Bangladeshi, Indian and African Caribbean communities. In recent years

the diversity of the population has grown and there are now communities of Albanian, Russian, Turkish, west African and Polish speakers. The percentage of minority ethnic pupils in schools in January 2006 was 50 per cent (Museums Luton 2009, 13).

Over 100 recognised languages are spoken across Luton and 44% of children have English as a second language (Museums Luton 2010). This poses challenges for communication issues through exhibition interpretation, customer care and learning programmes. It also gives an indication of where contemporary collecting from communities might be focused in the future. It will also inform a range of different policy areas, from exhibitions through to the service's workforce diversity strategy, to ensure that communities are better represented in the displays and staffing of the museum.

The profile highlighted issues relating to deprivation: "[W]ithin the East of England, Luton ranks third highest for deprivation... with four wards featuring in the top 10% most deprived areas in England and Wales" (Museums Luton 2010, 77). Coupled with issues such as "31% of people of working age have no qualifications" (Museums Luton 2010, 9) this begins to give a picture of some of the real social issues that communities face. This will potentially inform Museums Luton's policies on fees and charges, volunteering and adult learning programming.

Information from the profile is useful to all sections of the museum when considering current and new programmes.

However, it shouldn't be used in isolation as the groups discussed are not homogenous and statistics alone do not give a full insight into particular communities. It might be easy to extrapolate this information and transpose it to museum policy without talking directly to actual visiting and non-visiting audiences. Therefore, a deeper understanding of these issues is needed.

Stage 2 – Knowing who is visiting and who is not: As Black (2005, 52-3) argues, "survey work to establish who is actually coming will tell the museum all it needs to know about under-representation among those who should be coming to the facility they are currently providing." Museums Luton conducts a summer survey each year (August–September) to capture demographic and customer service information from visitors (Museums Luton 2010). The questions in the demographic data were altered in 2009 to more closely mirror the demographic categories within the Community Profile. Data was also used from the annual site visitor figures, and the Performance Indicator data gathered for Renaissances in the Regions to create a basic Visitor Profile (Museums Luton 2010).

Although the summer survey is a relatively small sample size, the Visitor Profile can be mapped against the Community Profile to identify which communities are under-represented on-site. For example, the cross-referenced analysis showed that both sites attract a similarly low proportion of young people (Museums Luton 2010, 63) when compared to the high percentage shown in the census data for Luton. It also highlighted that 6% of visits to Museums Luton are by

disabled people (Museums Luton 2010, 63) compared to 18% of the national population being registered as disabled people (as sourced from the Employers Forum on Disability website).

This information allows the Museum to begin to highlight areas of concern that need to be addressed. An analysis of the meaning behind the data and the implications for Museums Luton is currently being written.[8] Issues that are obvious when looking at the profile are the need to prioritise consultation with young and disabled people and the need to conduct research on the potential of the museum's adult learning programmes to support learning and skills development needs in the community.[9]

This approach mirrors the stance of Connolly and Hinand-Cady (2001, 18) who indicate that "[A] prerequisite for an organization beginning audience development work is a solid understanding of its audiences." HLF however warns that: "[W]hilst classifying people into groups can be helpful as a way of targeting what you do, there are also pitfalls in this approach. These priority groups are not homogeneous or coherent. In fact, differences within a group may be as marked as those between groups" (HLF 2009, 8).

This gives a strong indication that the next step should involve consultation with key communities to really understand their interests and needs, along with barriers to access.

Step 3 – Consultation with communities and auditing provision: Without an audiences audit there is a danger that time, effort and resources are spent on audience development projects that are built on perceptions rather than on reality

(MLA 2006b, 21). In response to the initial findings from the Community Profile, Museums Luton is in the process of setting up three long-term consultation forums with families, young people and disabled people. Families are an important audience as from Performance Indicator data they are the largest core audience for the museum sites alongside schools (a consultation group has already been established with teachers). Young people and disabled people are also a priority for consultation as they are under-represented in the Visitor Profile. In 2010, further consultation groups will be considered in light of the full analysis of the Community and Visitor Profiles and it is likely that BME communities will be a priority for the next phase of consultation.

For Museums Luton, the aim of these consultation forums is to develop a mutually beneficial partnership where the museum gains knowledge about the community, gathers practical support in the development of new programmes, and that the communities involved also gain tangible benefits from their involvement.[10] Hollins (2010) discusses the need for museums to move beyond a mode of research with marginalised communities such as disabled people, where the museum seeks to merely find answers to a question or topic that is "on the museum's mind." Hollins outlines a more equitable mode of research which aims to create shared aims and ownership of the process (Hollins 2010, 232-233).

For example, with the Families Forum, direct benefits for the families were discussed and they decided that they wanted to get involved in interesting projects to widen the

children's horizons (the families involved come from one of the most deprived wards in Luton), and they wanted their views to be heard as they have a wealth of ideas to offer. Joint aims were developed from these discussions and the families are being trained to act as "critical friends" with plans for them to conduct a family-friendly audit of the museums. They are currently working on the development of new family activities to support exhibition spaces at Stockwood Discovery Centre alongside front-of-house staff.

This reflects the strong and sustainable relationship that Audiences London (2009, 2) discussed earlier when talking about how to attract a greater range of visitors. The ultimate aim of this type of long-term consultation is to more fully understand the needs and interests of communities, so that the museum can refine its exhibition and learning programmes, along its marketing strategies, and therefore expand the range of mainstream communities like families who visit the site. It is, therefore, a mechanism to ensure continued success and expansion of core audiences.

With marginalised communities, this type of consultation can support staff to increase their awareness, confidence, knowledge and skills to work with more closely with them. It can affirm the service's commitment to increasing access, and support long-term planning to identify and tackle barriers to access, with the direct support of the community. Auditing of services with communities can reap great rewards as communities can act as an external "fresh set of eyes" to unlock issues and give new perspectives.

To create a whole organisational approach, the knowledge and skills to understand and work with excluded communities need to spread beyond outreach staff. To support this evolution, staff training can be an important step forward along with the involvement of a wide range of staff in the audience development process.

Stage 4 – Setting up a cross-organisation working group: As Connolly and Hinand-Cady (2001, 13) advise in their guidance on how to develop an audience development planning process, the next step involves setting up a Cross-Organisation Working Group to explore how audience development is an integral part of different staff members' remits. At Museums Luton, this working group was set up in September 2009[11] and staff from across the museum are involved, including senior managers, front-of-house, curatorial, design, marketing, learning and audience development. This group has been tasked with the development of an Audience Development Plan which will inform the future direction of audience-related and community issues across the museum. The initial sessions with this group focused on all staff developing a shared understanding of audience development and how it related to their work area.

Two important structural issues were also addressed in terms of staffing. The Community Outreach Coordinator's job title was changed to Audience Development Coordinator, and the job description was altered to acknowledge that this post-holder's role included audience development, community outreach and museum-based access issues.

Also, key members of staff were given responsibility for leading on audience development, including a member of the senior management team, the Audience Development Coordinator and the service's Marketing Officer. This decision was taken to ensure that responsibility sat with staff who are in the position to respond to the communities' advice and translate it to action. It also acknowledged the shared remit of audience development and marketing staff in understanding, consulting with and communicating to audiences.

Stage 5 – Development of an audience development plan: "Successful museums have to be proactive in planning their audience development strategies. A well grounded strategic plan will help museums to move efficiently from where it is now to where it wants to be" (Waltl 2006, 6). The Audience Development Working Group will assess the information from the Community and Visitor Profiles and work with senior managers and the Community Forums to create strategic aims and priorities for future audience development work. On a practical level this will then translate into the production of an Audience Development Plan. As advised by HLF (2009, 12) this needs to detail what Museums Luton will carry out to encourage and deepen participation with visiting and non-visiting groups. As HLF (2009:12) outlines, the plan should "set out clearly what you propose to do and who will be responsible; it should identify target audiences, activities, timescales, measures of success and the resources required (staff, money, facilities, and skills/knowledge)." The plan will create short, medium and long-term outcomes, with

some immediate quick wins that can be delivered to create momentum, and demonstrate that the planning process is not just a paper exercise.[12] Crucially, the Audience Development Plan will identify which communities will be a priority to work with for site-based and outreach work.

Stage 6 – Mapping community contacts and local organisations: This stage does not sequentially need to sit at this point in the process and can come earlier, while the Community Profile is being developed. In terms of staff capacity, however, it can be a time-consuming job and so Museums Luton is currently working with other audience-focused staff across the Trust to map contacts.[13] There are a myriad of groups that have been in contact with the Trust's museums, libraries and arts services and collating these details will produce a valuable resource to support future developments, as they can be mapped against the Community and Visitor Profiles to see which groups have an existing relationship with the museum, and which groups may need to be contacted for the first time.

Stage 7 – Implementation of the audience development plan: This stage may be challenging for some staff as it may take them outside their comfort zone to meet communities, respond to their advice and be accountable to them for the changes that are implemented. Staff may need training or support during this stage to ensure they develop the knowledge, skills and confidence to successfully work with key communities to implement the plan. With the specific nature of the Audience Development Plan which will outline key tasks, staff responsibilities, budgets and timescales,

this means that senior management and the Audience Development Working Group can monitor its progress.

Stage 8 – Evaluation: Evaluation of whether the implemented plans have been successful is an essential step in the process. Economou (2004) highlights that the crucial role for evaluation is measuring the effectiveness of the implementation of strategic plans. As HLF (2009, 11) describes, this process becomes cyclical as evaluation informs future planning. In the future, the Community and Visitor Profiles will need updating to reflect changes in the demographics of Luton and visitor patterns on-site. Input from the Community Forums and Audience Development Working Group will inevitably mean that strategic plans will need to evolve to respond to the issues that arise. Evaluating the impact on the staff, Community Forum members and museum developments will be important in demonstrating the benefits of an audience-centred rationale to key funders, and to evidence that Museums Luton is delivering on its mission statement and Forward Plan objectives. As Black (2005, 61) describes, "[A]udience development planning is a long-term challenge" but the rewards from this process can be multi-layered for the museum, staff and communities involved and therefore need to be captured and communicated.

Conclusion

Museums Luton clearly has some distance to travel along the road towards the successful implementation of its audience development planning methodology. Before the audience

development process was initiated in 2009, significant steps had already been taken by museum management to focus on marginalised audiences through community outreach projects. This work, although highly successful and beneficial to the museum, was not able to create an holistic approach to community issues across the whole organisation. This in part was due to the original remit of community outreach posts to focus on communities beyond the museum walls. A more strategic and coordinated approach was called for and good practice from the sector informed a process of audience development. This involved giving responsibility for the process to key members of staff to move the remit of the work beyond community outreach staff. The creation of a Community Profile for Luton and the Visitor Profile for Museums Luton were important steps towards the creation of an Audience Development Plan, with a cross-organisation working group overseeing its completion and implementation. The creation of Community Forums that have an equitable relationship with the museum, and who are involved in shaping the future direction of plans was also an important step. These groups would not only give their opinion and advice but would work on initiatives which allowed shared aims and priorities to be met. Crucially for this process, the community members would directly benefit from their involvement, with an aim of creating a sustainable long-term relationship.

It is anticipated that this process will support Museums Luton in fulfilling its aims to listen to communities and

place them at the heart of the museum, and that audience development planning will be a mechanism that enables policy to move into daily practice, with museum staff working with communities to ensure that developments are genuinely accessible. This strategic approach, led by senior management, will demonstrate a commitment to prioritising audiences' needs. As Black (2005, 62) proclaims, "[A]mbitions to develop museums as inclusive institutions will remain no more than aspirational until they are absorbed into both the ethos and the senior management teams of museums."

Waltl (2006, 2) discusses how this relates to the wider museums sector and society: "[M]useums have entered a time of change: they are asked not only to justify their funding but also to redefine their role in society." As Matarasso (2006, 62) so eloquently describes, museums can have an important role in supporting different communities to navigate their way through the complexities of contemporary society:

> The kind of culturally inclusive museum I imagine is not a static display of treasures, but a space within which we can all explore and debate values, meanings and identity through contact with objects. It is a place for storytelling, where the silent, the marginalized, the newly-arrived and the despised can, for once, be the subject of their own narratives rather than the object of other people's. It is a place of change, but one in which the consistent threads of museum values - education, for example, tolerance, trust in people, dialogue and independence - always link the past, the present and what is to come.

For an organisation like Museums Luton, these issues are

central due to the diverse nature of the community landscape within which it is located. An audience development methodology can be a mechanism to help it balance the needs of existing visitors with its aims to reach out to excluded communities. Only time will tell whether this strategy will enable the museum to achieve its full range of objectives. However, the precedent set by the Renaissance East Midlands' (2008) audience development programme, *Engaging with Your Audiences*', which supports 30 museums and arts organisations in implementing a similar audience development methodology gives a favourable indication that this process can give rise to surprising, rewarding, challenging and interesting outcomes that indeed place audiences at the heart of museums, alongside their all-important collections.

Notes

1 This number is the number of posts and includes part-time, apprentice and casual staff (rather than full time equivalents). Information received in an email from Fatima Choudhury, Learning Development Officer, Museums Luton, 10th March 2010.

2 Information received in an email from Karen Grunzweil, Audience Development Coordinator, Museums Luton, 11th March 2010.

3 A £6.5 million pound refurbishment funded by Luton Borough Council, Heritage Lottery Fund, Objective 2 European Funding, DCMS/Wolfson Foundation, Museums and Galleries Improvement Fund, Waste Recycling Environmental Ltd., Garfield Weston Foundation and Renaissance in the Regions. Information sourced from Museums Luton's website.

4 Information received in an email from Karen Grunzweil, Audience Development Coordinator, Museums Luton, 11th March 2010.

5 Information given at the MuseumEtc Conference, 14th December 2009.

6 A full list of sources are listed in the Community Profile published by Museums Luton (2010). This is available via Museums Luton's website.

7 The Community Profile is currently in draft format. Some page numbers currently given may change in the final version.

8 Information received in an email from Karen Grunzweil, Audience Development Coordinator, Museums Luton, 11th March 2010.

9 A report has been commissioned through the Learning Revolutions grant scheme. Information received from Terry Salt, Barnfield College, 10th October 2009.

10 Minutes of Audience Development Working Group, November 2009.

11 Minutes of Audience Development Working Group, November 2009.

12 Information from minutes of Audience Development Working Group, November 2009.

13 Information from minutes of LCST Audience Development and Community Engagement Sub-group, August 2009.

Bibliography

Audiences London. 2009. *A short guide to community engagement*. London: Audiences London.

Bennett, Tony. 1995. *The birth of the museum*. London: Routledge.

Black, Graham. 2005. *The engaging museum. Developing museums for visitor involvement*. Abingdon: Routledge.

Connolly, Paul and Marcelle Hinand-Cady. 2001. *Increasing cultural participation: An audience development planning handbook for presenters, producers, and their collaborators*. New York: Wallace Foundation.

Dodd, Jocelyn. 1992. Whose museum is it anyway? Museum education and the community. In *The educational role of the museum*, ed. Eileen Hooper-Greenhill, 131-133. London: Routledge.

Economou, Maria. 2004. Evaluation strategies in the cultural sector: The case of the Kelvingrove Museum and Art Gallery in Glasgow. *Museums and Society 2*, 1: 30-46.

HLF, 2009. *Thinking about... audience development*. London: HLF.

Hollins, Heather. 2010. Reciprocity, accountability, empowerment. Emancipatory principles and practices in the museum. In *Re-presenting disability. Activism and agency in the museum*, eds. Richard Sandell, Jocelyn Dodd and Rosemary Garland-Thomson. 228-243. Abingdon: Routledge.

Kavanagh, Gaynor. 1990. *History Curatorship*. Leicester: Leicester University Press.

Kirton, Gill and Anne-Marie Greene. 2006. *The dynamics of managing diversity. A critical approach*. Oxford: Elsevier.

Kotler, Neil and Phillip Kotler. 2000. Can museums be all things to all people? Missions, goals, and marketing's role. *Museum Management and Curatorship*. 18, 3: 271-287.

Lang, Caroline, John Reeves and Vicky Wollard. 2006. *The impact of government policy*, eds. Caroline Lang, John Reeves and Vicky Wollard. 19-28. Aldershot: Ashgate.

Luton Cultural Services Trust, 2009. *Luton Cultural Services Trust: Our vision, values and priorities 2009-12*. Luton: Luton Cultural Services Trust.

Luton Lesbian, Gay, Bisexual and Transgender Steering Group, 2004. *Out about Town: Survey of the needs of lesbian, gay, bisexual and transgendered people in Luton 2003/2004*. Luton: Luton Lesbian, Gay, Bisexual and Transgender Steering Group.

Luton Museums Service, 2003. *Forward plan 2003-2008*. Luton: Luton Museums Service.

Luton Museums Service, 2007. *A moving experience: The Travelling people project. An evaluation report*. Luton: Luton Museums Service.

Matarasso, Francois. 2000. *Opening up the china cabinet: Museums, inclusion and contemporary society*. Paper presented to the Museums Association conference, October 16, Jersey, UK.

MLA East Midlands, 2006a. *How to... Develop a community profile. A guide for museums, libraries and archives*. Leicester: MLA East Midlands.

MLA East Midlands, 2006b. *How to... Write an audience development plan. A guide for museums, libraries and archives.* Leicester: MLA East Midlands.

Museums Luton, 2008. *Oral history: Engaging schools, engaging young people, engaging communities. Case Studies from the Luton Voices project.* Luton: Museums Luton.

Museums Luton, 2009. *Forward plan 2008-2011.* Luton: Museums Luton.

Museums Luton, 2010. *Community profile.* Luton: Museums Luton.

Nottingham City Museums and Galleries, 2006. *Community audit 2005-6.* Nottingham: Nottingham City Museums and Galleries.

Renaissance East of England, 2006. *Broadening participation. A summary of the East of England hub plan 2006-8.* Norfolk: Renaissance East of England.

Renaissance East Midlands, 2008.*Engaging with your audiences. Part 2: Understanding your communities needs.* Nottingham: Renaissance Eat Midlands.

Renaissance Review Advisory Group, 2009. *Renaissance in the Regions: Realising the vision.* London: MLA.

Reussner, Eva M. 2003. Strategic management for visitor-oriented museums. A change of focus. *The International Journal of Cultural Policy* 5, 1: 95-108.

Social Exclusion Unit, 2004. *Tackling social exclusion: Taking stock and looking to the future.* London: Office of the Deputy Prime Minister.

Waltl, Christian. 2006. *Museums for visitors: Audience*

development: A crucial role for successful museum management strategies. Paper presented at the INTERCOM conference, October, Taiwan.

Watson, Sheila. 2007. *Museums and their communities*. London: Routledge.

Websites

Oxford English Dictionary. http:www.askoxford.com/concise_oed/community?view=uk, last downloaded 6th March 2010.

Museums Luton. http:www.museumsluton.com/cinehubEast/museumsluton-exhibition.nsf/LookupAreas/09EF432 DFBEEDCB6802574F2003E9BCA?OpenDocument, last downloaded on 15th February 2010.

Luton Borough Council. http://www.luton.gov.uk/internet/social_issues/population_and_migration/luton%20 observatory,%20census%20and%20statistics%20data/census%20information, last downloaded 17th September 2009.

Luton Borough Council, Research and Intelligence Team. http://www.luton.gov.uk/internet/Social_issues/Population_and_migration/Issues%20relating%20ONS%20 population%20estimates%20-%20report%20by%20 Luton%20Council, last downloaded 17th September 2009.

Employers' Forum on Disability. http://www.efd.org.uk/media-centre/facts-and-figures/disability-in-uk, last downloaded 12th February 2010.

The Ignorant Museum: Transforming the Elitist Museum Into an Inclusive Learning Place

YUHA JUNG

Pennsylvania State University

Museums have historically functioned as places for collecting, preserving, researching, and exhibiting significant objects related to human and natural histories, traditions, arts, and knowledge. While today's museums are taking on a greater educational role, the historical depository function can still be felt in museum practice. For example, the mission of many art and historical museums remains to expand, preserve, and exhibit their collections. While this kind of mission can be one of the most fundamental functions of museums, when art museums focus too much attention on their objects' aesthetic or historical significance, they risk neglecting their role as educational institutions. Instead of inviting visitors to engage in meaning-making, the objects are presented as if they have a single monolithic significance. As a result, only those people who have access to and interest in the objects' aesthetic, historical, and cultural significance feel comfortable valuing and relating to them. If the museum does not encourage visitors to engage with those objects in their own ways and to consider their relevance to their own memories, history, and knowledge, the museum becomes a mere depository that benefits only a few people. In such a case, as expressed in Paulo Freire's book, *Pedagogy of the Oppressed*, the museum becomes an oppressor as it imposes its rarified beliefs and knowledge upon its visitors and shuts many out from deeper participation. In the next section, I expand on this idea of the museum as oppressor by analyzing Freire's theory in the context of the museum setting.

Freire argues that the world's people are divided into two

groups – the oppressed and the oppressors. According to Freire, the oppressed are controlled by the oppressors and therefore, are unable to fully exercise their agency.[1] Because the oppressors care only about gaining control over others, they create a false reality in which injustice, exploitation, and violence are used to gain power over the oppressed.[2] Freire's oppressed-oppressor binary constitutes a metaphor for what happens in many museum practices. In the traditionally assumed museum-visitor relationship, the voice of the museum dominates over those of its visitors. The museum guides visitors as to what to see, what to read, and where to go next. Visitors are treated as passive recipients of knowledge as opposed to learning agents. As a result, both the museum and visitors become depositories: the museum is understood as a depository of history, knowledge, and art, and visitors as depositories of what the museum has contained, collected, and imposed.

Many museum practices embody this oppressed-oppressor binary with respect to the museum-visitor relationship and relationships among museum professionals. Visitors, who cannot find their interests and epistemological ways reflected in the museum's exhibitions, programs, lectures, or other events, can feel marginalized from museum culture. The museum, then, is not experienced as a place for relevant learning but as a warehouse of irrelevant and meaningless objects. Visitors with this kind of experience are unlikely to return. Similarly, there is a hierarchical relationship among museum professionals in which power is unequally distributed. While directors and curators are

considered object experts and are imbued with the power to choose exhibition themes, objects, and art works, other staff members, including educators, are often excluded from major decision-making processes.

I recently had a chance to discuss this issue with a local museum educator. According to the educator, curators in her museum who are experts in different genres (such as Renaissance art, contemporary art, and Western painting) work independently in developing, researching, and planning exhibitions. Part of the educator's work is to create accompanying programs afterwards. In such cases, each curator's work offers a single viewpoint, failing to reflect collaboration and diverse perspectives. As long as museums function like the oppressed-oppressor relationship, their practices will not be able to change in an inclusive and democratic way.

The pedagogy of the oppressed

According to Freire, in order to obtain agency, people must identify old ideologies and their causes and transform an old world into a new situation.[3] Freire introduces the pedagogy of the oppressed as an ideal approach to transform the old world into a more humane and just society. The pedagogy of the oppressed is a pedagogy of humankind which is generous, authentic, and humanistic and, importantly, developed by the oppressed themselves.[4] Through the pedagogy of the oppressed, the oppressed can be empowered to think critically about their oppressors and about the role they

play in their own subjugation. In order to change their lot in life, the oppressed must understand reality not as a fixed world but rather as a limiting situation which is capable of transformation.[5]

Can museums' old ideologies and their causes be challenged and transformed through a pedagogy of the oppressed? What are the oppressive ideologies and their causes in museum culture? Traditional museum practice and development are certainly implicated. David Fleming argues that museums have excluded socio-economically less fortunate groups of people "not by accident but by design." [6] In part to ensure their financial viability, museums have restricted themselves to meeting the needs and interests of educated, middle-class, economically powerful people. Also, the fact that museums have been run by an elitist minority has affected what they have collected, how they have been managed, and for whom they have tailored their programs.[7] Fleming especially criticizes the role of curator-directors in museum practices for not prioritizing inclusive museum practices since they have personally benefited from their social status and power within the hierarchical organization.[8] In addition, Fleming points out that these professionals tend to focus on the "pursuit of academic excellence" at the expense of communicating effectively with lay audiences.[9] As a result, they neglect community education and social inclusion. This traditional development of museums can still be felt in many museums today. The authoritative Euro-centric discourse and elitist notion that museums are for the culturally "refined"

remain unspoken but also unchallenged among many in the museum world.

In order to transform this historically-influenced museum discourse into one which is more inclusive, I will further explore the notion of a flexible, mutable world through drawing on more specific ideas from Freire and Jacques Rancière's book, *The Ignorant Schoolmaster: Five Lessons in Intellectual Emancipation*. I will do this through comparing museum practices to school education.

Naming the museum

According to Freire, the narrative of the pedagogy of the oppressor is that students are empty objects who must listen to what their teachers say. In this form of education, students are seen as containers or receptacles which can be filled up by teachers.[10] Freire uses the banking system as a metaphor to describe this view that academic knowledge is deposited into students' minds.[11] However, in the pedagogy of the oppressed, this system of unidirectional transfer of knowledge becomes multidirectional. In its place, a system of mutual exchange between teachers and students is created.[12] Students think critically about the educational materials and content and provide constructive critique and diverse perspectives to constantly improve their educational environment. Likewise, teachers strive to understand what their students want and to engage them in critical thinking. The result is a horizontal relationship in which teachers act as partners with students in devising curricula through problem-posing

communication.[13] As the vertical characteristics of banking education are broken down, students are liberated from their former role as submissive depositories of knowledge.[14]

Similarly, in an oppressive museum, visitors are considered as containers or receptacles while curators are charged with depositing information and knowledge which may or may not be relevant to them. However, when problem-posing education is exercised, visitors can act as teachers and museum staff can act as students. They all can learn from and teach each other. Through mutual relationship, humanization, and critical thinking, visitors can digest museum offerings not as authoritative truths but rather as something to be changed and interpreted differently, based on their own personal histories, memories, knowledge, and experience. A vertical relationship between museums and visitors ceases to exist when visitors are acknowledged as learning agents and communicative beings and when reality is recognized as mutable and therefore, transformable.

One important aspect of the pedagogy of the oppressed is the notion of praxis, which consists of action and reflection. Without action, words become mere empty vessels of reflection.[15] In order to transform the world, action is essential. However, action and reflection must be balanced. If one is stressed more than the other, the result is either activism or verbalism, both of which create an unhelpful dichotomy in the world.[16] According to Freire, human beings are not born to be silent but to work in "action-reflection".[17] In order to change the world and live in the praxis of action-reflection according

to their own agency, people must name the world and then rename and new-name it to alleviate problems.[18]

"Naming" is a process of recognizing one's own situation in relation to other people, society, and larger systems and being critical and reflective about the recognition. Once problems are identified, recognized, and reflected, the process of renaming and new-naming follows, the process to find solutions and create new situations. However, naming, renaming, and new-naming should not be a one-time practice. Rather, the cycle must continue in order for more positive transformation to take place because things always change and new situations and solutions become obsolete and irrelevant. Here, dialogue comes into play.

Dialogue involves not only a simple exchange of ideas, but rather, a process of creation and re-creation based on love for the world and its people.[19] According to Freire, dialogue builds mutual trust and horizontal relationships that bring people who are involved with the dialogue into closer partnership as they name the world together.[20]

It is my hope that the current pedagogy of museums can be transformed and changed into a visitor- and education-oriented pedagogy through this praxis of reflection, action, naming, and renaming based on dialogue, love, mutual trust, and horizontal partnership. Museum professionals and administrators should embrace the notion that the reality of museum practices is not fixed but rather mutable and transformable. They must challenge the current pedagogy of museums through collaboration, dialogue, and

communication among themselves and with their visitors. By developing mutual, communicative, and horizontal relationships and exercising the pedagogy of the oppressed, museums can develop their pedagogy in ways that are relevant to visitors' points of view. The content of their educational programs and exhibitions can be renewed and recreated constantly. In this renamed museum pedagogy, museum professionals can act as facilitators who understand that reality is transformable and recognize problematic issues rather than overlooking them. They have the opportunity to invent new ways of empowering their visitors to learn in a personal and communicative way.

Emancipating museum education

Another approach that can change museums into communicative, welcoming learning places is the approach Rancière lays out in his book, *The Ignorant Schoolmaster.* Rancière tells the story of a French professor, Joseph Jacotot, who was exiled to Belgium in 1818 and offered a teaching position at the University of Louvain.[21] Although he did not speak Flemish and his students did not speak French, Jacotot discovered that his students actually learned French indirectly through a collaborative effort to understand a class textbook written in French.[22] According to Rancière, Jacotot did not give his students any explicit explanations about French grammar, spelling, or conjugations.[23] Rather, his students relied on the book, its translation, and their desire to learn French, just as children learn their mother tongues

through observing, repeating, failing, trying, and verifying.[24] Instead of using an established pedagogical method, Jacotot relied on his students' will to learn.

Rancière uses this story to argue that the traditional emphasis on explication from school masters, which generates a dichotomy between masters and students – the knowing and the ignorant, the capable and the incapable – creates an intellectual hierarchy.[25] Traditional school masters are at the top of the intellectual hierarchy. They impose their knowledge on their students whom they consider to be empty vessels while missing out on the educational benefits of a more communicative, horizontal approach. These school masters fail to understand that students actually learn best through experiences, chances, failures, and self-corrections. According to Rancière, explanatory education involves the notion that one knows better than the other who cannot understand without help from the master.[26] This division of superior and inferior intelligence actually leads people toward "stultification".[27]

Rancière's criticism of school masters and their "explanatory" way of teaching has much in common with Freire's critique of banking system education. In both perspectives, a binary division of teachers and students is challenged and the view of students as empty containers or depositories of imposed knowledge is rejected. Both approaches place students instead at the center of learning processes and empower them to act as learning agents. In addition, they both emphasize the importance of reflection,

action, critical thinking, and the will to transform the old ideologies of unidirectional, oppressive, hierarchical education into learner-based, multidirectional, mutual, and democratic education.

Institutionalized museums have also been criticized for their dichotomy of superior and inferior intelligence through the imposition of an explanatory voice. For example, many art museums write their exhibition labels based on art historical knowledge without considering their audiences. As a result, the labels often contain jargon and difficult terminology that are unfamiliar to people who do not have an art historical background. I have often felt frustrated when I have come across museum labels that I cannot understand without a dictionary and supplemental background knowledge. While I am certain that this is partly because my mother tongue is not English, the terms are often unclear and difficult to native speakers, too, especially children. Museums limit their potential audiences by trying to teach or impose certain knowledge which creates an intellectual hierarchy between them and their audiences. This kind of museum practice also diminishes visitors' desire to learn and experience in museums.

According to Rancière, a method of equality is a method of the will.[28] People can learn anything without an explication from masters when they are motivated. A pure relationship should be established between teachers and students based on free will and on the liberation of intelligence.[29] Through his experiment, Jacotot discovered that one could even teach a foreign language when his or her students are emancipated.

Students need to feel that they are not at the bottom of the intellectual hierarchy but rather that they are learning agents, capable of using their own intelligence in stimulating ways. In order to be emancipated, people need to understand the true power of the human mind and believe that they can learn by themselves.[30] To achieve emancipation in museums, museum professionals must understand that they are not the only ones who distribute and create knowledge but that their audiences have their own intelligence and abilities to create their own knowledge. While museum professionals do have a role in conveying specialized knowledge, they must also prepare a learning environment where visitors are invited to interpret that knowledge in ways that are relevant to their lives. They also should understand that there is not only one way of learning but that people have various ways of learning through observing, repeating, failing, trying, and correcting.

The visitors, in turn, bear a responsibility to make sure that their voices are heard and their needs are reflected and to challenge, when appropriate, what is presented to them in museum exhibitions, events, and programs. They should understand that their relationships with museum professionals and institutions are mutual, horizontal, and flexible and that they are capable of interacting and collaborating to improve the museum environment. In addition, they should seize opportunities to personalize the public knowledge available in museums instead of simply accepting any historical or aesthetic significance captured on labels. They will benefit from embracing the notion that

they are at the center of their own meaning-making processes and that whatever they make sense of from what they see, hear, read, and feel in museums is of value.

Ecological museum pedagogy

In order to incorporate the two theories, the pedagogy of the oppressed and the emancipatory education of Freire and Rancière, in museum practices, I suggest the adoption of an ecological mind-set among museum professionals and audiences as a way to reduce the authoritative, elite, and object-based quality of museums. An ecological approach involves seeing the world with an holistic view and treating individuals not as basic social units but, rather, as part of the natural world. Nature must be regarded not as an object or raw material to be used up for people's own gain, but as a system of interconnected and interdependent ecosystems that allow biodiversity, including the existence of humankind.[31] This perspective contrasts sharply with the historically dominant Eurocentric mind-set in the current education system, which embraces a human/nature dichotomy and an anthropocentric view of community as a collection of autonomous individuals.[32] The ecological mind-set prevents such modernistic dichotomous and contradictory ideas that the world's people are divided based on their social condition, race, gender, cultural background, sexual orientation, or educational level. Rather, it holds that everyone is equally valuable, intelligent, capable, and worthy of respect.

This ecological approach shares characteristics of the

pedagogy of the oppressed and emancipatory education. For example, the ecological point of view understands the importance of horizontal relationships among creatures, people, and cultures, which are essential for the survival of ecosystems and all living organisms on the earth. Therefore, the metaphor of ecology is applied for school and museum education. When an ecological mind-set is exercised in museum pedagogy and practices, museum professionals can understand that they and their visitors are interconnected and interdependent and therefore, they cannot sustain their practices if they ignore the private knowledge of their visitors and the differences among them. Through ecological museum pedagogy, the old pedagogy can be named, renamed, and new-named through collaboration, dialogue, and communication among museum professionals and with their visitors. Ecologically-minded museum workers will think critically about their own practices, identify current problems, and create a new museum culture and practices that can be challenged again through a repetitive process of naming, renaming, and new-naming. In other words, museum professionals must evaluate and revise their current pedagogy and practices continually and collaborate with each other and other museums, cultural and educational institutions in order to transform the current situation into a more inclusive, democratic learning environment. They should converse with each other to exchange, create, and renew ideas through meeting on a regular basis.

However, museums and their professionals cannot

perform this ecological transformation without consulting and communicating with their audiences, museums' most important constituencies. Through thorough visitor studies, such as visitor surveys, casual conversations, and in/formal interviews, both counterparts should exchange and share what they feel and want in museum practices based on horizontal relationships. As a result, they will constantly communicate and collaborate with each other and build a solid community based on trust and love.

Another solution to transform museums into more inclusive, democratic, and education-based learning places and to encourage dialogue, communication, and collaboration among museum professionals and visitors is to neutralize museums' hierarchical staff organization. One way to dissolve this institutionalized notion of education and vertical relationships is to abandon the notion of experts through the process of "de-professionalization". De-professionalization involves removing power relationships.[33] For example, doctors should be seen not as experts of medicine and cure, but rather as people who can share knowledge and apply skills to help other people become healthier. Likewise, museum curators and directors should be understood not as art experts but as educators whose role is to expand and enhance visitors' learning experiences. In this atmosphere, museum visitors will feel more comfortable, welcomed, and respected, and, as a result, they are more likely to participate in museum programs and provide feedback to improve their museum community.

Lastly, I would like to urge both museum professionals and

visitors to understand museums not as mere depositories of art, history, and knowledge, but genuine, effective, enjoyable learning places. Fostering an ecological mind-set among museum professionals and their constituencies will help museums become places where interactive dialogue takes place, a horizontal point of view is involved and valued, and everyone is made to feel welcome and respected.

References

Bowers, C. A. Cultural Diversity and the Ecological Crisis. In *Critical Essays on Education, Modernity, and the Recovery of the Ecological Imperative*, 163-178. New York: Teachers College Press, 1993.

Prakash, Madhu Suri. and Esteva, Gustavo. *Escaping Education: Living as Learning within Grassroots Cultures*. New York: Peter Lang, 2008.

Fleming, David. Positioning the Museum for Social Inclusion. In *Museums, Society, Inequality*, edited by Richard Sandell, 213-224. London: New York: Routledge, 2002.

Freire, Paulo. *Pedagogy of the Oppressed*. New York: Continuum, 1993.

Orr, David W. *Ecological Literacy: Education and the Transition to a Postmodern World*. Albany: State University of New York Press, 1992.

Rancière, Jacques. *The Ignorant Schoolmaster: Five Lessons in Intellectual Emancipation*. California: Stanford University Press, 1991.

Notes

1 Paulo Freire, Pedagogy of the Oppressed (New York: Continuum, 1993), 25-27.

2 Ibid., 25-27.

3 Ibid., 29.

4 Ibid., 35-36.

5 Ibid., 31.

6 David Fleming, "Positioning the Museum for Social Inclusion," in Museums, Society,

Inequality, ed. Richard Sandell (London: New York: Routledge, 2002), 213.

7 Ibid., 213-219.

8 Ibid., 213-214.

9 Ibid., 214.

10 Paulo Freire, Pedagogy of the Oppressed (New York: Continuum, 1993), 52-53.

11 Ibid., 53-54.

12 Ibid., 61-62.

13 Ibid., 60-62

14 Ibid., 60-62.

15 Ibid., 68 69.

16 Ibid., 68 69.

17 Ibid., 69.

18 Ibid., 69-71.

19 Ibid., 69-73.

20 Ibid., 69-73.

21 Jacques Rancière, The Ignorant Schoolmaster: Five Lessons in Intellectual

Emancipation (California: Stanford University Press, 1991), 1.

22 Ibid., 1-4.

23 Ibid., 3.

24 Ibid., 9-10.

25 Ibid., 5-7.

26 Ibid., 6.

27 Ibid., 8.

28 Ibid., 12.

29 Ibid., 13.

30 Ibid., 15.

31 David W. Orr, Ecological Literacy: Education and the Transition to a Postmodern World (Albany: State University of New York Press, 1992), 92-95.

32 C. A. Bowers, "Cultural Diversity and the Ecological Crisis," in Critical Essays on Education, Modernity, and the Recovery of the Ecological Imperative (New York: Teachers College Press, 1993), 164, 170-171.

33 Madhu Suri Prakash and Custavo Esteva, Escaping Education: Living as Learning within Grassroots Cultures (New York: Peter Lang, 2008), 120.

A New Approach to Museum Exhibit Design: Exhibit Pattern Analysis

JANE KALAGHER

Assisi Institute

Brattleboro, VT

Creativity involves breaking out of established patterns in order to look at things in a different way. Edward de Bono

As a museum professional, you've likely given thought to what makes visitors look at one exhibit rather than another. What is it that visitors see in the moment they first glance at an exhibit? My research suggests that the first glance either attracts or does not attract them to the exhibition. This essay examines that question and asserts that it is the initial underlying patterns of an exhibit that structure the groundwork for an immediate resonance or dissonance between exhibit and visitor. It explores the potential for designing exhibits that offer visitors powerful seductions to meaning-making experiences and entrances visitors to immediate emotional resonance with the exhibit's soul. *Entrance* has a doubled meaning in this moment – it means in the active tense "a doorway into" and in the passive, "a fascination that bewitches." The synergy of the two meanings introduces a new approach to exhibit design, something I have defined as Exhibit Pattern Analysis.

The methodology of this new approach combines the extraordinary lenses described by the advances of the "new sciences" (Bohm 1980) and the most powerful understandings of depth psychology (Conforti 2003). It is not a simple formula, but rather a collaboration of perspectives that helps us identify, translate and analyze the evocative (dominant) underlying pattern of the image, theme or story expressed by a particular museum exhibit. Exhibit Pattern Analysis suggests

that when all elements of the exhibit are consistently related to, and aligned with, this dominant underlying pattern, the conditions for emotional resonance between exhibit and visitor is substantially magnified. This essay offers the reader a look into a new perspective.

The power of resonance

Why should we be concerned about resonance? Because it moves us more deeply into an understanding of ourselves and more powerfully into a relationship with our environment. Consider the notion of the resonance between two people falling in love. When this phenomenon occurs, we feel bewitched. We reel into a delicious orbit of fascination with the other. Science tells us we are chemically altered by the emotional alchemy of attraction. The chemistry is felt whether we understand it or not. The power of the resonance creates an emotional field that moves everyone in the vicinity. We are all attracted to falling in love.

The future of the lovers' relationship is unclear, and we are immediately aware that levels of complexity exist in the relationship, and many factors will define the course of the relationship. Yet, we know that the opportunity is there for numerous possibilities.

Museum exhibitions are potentially our lovers' lanes for the curiosity-driven museum visitor (Rounds 2006) and the artistically inclined. Strong and congruent museum exhibits create powerful attractions welcoming a polygamy of lovers. Many factors will entice the visitor to be entranced. We need

to remember the stories of our beginnings: Psyche is the Greek Goddess most known for her beauty and wherever she is, Eros is never far behind. Love and beauty go together, beauty and love are a famous pair, and together embody the underlying archetype of attraction.

Underlying patterns = archetypes

When we speak of underlying patterns, we are talking about the concept of the deep structures of living things. The biologist, Adolph Portmann (Portmann 1964), says that deep structure exists below the threshold of visibility. It may not be visible but we see its evidence in many fields. For example, in the field of biology the invention of the electron microscope revealed to us a whole new world of deep structures of the external environment, i.e. the microscopic complexities of nature's species, earthly environments, and solar system phenomena. Likewise the architecture and archeology of the inner world was explored and examined by Swiss psychiatrist, Dr. Carl Gustav Jung, who identified the functioning of what he termed (the *a priori*) collective unconscious (or objective psyche) from which the personal unconscious (similar to what Freud termed the unconscious) arises. Jung's research into what he termed the collective unconscious, the inherent accumulation of cognitive and behavioral tendencies of the human species, is similar to the functional complexity of the interconnected universe, recently described by 20th century quantum physicists (Bohm 1980).

Because the concept of deep structure is rather abstract

and not seen on a visual level, one way to think and talk about deep structure is to talk about patterns. Patterns are both seen and unseen. We see patterns in the physical world, in nature, in our bodies. We do not see patterns in our mental world but do experience them: thought patterns, belief patterns, emotional patterns, and behavioral patterns. We also experience patterns in the form of stories, symbols, myths, artwork, and music. And, of course, we experience patterns in museum exhibitions.

When an exhibit is so well done that it moves the viewer into the experience of the underlying archetype (eternal essence), the viewer is moved into the emotional moment in which the individual response coalesces with the emotional response typical of all humanity. In this moment the viewer is helped simultaneously in the recognition of personal apprehension and infinite remembrance. This is a moment of transcendence that cannot be explained by reason alone. It is the experience of being moved by the essence of powerful artistic expression that takes us both far beyond, and more deeply into, our place in the journey of humanity.

The application of Exhibit Pattern Analysis looks at the dominant underlying patterns of an exhibit, the evocative and dominant archetype. Archetypes are the universal deep structures of an exhibit as opposed to its surface structure. The archetype holds the deep message or essence of what the image, theme or story is expressing. The archetype usually goes deeper than the topic or subject of an exhibit and touches the unconscious, often bypassing cognition. It is important to

note that archetypes hold universal experiences regardless of culture and time in history (more about this later). Findings from brain studies show that humans are wired and highly receptive to archetypal experience (Conforti 2003).

Exhibit Pattern Analysis asserts that it is this unconscious relationship with the exhibit archetype that the visitor instantly experiences. If all the exhibit elements are coherent and creative to the archetype, this resonance is automatically magnified. Exhibit Pattern Analysis is an approach that differs from most work in the field because it focuses on the initial underlying patterns or archetype of an exhibit with which visitors deeply resonate but do not consciously apprehend. They are moved by the congruence to deeper levels of understanding that are typically out of reach when there is no archetypal resonance. For example, seeing a photograph of penguins in a meadow is disturbing because it represents archetypal dissonance. Seeing them on an ice flow is calming, because it is coherent with the archetypal domain of the penguin. Exhibit Pattern Analysis suggests that when the initial underlying archetypal patterns inform all the design elements of the exhibit, the exhibit will be highly attractive to viewers because archetypal coherence always heightens the intensity of the exhibit's seduction and pulls visitors into the eternal emotional resonance of the species.

Archetypes and underlying patterns

In general, an archetype comprises the core, fundamental and universal properties or underlying patterns that make

something what it is. Archetypes represent the millennial repetitions, the most typical, inherited tendencies of mankind. An archetype is the basic configuration of something that identifies itself as a universal pattern. It is significant to note that this configuration holds true from the physical realm through to the symbolic realm. Let's take the simple example of the archetype of a chimney. The core properties or basic nature of a chimney is to eliminate or vent by-products from some type of heating process and provide a draft to continue the circulation of air that keeps the heating process going. A chimney is a system of sorts. The conversion of fuel into heat, no matter its source, needs a way for by-products to escape, and a chimney supports this process. A chimney also provides the mechanism (draft) to continue the flow of air that feeds the heat conversion.

An archetype holds varying degrees of complexity in terms of its physical and symbolic form but stands alone from personal associations. For instance, an individual may view an exhibit about a chimney or dream about a chimney and make many personal associations: Santa Claus climbing down a chimney, a chimney fire from the build-up of soot, a childhood memory of a bird flying down a chimney. Yet, the archetype of *chimney* is something that allows for a system of exchange. The previous paragraph addressed the chimney archetype in its physical form. In the symbolic realm, one could say a chimney represents a respiratory system of exchange that occurs in every living cell, organism, and system throughout life cycles. Even the planet has a

respiratory system. The chimney symbolizes a process that keeps a constant equilibrium within a system. In either domain, the invariable nature of *chimney* exists regardless of personal associations, culture or time in history.

One could say that archetypes are like prototypes – standard examples of universal images, themes or stories inherent in the human psyche. Everything we see in the material world has an archetypal base to it. Every image, every theme, every story has a universal origin which contains the ancient roots or essential features of itself.

In Jungian psychology, an archetype is defined as "a collectively inherited unconscious idea, pattern of thought, image, etc., universally present in individual psyches." (*Webster's Unabridged Dictionary* 1996). Another example of this is the archetype of the hero. The hero, like all the archetypes, is present in the physical as well as symbolic worlds. For example, we may know an actual hero within our personal life. We "know it" because it is universally present in individual psyches. Down through the ages, the hero archetype has been represented in the symbolic realm. Different cultures have their own versions and stories of the hero, but the ontology of the hero image is the same: someone who possesses and demonstrates daring, brave deeds and noble qualities at risk to himself. When we experience or hear about someone who has exhibited these patterns of behaviors – such as saving a child from a burning building with risk to himself – we, both as individuals and collectively, are aware that this individual is a hero.

Archetypes are the invariable and fundamental nature of

form and structure within psyche and matter. Each archetype contains its own specific archetypal patterns. Patterns may be defined as a regular or repetitive form, order or arrangement of matter, thoughts, behaviors, and ideas. In his book, *Field, Form and Fate*, Michael Conforti states:

> [Archetypal] *Patterns can be viewed as material representations of archetypal, informational fields expressed in space and time. They exist as external mappings of internal processes, be it morphogenetic promptings in the biological domain or symbolic, archetypal expressions found in the human psyche.*

These patterns are the morphogenetic (i.e. dealing with form and structure) underpinnings, the innate ordering principles (Rounds, 2006) of the core properties of a particular archetype. One might liken archetypal patterns to blueprints. A pine tree, for example, contains certain innate properties or patterns that distinguish it from an oak tree. As long as pine trees have existed, the configuration of these dominant properties or patterns has existed.

Museum exhibitions and archetypes: the connection

By definition, museum exhibitions are expressions of archetypes because they express images, themes or stories. Museum exhibitions are about something that touches our senses and our hearts. Exhibits are amplified expressions of archetypes because the image, theme or story is taken out of context from the real world and created in exhibition form. This usually occurs within the confines of a museum or a

special space designated for the exhibition. In a sense, the exhibition isolates and spotlights the dominant archetype it is expressing in a way that intends to capture its audience. Like a picture frame, it focuses our vision.

The dominant archetypal patterns of the exhibition are the common threads that resonate deeply within visitors' psyches regardless of culture, society and time in history. When all elements in a museum exhibition relate and work together to express its image, story or theme in a powerful way, the opportunity for visitors to connect with the archetype increases. This holds true whether visitors are cognizant or unaware of the underlying exhibit patterns within the museum exhibition. More than likely, they are not conscious of these patterns. Yet, on a deep unconscious level, visitors "know it", because there is a universal pattern that exists *a priori* as a universal reference point. Similar to the experience of a gourmet meal, a person may not identify, be aware or notice all the subtle ingredients in the meal, but they know a great meal when they see and taste it. All the consistent patterns of quality ingredients, specific methods to cook a particular meal, flavors added, presentation, and attention to detail make it a gourmet experience.

Human beings engage with great museum exhibitions in the same way they do with other great visual media. One reason is that archetypes function as our essential meaning-carrying structures (Conforti 2003). For example, family photographs (images) that depict us as babies or young children help us remember and integrate who we

were and who we are becoming. Watching a great film, such as *Shawshank Redemption*, is another example. This movie expresses the deep underlying archetypal theme of human survival and friendship with which human beings relate, regardless of physical, social or cultural environment.

So, too, museum exhibits often function as meaning-carrying structures that capture the archetypal dominants (those deep structural patterns) that express the integrity of the specific theme that's being represented. We have all experienced or can imagine, museum exhibitions that are able to give us a sense of meaning about humanity, nature and our world. Museum exhibitions have been and can be powerful sources of archetypal expression offering visitors the opportunity to engage with and increase awareness and understanding of their past, present and future. Museum exhibits provide the bridge between the universal archetype and the individual's personal or subjective perspective (this point will be addressed later in the essay).

Scientists, psychologists, artists and storytellers have noted that there are certain universal patterns or motifs that resonate with people down through the ages. As mentioned, current brain studies are showing that our minds and bodies are designed to respond to universal patterns. V.S. Ramachandran, Director of the Center for Brain and Cognition and Professor with the Psychology Department and the Neurosciences Programme at the University of California, San Diego, raised this question in one of his lectures: are there such things as artistic universals? Ramachandran states that

"obviously culture plays a tremendous role, otherwise you wouldn't have different artistic styles – but it doesn't follow that art is completely idiosyncratic and arbitrary either or that there are no universal laws." (Ramachandran 2008).

E. H. Gombrich, the art historian, suggested such universals and describes them as the "logics of aesthetics" (Gombrich 1984). He suggests that there are certain universal patterns, shapes, structures of form that have been in existence at least since the humans have been.

A museum exhibition as a meaning-carrying structure

Our experiences with the archetypes (images, themes, stories) are one of the ways that human beings make meaning of the world (Conforti, 2003). Meaning-making is multi-dimensional, including not only cognitive experiences but emotional ones as well. Findings from current brain studies are saying this too. Interestingly, Antonio Damasio, a neuroscientist, states in his book, *Descarte's Error*, that new brain research shows that emotion and rationality are on the same continuum. They are **not** separated but connected (even anatomically) in significant ways. Damasio says that emotions are not a luxury. They play an important role in communicating meaning to others (Damasio 2005).

One can easily see, then, that our experiences with museum exhibitions hold great possibilities for individuals and groups to connect with and experience the powerful expression of archetypes. Individuals, as well as humanity as a whole, search for meaning in this too-rushed world and

are drawn to meaning-carrying structures, such as museum exhibits, that satisfy our desire to learn and understand more about our environment and ourselves. The following excerpt is a striking, as well as inspiring, call to exhibit designers:

> The most exciting potential of the meaning-making paradigm lies in the possibility that we can learn to create exhibits that visitors experience as powerful vehicles for exploring such 'deep meaning'. Jay Rounds, Ph.D. Exhibitionist, Fall, 1999

Below is an example of a resonant exhibit that expresses archetypal coherence and creativity. In the case of this complex exhibition, the dominant archetype is its stated theme: wolves and their relationship to humans.

The museum exhibition titled, *Wolves and Humans: Coexistence, Competition and Conflict* is an outstanding example of how an exhibition is a meaning-carrying structure that creates a strong resonance and engages the visitor with the exhibition. This particular museum exhibition opened in December of 1983 at the Science Museum of Minnesota; closed in July of 1984; and toured for eight years before becoming a permanent installation in 1993 at the International Wolf Center in Minnesota.

"The exhibition defined a theme – wolves and their relationship to humans – and explored that theme through the disciplines of the sciences, humanities, and arts." (McLean and McEver 2004). The feature display shows a re-creation of a wolf pack active during the winter kill of a white-tailed deer in a north woods setting (McLean and McEver 2004). The viewer

observes a wolf pack involved in a basic survival activity. The unique roles, postures, sounds, and other behavioral interactions that various members of the pack take during a winter kill of a white-tailed deer are brought to light in a way that draws the visitor into the world of the wolf.

The scope of the exhibition includes multiple supporting exhibits or elements: folklore, paintings, sculpture, literature, scientific and historical research and the like. Some elements are interactive such as a *howling booth* and a walk-in wolf den while others describe many cultural and human perceptions of wolves, whether real or imagined. Yet, each element of the exhibition consistently relates to and supports the particular theme: wolves and their relationship to humans. The dominant archetypal pattern is the major meaning-carrying structure. The supporting elements intensify the experience. It is this amplification of, and coherence with, the dominant archetypal pattern – wolves and their relationship to humans – that creates such a powerful resonance whereby the visitor is entranced and absorbed into the world of the wolf.

As visitors interact with this exhibit, perhaps they are unaware of the deeper, more complex and profound, levels of meaning it offers. Some might gain a deeper understanding of the benefits of finding ways to coexist with wolves. Others might take the theme to a deeper level, comprehending the fragility of our planetary environment. These core properties or deep underlying ordering structures of the exhibit can create influence and resonance within the human psyche, offering the visitor an experience full of meaning, satisfaction

and possibility. And, it meets each visitor wherever they happen to be on their identity journey.

Yet, regardless of people's individual perceptions, there is an archetype, an ancient blueprint, which is *wolf* and not *elephant*. Also independent of individual perception, specific underlying repetitive principles in the relationship between wolves and humans do exist. Down through history, wolves and humans have been connected in very particular ways as the exhibit title indicates. We have coexisted, competed and have been in conflict with wolves.

Museum exhibition meets individual experience

The Exhibit Pattern Analysis approach asserts that the more related and consistent the deep underlying patterns of the exhibition are to the image, theme or story it represents, the more powerful the resonance with the visitor. A powerful resonance not only captures the attention of visitors, but it bewitches them, bringing visitors into its orbit. Like a great book, you become caught up, entranced, and absorbed into the world of the story. The field of physics has a term for this phenomenon. It is called entrainment and can be defined as "the process whereby two connected oscillating [fluctuating] systems [exhibit and visitor]...fall into synchrony." Entrainment results from processes that are called self-organizing. (Collier 2000). Conversely, the less consistent the various exhibit elements are to the image, theme or story, the lesser the degree of entrainment with the visitor and therefore the less possibility for meaningful interaction. Remember

that each part of an exhibit element affects the invariable nature of the exhibition. It either adds to it or subtracts from it. All parts are not just component parts but are intensifiers related to the dominant archetypal expression.

With that said, visitors' personal associations or subjective thoughts and feelings are extremely important to consider. After all, visitors have always given personal meaning to exhibitions. They have always made their own interpretations. Exhibit Pattern Analysis contends that when visitors are compelled by a commanding archetypal resonance with the particular museum exhibition, their own personal experiences, associations and reflections not only come forth but become much clearer against the backdrop of such powerful archetypal expression. This condition is the prerequisite for resonance and clarity. Visitors are consciously or unconsciously drawn to the exhibit because its message or meaning is consistent, strong and clear. Archetypes tell a truth, they are "nature's constants" (von Franz 1996) and remind us of our temporality, limited perspectives and place in evolution, of the nobility and humility of being an irreplaceable link in the chain of eternity. The clarity offered by an exhibit is analogous to an archetypal mirror of sorts. Any inconsistencies in the mirror – such as scratches, dirt, or moisture – will cloud a person's reflection. The clearer the mirror is, the clearer the reflection. The more congruent the exhibit is with its archetypal dominant, the more its visitors may become aware of their unique relationship (alignment) to the archetype. On the other hand, anything that detracts from

the clarity of the exhibition's message will dilute resonance and clarity for visitors.

Museum exhibitions as a meaning-making opportunity
Applying the principles of Exhibit Pattern Analysis, the museum design and/or development team can lay the groundwork for an interchange between exhibition and visitor. This juxtaposition between the museum exhibition that resonates and the visitor with his or her personal experiences, associations and reflections (the subjective) serves as the visitor's entry point for interaction with the exhibition. The relationship has been created. Access to the message has been made. One has entered the tone of the exhibit and has become entranced. The potential for a meaningful experience is set. Arthur Ganson, a renowned kinetic sculptor, beautifully describes this concept when he says, "...the work [image] exists on a kind of edge between clarity and ambiguity and if the conditions are right, the work can lead someone out into a field... [where personal construction exists]." (Ganson 2005). When the exhibit resonates with the visitor, the outcome is a meaning-making opportunity.

This interactional field allows the viewer opportunities to gain a deeper understanding of his or her personal alignment and experience with the archetype on any number of levels. Perhaps the viewer will experience an insight, a change of perspective, a specific memory or a great sense of appreciation for what is being expressed. Even a clear yet negative experience has value for meaning-making. For instance, the

image of a wolf might conjure up negative thoughts, feelings and perceptions in a person's mind depending upon the individual's stories, personal experience and knowledge of wolves. Yet, the archetypal expression of *wolf* in an exhibition offers a safe and engaging way to interact and experiment with negative as well as positive thoughts, feelings and perceptions. It allows the visitor to inquire, investigate, and experiment with new perspectives about wolves and their relationship to humans.

Outcomes: a kinetic sculpture, Machine with Chair

To illustrate how the application of an Exhibit Pattern Analysis can powerfully enhance an already excellent sculptural exhibit, we will describe and discuss an incredible piece of work titled, *Machine with Chair* by the well-known kinetic sculptor, Arthur Ganson. Words can say only so much; therefore to actually experience the work, visit www.exhibitsmatter.com/chair.html.

Ganson's mechanical sculptures are in motion and often integrate human qualities in the space and form of machines and nature in a whimsical way. Visualize different sizes of round, mechanical metal gears that have an almost upright human shape but are taller in height. One gear, resembling an elbow, has a long arm-like appendage that moves up and down. Now, imagine this machine in motion, moving laterally down a track. As it moves in a slow, steady even pace, it approaches a bentwood chair obstructing its path. What will happen? The viewer waits to see. Slowly but surely,

the appendage slips into a fixed part behind the seat of the chair and securely picks it up. It brings the chair overhead in an arc-like fashion and places it down gently on the other side of its path and continues on its way. Other things are happening simultaneously. Light and shadow play their part with patterns on the wall behind the sculpture. The viewer notices the different colors, textures, shapes, and sizes of the component parts of the machine as well as the simple clean lines of the bentwood chair. While all this is taking place, a beautiful piece of music accompanies the work.

Exhibit Pattern Analysis of the sculpture

The purpose of the brief discussion that follows is to give the reader an overview of how the exhibit pattern analyst might consult on a design project. It highlights the essence of the analysis without getting enmeshed in the specific details.

What is the dominant theme being expressed? As mentioned earlier, exhibitions are expressions of archetypes. So, too, *Machine with Chair* is an image, an archetypal expression of something. After reading and examining the image patterns, we found the dominant archetype of the sculpture to be "human connection with the sensual".

What sensual patterns are being expressed?

Sight: Motion; dimension of light and shadow; graceful movement of the machine as it connects and picks up the chair; gentle display of the chair in motion; precise placement when the machine puts the chair down. The machine itself is sensual

with form, curves, angles, colors, texture, pace and dimension. The lines of the bentwood chair are clean, curved and simple.

Touch: While the visitor doesn't actually touch the sculpture, one notices all the textures (as mentioned above). Touch is suggested and demonstrated in the gentle, yet deliberate physical connection the machine has with the chair.

Sound: The musical piece accompanying *Machine with Chair* was indeed beautiful. Yet, the Exhibit Pattern Analysis revealed it to be not as powerfully congruent with the overall archetype as it might. Let's take a look at an example of a musical piece that is highly congruent with *Machine with Chair*.

First a few thoughts on how musical structure plays into the picture. We know from the field of harmonics that music also contains specific underlying physical structures or properties that can express highly specific images, themes or stories. Like museum exhibits, the innate structures of musical patterns can capture the archetypal expression of what they are representing. For example, wherever indigenous peoples have settled, peasant music has existed. Instruments of various types, including a person's mouth and voice, are often used to set a beat to weaving or working in the fields. In this case, the deep, underlying musical structures might serve to express the archetype of survival. Although the musical sounds and rhythms might be different in style depending upon the culture, time in history or task, it matches the pace of the work. For instance, the rhythm and pace might match the weaving shuttle or set the pace for picking cotton. It seems that certain frequencies or regularities capture or match specific activity.

It could be said that the expression of this type of musical structure entrains the peasant workers for the survival benefits of efficiency, cohesiveness, and conservation of energy.

Analysis recommendation

Bach's *Air on the G String* was found to be extremely coherent with the dominant archetype of the sculpture's major archetype: human connection with the sensual. One might say that Bach's *Air* is on the same frequency as *Machine with Chair*. The musical patterns match the precise movement and pace of *Machine with Chair*. The tempo and bass hit the senses (sound and touch from the standpoint that one feels the vibrations of the bass). There is musical build-up and anticipation as well as musical resolution that fit perfectly with the build-up, anticipation and resolution of the piece as the viewer watches the journey. The underlying musical structures augment and amplify the work, bringing forth the sensual. This synergistic phenomenon creates a powerful resonance that pulls – entrains – the visitor into the orbit of human connection with the sensual. The underlying structures of both the sculpture and Bach's *Air* are timeless.

Chia Han-Leon asks in his article, *To Bach is to be Human: a 250th Anniversary Tribute to Johann Sebastian Bach* (Han-Leon, 2001) "Is there nothing more than a beautiful melody?" He goes on to say:

> *Yes, perhaps it is nothing more – but that is a key to Bach's universality of appeal – there is a nothingness to the connections that surround and attach the Air to our earthly world. It is so*

detached, in a sense, from its social environment that it becomes very difficult to place chronologically... I for one am unable to place the 'time' of this piece. It is timeless.

Listening to Bach is like watching energy pass from gear to gear in a complicated – but perfectly aligned and synchronized individual parts – machine. Machine turned to art. And somewhere in between – because humans err – art to humanity. (Han-Leon, 2001)

Like Bach's music, *Machine with Chair* is machine turned to art. Without any music, *Machine with Chair* is highly coherent. It entrains and allows the visitor to enter archetypal domain of human connection to the sensual. The original music, according to Exhibit Pattern Analysis, actually detracts from the work. Accompany it with Bach's *Air* and *Machine with Chair* becomes an extraordinary piece of work. The deep structure, the underlying patterns of both sculpture and Bach's *Air* are a congruent archetypal match. The amplified resonance by such synergy is striking and extremely powerful. The deep, underlying structures of both the sculpture and Bach's *Air* are timeless. *Machine with Chair* truly resonates and seduces the visitor. Imagine the possibilities for collective and personal meaning-making to occur.

Summary

This essay gives the reader an overview of a new methodology called Exhibit Pattern Analysis that seeks to intensify the museum exhibition design process. The approach draws on

principles based on archetypal field theory. The aim of Exhibit Pattern Analysis is to find ways to present an exhibition that can actively draw visitors into an immediate and strong resonance with the image, theme or story that the exhibition represents. A strong resonance increases the likelihood for the visitor to gain access to the exhibition's message on multiple levels. This type of affinity, coupled with a creative design team, makes for an environment ripe for novelty and meaning to take place. The desired outcome is the opportunity for visitors to experience and explore those ancient yet ever-present questions relating to man's individual and collective search for meaning.

The application of Exhibit Pattern Analysis involves identifying, translating, and analyzing archetypal patterns from the inception of the exhibit idea and continues throughout the design process. The methodology seeks to detect patterns that dilute, detract and are dissonant with the exhibit's core concept. Interestingly, even outstanding exhibits, such as *Machine with Chair*, may display subtle patterns that are inconsistent with its archetypal theme. The new sciences inform us that even subtle changes introduced into a system can significantly influence it (Abraham, 1990). The old adage – an ounce of prevention is worth a pound of cure – reminds us that it is well worth applying exhibit pattern analysis at the beginning of a design project, rather than correcting misalignments after-the-fact, which are always more difficult and costly to change. The Exhibit Pattern Analysis approach offers the museum exhibit design

team a highly refined lens that can evaluate the degree of archetypal pattern coherence that the exhibition holds. It saves time, energy and resources because it clearly defines an optical center for the vision of the design team as they plan how visitors will enter and become entranced with the meaning of the art.

References

Bohm, David 1980 *Wholeness and the Implicate Order* London & NY: Routledge.

Conforti, Michael 2003. *Field, Form and Fate* (pg 18) Louisiana: Spring Journal, Inc.

Damasio, Antonio 2005 *Descartes' Error* US: Penguin Group.

Gombrich, E. H. 1984 *The Sense of Order* London: Phaidon Press Limited.

Ganson, Arthur. E-mail conversation with Arthur Ganson, 2005.

Ganson, Arthur. *Machine with Chair* http://www.arthurganson. com/pages/Sculptures.html

Han-Leon, Chia 2001 *To Bach is to be Human* pg 3-4, retrieved December 12, 2005 from http://www.inkpot.com/classical/ bach.html.

Jung, C.G. (Author), Adler, Gerhard (Translator), Hull, R.F.C. (Translator) (Paperback - Aug 1, 1981) *The Archetypes and The Collective Unconscious* (Collected Works of C.G. Jung Vol.9 Part 1) (Paperback)

Kalagher, Jane. Audio/video clip of Machine with Chair by Arthur Ganson. http://www.exhibitsmatter.com/chair. html

McLean Kathleen, and Catherine McEver, eds. 2004 *Are We There Yet? Conversations about Best Practices in Science Exhibition Development* (pg 47). San Francisco: Exploratorium.

Portmann, Adolph 1964 *New Paths in Biology* New York: Harper & Row Publishers.

Ramanchandran, VS. Added to website 2008 R Ramachandran: *Aesthetic Universals and the Neurology of Hindu Art.* Guest speaker and lecture filmed on: http://www.superaflam.com/video/7ZTvHqM-_jE/Aesthetic-Universals-and-the-Neurology-of-Hindu-Art-Vilayanur-S-Ramachandran.html

Rounds, Jay 2004. Strategies for the Curiosity-Driven Museum Visitor. *Curator* 47:4

Rounds, Jay 2006. Doing Identity Work in Museums. *Curator* 49:2.

Von Franz, Marie-Louise 1996. *The Interpretation of Fairy Tales* Boston & London: Shambhala.

Webster's New Universal Unabridged Dictionary 1996 Random House Publishing, Inc., Barnes & Noble, Inc. (pg 109).

Guests are Our Heroes: Redefining Immersion in First-Person History Programs

AILITHIR MCGILL & ADAM BOUSE

Conner Prairie Interactive History Park

For close to a decade, Conner Prairie Interactive History Park in Fishers, Indiana, USA has been exploring bold new ways to get guests excited about history. Since 1974, Conner Prairie has used first-person historical interpretation in immersive environments to connect visitors to Indiana's past. Most recently, the organization has refined its definition of immersion to include a heavy emphasis on giving guests the opportunity to role-play. These role-play opportunities range from fairly minimal participation in a crowd, up to substantial participation as a central player in an event. This essay seeks to outline the evolution of Conner Prairie's latest definition of immersion, to describe specific applications of this new approach, and to share anecdotal evidence of what the results of this approach appear to be. Our hope is that by sharing some of Conner Prairie's insights, we can inspire peers in the field of guest engagement to find new and better ways to create outstanding guest experiences.

Currently, Conner Prairie Interactive History Park' consists of five major historic areas, as well as other notable daily activities. While most of this essay will focus on its first-person interpretive programming, it is worth describing the programming featured in each area to illustrate the scope of an average visit to Conner Prairie. *1836 Prairietown* has traditionally been seen as the centerpiece of the park. It is an immersive village, made up of composite families presented through first-person interpretation that represent the types of people and activities common to Hoosier communities during the early stages of westward expansion. The *Conner Homestead*

is the area where guests get to explore the historic home of William Conner (a relatively unknown early American settler), see and participate in textile activities, and dip candles. This area also features the always-popular *Animal Encounters* barn, where guests get to meet, learn about, and groom historic breeds of farm animals. *1816 Lenape Indian Camp* is a recreated fur trading camp, where both first- and third-person facilitators share stories and activities characteristic of the first year of Indiana's statehood. *1886 Liberty Corner* is an immersive family farm, where guests are encouraged to take on the role of a farmhand and help the family with their daily chores. The *1859 Balloon Voyage* is our newest experience area, where guests are introduced to the story of the first successful airmail delivery in the United States and have the opportunity to take their own tethered balloon flight. Other experiences at Conner Prairie include daily Museum Theater performances that give guests the chance to rest, while being emotionally engaged in various stories. Also, we feature several opportunities in our Welcome Center, including daily children's crafts in *Craft Corner*; *Discovery Station*, our historically-themed indoor play space; and (as of 2010) *The Science Lab*, featuring activities that explore the science of the past.

Our regular operating season occurs between the beginning of April and the end of October, with special programs available throughout the winter. The Welcome Center is open to guests year-round. The park encompasses a total of nearly 800 wooded acres, 200 of which compose the core of the park grounds and welcome approximately 300,000

visitors each year – nearly 100,000 general admission guests, over 40,000 school children, and close to 10,000 visitors who come as part of group sales. The remaining 150,000 or so guests come to see the Indianapolis Symphony Orchestra perform at our outdoor amphitheater during the ISO's summer concert series. Conner Prairie's $9,000,000 annual operating budget is devoted to offering a wide range of outstanding experiences all designed to inspire guests' curiosity and foster their learning about Indiana's past. Since 2005, the park has seen a steady increase in attendance, membership, and financial support.

The organization's track record of success serves as some evidence for the fact that Conner Prairie has developed a reputation for offering unique and enjoyable ways to substantially participate in the overall experience. However, this was not always the case. For more than two decades, Conner Prairie built its reputation on strict historical authenticity. Guests would come to Conner Prairie to witness activities in the 1836 village, and the expectation was that visitors would watch and learn. Programming was built on the idea that the most effective way to educate the public was for the museum to be a central authority, selecting the key facts necessary to understand larger historical concepts and presenting those facts in monologues presented by rigorously-trained historical interpreters. In this paradigm, guest experience was secondary to historical accuracy, as it applied to the interpreters' experiences. By that, I mean that interpreters passionately strove to reenact daily life in the 1830s as rigidly as possible. Visitors, therefore, receded into the background,

becoming voyeurs in a foreign community. Interpreters were allowed to use artifacts – both reproduction and originals from the teaching collection – but were instructed to protect those artifacts from visitors, who were encouraged to look but not touch. In this approach, interpreters were evaluated upon their ability to share the designated number of facts assigned to each post with each group of guests who wandered through. Although Conner Prairie has moved away from this approach, it was widely accepted at the time and initiated a dedication to using environmental immersion as a way to engage guests.

Change was spurred by the results of learning studies that had been undertaken between 1999 and 2002, in which guests' visits were recorded and their conversations analyzed. These discussions revealed that guests greatly struggled with the structured monologue format. Not only did they feel as though they were intruders into this unusual community, but they also did not feel comfortable discussing their reactions, questions, and interests with the interpreters or even with each other in the presence of the interpreters. This forced them to restrict their conversation (an element that is a critical part of successful free-choice learning[2]) to the time in between staffed locations, when they had no access to additional information. These studies reveal many situations in which parents, whose children looked to them to make sense of these complex historical experiences, misinterpreted the information they had heard, sometimes fabricating wild explanations, other times drawing simple, but inaccurate, assumptions, and, on occasion, admitting frustrated defeat.

We also captured examples of groups coming up with great questions after they left one post that, if answered, might have sparked a whole new interest in history. However, as soon as these groups entered the next post, they were bombarded with a new character's obligatory monologue, and their questions were either lost or pushed aside in favor of the new information at their fingertips.

This evidence convinced key leaders that if Conner Prairie were to remain relevant, let alone grow, the institution would have to adopt a new, progressive approach – one that welcomed guests into the experiences and encouraged them to be curious, explore, and have fun while making sense of their encounters with the past. In 2003, we unrolled our *Opening Doors Initiative*, an institution-wide mandate to put guests at the center of our daily operations. This meant that guests would no longer be encouraged to act as anachronistic voyeurs in this historic world, meant to see and not necessarily be heard. They dubbed this approach *Opening Doors* to emphasize the importance of hospitality, comfort and engagement, or personal connection to the subject matter. Hands-on activities, directed questioning, and conversation became the new tools for success. Teams of interpreters were organized to brainstorm and develop participatory activities and approaches, and this effort proved to empower the staff in the process of creating this new brand of Conner Prairie experiences. The next learning study we conducted in 2004, indicated that our changes were encouraging guests to stay longer and foster a broader understanding of and appreciation

for their historic adventures.[3] Of course, as effective as these efforts have proven to be, we began to see key opportunities to take immersion even farther, allowing guests to take a more integral role in their experiences.

Some of the first anecdotal evidence to shape our post-*Opening Doors* efforts revealed that guests sometimes became fatigued with the active participation required in the historic areas. While they enjoyed the games, hands-on activities, and conversations they had with staff, they often needed a break to rest and reflect. Therefore, we started exploring ways to include theatrical performances into daily events.[4] Once we started offering performances in designated theatrical spaces using formalized and professional museum theater techniques, we received requests from guests to incorporate similar vignettes into Prairietown and Liberty Corner experiences. Up until this point, interpreters in Prairietown had little-to-no theatrical training, and equally little direction. When characters interacted in Prairietown, it was unrehearsed, and often failed because, while interpreters were well-trained to facilitate hands-on activities within the historic setting, they did not have any guidance on how to improvise character-driven interactions that would be engaging and entertaining for guests. In developing a strategy to tackle this problematic feature of daily programming, we decided to use our highlight programs as a vector for training staff to develop interactive improvisational skills.

The first program to receive our scrutiny was our 1836 Wedding, commonly referred to as *The McClure Wedding*. This

was a highlight program, meaning that it was a special event that illuminated a particular aspect of life in the past and should serve as a high point in guests' visits. This particular highlight program was an annual favorite among both staff and guests because of its celebratory elements. In its traditional form, The McClure Wedding featured the union of Ada Noreen McClure, the daughter of Prairietown's carpenter, to James Cox, a young farmer from outside of town. During the program, guests could watch and occasionally help the two families prepare for the ceremony. The event also featured a large feast, made up of food prepared by interpreters throughout town, and all the interpreters connected with the wedding enjoyed sitting together and eating the rich, historically accurate food, while guests watched. After the very short and simple ceremony, guests were invited to participate in period dances, after which, the newly-wed couple would tour the town and thank other characters for their contributions to the wedding. This program was cute and fun, but slightly awkward for guests because it was unclear as to just how they should interact with the characters. What is more, since the characters' relationships and motivations had never been formally fleshed out or rehearsed, interaction among the characters felt stilted and shallow, emphasizing the pretence of the interactions, rather than lessening it. Guests were pushed farther away from the past because they could not interact with these characters naturally. There was still a barrier between the guests and true engagement with the past, and this is what made The McClure Wedding a

perfect subject for our theatrical experimentation.

As we thought through how to improve guests' experiences at the McClure wedding, we looked to other theatrical venues for ideas. We soon ran across efforts undertaken by various improvisational groups throughout the United States that shared certain features with our first-person programming. For one thing, programs such as *Tina and Tony's Wedding*, an improvised production featured at Chicago's Second City, put guests in the middle of the action – actors would mingle amongst guests in the midst of immersive sets. The key difference is that the audience in *Tina and Tony's Wedding* had a role to play – they were guests to the wedding, just like many of the actors, and were prompted to participate in small talk with most of the characters throughout the performance. This chitchat was designed to help orient the audience to the story, relationships, and underlying tensions. The audience ate the meal at the reception right along with the actors, had the opportunity to offer toasts, and could cavort alongside the boisterous bridesmaids and groomsmen. As we studied this highly successful piece, we realized that this could be a perfect model for the Prairietown wedding. If we could coach staff to make some of the same assumptions that the actors made with their audience, while providing some key interactive props like food and drink, most of the major barriers preventing guests from engaging fully with the past would be gone. We identified three key changes that we needed to make in our highlight programs to help achieve this new level of equality for guests; we needed to identify

some central conflicts or tensions to drive action, we needed to flesh out our character's relationships and motivations, and we needed to deliberately promote all of the ways that guests could participate in the event.

So, we began looking for ways to apply these changes to the wedding program, which we renamed *James and Ada's Wedding*. We rewrote the training materials to focus on the relationships between the characters and how those relationships could drive conflict, humor, or tenderness. For example, these descriptions included information about the groom, James Cox, Jr., and his relationship with his father. Whereas, before, these two characters were deemed ancillary to the program – only necessary as *groom* and *father of the groom* and not as facilitators of guest activities – we realized that tension between these characters could spark engaging and natural conversations between characters and guests. If James Cox Sr. was perceived as overbearing and obnoxious, it would give James Cox, Jr. the opportunity to reveal to guests that he hoped to move his new bride West as soon as possible. This tension could, in turn, allow Ada's stepmother to share her deep sadness at having to say goodbye to Ada, who had become her closest friend over the course of her own marriage, which had been more about convenience than love. In turn, Mr. McClure could admit that he had grown to deeply respect his second wife and that he, too, would miss his only daughter. And so on. Once we started fleshing out the possibilities, we realized that we had a gold mine of archetypical relationships and tensions that could make these characters feel real and

give them natural conversation starters with guests.

The training materials also laid out expectations for what types of activities each character would be expected to facilitate. For example, the groom's mother would need to be the overall coordinator, making sure that everyone was in the right place at the right time, and would oversee the distribution of wedding cake to guests after the ceremony. The Justice of the Peace, on the other hand, would enlist guests in helping him collect vital information from the bride and groom and then would have guests help him rehearse the proceedings.[5] The bride's friends and her brother would be in charge of facilitating ongoing games, spreading general gossip about the couple, and causing mischief, all in an effort to be continually orienting guests to who was who and what this event was all about. Once staff members were given the opportunity to talk through their roles, relationships, and duties in quick rehearsals leading up to the program, they found new and exciting opportunities to approach guest engagement.

Additionally, once we started looking, we realized that we had a wealth of opportunities to get visitors involved as guests to the wedding in natural and comfortable ways. Not only were there multiple set-up and clean-up activities throughout the event that interpreters needed help with, but different types of games could be taken up at any moment. Additionally, each of the characters was able to seek advice from guests, and could solicit guests' help delivering messages, planning mischief, or preparing food and other contributions to the ceremony. In our short rehearsals with interpreters,

we facilitated discussion about how to use these activities strategically. We soon realized that it was important to have several opportunities for participation available at the same time throughout the event, so that each guest had higher odds of finding an activity that really appealed to their personal interests and experiences. Also, we invested in ten gallons of lemonade and small paper cups, and asked our kitchen staff to help us prepare large versions of the period cake recipe in our commercial kitchen so that everyone could have a slice. Not surprisingly, the presence of this food encouraged guests to linger until the cake was sliced, but what did surprise us was just how amazed and delighted guests were to partake in these authentic refreshments.

Of course, guests' reactions to food were not the only anecdotal evidence we have been able to collect. In this new iteration of an old favorite, we have found that a larger percentage of guests seems to become quickly comfortable with the idea of taking on even a small role. Because they are immediately welcomed into the party as friends and guests to this happy event, they seem to feel more confident in carrying on natural conversations with the characters. Since the characters also felt confident in their relationships and responsibilities at the event, they were able to reward guests with fun and natural conversation and activities that helped build guests' confidence even further. As the event builds, so does guests' confidence and their willingness to participate. After enough positive interactions with interpreters, we have found that guests are willing to take

on increasingly specific tasks. Guests go from joining in on cheers and applause, to helping set the table, to eating cake, to occasionally even offering toasts and advice to the couple. Clearly, guests' comfort with participation is also related to many other factors, but anecdotal evidence seems to indicate that repeated positive and natural reinforcement within the experience may increase their likelihood to participate in the immersive environment.

Additionally, we found that the comfortable atmosphere seems to foster discussions comparing the present to the past. While guests might at first feel that the differences between 1836 and today are glaring, this role-playing approach helps to emphasize some of the ways that life has remained the same. The vast majority of guests have some previous experience with weddings – even most children have either been to a wedding or have seen one portrayed on television. Immediately, they can identify and latch onto the elements of the 1836 wedding that they recognize – perhaps the nervous groom, the blushing bride, the food and sense of celebration, or the general interest in sharing advice and stories. We have found that after being immersed in these comfortable and familiar elements, guests begin to easily discuss their personal wedding experiences with interpreters. It is in those moments that guests really begin to synthesize understanding – when a female guest describes her own wedding dress, the interpreter might ask if she has seen the beautiful new dress Ada's stepmother and mother-in-law made for her. After a moment of processing, that female guest may acknowledge

that she has seen the dress and ask about why it is not white, which can lead a skilled interpreter to point out that white dresses, although very pretty, are not very practical for the wives of farmers. Here, the fact that white wedding dresses were not yet an established tradition can be shared in a way that truly resonates with the guest. We have witnessed this sort of interaction happening over and over again during this type of program and are very excited by the implication.

In fact, this approach to the 1836 wedding has been so promising that we have applied the same approach to other highlight programs. It was obvious that this approach would also work with our *1886 Liberty Corner* wedding program, and we soon began fleshing out the conflict, character motivations, and opportunities for guest participation. The 1886 wedding, now referred to as *A Farm Wedding*, gave us a few new opportunities for guests. For one thing, by 1886, it was common for a bride to carry a bouquet, so guests could help pick and arrange beautiful flowers from the garden for the bride. Additionally, wedding gifts had become more common, and interpreters could engage guests in thinking up appropriate trinkets, even searching through catalogues to find just the right thing. Finally, one major augmentation to guest role-play in the 1886 wedding developed by accident. A deficit in staffing led to a vacancy – we had no one who could portray the Best Man! So, the staff decided to see if they could find a guest who was willing to stand up with the groom, and by the time the wedding ceremony rolled around, they had found two very eager and delighted young men to fill the role.

These two boys were regulars – members who came with their family several times every season – and they were thrilled to have the honor of participating so fundamentally in this important and fun event.

When a coworker from another department at Conner Prairie mentioned that he had always wanted to see guests participate in an election in Prairietown, managers immediately started building a program around his idea. Within weeks, managers had outlined a new program called *Fence Inspector Elections*, and had even partnered with a local University to have students flesh out the program. The final result is an event where an election for an important local office (Fence Inspector[6]) is held in Prairietown. Throughout the morning, interpreters look for natural opportunities to talk about the election with guests, orienting them to the situation. Three local residents are running in the election and deliver short speeches elucidating their platforms, which happen to also represent the major political movements of 1836. Once those speeches are done, the Inspector of the Polls turns to the audience and inquires whether or not any of the members of the crowd (the guests) also wish to run. Each time we have run this program, we have had at least one guest step forward and declare his or her candidacy. Everyone, then, is given the chance to vote, and after a little while, the votes are counted and a winner is declared. It is important to note that each time we have had a guest run in the election, he or she has won by a landslide, garnering the vast majority of guests' votes. It is also interesting that all guests expect and

appreciate getting to participate in the voting process, even while acknowledging that many of them would not be allowed to vote in a real 1836 election. While staff still struggle with the best way to deal with this anachronism, the majority of guests seem to have no problem with, or aversion to, it.

The successes from these programs worked as a stimulant for managers and staff alike. When we had started talking about changing the 1836 wedding programming, interpreters voiced reticence and concern. Many of them did not feel that there was anything wrong with the program as it had previously existed, and some were concerned that our efforts to flesh out the characters could be perceived as disrespectful. They were concerned that the characters would come across as stereotypical and lampooned, rather than as earnest and believable. However, once they saw the effect our artful approach could have on guests, their moods started to change and they began showing enthusiasm for the new approach. Managers, too, had been concerned about how this approach might fit into daily operations, but once they witnessed its effects on guests and staff, they were immediately inspired to apply these principles to daily interpretation.

Soon, we moved beyond applying these techniques only to highlight programs. Daily interpretation in both *Prairietown* and *Liberty Corner* began to shift to incorporate opportunities for guests to be a part of the story. Instead of guests being welcomed into Prairietown homes as museum guests who are expected to yield to the pretence of being in the past, we now want guests to feel welcomed to enter as equal players

in the story, if they care to. We now encourage the staff to engage guests in conversations that give them a role to play – the blacksmith's wife might comment that you must be part of that new family that just moved onto a nearby farm, or ask if you are stopping to rest and have your wagon repaired as you continue your journey to the western frontier. When guests enter Mr. Whitaker's store, he will drop hints about what the best deals are in the shop, and will be willing and able to haggle over prices and share the latest town gossip, all while finding ways to cheerfully and warmly accept whatever responses guests offer in return. This type of guided role-playing led us to develop our *Farmhands* program – the core experience in our *1886 Liberty Corner* area – in which guests get to become helpers on the family farm, participating in a wide variety of daily chores and activities alongside the interpreters.

In each of these examples of Conner Prairie's current brand of immersion, guests are given natural and comfortable opportunities to be a part of the event in order to foster learning and long-lasting memories. While this approach has been most directly applied to first-person interpretive environments, it is also beginning to be applied to other existing programs, as well as becoming a standard part of new experience development. For example, a key element of Conner Prairie's most recent experience, *1859 Balloon Voyage*, is the opportunity to experience a balloon flight, just like Indiana's early aeronauts. One of the hopes for this experience is that it helps guests replicate the sense of wonder and

excitement that both the early balloon pilots and spectators must have felt when witnessing this historic event.

And this brings us to what is perhaps the most intriguing and exciting part of this programmatic evolution. Conner Prairie began its efforts in immersive environments by focusing on reenacting authentic behaviors for visitors to see. We then moved forward, thanks to a new understanding of the connection between participatory engagement and learning, and began offering authentic historic activities for guests to do. Most recently, we have built on this strong foundation and have opened up different kinds of authentic roles for guests to actually be. And through the process of taking on an authentic role, whether as minor or major player, we suspect that guests are engaging emotionally with the past in ways that create deep, personal, and long-lasting connections and memories. This creates an entirely new dynamic for our guests to experience, a new way to understand the past – emotional authenticity. They don't just get a sense for how things used to be, but for how things used to feel. And through this connection, guests come to a clearer understanding of just how much we in the present have in common with the people of the past.

More work needs to be done to systematically document the results of Conner Prairie's latest efforts to engage guests with history. Another learning study could help illuminate how guest behaviors and discussions have continued to change. Other broad studies that could compare the level of recall and types of memories guests have from their Conner

Prairie experience with experiences at other historical venues could also help illuminate the true impact our programs have. However, even without rigorous data, we hope that our current assumptions ring true with our colleagues throughout the museum and history fields. By sharing our experiences, intentions, and anecdotal results, we hope to inspire our peers at other institutions to identify new and deeper ways to welcome guests into the core of their programs. Perhaps we will find that by casting the people who come to our institutions not as visitors or as guests, but as heroes, museums and history organizations can themselves begin to play a new role in the twenty-first century.

Notes

1 Conner Prairie adopted the title of "Interactive History Park" in 2009 after many months of intense discussion, debate, and research. Up until that point, we referred to ourselves as a museum.

2 The features of informal learning in museums and other cultural organizations have been discussed by many authors, but Conner Prairie has particularly relied on the works of Falk & Deirking and Leinhardt & Knutson. Listening in on Museum Conversations by Leinhardt & Knutson uses excerpts from guest conversations, including some from Conner Prairie, to illustrate the important role that dialogue plays in informal learning environments. Learning from Museums by Falk & Dierking explores the elements critical to fostering successful and long-lasting learning in museum settings.

3 These results are discussed in an article called "The Culture of Empowerment: Driving and Sustaining Change at Conner Prairie" written by Ken Bubp and Dr. Mary Theresa Seig in Volume 51, issue 2 of Curator magazine.

4 This effort to add professionalized museum theater experiences at Conner Prairie is described in a forthcoming article by Ailithir McGill to be published by the University of Alabama Press in an edition entitled Enacting History, edited by Scott Magelssen and Rhona Justice-Malloy.

5 This role opened up all sorts of comedic opportunities, including allowing the Justice of the Peace develop the habit of constantly getting the bride's name wrong.

6 Fence Inspector, or Fence Viewer, was a local position that helped to mediate property disputes.

A Testing Process: Urban Evolution
A Young People's Project

TOM PINE COFFIN

Audience Development Officer

Culture, Tourism and Venues Service

Stockport Metropolitan Borough Council

It started off as an idea that sort of morphed into three or four different concepts. The whole thing was designed by young people to raise issues that they thought were important to them, that they were thinking about... I'm sure that everyone in the group will remember this for the rest of their lives. You speak to a lot of older people – as we did, interviewing them – and they do have a lot of bad impressions of young people, and I think this just is evidence that you can really get involved in projects, you can really do things that will change people's opinions. – Brent.

In September 2008, staff at Stockport Metropolitan Council's then Arts, Culture and Visitor Attractions Service began to consult with potential volunteers in youth centre settings about the possible characteristics of a heritage project that they felt they would like to get involved in. This would lead to summer activities and an exhibition, but everything else was up for negotiation.

The context for Urban Evolution
In the previous eighteen months, staff had collaborated with teenagers and youth workers on several short-term projects. These focused on less traditional, socially relevant heritage themes, and particularly on the use of film making and animation. Subjects covered included alcohol, drugs, and domestic violence, and the content proved popular, with prospective partners making enquiries on a regular basis.

These projects, though undoubtedly successful in

engaging challenging young people effectively, were – like many such initiatives – partly expedient, in the sense that they had been tailored quickly around the availability of funding and partnerships brokered at relatively short notice. Predictably, these projects had raised several issues, ranging from challenging behaviour to contrasting organisational priorities in the context of partnership. At the same time, staff had questioned their own confidence as museum professionals in keeping young people interested, but were ultimately emboldened and encouraged by the experience.

The service's Audience Development Team had long nurtured a conviction about the potential for a more ambitious project that would make greater demands of staff and participants alike. During early 2008, the service was in the early stages of renewing a wide-ranging event and exhibition planning process that brought together key staff from across a geographically fragmented service.

The background to this process – a recognised need for more effective co-ordination across the board – will be familiar to many working in the sector, and it cannot be overemphasised that the access to such a forum was crucial to the early development of what would become an adventurous and challenging initiative. But at this stage, we simply proposed to build upon our recent progress by developing an exhibition and summer activities programme to engage young people more effectively in general.

The in-principle buy-in achieved in a single meeting delivered the necessary goodwill to develop some traction.

Such positivity amongst staff mattered because few in the service could boast long-term experience of engaging young people in the informal learning context. Since the process promised to be daunting for many (and perhaps all) staff, the opportunity to inspire and reassure via a recognised forum was key. This is not to negate the importance of negotiation with colleagues. Yet it would be reasonable to suggest that the main difference between the Audience Development Team as proposers and the staff at large was, more than anything, a preparedness to jump in at the deep end – with many practical anxieties forestalled until a later stage.

Having established the principle, staff commenced a consultation exercise with some (but by no means all) of the tools required to enact a long programme of engagement from start to finish. Helpful in the process were several tools offered by the Heritage Lottery Fund's advice for grant applicants – particularly the Heritage Tree exercise[1] – and these provided valuable guidance in exploring young people's own associations with the idea of heritage.

By now, staff were envisaging a project that was becoming more ambitious by the day. A strong application would enable a levering-in of external funding. This in turn would develop the service's capacity to deliver exhibitions and projects by enabling the acquisition of new display hardware and the development of new forms of interpretation. Above all, these plans would dovetail with young people's stated aspirations and an externally-funded project would far exceed core capacity to meet them – as long

as these aspirations could be identified.

An application to the Heritage Lottery Fund's Young Roots programme was projected for early November 2008, with a funded project ready for initiation in early 2009. During the course of discussions with 100 young people in five Stockport youth centres, there crystallised a number of connections with the idea of heritage (and many illustrations of disconnection) that enabled the subsequent development of a better-tailored engagement process.

For example, it became clear that young people might well be interested in the "old stuff" found in museum collections, but equally that there were strong intergenerational barriers to embracing a sense of connectedness. Hence, in answer to the question, What have I inherited? (one we also asked subsequently of our volunteers), we gathered the following responses, in young people's own words:

Our volunteers answered: Art – Nanna; musical talent – can play instruments; football; slang (2); my dad's height, my mum's hair, my stunning looks; sport and brains;

Our consultees answered: grandma's necklace; teddies from pets; dragonfly bracelet from neighbour; picture of my dad on a football team; medal from great-grandad in the war; grandad's ring; watching County, and talking about County, with grandparents.

However: I feel remote from their history; not interested in my grandparent's story; boring in the past; not inherited anything, grandad doesn't talk about his life; they had Jesus as their role model.

A negotiated process

While staff were able to successfully gather a range of compelling evidence to demonstrate an appetite for the project, they were also now confronted with the challenge of converting 100 consultees into a quorum of dedicated young people keen to pursue the newly-crystallised objectives that had emerged from the process of negotiation.

Influenced by the experiences of three other museums' youth forums[2] it seemed clear that the project would require between eight and twelve willing young volunteers who would turn up consistently throughout the year. There was a strong feeling that the group would require external resources to back their ambitions sooner rather than later; this was the resource that would enable staff to convene, feed and water the group over an extended period of time. However, the Heritage Lottery Fund offered strong encouragement to convene the group prior to submitting the bid, rather than submitting any application on behalf of the consultees alone. At this stage, 31 had registered their solid interest.

Staff grew concerned that it would be difficult to initiate preparations for an ambitious project without mismanaging young people's expectations. It appeared that the inevitably contrived and time-sensitive process of developing a bid around specific criteria would be prohibitively unengaging for a challenging audience. In time, it would become clear that these expectations were at once well-founded while also an underestimation of the young people's capabilities. A recurring feature of consultation had been that young people

would be reluctant to become or stay involved in a process that relied too much on writing or any kind of work that was too much like school.

The project, provisionally entitled *Make it Live*, launched in January 2009. Initially involving fifteen young people, the group would grow to twenty-one before ultimately shrinking to a quorum of twelve towards its end (the reasons for which will be discussed). Throughout the project, the group would meet at least once a week with a regular session on a Tuesday evening. Specially tailored in-depth projects and trips to other museums were to be offered during holidays and at weekends, once funding had been secured.

More immediately, in the five weeks that followed, the project team strove to communicate the specific purpose of each session openly. As a means of establishing baseline evidence about the young people's views of museums, they were invited both to relate their feelings about museums generally, and to respond to an exhibition at Stockport Story Museum: a show marking the 125th anniversary of Stockport County Football Club. This had been relatively well-funded (from core resources) and had involved a greater-than-average degree of community input from fans' groups.

The tenor of the responses is well represented by the results of another Heritage Tree exercise using sticky notes. Responses, again, are presented in young people's own words, and arranged according to their own familiarity with museums:

I think museums are:

Yellow answers (never normally visit museums)
Boring
Fun if it's about war
[Need] more things which appeal to teenagers
Not what we want to see
Rubbish [maritime museum]
I like to be impressed by interesting information
I'd like more things to physically do.

Green answers (sometimes visit museums)
Hat Works is crap – don't visit
Hat Works is rubbish, hats are boring
Everyone looks very serious
Absolutely brilliant e.g. Science & Industry,
Toy museum
Cool, a lot to look at – very interesting
Rubbish, not a lot to look at
Science & Industry Museum is the only place I like

Orange answers (regularly visit museums)
Sometimes doesn't make people feel engaged with it
Free!! (a lot of the time)
Involve audience
Not enough
The workers can be snotty
White space (usually makes people nervous)
Place to learn about my heritage
Museums are usually dusty

Good, I like football museums
Can help give ideas in things it associates with
Too much text
Can challenge the mind
They look for a certain target audience
People say "Shhhhhhhhh!" if you chat
More interactivity.

Vital throughout this critiquing process was the generosity of
the museum's curator in exposing her own work to sometimes
unsympathetic scrutiny by unfamiliar young people. They,
after all, were largely unaware of the context and specific
challenges of the curator's role, particularly at such an
early stage. Her accommodation of young people's ideas in
negotiating issues that would usually be resolved quickly
and efficiently by an experienced professional were to remain
key throughout. Indeed, her openness was to underpin the
ultimate success of the project eleven months later.

Furthermore, members of the museum's curatorial staff
conducted handling sessions and tours of the stores in
order to identify the areas of strength and weakness in the
collections. Thus it was possible to garner a body of evidence
about where the service was already able to match the group's
interests (positively in a few places, as it turned out) and to
assess the significant scope for a contemporary collecting
element within the project.

A range of activities acceptable as consultation were
deployed, but these were cumulatively challenging to

our group when presented week-by-week as an in-depth process. Such activities ranged from brainstorming through discussion to mood-boarding, a more visual approach using cut-and-paste techniques. Early in this process, the staff's rapport with the group (and the group dynamic) lacked the maturity to throw up the kind of candid feedback that could be obtained in its later stages.

Still, predictable feedback did suggest that an over-reliance on writing (via flip-chart brainstorms and sticky notes) was a barrier, even if participants' negative comments on sandwiches were far more forthcoming! There were also several instances of challenging and boisterous behaviour, in some cases leading to sensitive "morning after" negotiations.

Certainly, the process of developing a bid as democratically as possible was successful in developing our evidence base for an application. Through direct user testimony, we were able to define with confidence what young people were seeking in terms of skills, knowledge and a meaningful experience. Through a rather laboured process based on consensus, the group also selected a number of heritage themes that they wished to address through the project. Two or three minutes later, they had devised a title, which stuck: *Urban Evolution: We Are Here.*

A democratic process had been valuable in yielding the thorough body of evidence that would guide the onward development of a project plan. But it had also been taxing and time consuming, representing many weeks' work. Moreover, staff did not feel confident at each stage of sustaining the group's

urban evolution interest. In effect, a trade-off had emerged between meaningful participation and enjoyable engagement; it was a tension that staff would continue to manage and readjust throughout the project, and whose consequences for efficient and engaging collaboration would sometimes be hard to gauge.

Awkwardness, however, was not always the dominant feature. For example, staff were able to harness the group's natural sense of irreverence in order to galvanise them. In identifying their target audience, the volunteers were asked to caricature a typical museum visitor by dressing up, and to record an imaginary visitors' book entry by the same user after experiencing a young people's exhibition. One entry read:

I never knew that Stockport youths were so intelligent!

The exhibition changed my view of young people because they are not as useless as I thought.

The best thing about it was that youth moves me mentally and physically upstairs!

Having worked through a number of different processes, the group finally agreed upon a Project Statement that defines in their own unique words what they hoped to achieve collectively. *Urban Evolution:*

Will explore heritage in themes such as (WHAT)

- Places
- Drugs
- Street crime
- Communicating with each other
- Inheritance

By (HOW):

- Presenting video evidence
- Creating atmosphere
- Putting yourself in someone else's shoes

And present it to an audience of (WHO):

- Older people who visit museums
- OAPs
- Journalists, police and politicians
- People of the same age as us.
- People who don't have much contact with young people
- Teachers
- Parents

So that they (WHY)

- Realise that young people aren't always to blame
- Improve awareness of different families and children
- So they don't stereotype young people
- To show young people can concentrate on a project and do a good job.

In submitting final proposals to the Heritage Lottery Fund, it was necessary to define carefully the added value that would be delivered with the help of extra funding; in other words to clarify which elements of an exhibition and activities programme could be core funded in the normal way, and to

elaborate upon the ways in which young people's decision making role could become more consequential thanks to additional resources.

At times this proved to be a messy process of differentiation, but our objectives were as follows:

- To extend and enhance at least eight existing opportunities for young people to volunteer and collaborate with professionals on the development of a museum exhibition that matches their stated ambitions.

- To empower young volunteers to explore and express their ideas about heritage more creatively using nontraditional means as identified in early development work, and developed through the course of the project.

- To enable young volunteers to share their learning about heritage with a wider audience of young people by devising a programme of activities tailored specifically to their peers.

- To enable young volunteers to share their learning about heritage with a wider audience of young people by devising a programme of activities tailored specifically to their peers

- To offer the young volunteers the chance to pilot new means of promotion and marketing that exceed the penetration of existing resources.

- To develop a legacy of skills, equipment and materials that can be used to sustain and support the involvement of young people in future.

A granular process

Thanks to the young people's contribution, the project was successful in obtaining £25,000 from the Heritage Lottery Fund. This sum would support the delivery and development of an enhanced exhibition and a more adventurous activities programme than would otherwise have been possible.

Pending a decision, staff had in fact pushed forward with project development over a three-month period. During this time, they concentrated on the activities programme, inviting the group to evaluate a series of hands-on activities that could be delivered in-house, and gathering their suggestions for improvement.

It was important for the group to differentiate their ideas according to what might be achieved with varying degrees of extra resourcing, or indeed with none. While this process was fundamentally a constructive one, it was difficult at times to ensure that the young people remained aware of the financial questions that might threaten their most ambitious ideas. Meanwhile, staff sweated over the outcome of the bid process and worried about the prospect of having to inform the volunteers of an unsuccessful result after so much hard work on their part.

In fact, when the group was informed of the positive outcome, it proved difficult for them to grasp the implications of what seemed a large sum of money. A memorable reaction ran, "Why would they want to give that much money to us?" Despite the promise of extra facilitation, of artists' involvement, and of new equipment and hardware, it was

challenging for the group to interpret numbers on paper as real, transformative potential.

In the weeks that followed, the group divided into three, each numbering between four and six. They knuckled down to discrete aspects of the newly-funded, enhanced project: exhibition development, activity development, and marketing and publicity. All three of these task teams were facilitated by at least one specialist – a curator, an informal learning practitioner, a marketing officer and a graphic designer. It was during this phase that the young people began to comment upon tangible, meaningful progress. According to Sol, there were now prospects of a genuinely exciting outcome:

> ...especially through the blueprints I saw before. They're something I wouldn't be able to have without this funding. I don't know how much would be possible without it. I think it would simply be rearranging a limited amount of what we already had. A new exhibition, it would maybe be a halfhearted attempt at having a go, but this proper exhibit is going to work, I think, thanks to the funding that we've received... the collections and the items, no, we wouldn't have had activities or any of this without funding.

These effects were unequivocally positive. Yet while some key aspects of the project plan were bearing fruit, other aspects of the process had begun to look more challenging. While a core group of twelve young people had emerged over as many weeks' sessions, attendance and commitment began to fluctuate.

In part, a delayed funding decision had given rise to a clash with school and college exams. Such a granular approach to the project, while important to the project plan, began to compound the issue. An involved planning process had been broken down into a series of complex component decisions, many of which would usually be taken by professionals based on learned assumptions. Here, however, each team had to be nurtured and supported through a discussion of complex rationales, measured discussions and balanced decision making processes.

Staff remained exceptionally keen throughout that volunteers should be given every opportunity at each stage to challenge museums' received wisdom. With hindsight, and in view of their finished exhibition, it has become very clear that they did so. Yet as a workable process, it was sometimes uncomfortable and gruelling for the young people, not to mention the museum staff. Numbers were a constant concern: while up to fifteen young people could be comfortably supported by the project, the task teams were smaller and very focused. The very granularity of the process demanded this, but the nature of young people's lives ensured that these groups were in some weeks unevenly populated or critically under-subscribed. Exams aside, this could be attributed to a combination of cliques – and sometimes established tensions – within the group (or, if one couldn't come, neither would his or her friends) and to other commitments.

More fundamentally for staff as professionals, it was proving difficult to maintain a positive balance between

signing off urgent decisions on the one hand, and providing creative means of accessing the decision making process on the other. In some cases, the balance was a productive one, as illustrated by this excerpt from a semi-structured interview between youth worker Alex, and Sol:

> *Alex: Getting to know the people and the curators, does that reinforce your ideas about museums, has it changed them, the notion of... I don't know how you feel the team's been operating here... how's the way they've approached the whole activity? Has it been positive? Are there some pros and cons there?*
>
> *Sol: It's effective. We've learned things along the way. The workers involved, they've never put their tasks before helping us to learn what they're doing at the same time, so they won't just do what they have to do, they'll show us what they're doing to help us learn at the same time.*

Yet as with any group, staff encountered a spectrum of learning styles, preferences and temperaments. Understandably, some volunteers thrived on discussion, debate and intellectual challenge. Others, meanwhile, responded more positively to hands-on engagement. To maintain an engaging freshness of approach over the course of over 40 weekly sessions was difficult. Evaluation rarely substantiated the deepest of professional concerns or fears yet, as reflective practitioners, staff became painfully aware that engagement as an enjoyable characteristic of the project risked being sacrificed at the altar of meaningful (and perhaps inherently involved) decision making and negotiation as part of the participative process.

According to Dan:

> *Like, you do get really creative. It's just certain parts that, we need to try and keep people's interest. I know it's not the easiest thing to do. I do prefer to be doing stuff instead of sat talking through, not sat still doing one thing.*

For staff entrusted with what had become a very detailed iteration process, this seven-month period had shown the value of meaningful partnership from start to finish. The opportunity to seek advice and support from approachable partners at Youth Action Stockport and from local authority youth workers was key.

They provided benchmarks for quality participation, practical pointers, and humane reference points throughout what was, for most of the staff involved, a very challenging degree of engagement with young people. Furthermore they were able to offer valuable assistance in accrediting every volunteer's efforts appropriately.

As if to compound staff anxiety, the funded part of the project had been delayed, while the deadlines for planning summer activities, for developing print, and ultimately for launching the exhibition had remained constant. This gave rise to specific time pressures, but also to other challenges more unique to the participative process.

A compressed process

August and September 2009 were characterised by a period of intense interaction with young people over and above the

regular Tuesday night sessions. Loose ends remained to be tied up as staff tried to maintain young people's ongoing participation in every aspect of promoting, planning and delivering a seven-day activities programme for their peers during August.

Since the project's timescales had become severely compressed, staff had also found themselves faced with organising several artist-led interpretation projects (geared to the needs of the exhibition) over the ensuing two months. Ultimately yielding an excellent photographic display, three short films and a sculpture, all of these proposals had been put forward at short notice by volunteers on the exhibitions task team.

Staff became acutely aware of the consequent risk: that the group might become severely oversubscribed, and thereby disillusioned, over several weeks as we tried to negotiate their involvement in a critical mass of projects. The following exchange between our volunteer evaluator Katie Belshaw and a fellow participant, however, was typical:

> Katie: *Was the summer too demanding, just right, or not demanding enough?*
>
> Meshach: *I'd say it was optional. It was optional whether you got involved or not, so... I'd try to give it more time to take part in some of the activities, get involved.*

Retrospectively, our evidence suggests that the young people rarely, if ever, felt especially taken for granted, and felt self-assured enough to decline these projects if they wished. However, to communicate opportunities remained

challenging throughout the project, particularly in cases where young people's involvement was intense and/or elective (and where arrangements were therefore irregular across the whole group or confusing).

While staff provided plenty of notice for the young people to sign up, groupings tended to fluctuate. Young people's work commitments frequently intervened, and short-notice reminders via Facebook and text messages proved to be the indispensable media throughout, with the group consistently less responsive to letters and emails.

The summer activities masterminded by the group were a success when measured against what had in the past been a low baseline of free-choice youth engagement. A total of 102 young participants were attracted to three different museum sites for activities as diverse as catapult making (which the young people conceived as a kind of metaphor for gang conflicts) and the collaborative retelling of an Edwardian murder story through the creation of a graphic novel with artists Jim Medway and Louise Ho.

For staff, this represented a positive foundation on which to build future engagement. However, it became clear that young people (without prior experience of the gradual audience development process) had envisaged a more spectacular transformation, as illustrated by this extract from a semi-structured interview:

Pamela: What was the worst thing about the summer activities?

Cam: The weather. The amount of people that didn't turn up.

Turnout, yeah.
Pamela: Turnout at the actual activities?
Cam: Yeah. Turnout for the actual activities.
Pamela: We're you expecting more?
Cam: Loads.
Brad: Millions.
Cam: But you were like, "it's great it's great!"
Brad: Ha ha! "We have young people!"

Despite staff concerns, at no point did this sense of frustration threaten to derail young people's interest in the project overall, although similarly unmanaged expectations were articulated anecdotally following the launch of the exhibition. Here members of the group had visited the exhibition on a weekday in mid-afternoon only to encounter the building at a traditionally quiet time.

Rather more frustrating for project staff was the process of preparing in earnest for the exhibition itself. The three task teams became two, focusing on design and content. Young people made excellent progress in writing object labels based on their own perspectives and thoughts, planning the layout of the gallery, short-listing objects for contemporary collecting, and working with a designer on the look and feel of the exhibition.

Yet just as a sense of excitement began to crystallise, time was simply too short for them to remain in control of every aspect of the process. As a result, some of the interpretation had to be negotiated with the group rather than originated

by them, and there was insufficient leeway for young people to work on the acquisition of hardware or collections documentation as had originally been envisaged.

Still, the group was determined to make its presence felt consistently and to retain an authorial voice even where a text panel had been ghost-written, in the third person, by staff. As one volunteer remarked, "that just sounds condescending – like old people talking about young people."

The exhibition

The exhibition, *Urban Evolution: We Are Here*, launched on 11 November 2009, and ran until 28 February 2010. At the time of writing (prior to the exhibition's closure) only incomplete figures are available, but the volunteers' testimony suggests that the project meets their aspirations, even where some had struggled with the more painful aspects of the process and (in one or two cases) retreated temporarily from the project:

It definitely makes you feel quite proud that with the right people, with the right thing, you can really achieve something that's worthwhile – Brent.

We set out to say we don't just sit around on street corners, and we can do something good with our time, and seeing the exhibition come together now, it's like we've completed what we set out to do in the first place – Dan.

It's better than I thought it would be. I suppose I thought it was going to be boring but it's not. It's very exciting – Jodie. The ideas we had at the start, at the end we kind of got that idea in a more viewable picture. When we first had the ideas and wrote them

down on paper, now we can see it real and, like, in your face.
Just for one exhibition we've done a lot of things, you know, in
design, creating, stuff like marketing. – Antony.
We were all able to get out there, change some stereotypes,
and work towards creating a good reflection of today's youth.
I think we achieved that. The whole layout and how to make it
visually accessible to the general public was quite an interesting
challenge. – Sol.

A sample of results taken from an electronic survey also suggests a positive impact on the audience. For example 42.9% of respondents agreed strongly that they had learned that "young people can be motivated and achieve something worthwhile", with 29.2% in general agreement. Additionally, 35.2% agreed strongly that they had developed "a new perspective on young people now that I've seen what they can achieve".

A further proposition yielded more general evidence about visitors' attitudes to community exhibitions following their experience of *Urban Evolution:*

This is the first time that a group of volunteers has been involved in every decision about an exhibition at Stockport Story Museum. Which of these statements do you agree with?

The community involvement has made the exhibition more
relevant to me, my family and friends:
 • Agree 58.3%
 • Neither agree nor disagree 17.9%
 • Disagree 9.5%
 • No opinion 14.3%

This community exhibition has made me proud of Stockport and its people:
- Agree 51.2%
- Neither agree nor disagree 17.9%
- Disagree 13.1%
- No opinion 17.9%

I think community exhibitions provide great opportunities to gain skills and knowledge through volunteering:
- Agree 54.8%
- Neither agree nor disagree 16.7%
- Disagree 9.5%
- No opinion 19.0%

Community exhibitions are a chance for museum staff to learn something from the people of Stockport:
- Agree 58.3%
- Neither agree nor disagree 15.5%
- Disagree 9.5%
- No opinion 16.7%

Would you like to see more community-led exhibitions here and at other places in Stockport?
- Yes 81.7%
- No 9.8%
- Not sure 8.5%

It must be said that despite robust positive evidence,

other figures suggest a degree of polarisation over such an unfamiliar approach. This, perhaps, was predictable:

I think that exhibitions should only be run by professionals:
- Agree 35.7%
- Neither agree nor disagree 17.9%
- Disagree 29.8%
- No opinion 16.7%

I think community exhibitions are a great idea, but this doesn't really work for me:
- Agree 34.5%
- Neither agree nor disagree 21.4%
- Disagree 27.4%
- No opinion 16.7%

A beneficial process?

As Stockport Story Museum prepares to dismantle the *Urban Evolution: We Are Here* exhibition, the staff responsible have begun to take steps to preserve its legacy, in particular as a continued process.

Sadly, it will not be possible to support the same frequency of engagement with young people from the service's core resources. For now, a new forum, now called Youth Culture Stockport, convenes and continues to grow on a fortnightly basis. This is welcome and refreshing; due to the nature of Urban Evolution, it had become a closed shop at an early stage due to the amount of time that needed to be invested in the volunteers' learning and collaboration.

Though its ambitions are rather more modest for the coming year, *Youth Culture Stockport* aims to secure a continued, vocal presence in service development. As such, it has its own regular agenda item in the service's planning meetings, and aims to secure embedded involvement in a broader array of projects across a greater number of museum sites than before.

Such an approach will enable this growing body of young people to consolidate their position, to develop their awareness of a broader spectrum of museum work, and to nurture their own ambitions for the future. Meanwhile, staff will continue to seek the optimum balance of enjoyment through engagement, allied to the most meaningful approach to participation that is realistically possible.

Notes

1 See Heritage Lottery Fund and National Youth Agency, Young Peoples Heritage Projects: A Model of Practice (2007) at http://www.hlf.org.uk/HowToApply/ furtherresources/Documents/YR_ModelOfPractice.pdf - accessed 28 June 2010.

2 Thanks are due to staff and young people at Manchester Art Gallery, The Manchester Museum, and Wolverhampton Art Gallery for their help and willingness to share their experiences.

ABOVE: Young volunteers Cam and Brad prepare to unveil young people's bedrooms from the 1950s and the present day shortly before the launch of their co-curated exhibition, *Urban Evolution: We Are Here*, at Stockport Story Museum. Photo: Pauline Nield.

BELOW: Young volunteers assess the visitor experience at Bramall Hall, Stockport during the *Urban Evolution* project.

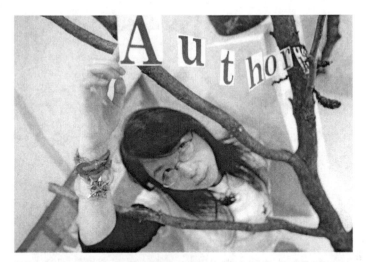

ABOVE: Volunteer Karen puts the finishing touches to a sculpture for the *Urban Evolution* exhibition at Stockport Story Museum. Working with a sculptor, the volunteers wanted visitors to reassess their own roles in perpetuating media stereotypes about young people. Photo: Pauline Nield.

BELOW: Volunteer Danielle demonstrates a simple interactive to prove that anyone can be a hoodie, at Stockport Story Museum. Photo: Pauline Nield.

Provision for Visually-Impaired Visitors

CAMILLA ROSSI-LINNEMANN

Education & International Relations Department

National Museum of Science and Technology

Leonardo da Vinci, Milan

Museums are asked to participate in the general enhancement of social inclusion processes. However, practical issues of sustainability force institutions to justify the use of resources for the largest possible number of users. This essay briefly describes a number of Italian museums that cater for visually-impaired visitors, showing how special programmes devised for a minority can influence mainstream provision and benefit institutions and their users at large.

Disability is actually part of a continuum spectrum of physical, intellectual and emotional abilities that vary from individual to individual. www.artbeyondsight.org

Between 1-3% of the European population is considered to be visually-impaired. European museums, as institutions "in the service of society and its development", are asked to participate in the enhancement of social inclusion promoted by contemporary Europe (art. 136, 137 Amsterdam Treaty). Yet limited funding and resources can encourage museum professionals to organise priorities so that resources are spent to benefit the largest possible number of users. From this perspective it becomes more and more important to embed programmes for minorities into mainstream provision, using what is being created to answer special needs as a tool for reaching the many.

This essay presents findings from a brief state-of-the-art survey conducted in 2006. The aim of the survey was to identify how special programmes for visually-impaired

visitors could influence aspects of the general organization of museums. A number of Italian institutions of different size and nature were invited to respond to a preliminary questionnaire. Among the 81 responding professionals, 27 were then contacted and interviewed to gain a more detailed and qualitative insight into their practice. The idea was to see if special programmes could positively influence mainstream provision and come to be considered as something other than a "luxury" which poorer institutions could never afford.

Results showed that working on special programmes did indeed help institutions in a broader sense. This essay describes four general outcomes that appeared to recur and be appreciated. Designing special programmes for visually-impaired visitors often led to:

- the development of networking strategies and the emergence of new connections with local communities and institutions;
- a general improvement in the explainers' level of awareness and professionalism;
- the creation of new handling collections and related educational opportunities;
- new thoughts on ways to organise and present objects through touch tours, audioguides and multisensory exhibits that ultimately benefit visitors of all ages and abilities.

When developing programmes for visually-impaired people, museum professionals often seek external advice that can

guide them in new and often unexplored worlds of needs and solutions. In the case of Italian museums, recurring external experts include specialised cultural institutions – such as the Museo Anteros in Bologna and the Museo Omero in Ancona – and large associations such as the UIC – Unione Italiana Ciechi (Italian Union for the Blind) and the Istituti dei Ciechi (Institutes for the Blind). These connections are normally created at an initial stage – when programmes are designed and planned – and then reinforced by ongoing revision and staff training. In Italy, networks among museums are increasingly coming to be understood as positive structures (Negri 2001), reinforcing collaboration and exchange among peers and other professionals. These "forced" collaborations confirm this and appear to reinforce institutions at various levels, embedding them deeper in the community they serve, encouraging more visitor-oriented design, attracting public attention, publicity from the media and consequent new sponsorships.

In many cases, museums choose to collaborate directly with visually-impaired visitors, who may then come to play an essential role in shaping the very nature of the institution. This is the case with the local Museo della Bonifica in San Donà di Piave. Curators are considering the possibility of becoming a point of reference for blind people who participated in World War II, designing a display that will reflect the work of those who used their enhanced sense of hearing to help protect the community from bombing. This project is an example of how collections can be reinterpreted to include and reinforce the

identity of a minority within its community.

Special programmes may also call for other, non-specialist, external collaboration. For example the Museo Geologico G. G. Gemellaro in Palermo has created a fossil handling collection and designed a special visit programme in collaboration with a teacher from a local Institute for the Blind. The handling programme is now available as part of the mainstream educational offer for schools, so that students are also given the chance to touch. Curator Carolina Di Patti describes how this new offer led to a growing need for human resources. The situation encouraged the museum to participate in a university project called *Museum and Territory*, that led to the hiring of five collaborators from regular community service groups. This chain of actions ultimately created a new and strong connection between the institution and young members of the local community who hadn't previously been involved.

Lack of funding for special programmes may also drive museums to link up with other cultural associations that can contribute financially. At the GAMEC – Galleria d'Arte Moderna e Contemporanea in Bergamo – free touch tours for visually-impaired visitors are offered all year round by the Lions Club. Thanks to this private funding, museum explainers were trained by UIC specialists.

In the Civico Museo di Scienze Naturali in Voghera, the low-budget refurbishment of a gallery devoted to a new handling collection encouraged the museum to collaborate with convicts working in the carpentry of a local detention

centre. The collaboration was widely covered by the media – something that led to another spin-off benefit: the City Council signed an agreement with the detention centre to carry out public works. This example highlights how effective networking undertaken by socially-recognised cultural institutions such as museums can influence the community at large, sometimes helping to change perspectives on minority or secluded groups.

In 2006, MART: Museo Arte Moderna e Contemporanea di Trento e Rovereto, launched the project *Museum without barriers*, funded by the Fondazione Cassa di Risparmio di Trento e Rovereto. The aim was to make all the museum's collections accessible to visitors with any kind of sensory disability. Visitors with hearing impairment are offered guided visits conducted by a museum explainer paired with an Italian sign-language interpreter. For visually-impaired visitors, a number of touch tours of the collections have been organised, covering a selection of original works of art available for tactile exploration, supported by complementary resources such as Braille paper prints and tactile drawings reproducing a number of other works. As a result, according to the Education Department's Silvia Ferrari and Denise Bernabé, specialised associations are now involved in every step of new projects: from the training of explainers to the choice and design of promotional material.

In Italy, funds for training and expert trainers and consultants are extremely scarce. Yet when developing provision for visually-impaired visitors, museums tend

to spend more time and resources in this area. Specialised training is highly appreciated by museum professionals and explainers as a way of improving their abilities and skills.

In 2002, the Museo Civico di Scienze Naturali "E. Caffi" in Bergamo hosted an important international conference on the subject of museums and visual impairment. In the same year the museum created a permanent sensory trail through the collections and organised a training course for its staff in collaboration with the local Association for the Blind. The knowledge and awareness acquired during the course inspired curators to design a number of multi-sensory exhibits. Explainers gained expertise in leading multi-sensory visits for the general audience, integrating their guided tours with references to sounds and smells and becoming more confident in inviting children and adults to explore zoological and geological exhibits through touch and sound. This collaboration with external experts was greatly appreciated and triggered ideas for new training schemes. For example, the winner of the Urania literature competition was invited to deliver a storytelling workshop, and the local UIC became a close partner in the creation of a new audioguide. These external contributions also increased the institution's general visibility on the press, attracting new sponsors and collaborators. The virtuous circle initiated by the simple need for specialised training led to the museum's becoming one of the best-known institutions in the area.

V.A.M.I. (Volunteer Association for Italian Museums) has been conducting special tours of the Pinacoteca di Brera in

Milan since 1994. The association strongly invests in training to develop language skills and strategies, considering verbal communication as the key to successful visitor engagement, and as a means of encouraging reflection, emotion and feeling. The visits conducted in the Pinacoteca di Brera focus on four paintings: the *Urbino Altarpiece* by Pier della Francesca; *The Marriage of the Virgin* by Raffaello; *The Pietà* by Giovanni Bellini; and *The Dead Christ* by Mantegna. These four works are central to the development of dialogues on the Renaissance, on the birth of perspective and on the centrality of man. The challenge faced by V.A.M.I. explainers is to find ways to effectively communicate concepts that are typically linked to vision, such as perspective and colours. V.A.M.I. guides use verbal description and tactile maps with Braille captions first to orient visitors in the galleries and then to describe paintings. The description of the paintings takes place in front of the works of art, allowing visitors to discover their setting through sounds and spatial orientation. In V.A.M.I. tours, verbal description is effectively combined with the haptic language of tactile drawings and gives visitors a chance to experience both the evocative power of words (by mentioning a "tree" we evoke the listener's personal mental image of the subject) and the assertive precision of figurative representation (once drawn, the tree acquires a set of definite objective characteristics). The possibility of using metaphors is thoroughly explored, as they seem to be an extremely powerful tool to describe certain non-tangible phenomena such as shades or clouds. It might, for example,

be useful to explain the concept of shade by referring to the water diverted by the body in the shower. Other ideas may be described through synaesthesiae that commonly surface in our language when we describe situations through multi-sensory feelings. Examples are expressions such as *warm colours, soft light,* or *rigid composition.* In describing the works of art, V.A.M.I. guides follow a three-part methodology, going from the formal description of actors, spaces, actions, interactions and background, to the iconographic and iconological explanation. A single painting is represented by a number of different tactile diagrams created with the Minolta technique, each focusing on a specific layer or aspect of the image. The progressive exploration of the drawings offers the visitor a possibility of recalling and verifying aspects from the verbal descriptions. This allows the building of a complete representation of the image through an intellectual association of different elements. For example, in the first overview drawing of Raffaello's work (Fig. 1) the people in the foreground and the temple in the background appear to have the same dimensions. Yet when this drawing is compared with a diagram that shows a birds-eye view of the subject, the real dimensions of the building can be perceived, giving a first insight into the rules of perspective. A similar approach has been used in the Galleria Borghese in Rome by V.A.M.I. President Alberica Trivulzio, who leads a group of volunteers to guide visually-impaired visitors on the tours *Caravaggio Sacred and Profane* and *Gian Lorenzo Bernini: the Age of Baroque.* V.A.M.I. Vice-president, Anna Targetti confirms that the

Figure 1: The Marriage of the Virgin by Raffaello.

special training and the experience with visually-impaired visitors have enhanced the communication skills of V.A.M.I. guides. They have refined their sensitivity in perceiving visitors' needs and interests, they have worked on their verbal description techniques and learned how to guide observation through sequenced explanations, and they can now develop effective narrative contexts that enhance the involvement and understanding of all their publics.

In modern typhlology the relationship with "the real thing" is considered essential (Soldati 2005). Not only does it provide the possibility of discovering objects which would otherwise be known only through descriptions, but it also offers the opportunity to learn touching techniques and hand movements, such as the six analysed and schematised by Lederman and Klazy (1998). Museums are thus places where learning of new sensorial and cognitive skills can take place. In order to enhance the learning experiences of visually-impaired visitors, museums might decide to acquire new sets of original handling objects, models or other supporting devices. These new acquisitions often become part of the museum's educational resources, available for all visitors.

The Museo Civico D. Dal Lago in Valdagno has a gallery dedicated to geology and palaeontology, where a number of fossils have been framed, made available for tactile exploration and provided with Braille and large print labels and short guidebooks. Issues of conservation brought interesting repercussions. The touchable fossils had to be chosen carefully from the less precious items in the collections,

but the inadequate number of samples encouraged the museum to ask amateurs to donate new touchable items, thus triggering a process of inclusion of another community, that of local collectors. Curator Bernardetta Pallozzi comments that the newly assembled set of objects benefits the museum audience at large: "Everyone enjoys touching, from young children to adults". Encouraging all visitors to approach the samples through tactile investigation has enriched the interpretation process in general. Another positive "collateral effect" observed by Mrs Pallozzi is the fact that many children were also curious to touch the Braille labels. This frequently triggered reflections on the world of visual impairment, creating a tangible connection to a reality that might be unfamiliar to many young children.

However, not all museums choose to let visitors handle original objects from their collections. Conservation issues pose some obvious limits to object handling, and the most common solution is to try and reproduce the objects as meticulously as possible – as in the case of Civico Museo di Storia Naturale in Voghera, where faithful models of the natural samples have been placed next to the cases and can be touched by all visitors.

Yet there are also some issues related to the very nature of objects themselves and the way we perceive them. Not all objects are easily "readable", even by expert hands. Large objects for example pose some problems, as it is difficult to understand shapes and proportions correctly when the object of our tactile examination is larger than our arm

THE NEW MUSEUM COMMMUNITY

length. The Museo Archeologico Nazionale in Parma has developed a project that consists in the creation of a tactile trail among the museum's permanent collections, which can be experienced by all visitors. The plan comprises the installation of tactile plans, Braille captions and Loges signs, but also the creation of smaller models of large objects that cannot be manipulated because of their size. Small models, real objects for manipulation, Braille and large print texts and other typhlodidactic tools will be available for integrated use, in order to cater for different types of visual impairment, including weak eyesight common in elderly visitors.

The Museo Omero in Ancona also chooses different approaches, depending on the items. It holds collections that were specifically selected for tactile investigation – from architectural models, to small-scale reproductions of antique sculptures, and from original archaeological objects to plaster casts of modern sculptures. A rich programme of temporary exhibitions presents original works of art, often combined with events that involve food-tasting, poetry and music.

Visual art poses another set of problems. How can we gain a full understanding and an aesthetic appreciation of bi-dimensional visual works of art through touch? Can we experience aesthetically – appreciate the beauty of, and be moved by – a painting that we cannot see? At the root of aesthetic theories is the history of perception studies, which try to determine the role played by the intellect and the senses in our knowledge of the world. Locke and Leibnitz both considered intellect as a fundamental actor in perception and

Kant referred to it as the capacity to recognise and organise sensory data through the innate intellectual categories of time, space and cause. Drawing upon this tradition, the German physiologist Helmholtz (mid-1860s) asserted the importance of the psychological area in the study of perception, which was understood as the result of unconscious associations of data stemming from our memory (Meulders 2005). In the twentieth century, this idea was developed by the psychology school of human information processing (Gregory, Neisser and Rock). Arnheim and Gombrich re-proposed similar concepts with specific application to the perception and interpretation of art. In this perspective, as Pedro Zurita (2006) from the World Blind Association states, the perceived image belongs to the intellectual sphere and the aesthetic evaluation results in the pleasure of imagining, associating, understanding and interpreting. Dellantonio (1993, 54) has argued that "although touch and vision are two completely different systems on the anatomic, functional and psychological level, one can reasonably talk of an equivalence between the two modalities when considering their efficiency in determining the subjective perception of objects". Even concepts that are traditionally linked to vision such as perspective, overlapping of objects or viewpoint can be effectively communicated to blind people, as exemplified by the V.A.M.I. experience described above. Such concepts have been experimentally proved to be understandable for visually-impaired individuals (Garbin and Bernstein 1984, Kennedy 2003). Grassini (2000) describes tactile aesthetic

experiences as intellectual processes that resemble the ones stimulated by words: words come in a sequence, conveying meaning in time so that the global sense actually results from the addition of distinct layers. The images generated by poetry can be beautiful, yet – just as images produced by touch – they are more a creation of our intellect than of our senses.

Loretta Secchi, curator of the Museo Anteros in Bologna is the most important Italian researcher in this field. She describes the Anteros museum as a "tactile manual, useful for understanding the historical and aesthetic meaning of works of art" (Secchi 2006, 239). Opened in 1999, the Museum hosts a collection of specially made white plaster bas-reliefs (Fig. 2) reproducing some of the most famous paintings from all periods. Technical bas-reliefs draw on the tradition of ancient perspective bas-reliefs, and they represent an intermediate solution between two- and three-dimensional representations. Visually-impaired visitors are guided in the investigation of these bas-reliefs following a three-stage exploration process, which draws upon the Panovskian three-level interpretation theory. The idea is that – in order to fully appreciate a work of art – we will first explore its shapes and geometrical structures (pre-iconographical knowledge), then recognise its contents (iconographical knowledge) and finally interpret the meaning of the work (iconological knowledge). Verbal descriptions, kinaesthetic reproductions of body positions and other haptic explorations such as enlarged photographic details integrate the tactile experience where appropriate. The combination of these different tools

Figure 2: white plaster bas-reliefs reproduce some of the most famous paintings from all periods.

contributes to the construction of a broad comprehension of bi-dimensional works of art. Technical bas-reliefs represent an intermediate solution, which stands between the symbolic translations of typhlodidactic tools (for example tactile drawings with strong coded textures for distinguishing images and surfaces) and the realistic features of three-dimensional objects (for example all-round models, which appeal to the spontaneous and immediate understanding of touch). The sense of depth that in images is created by the rules of perspective, is re-created in bas-reliefs through a number of simplified raised figures that stand out differently from the background. Stiacciato, bas-relief and high-relief are used to differentiate subjects and backgrounds. Plaster

allows the reproduction of many different textures that can correspond to different substances such as skin, hair or water. The code chosen for these correspondences is not universal and is based more on natural sensory associations than on actual conventions. The use of a single material avoids the over-solicitation that might derive from multi-material tools, which might give too much simultaneous information and overlapping emotions.

Technical bas-reliefs are one solution. Other "translation" experiments include the use of a combination of different tactile drawings – such as the ones described above and used in the Pinacoteca di Brera in Milan and in the monastery of San Domenico in Cagliari – and the use of multi-material resources. This last technique is supported by Lancioni (2006), who argues that "transposing techniques" usually make very limited use of the available expressive means. He argues that touch can experience many different dimensions: linearity, texture, temperature, resistance and thus suggests that in approaching art, visually-impaired people should be presented with layered stimuli that can subsequently be synthesised in an aesthetic experience. It is not a case of building a multi-material reproduction of the painting, but of offering an organised variety of partial stimulations.

The common idea underlying all these different solutions is that collections can be enriched by a number of reproductions that help us to construct knowledge in layers. When presenting collections, curators may want to take into consideration these theories of perception and learning,

which basically state that with or without visual impairment, we all read works of art through similar semantic systems, organising (most of the time unconsciously) our learning experience through a number of layered cognitive and sensory processes. Technical bas-reliefs and tactile drawings are used for specific audiences, yet the creation of multisensory sets of tools is another positive outcome of special programmes. In fact, the need to cater for special audiences often encourages curators to rethink the way collections can be presented to the general public.

In more traditionally designed museums, the creation of special trails can be a lever for rethinking how collections are presented in general. Academic approaches can be balanced by a new focus on the way inexpert visitors tend to perceive things. Tools such as multisensory exhibits or audioguides can be produced for the general public and adapted to special needs with simple solutions. The space itself can be reshaped following universal design principles and new activities might emerge which can be integrated into mainstream educational provision.

At Explora – the children's museum in Rome – the issue of accessibility is strongly connected with the general educational aim of the institution. Exhibits were designed to be accessible for visually-impaired visitors from the very beginning. Consultation with different disabled associations shaped some of the exhibits, offering multisensory experiences that could easily be used by families on their own without any specialised help.

Yet the exhibits are by their nature designed to be highly interactive and hands-on. The common way of making existing historical collections accessible is to organise touch tours such as the ones mentioned above. The organisation of touch tours can lead to the creation of other types of hands-on activities such as the "accessible" science experiments organised by the Istituto e Museo di Storia della Scienza in Florence in collaboration with the local UIC.

The space might also be remodelled by the existence of special programmes as in the Museo dei Gladiatori in Santa Maria Capua Vetere, where Braille panels and audioguides have been integrated with ramps that allow all visitors to reach the sculptures, or in the Museo Civico D. Dal Lago in Valdagno, where the visual impairment accessibility project attracted funds which improved the general accessibility of the space.

Where guided tours are not available, or where the aim is to help visually-impaired people explore spaces on their own, audioguides are frequently used. They can integrate touch tours and Braille captions – as in the Musei Civici in Reggio Emilia – and still be used by the general public.

Audioguides designed for visually-impaired visitors can be enriched with more descriptive information about the objects and with spatial orientation directions. At the Galata Museo del Mare in Genova, special audioguides for visually-impaired visitors were designed in collaboration with the department of Biophysics of the University of Genova. When users approach a "hot spot" in the exhibition the audioguide

picks up a radio signal and a voice reads out the title of the exhibit. The related oral descriptions can be played by touching the audioguide screen. Spatial indications are given at the entrance to each gallery with very explicit indications such as "we are now entering gallery x, which has three glass cases in the middle, and more cases along the wall. On the right there is the entrance to the next gallery".

Audioguides can also be enriched by music and sound to make the visitor's experience of the object more engaging and complete through an emotional and multisensory approach. At the Galata Museum, this idea has shaped the layout of the collection. In fact, the galleries offer an entertaining experience, with multisensory stimuli obtained by combining traditional exhibition cases with full-scale environmental settings, evocative music, large-scale puppets, spoken original texts, and educational spaces for hands-on activities.

In Italian museums, issues of inclusion still conflict with a great lack of funds and resources and with the persistence of a "traditional" management model that is the product of a complex combination of cultural, historical and economic factors. Yet some museums have decided to invest in provision for visually-impaired visitors. Professionals from these institutions recount that working on special programmes has actually led to a number of positive side effects that have ultimately benefited both their audiences and their internal organisation. Engaging in the design of efficient and cost-effective solutions can force museums to seek external advice and thus promote new connections with the local

community and other institutions. Specialised training of staff may improve communication skills that enhance the overall quality of programs and provision. Collections can be integrated with new items, models and resources and they can be reinterpreted to encourage a better and more complete understanding of the objects. Multisensory exhibitions can enhance learning and emotional responses, touch tours can add a sensory dimension to the understanding of collections, audioguides can be modified to include orientation directions and universal design solutions can be adopted to make spaces more usable by all visitors.

Overall, working on special programmes seems to trigger virtuous circles of good practice. Institutions that decide to embark on this type of adventure appear to be rewarded with the opportunity of challenging their priorities, adopting new perspectives and designing flexible new solutions that contribute to a redefinition of both their general offer and their identity in the face of society.

References

Bellini A. (ed.) 2000. *Toccare l'arte. L'educazione estetica di ipovedenti e non vedenti*. Roma: Armando Editore

Dellantonio A. 1993. *Il tatto. Aspetti fisiologici e psicologici*. Padova: Cleup Editrice

Farroni R. (ed.) 2006. *L'arte a portata di mano*. Roma: Armando Editore

Garbin, C. P. and Bernstein, I. H. 1984. Visual and haptic perception of three dimensional solid forms, *Bulletin of Psychonomic Society*, 24 (2), 121-124

Grassini, A. 2000. I ciechi e l'esperienza del bello: il museo Omero di Ancona, in A. Bellini *Toccare l'arte. L'educazione estetica di ipovedenti e non vedenti*. Roma: Armando

Kennedy, J. M. 2003. Haptics and projection: drawings from Tracy, a blind adult, *Perception*, 32, 1059-1071

Lederman, S. J. and Klatzky, R. L. 1998. Hand movements: a window into haptic object recognition, *Cognitive Psychology*, 19, 342-368

Lancioni, N. 2006. Toccare ma non guardare. La semiotica e il problema della trasposizione tattile delle arti visive, in R. Farroni (ed.) *L'arte a portata di mano*. Roma: Armando Editore

Meulders, M. 2005. *Helmholtz: dal secolo dei lumi alle neuroscienze*. Torino: Bollati Boringhieri

Negri, M. (ed.) 2001. *I sitemi museali in Europa: una sfida per il futuro*. Proceedings from the international convention of the Provincia di Milano, 9-10 March 2001, Milano

Soldati, A. 2005. Imparare a toccare. Toccare per imparare,

Luce su luce, 2 , 22-24

Zurita, P. 2006. L'accesso dei non vedenti alle arti plastiche – una prospettiva mondiale, in R. Farroni (ed.) *L'arte a portata di mano*. Roma: Armando Editore

For more information on the institutions and programmes mentioned:

Ancona: Museo Omero http://www.museoomero.it

Bergamo: Galleria d'Arte Moderna e Contemporanea - GAMEC

http://www.gamec.it

Bergamo: Museo Civico di Scienze Naturali "E. Caffi"

http://www.museoscienzebergamo.it

Bologna: Museo Anteros http://www.cavazza.it/museoanteros

Florence: Istituto e mMseo di Storia della Scienza Firenze

http://www.imss.fi.it/indice.html

Genova: Galata Museo del Mare http://www.galatamuseodelmare.it

MART: Museo Arte Moderna e Contemporanea di Trento e Rovereto

http://www.mart.trento.it

Milan: Associazione V.A.M.I. http://www.associazionevami.it

Milan: Pinacoteca di Brera http://www.brera.beniculturali.it

Palermo: Museo Geologico "G.G. Gemmellaro"

http://www.unipa.it/museogemmellaro

Parma: Museo Archeologico Nazionale

http://www.archeobo.arti.beniculturali.it/Parma

Reggio Emilia: Musei Civici http://musei.comune.re.it

Roma: Explora - Museo dei bambini http://www.mdbr.it

Roma: Galleria Borghese http://www.galleriaborghese.it

San Donà di Piave (VE): Museo della Bonifica

http://www.museobonifica.sandonadipiave.net

Santa Maria Capua Vetere (CE): Museo dei Gladiatori

http://www.culturacampania.it/site/it-IT/Patrimonio_Culturale/Musei/Scheda/

santa_maria_c.v._gladiatori.html

Valdagno (VI): Museo Civico D. Dal Lago

http://www.comune.valdagno.vi.it/a_259_IT_438_1.html

Voghera (PV): Civico Museo di Scienze Naturali

http://www.comune.voghera.pv.it/on-line332/Home/Municipioon-line/Affarigenerali/
Istituzioniculturali/MuseoScienzeNaturali.html

For information on other Italian museums accessible for visually-impaired visitors
see: www.bibciechi.it/enti/musei.htm

Consultation or Confrontation? Lindow Man, A Bog Body Mystery

BRYAN SITCH

Head of Human Cultures

Manchester Museum

When the British Museum offered to lend the well-preserved adult male human body dating from the late Iron Age or early Romano-British period known as Lindow Man, the Manchester Museum eagerly accepted. Not only was this an opportunity to put into practice recent work by the university Museum on the ethical treatment of human remains, it was also a way of engaging directly with communities in the North West and further afield who had a justifiable interest in the body. This paper describes the consultative work undertaken by the Manchester Museum with community representatives and offers a methodological framework, which it is hoped will be of interest to colleagues and other practitioners working with potentially sensitive, even controversial, subjects and highlights some of the challenges of more inclusive ways of working.

Lindow Man

In the summer of 1984 a human leg was found on a conveyor belt at the commercial peat works on Lindow Moss near Wilmslow to the south of Manchester. The production line was closed down and the police called in case the circumstances were suspicious. A year earlier, the same workers had found a human skull and initially it was thought these were the remains of a local woman who had disappeared some years earlier. In a landmark case the former husband, who had been serving a prison sentence and had confessed to fellow inmates that he had murdered his wife, was found guilty of her murder, even though the head had been radiocarbon-

dated to the early Roman period (Stead, Bourke and Brothwell 1986, Stead and Turner 1987, Turner 2009). When the leg was discovered in 1984, there was no way of knowing whether these were the remains of the missing murder victim or part of another ancient body. Fortunately, the Coroner and the police allowed archaeologists to lift the body in a block of peat pending preliminary dating, and subsequently radiocarbon-dating showed that the body was ancient.

The body was taken to the British Museum where it was studied in great detail by a team of scientists led by Dr Ian Stead using the most advanced forensic techniques and scientific equipment available at that time. The report concluded that the body probably dated from the late Iron Age and that Lindow Man, as he came to be known, had suffered a violent death (Stead, Bourke and Brothwell 1986). There was evidence of blows to the head, a ligature was still in place around the neck and the throat had been slashed. The trio of fatal wounds, it was suggested could be interpreted as evidence of the Triple Death, each way of killing the victim being dedicated to a particular Celtic god (Ross 1986). The sensational findings of the forensic examination, the macabre background to the discovery and the fact that this was the best-preserved example of a bog body to have been found in the UK, all made Lindow Man an archaeological find of national and international interest. The body was treated with polyethylene glycol (PEG) and freeze-dried in order to conserve it for public display. The Coroner ruled that the body should go to the British Museum which could provide

the appropriate level of conservation and care and where the body would be seen by the largest number of people.

The acquisition of the body of Lindow Man by the British Museum was greeted with dismay in the North West. A local woman, Barbara O'Brien, co-ordinated a campaign to repatriate the body to a museum in the region and mobilised influential people to challenge the appropriation of Lindow Man by the British Museum. As part of the campaign, a choir of schoolchildren from Lindow Primary School recorded a song *Lindow Man we want you back again*. The repatriation campaign was unsuccessful, however, and Lindow Man has been displayed at the British Museum ever since, apart from temporary loans for exhibition at the Manchester Museum in 1987 and 1991. The unsuccessful Lindow Man repatriation campaign of 1986 is analogous to higher profile national and international debates about restitution of cultural property (such as the Lewis chess pieces, the Stone of Scone, the Elgin Marbles and the Rosetta Stone) though it has not yet featured in discussion in its own right (Greenfield 1989).

The context of the Manchester Museum's consultation

When the British Museum offered Lindow Man on temporary loan to the Manchester Museum for a third time in 2005, staff were mindful of the popularity of the earlier exhibitions but also of how much had changed in the generation since the discovery of the body (Alberti 2009). Firstly, human remains were regarded as more contentious partly because of the Alder Hey Hospital scandal, in which it was revealed that organs

had been removed from the bodies of deceased children without the knowledge of the grieving relatives, and partly because of the repatriation of human remains to indigenous communities in Australia, New Zealand and North America (Butler 2001, McKie 2003, Ellis 2004, Fforde 2004, Henderson 2007).[1] The Manchester Museum had itself participated in a number of repatriations of human remains (Morris 2003). It was also clear that this subject was the subject of active debate in the wider museum profession (Vaswani 2001, Kelly 2003, Anonymous 2004, Gill-Robinson 2004, Carroll 2005). At the Manchester Museum, as a university museum, there was intense interest in developing the exhibition as an example of good practice in the ethical treatment of human remains and in sharing the results of research with colleagues across the sector. For these reasons the ethical treatment of human remains was important to the team working on the Lindow Man exhibition.[2]

Ethical concerns received fresh impetus when, shortly before Lindow Man came to the Manchester Museum, the *Body Worlds* touring exhibition opened at the Manchester Museum of Science and Industry (MOSI). For a few weeks it was possible to visit two exhibitions within a few miles of each other in the centre of Manchester exemplifying very different approaches to human remains. The Bishop of Manchester criticized the lack of respect shown for human dignity inherent in Gunther von Hagens' carefully posed exhibits in *Body Worlds* (Ottewell 2008). There have been claims that the bodies of executed Chinese prisoners have been used to create the plastinated

exhibits (Leake 2010).

In addition to more concerted discussion about the ethical treatment of human remains, there was also sensitivity to new ways of working on exhibition projects at the Museum, placing much greater emphasis on consultation and indeed co-production of projects with interested parties in the community (Lynch and Alberti 2010). Sharon MacDonald (Department of Museology, University of Manchester) has talked about making transparent the exhibition-making process and involving the public. Staff at the Manchester Museum were encouraged to treat consultation as a crucial stage in the development of all projects, exhibition related or otherwise.

Finally, there had been considerable discussion among archaeologists, anatomists, museum curators and anthropologists about the interpretation of Lindow Man. Even the most detailed scientific and forensic evidence had not proved definitive or authoritative (Hill 2004, Hutton 2004). There seemed to be little agreement about how and why Lindow Man had died, one writer suggesting that he had died accidentally (Briggs 1995). One anatomist questioned whether the cord around Lindow man's neck was a ligature, suggesting it was a necklace (Connolly 1985). Lindow man's dating had also been revised, placing him in the mid-to-late 1st century AD (Gowlett, Hedges, Law 1989) – about the time of the Roman annexation of northern Britain. Fresh approaches stressed the liminal quality of the landscape (Giles 2009) and the potential to apply sacrificial theory to Lindow Man (Girard 1977).

It seemed there was little that was not contested about Lindow Man. In the circumstances the Museum could not claim to have all the answers and the involvement of wider networks of interest and expertise in a public consultation was required. For all these reasons it was imperative to consult with people outside the Museum. In addition, arguments have been advanced in the profession that museums should not only consult with members of the public but work with them as co-producers. Another high-profile exhibition project at the Museum, *Myths about Race*, ran into difficulty because of the different expectations of the participants and the perhaps inevitable tensions generated by the institution's imperative to meet a project deadline with a given outcome, an exhibition (Lynch and Alberti 2010).

Consultation

In February 2007, a wide range of professional and community representatives was invited to take part in a public consultation about the Lindow Man exhibition, including museums curators, archaeologists, students, a member of the Manchester City Council, and pagans (Fig. 1). Some 35 people attended. Staff leading the event were careful to explain that whilst the Museum valued what people had to say it could not undertake to implement everything that was suggested during the consultation and that it, the Museum, had to make the final decision about what was delivered, although it would explain why a particular course of action had been taken. After an introductory presentation, which summarised

Figure 1: Lindow Man Consultation at The Manchester Museum February 2007.

what was known, or rather not known, about Lindow Man, the participants were divided into smaller mixed groups for discussion. In any one group there were archaeologists, museum curators, representatives of local and regional archaeology societies, members of the public and pagans. A member of the Museum staff acted as a facilitator in each group, took notes and reported back to the larger group in a plenary session in the afternoon.

Despite the differing backgrounds, perspectives and opinions of the participants, there was remarkable unanimity in the responses. All agreed that the Museum should present Lindow Man in a sensitive and respectful way and that Lindow Man's story, or rather stories, should be told from different points of view, taking account of the different interpretations of the body. It was felt that there should be a choice as to whether to see the body, with a separate route for visitors who did not wish to see Lindow Man. The consultees asked that Lindow Man's body be displayed towards the end of the exhibition and that the Museum provide an offerings

box, where visitors could leave a small token of their respect if desired (Sitch 2009). A written report was sent to the consultees and made available on the Manchester Museum website.[3] Consultees were asked to ratify the summary which most did, though some expressed reservations. On the whole there was very positive feedback about the consultation.

The exhibition

Tensions surfaced after the consultation, however, when it was felt that the discussion had gone too far in design terms and had been too prescriptive, particularly about the placing of Lindow Man in the exhibition and the way in which the body should be presented. Whilst it had been suggested at the consultation that the body should be presented in a neutral setting so as not to privilege any one interpretative approach, the suggestion made by the consultees that the body be shown against a background depicting the landscape of Lindow Moss, was, in itself, an act of interpretation. It also transpired that placing Lindow Man towards the end of the exhibition and creating a separate corridor for visitors not wanting to see the body could not be accommodated within the narrow confines of the Museum's Temporary Exhibition Gallery. These findings were reported back to the consultees and a further session was held to present the design of the exhibition complete with a mock-up of the display units in February 2008.

The public consultation guided the interpretative approach to the exhibition in other far more tangible

Figure 2: The Lindow Man exhibiton at The Manchester Museum showing the innovative design.

ways. The consultees were aware that many of the "facts" surrounding Lindow Man, including the circumstances of his death, were contested. Since Lindow Man meant different things to different people, they suggested that the exhibition should reflect a number of different interpretations. For this reason the Museum adopted a poly- or multi-vocal approach to interpretation, allowing flexibility and freedom to explore different attitudes towards the body without having to present any particular interpretation as definitive or authoritative. This approach also gave a structure to the exhibition. It was decided to explore Lindow Man's meaning through the eyes of a forensic scientist, a landscape archaeologist, two museum curators, the person who discovered the body, a former peat worker, a member of the Lindow community and a pagan. In the summer of 2007 the writer interviewed seven individuals,

each of whom had had personal experience of Lindow Man. Textual and audio excerpts from these interviews, together with personal memorabilia and other exhibits, formed the backbone of the exhibition. (Fig. 2)

In the Interpretation Strategy for the exhibition, the Museum acknowledged that people learn in different ways and, for that reason, provided many different ways for visitors to engage with the subject matter. These included the exhibits themselves, Find-Out-More files, a section-by-section library, interactives, audio and textual extracts from interviews with the contributors, an object handling table (staffed by volunteers), public comments cards boards, a programme of public events and activities and a Blog.[4] Not only did visitors see Lindow Man from different perspectives, they could interpret Lindow Man's stories in different ways and potentially make new meanings for themselves.

Response to the exhibition

Following the opening of the exhibition on 19 April 2008, there was a vitriolic response from the *Manchester Confidential* website and comments from the public were mixed. Local journalist, Jonathan Schofield, described the exhibition as:

> *almost entirely devoid of information or balance... Just give us the facts please, and let the audience decide when to empathise... The museum's role here was to educate and excite people, immerse them in another time. We should have had Iron Age tools and weapons, a reconstructed chariot, a section through a hill fort ditch, examples of Iron Age food to taste and*

*an Iron Age roundhouse in the museum forecourt. If that was
way beyond budget, we could for God's sake, have at least had
some bloody good wall displays.*

*...The museum appears to have given power of attorney to a
person who has no right whatsoever to speak for the corpse. It
also raises questions of how far should we allow spirituality
into museums? Will it end with a priest; an imam and a
'pagan' in institutions supposedly dedicated to reason not
superstition... coerce us into feeling the same. Just give us the
facts please... (Schofield 2008)*

The comments rested on the assumption that Lindow Man
was an Iron Age discovery and that an Iron Age exhibition
must necessarily incorporate elements such as a roundhouse,
a chariot or a hill-fort to be interesting. It was precisely this
type of prescriptive, stereotypical and formulaic response that
the Museum's Content Team was trying to avoid in presenting
Lindow Man from a variety of different perspectives. More
importantly, the interpretative approach that was followed
at the Manchester Museum in 2008-9 was precisely that
recommended by the public consultation.

One contributor to *Manchester Confidential* website said: "I
can't believe how bad it is. I am truly truly gutted. I love the
story of Lindow Man. How could they get it so wrong?". Others
questioned the justification for including the voice of a pagan
alongside that of a forensic scientist or the inclusion of 1980s
material such as comics and the Care Bear. Head of Learning
and Interpretation, Pete Brown, received a photocopy of a

letter from a member of the public, describing the Lindow Man exhibition as "shit, shit, shit." (Atkinson 2009).

Some visitors were obviously baffled by the polyvocal approach; others were affronted by the innovative design. Russell Hector, writing in *The Guardian* newspaper complained about the use of MDF shelving:

> All these voices are fascinating but they tend to crowd out Lindow Man, who lies in a dimly-lit box surrounded by all this talk. He is not helped by the design of the exhibition, which features long rows of blockboard shelves. The shelving, with its resonances of libraries and sober academic endeavour, diminishes the mystery of Lindow Man, who appears as an extra in someone else's show. (Hector 2008).

A fairer impression of what had been intended by employing this particular design approach can be seen in a photograph of the display of a bog body at the Landesmuseum fuer Natur und Mensch at Oldenburg, Germany (Sanders 2009, 182).

Typical of the comments made is an email response to the Lindow Man Blog from John Edmondson:

> ...I have not studied the available scientific literature on Lindow Man, being myself a botanist, but would prefer that museums would focus more on scientific enlightenment and exposition and the objects which support this process, and less on delving into the recesses of the human psyche. (September 4, 2008)

A few voices appear to have understood the point the Museum was trying to make:

Hold on folks, what the Museum is trying to do is brave. I went on Sunday too and while it is low on content, the individual viewpoints are interesting. Maybe with the Care Bear woman they want to start the debate about bringing Lindow Man back here? As for the pagan woman, it's an alternative viewpoint which I'd previously known very little about, so I found it refreshing. I agree that they could have made the actual area where the body was more exciting. It did seem a bit dumped there. (Brendan)

But what of the consultees? Emma Restall Orr, who took part in the public consultation as a member of the Honouring the Ancient Dead (HAD) network, felt shock (Restall Orr 2008). Whilst acknowledging that the personal perspectives in the exhibition added to the "very real sense that this withered piece of body preserved in a glass box is a human being" and welcoming the inclusion of an offerings box in the exhibition as requested by members of HAD, she felt as though she had just "witnessed an assault or a cat killed by a passing car lying dead on the empty road…" She focused on the two key elements of the public consultation that were not implemented in the exhibition: placing Lindow Man's case in the middle of the exhibition and not making clear the importance of the landscape and Lindow Man's connection to it. Visitors had no choice whether to see the body, with the result that people came across the body unexpectedly. She was not convinced that the placing of Lindow Man in the exhibition was dictated by lack of space. "It is a real shame they weren't able to find a solution

with regard to this crucial point," she remarks. Although she did not like the exhibition she was not convinced that she would like anything the Museum could possibly have come up with. She acknowledged the courage of the Manchester Museum, and the "radical, profoundly ethical vision based on sound consultation" with which staff approached the exhibition: "That the remit provided by that consultation didn't produce quite what was expected is perhaps a useful reminder about how we communicate and what it is that we share." Prof Piotr Bienkowski, former Deputy Director of the Manchester Museum, in open discussion as part of the annual archaeology Day School devoted to Lindow Man in November 2008, recognized that the Museum had "got it wrong".

Academic response to the Lindow Man exhibition was on the whole positive. Stuart Burch, said it is "to the Manchester Museum's enormous credit that it has sought to tackle these issues whilst stressing there are no 'right' answers... it is impossible to accuse this exhibition of being simplistic or shallow. It manages to convey intellectually challenging information and balances often contradictory interpretations." (Burch 2008)

Nick James writing in *Antiquity* picked up the point about repatriation and asked where was the most appropriate place to display the remains – and indeed whether they should be displayed at all. He felt that visitors were progressively distanced from the assumptions with which they entered the exhibition and that this had induced dismay, even cognitive dissonance. In other words, the exhibition was too far from

what was expected by the public but it was nevertheless right to challenge expectations because "public life badly needs the imaginative quality of critique offered by Lindow Man" (James 2008).

Helen Rees Leahy, Director of the Centre of Museology at the University of Manchester, wrote a review of the exhibition (2008) and was interviewed as part of a *Collective Conversation* at the Manchester Museum. In the latter she contrasted the 1987 and 1991 Lindow Man exhibitions with the most recent one. Commenting on the latter exhibition, particularly the way in which the Museum had stood back from its traditional authoritative role as sole interpreter of the exhibits, Leahy welcomed the inclusion of different voices but again asked whether there was too great a mismatch between what was offered and visitor expectations. The abandonment of a single authoritative narrative voice by the Museum, she said, made visiting the exhibition a disorienting experience for visitors.

None of this should detract from the conclusion that the exhibition was a success: between 18 April 2008 and 19 April 2009, 190,000 people participated in the Lindow Man exhibition project. Visitor surveys undertaken by Morris Hargreaves McIntyre showed that 50% of visitors came primarily to see Lindow Man and that 75% of visitors to the Museum had been to see the Lindow Man exhibition.

Discussion

Emma Restall Orr poses a key question about the exhibition that lies at the heart of this paper: how was it that an exhibition

based on an ethically sound methodology with the public consultation had proved to be so unexpectedly controversial even with consultees, who had been very enthusiastic at the start of the project? That is not to say that public consultation necessarily guarantees a positive response to any exhibition dealing with emotive subjects such as human remains, least of all one touching on the contentious issue of repatriation. Clearly, some of the consultees felt disappointed that the finished exhibition did not seem to reflect the key recommendations of the public consultation, although Museum staff at the consultation had been careful to point out that they could not implement everything that was proposed on grounds of practicality or finance. Ultimately, the Museum found itself constrained by the spatial limitations of its own temporary exhibition gallery.

The most bewildering aspect for some visitors, however, was not the location of the body in the gallery but the polyvocal approach to interpretation that brought in voices traditionally marginalized by society (Restall Orr and Bienkowski 2006). That a pagan viewpoint on Lindow Man should be included at all, let alone put on the same level as that of a practicing forensic archaeologist, was anathema to some contributors to the *Manchester Confidential* website or the Lindow Man blog. Including personal mementoes and reflections on the meaning of Lindow Man rather than the usual comfortable menu of exhibits believed to be representative of the Iron Age was regarded as unsettling, even deeply subversive. Clearly, the public consultation had not taken sufficient account of

the views of all museum visitors although representatives of a number of local and regional archaeological societies did attend the consultation. If anyone was going to complain about non-traditional exhibits in an archaeological exhibition, surely society members could have been relied on to express their reservations? They did not, and they were shown models of the innovative displays in advance of the opening. The public consultation, focusing as it did on people with some level of interest in Lindow Man, can hardly be accused of overlooking knowledgeable people.

Perhaps the earlier exhibitions had done their work all too well. They created a mould or a mind-set based on an orthodox archaeological exposition of Lindow Man, his life and times, that created expectations of the most recent exhibition which were never going to be fulfilled. The Project and Content Teams working on the Lindow Man exhibition wanted to do a different kind of exhibition to what had been done before, and, in any case, the interpretation of the knowledge that had underpinned the 1987 and 1991 displays had been questioned and challenged by a new generation of archaeologists, anatomists, anthropologists and cultural historians (e.g. Hutton 2004).

We might characterize the people who criticized the exhibition so fiercely as expert or connoisseur – people who feel comfortable about visiting and criticizing volubly what the Museum offered. They not only felt they knew the subject but thought it reasonable for them to hold specific expectations about the content of the exhibition and to

express dissatisfaction when those expectations were not fulfilled. That such expectations were based on out-of-date interpretation and simplistic or formulaic definitions of what ought to constitute a Lindow Man exhibition was immaterial to them. One visitor, apparently a member of staff of the University, commented: "Lindow Man was killed and chucked in a bog. End of story". Traditionally, such visitors have been a mainstay of museums, whereas the museum profession has taken steps over the last decade to encourage wider sections of society to visit museums and galleries. Despite criticism that the exhibition was dumbed down and object-lite, research by Pete Brown, Head of Learning and Interpretation at the Manchester Museum, has demonstrated using the technique of Personal Meaning Mapping (PMM) developed by Falk and Dierking (1992) that visitors did benefit in educational terms and that they increased the number and range of their concept and subject categories (Brown 2009).

Another aspect of this discussion is the assumption that consulting widely and engaging with the community should have produced a degree of buy-in. When the exhibition was pilloried on certain websites, the consultees themselves might have been expected to respond in defence of the project to which they had contributed. By and large this does not seem to have happened, either because some of the consultees themselves were disappointed with the exhibition, or because they lacked the confidence to speak up in a debate that at times was marked by particularly personal attacks, questioning the spiritual beliefs of the curators and even suggesting that they should

lose their jobs or that funding for the organisation should be stopped! One of the interviewees was castigated as a "self-appointed expert" when in fact she had been invited to take part in the exhibition because as a youngster she had participated in the unsuccessful repatriation campaign to return Lindow Man to the North West. She had sung in the school choir and still had a photograph of her and her classmates at the recording studio and the campaign t-shirt to prove it! It is perhaps unfair to have expected consultees to be drawn into a high profile debate about the exhibition when the Museum was itself caught off balance by the ferocity of the criticism.

Issues such as the widespread wish to see Lindow Man brought back to the North West were not addressed in the earlier exhibitions, perhaps because it was simply too sensitive an issue at that time for the Museum to consider addressing it, or because it would have been unpolitic to do so. To their immense credit, the present British Museum curators, J.D. Hill and Jody Joy, made it clear from the outset that the Manchester Museum was free to decide its own interpretation regardless. The social history aspect of Lindow Man, the resonance that the discovery of the body had, and indeed still has in the community, and the widely-held belief that he belongs in the North West, were featured in the recent exhibition and on the Lindow Man Blog and clearly have potential for further research. This kind of approach offers a way of making archaeological discoveries of direct relevance to local audiences with their very specific interests and sense of belonging in the place where they live. A conference held at Castleford in

2005 highlighted the importance of a sense of place, in which archaeology naturally plays a crucial role, in stimulating local identity and citizenship (English Heritage 2005).

In conclusion, it was surely right to carry out a public consultation in advance of an exhibition featuring such a contentious centerpiece as a 2000-year-old bog body for a variety of reasons: it was the appropriate course of action professionally; human remains in museums had become a more sensitive issue in society; and there was much ill-feeling in the region over the issue of repatriation. Nevertheless, following the opening of the Lindow Man exhibition in April 2008 the Manchester Museum was subjected to unprecedented public criticism, not because it had failed in its consultation but because some visitors fundamentally disagreed with the polyvocal approach and its implied "equality of authority" amongst those who spoke about the body. Far from being perceived as inclusive because it had incorporated the voices of those traditionally excluded from museum exhibitions such as pagans and ordinary members of the public (the finders of the archaeological discovery in question and a member of the originating community at Lindow), the Museum was criticized for putting them on the same level as the testimony of an acknowledged expert. This is rather interesting because it suggests that the action of presenting all of the voices in the exhibition as of equal value was interpreted by some visitors as the de-privileging of traditionally authoritative figures such as a forensic scientist (pers.comm. Pete Brown).

The most vociferous criticism came not from the experts

in the various disciplines, who were not in the least perturbed at rubbing shoulders with people holding completely different world views from themselves, but from more conservative members of the museum-going public who felt that the Manchester Museum had abdicated its responsibility to present authoritative and definitive interpretation of the evidence.

Ultimately museums can't please all the people all the time but it would appear that more inclusive ways of working, far from engaging wider audiences, can have the opposite effect of upsetting some visitors who may enter the museum exhibition with a particular set of expectations based on their long familiarity with such institutions. Such expectations will no longer automatically be privileged or regarded as authoritative as museums move towards socially more inclusive exhibition-making. Despite these challenges, the Manchester Museum learnt a great deal from the Lindow Man exhibition and consultation remains a very important part of any project. Consultation will continue with the intention of fostering meaningful debate and challenging people's preconceptions.

Notes

1. See Donnelly 2009 for more recent dismay about the removal of organs from bodies without permission.

2. The team working on the Lindow Man project included (in alphabetical order) Prof. Piotr Bienkowski, Stephen Booth, Pete Brown, Anna Bunney, Jeff Horsley, Tim Manley, Bryan Sitch, Anne Speed, Stephen Walsh and Michael Whitworth. We were kindly assisted in the development phase of the project by Dr. Melanie Giles, Tammy Macenka and Jim Rylatt.

3. http://www.museum.manchester.ac.uk/aboutus/ourpractice/lindowman/ fileuploadmax10mb,120485,en.pdf (accessed 6/1/2010)

4. http://lindowmanchester.wordpress.com/

Acknowledgements

The writer would like to express his gratitude to colleagues who worked on the Lindow Man project, to Dr Melanie Giles and students from the Department of Archaeology at the University of Manchester, and to the interviewees who allowed their testimony to appear in the exhibition, namely Prof. Don Brothwell, Susan Chadwick, Dr Melanie Giles, Dr J.D.Hill, Andy Mould, Bruce Mould and Emma Restall Orr. Pete Brown kindly allowed access to unpublished research on evaluating visitors to the exhibition using Personal Meaning Mapping and Dr Lindy Crewe kindly commented on an early draft of this paper. For any errors in the text the writer is responsible.

References

Alberti, Sam J.M.M., *Nature and Culture Objects Disciplines and the Manchester Museum*. Manchester: Manchester University Press, 2009.

Alberti, Sam J.M.M., Piotr Bienkowski, Malcolm J. Chapman, and Rosemary Drew. "Should we display the dead?" *Museum and Society* (2010)

Anonymous. "London Remains Row." *Arts Industry* 104 (January 16 2004): 2

Atkinson, Helen. "Uncover Those Mummies! Pete Brown's Hands-on Approach to the Display of Human and Animal Remains." *Heritage Key*, http://heritage-key.com/britain/uncover-those-mummies-pete-browns-hands-approach-display-human-and-animal-remains (accessed December 21 2009).

Briggs, Charles S. "Did They Fall or Were They Pushed? Some Unresolved Questions about Bog Bodies." In *Bog Bodies: New Discoveries and New Perspectives*, edited by Rick Turner and Rob G. Scaife, 168-181. London: The British Museum Press, 1995.

Brown, P. *Us and Them: Who Benefits from Experimental Exhibition Making?* MA diss., Leicester University, 2009.

Burch, Stuart. "Review of Lindow Man a Bog Body Mystery." *The Museums Journal* 108.7 (2008): 46-49.

Butler, Toby. "Body of Evidence." *The Museums Journal* 101.8 (2001): 24–27.

Carroll, Quinton. "Who Wants to Rebury Old Skeletons?" *British Archaeology*, May/June, 2005.

Connolly, Robert C. "Lindow Man: Britain's prehistoric bog body." *Anthropology Today* 1.5 (1985): 15-17.

Donnelly, Laura. "Bodies buried without brains." *The Sunday Telegraph*, December 20, 2009.

Ellis, Linda. "Museum Studies." In *A Companion to Archaeology*, edited by John Bintliff, 454-472. Oxford: Blackwell Publishing, 2004.

English Heritage. *Whose Heritage is it Anyway? Community Engagement in Heritage Management. The Castleford Conference 2005*. 12 page brochure. English Heritage, 2005

Falk, John, and Lynn Dierking. *The Museum Experience*, Washington, DC: Whalesback, 1992.

Fforde, Cressida. *Collecting the Dead: Archaeology and the Reburial Issue*. London: Duckworth, 2004.

Giles, Melanie. "Iron Age Bog Bodies of North-western Europe: Representing the Dead", *Archaeological Dialogues* 16.1 (2009): 75-101

Gill-Robinson, Heather. "Bog bodies on display." *Journal of Wetland Archaeology* 4 (2004): 111-116.

Girard, Rene. *Violence and the Sacred*. Translated by Patrick Gregory. London: Johns Hopkins University Press, 1977.

Gowlett, John A.J., Robert E.M. Hedges, and Ian A. Law, "Radiocarbon accelerator dating of Lindow Man." *Antiquity* 63 (1989): 71-9.

Greenfield, Jeanette. *The Return of Cultural Treasures*. Cambridge: Cambridge University Press, 1989.

Hector, Russell. "Rest in Peat." *The Guardian*. www.guardian.co.uk/artanddesign/2008/apr/28/heritage

(accessed December 21, 2009).

Henderson, Mark. "Museum surrenders vital clues to human evolution." *The Times*, May 12, 2007.

Hill, Jeremy D. "Lindow Man's Moustache." *The Times Literary Supplement*, March 5, 2004.

Hutton, Ronald. "What did Happen to Lindow Man?" *The Times Literary Supplement*, July 2, 2004.

James, Nicholas. "Repatriation, display and interpretation", *Antiquity* 82 (2008): 223-8.

Kelly, Patrick. "Bones of Contention." *Arts Industry*, 102 (November 28, 2003): 8.

Leake, Christopher. "Bodies' Exhibition Accused of Putting Executed Chinese prisoners on Show." *The Mail on Sunday*, October 1, 2010.

Lynch, Bernadette T. and Sam J.M.M. Alberti. "Legacies of Prejudice: racism, co-production and radical trust in the museum," *Museum Management and Curatorship* 25.1 (2010): 1-23.

McKie, Robin. "Scientists fight to save ancestral bone bank." *The Observer*, September 28 2003.

Morris, Jane. "Dead but not buried." *The Museums Journal* 103.12 (2003): 12-13.

Ottewell, David. "Bishop blasts 'body snatch' row." *Manchester Evening News*, February 5, 2008.

Randerson, James. "Give Us Back Our Bones, Pagans Tell Museum." *The Guardian*, Febraury 5, 2007.

Rees Leahy, Helen. "Under the skin." *Museum Practice* 43 (2008): 36-40.

Restall Orr, Emma. "Lindow Man in Manchester: on Display." *Honouring the Ancient Dead.* http://www.honour.org.uk/node/87 (accessed April 20, 2008).

Restall Orr, Emma. "Lindow Man in Manchester on Display." (http://www.honour.org.uk/node/87) accessed 6.1.2010.

Restall Orr, Emma and Piotr Bienkowski, "Respect for all." *The Museums Journal* (5), May 2006, p.18

Ross, Anne. "Lindow Man and the Celtic Tradition." In *Lindow Man the Body in the Bog,* edited by Ian M. Stead, James Bourke and Don Brothwell, 162-169. London: British Museum Press, 1986.

Sanders, Karin. *Bodies in the Bog and the Archaeological Imagination.* Chicago: University of Chicago Press, 2009.

Schofield, Johnathon. www.manchesterconfidential.com)/index.asp?Sessionx=IpqiNwImNwIjIDY6IHqjNwB6I(accessed December 21, 2009).

Sitch, Bryan J. "Courting controversy: Lindow Man a Bog Body Mystery at the Manchester Museum." *University and Museums Collections Journal* 2 (2009): 51-54.

Stead, I.M., Bourke, J. and Brothwell, D. *Lindow Man the Body in the Bog.* London: British Museum Press, 1986

Stead, Ian.M. and Rick C. Turner. "Lindow Man an Ancient Bog Body from a Cheshire Bog." *Transactions of the Lancashire and Cheshire Antiquarian Society* 84 (1987): 1-14.

Turner, Rick. "Finding Lindow Man." *British Archaeology,* July/August, 2009.

Turner, Rick and Rob Scaife. *Bog Bodies: New Discoveries and New Perspectives.* London: The British Museum Press, 1995.

Vaswani, Ratan. "Remains of the Day On the Ethics of Displaying Human Body Parts." *The Museums Journal* February (2001): 34-5.

Collective Conversations

MALCOLM CHAPMAN

Head of Collections Development

& GURDEEP THIARA

Curator of Community Engagement

The Manchester Museum

Since June 2004, the Manchester Museum has been working with diverse groups and individuals including local migrant communities, researchers and academics on a project called *Collective Conversations* to uncover hidden meanings and responses to its collection of natural and human history. The aim of the project is to work collaboratively with communities and academics to explore the meanings and responses to the collection. It is a break away from the traditional role of the museum as the single voice of authority and knowledge and a move towards building an understanding of the knowledge inherent in communities. Taking the concept of the museum as a contact zone (Clifford 1997), a meeting point between cultures, the Museum recreates this engagement in an environment where all voices have the opportunity to be heard: "... common ground cannot be staked out in a single narrative about who we were but only in a more intricate narrative about who we are. *Our Island Story*, in short, needs to become *Our Island Stories*." (Culture Minister David Lammy in DCMS 2006, 11) The Museum is attempting to create reciprocal and sustainable relationships with communities based on mutual understanding and shared interests and benefits.

Following the Museum's *Community Engagement Strategy* (Manchester Museum 2009), the main groups the Museum works with are communities of place, people and interest. Partners have included the Wai Yin Chinese Women's Society, Women Asylum Seekers Together and members of Manchester's Nigerian, Somali and Sudanese communities. This essay will explore how these groups have interacted with

the Museum in the development of *Collective Conversations* and what the longer-term impact of their participation has been on them as community members, on the representation of their communities within the Museum and the impact on Museum practice. Additionally, it will examine the wider impact through delivery on the internet, and the questions of cultural representation and accuracy of cultural knowledge this has generated.

In 2001 Resource, now Museums Libraries Archives Council (MLA) published the *Renaissance in the Regions* report which recognized the role museums have in society and identified five main aims for museums in the 21st century: to ensure excellence and quality in service delivery; to use collections to encourage enjoyment and creativity; to be an important resource and champion for learning and education; to promote access and inclusion; to contribute to economic regeneration (Resource 2001, 7-8). Specifically the report referred to museums' collections as their "currency... to convert into social and economic benefits" (Resource 2001, 19). By increasing access to collections it suggested that user profiles will change and museums will become more representative. Consequently they will be in a position to benefit individuals and communities.

They will become, it is claimed, "focal points for their local communities... providing public space for dialogue and discussion..." (Resource 2001, 21). The resulting creation of regional museum hubs was aimed at improving the sector's infrastructure and sustainability in order to deliver on this

social agenda.

This approach is rooted in the politics of groups in society experiencing or facing social exclusion, a contentious term used to describe those groups in society that are disenfranchised or marginalized on the basis of gender, race, sexuality, disability, class or religion. This work has commonly been addressed in the health, education and community sectors. The role the cultural sector may play within this is now being recognised both by government and the sector itself. The Museums Association report *Collections for the Future* in 2005 acknowledged that museums "are well placed to capitalize on a re-emerging awareness of the importance of the institutions and experiences that bind communities together" (Museums Association 2005, 10).

Groups and communities are increasingly demanding their rights as citizens and to have "their contribution to society recognized, and their children's rights to see their cultures represented in a serious and respectful manner" (Hooper-Greenhill 1997, 2). The liberation of culture itself is "not only about giving back or restoring a people's right to and control over their own management of their cultural heritage... the aim is to open the field to multiple voices, which represent a wide range of experiences and perspectives, and to give credence to bodies of knowledge... that have been historically overlooked and devalued" (Kreps 2003, 145). While such work can be seen as a threat to the authority of the museum in giving voice to others "a process of self-discovery and empowerment will take place in which the

curator becomes a facilitator rather than a figure of authority" (Witcomb 2003, 79). To the Manchester Museum the process of consultation is an essential element of its transparent practice in all aspects of its work, not just in traditional outreach activity – the Museum has developed a reputation for consulting on exhibition and policy development. Including these "alternative perspectives signals an important shift to a greater awareness of our place in a diverse community, and the assertion of a goal to promote social engagement with our audiences" (Chun et al 2006). In contrast, Lola Young (2002) has identified problems with the term inclusion itself as it fails to recognise the inherent inequality of consumption and opportunity. To Young, while museums can develop and run so-called outreach programmes aimed at inclusion they are run on an unequal basis, under traditional power relations.

Dialogue between museums and communities is not simple and straightforward, an individual community may have "many factions with differing views based upon... religion, political outlook, and status... [but can]... give people a feeling of ownership... and a museum's community relationships will be strengthened" (Simpson 2001, 48-49). What defines a community is essentially a sense of belonging, that there is some form of relationship between the members. It follows, therefore, that the "notion of community is inherently *othering*" (Hein 2000, 39), that by choosing to work with a specific community, the museum has excluded all others.

Stephen Lavine has noted that "even when museums consult representatives of minority cultures... they still

must consider how and on what basis their selection of such representatives have been made" (1992, 145). However, the "desire to achieve equal representation can only remain a desire... for there will always be some group who will find itself unrepresented" (Witcomb 2003, 80) through a number of means, not least choice, or being unaware there was an option to be represented in the first place. The main question, therefore, is who does the individual represent when they elect to represent a community? Who is it that they speak for? It would be simplistic to approach an individual who is prepared to talk to or work with the museum and then claim to be working with a specific community.

Funded by the *Renaissance in the Regions* programme, specifically through a work package focusing on how relationships with users can become central to how collections are used and interpreted, the idea of *Collective Conversations* began as a response to the desire within the Museum to increase access to the collection and to provide the opportunity and structure for communities to contribute to collection-related knowledge. At the same time members of the Museum's Community Advisory Panel were expressing concern that that the collection was largely under-used by the surrounding local communities and lacked important information about their history and community context. Inspiration for how to reconcile this came from James Clifford's essay *Museums as Contact Zones* (Clifford 1997), in which he recounted his experience of being present during a discussion between the Portland Museum of Art and a

group of Tlingit elders. Here the museum became "something more than a place of consultation or research; it became a contact zone", (Clifford 1997, 192) more a process of dialogue than a meeting point. Here the museum and communities re-negotiate interpretations about the collection in an environment where all voices have the ability to be heard. The Manchester Museum now uses the term *Contact Zone* for the space where the conversations take place, a designated room equipped as a film studio. In the Contact Zone participants sit around a low circular table to discuss the objects they have selected; the layout recreates the atmosphere of sitting around a fire telling stories. Its opening in September 2007 was attended by many of the Museum's community partners who participated in a traditional Yoruba ceremony conducted by the late Chief Babalawo Adeyela Adelekan who had participated in the programme himself.

There have been three main phases within the programme, phase 1 (2004-2006) focused on opening-up the anthropology collection, phase 2 (2006-2009) extended this work to all areas of the Museum and connected them to specific audience-led programmes, while during phase 3 the Museum will connect the programme to exhibition and gallery development and shift community engagement work from the periphery to the core of the Museum's work.

For each conversation the Museum works intensively with a community group to explore the collection and discuss what responses and ideas they have. These responses can be purely emotional, reminiscence, culturally-specific

or idea- or theme-led. Conversations between academic researchers and community groups have explored the relationship of the Museum's collection to the abolition of the slave trade, in particular researching where the wealth of the industrialists and merchants who contributed to the collection came from. Conversations amongst community members have explored their own cultural history, their personal experiences and their relocation from their home country to the centre of Manchester. Once the objects have been selected, the participants come back to the Museum to record their conversation in a purpose-built recording studio. Each conversation is facilitated by either a member of the community or a member of Museum staff. The resulting film is then edited, added to the collections database and finally posted onto the internet, currently through *YouTube*. A DVD copy of the full session is also passed on to the community group for their own use. Initially the films were posted online on the University of Manchester's streaming service and were accessed through the web interface of the collections management system. While this served the original purpose, it limited access to the films to those who stumbled across them or already knew they were there; that is, to the Museum and the participants. Wider access to the films has been made by posting them on *YouTube*[1]. This has the benefit of placing the films into a wider context, reaching newer audiences and, importantly, offering them an opportunity to respond directly with their own comments or to make links to other films of similar content or subjects. While there was some short-lived

concern amongst some participants that the Museum was losing control over how and where the films were to be viewed, these fears were alleviated once the connections between the films and other online resources were made. Increasing the ability of viewers to comment and make connections to other content is a central aspect of the Museum's wider digital strategy which is focused on delivering the content to the user, now participant, in a place and format in which they feel most comfortable.

As the Museum has a long-standing relationship with members of the local Somali community, in particular working with women refugees on projects concerned with literacy and health including *Telling our Lives* (Lynch 2002), there was an opportunity to enhance this relationship by exploring Somali objects from the collection. A member of the Community Advisory Panel brought a second group of Sudanese refugees from the Manchester Sudanese Cultural Society. With the Curator of Anthropology and Curator of Community Engagement working with key members from both community groups, the Museum and communities jointly selected objects for discussion which could tell something about everyday contemporary life in Somalia and Sudan. These ranged from photographs, combs, and a coffee pot to knives, shields and amulets and charms.

The first films show some of the Somali group examining the objects, reading the labels, conversing in Somali and translating their observations and inferences into English. The Museum's voice is not present other than through

the lens of the camera. A subsequent film of the Sudanese group is spoken mainly in English, with the exception of a spontaneous rendition of an Arabic song when three women were recalling memories and stories in response to the coffee pot[2]. This particular film demonstrates the trust the Museum places in the participants: as the song is sung they start tapping on the pot and swaying from side-to-side. Common to both experiences is how the objects are spoken about; how memories are triggered, their uses are discussed, the skills with which they were made are celebrated and drawn attention to: "...people take pride on what sort of designs they put on..." (Ali Rahman commenting during filming[3]). In a separate film from the same session a participant recounts a murder he witnessed in Southern Sudan which was carried out by a member of the Nuer tribe using a short hand-spear similar to one in the collection. This connection between a 19th century museum artefact and contemporary events which can be traumatic to witness was unexpected. For the members of the Sudanese group there is a power in the objects which "...carry memories for us" and can offer lessons for their communities today: "...young people might like to see how people protected themselves and handled weapons" (Ali Rahman).

These early films are about people giving their views and opinions and opening up the way in which the collection can be seen. "You do see people sometimes who would just pass by objects... they just look at it... and they move on. But that object had a history and traditions and had a lot of rich life

and knowledge around it and having made that discussion on film really made people look at those objects, even for the Sudanese themselves" (Ali Rahman[4]). In this way they share the curatorial view and interpretation of the collection; the films are all embedded into documentation records and therefore become part of the Museum's knowledge archive. These accounts sit alongside curatorial comments and have merit and validity in their own right. This can be seen – as pointed out by former Deputy Director Bernadette Lynch – as a process of "unlearning", in terms of organisational development, of confronting the prejudices and assumptions that have traditionally underlain most museums' thinking and practice. Community members can become actively engaged in the Museum's work, allowed to curate their own conversations with objects, and ultimately invited to share in some of the responsibility for the collections and their interpretation.

During 2007 the Museum was heavily involved in *Revealing Histories: Remembering Slavery*[5], a project taking place across eight museums and galleries in Greater Manchester which aimed to uncover the legacy of the transatlantic slave trade in the region's collections and the city's key contribution to the abolition of slavery. Within this framework, the Manchester Museum launched a *Revealing Histories* thematic trail reinterpreting existing displays in order to provoke debate on this important subject. How did Manchester Museum's collections come about? What is the story behind them? Research had been carried out by the Museum and the results made available for open discussion with different

communities. People were invited to examine and share their emotional engagement with objects in the Museum (which was particularly the case in the Museum's work with refugees). This again culminated in a series of conversations with targeted groups and a temporary exhibition. Objects for these conversations came from across the Museum. People were selected to take part based on their interest in and knowledge of the subject. They included Chief Babalawo Adeyela Adelekan, founder and patron of *Egbe Isese Esin Yoruba* (The Root of Yoruba Religion, Science and Cosmology), a society based in London which is a focus for the practice of Yoruba tradition, Nigerian women members of the Community Advisory Panel, a local Afro Caribbean educational group *Mapping Our Lives*, and the *Revealing Histories* researchers.

Looking at two sessions of films in particular there is strong evidence of people looking for their own culture, defined through origin or belief. The films where Chief Adelekan discusses traditional Yoruba religion, arts and beliefs have been viewed over 26,800[6] times, with the two most frequently viewed films[7] having high viewing figures in Venezuela and Cuba, both countries with religions incorporating elements of Yoruba beliefs and the worship of Shango, the god of thunder and lightning (Barnes 1989, Bascom 1972). A significant proportion of these viewers are looking specifically for content relating to Shango, as opposed to stumbling upon it when looking on *YouTube*. For example, of the 6,500 views of *Shango: Thunder and Lightning*, 36% came through the film being embedded in a third party website: www.ileshango.com alone

being responsible for 1,444 views. The majority of the other embedded links have been from social networks, implying an online community of interest. Such communities are similar to Benedict Anderson's nations in that they are "imagined... the members... will never know most of their fellow-members, meet them, or even hear them, yet in the minds of each lives the image of the community" (Anderson 1983, 6).

A short film[8] in which Ebi Ozigbo talks about a modern bell based on an ancient image of the Oba of Benin and his significance as a great warrior in the 15th century has been viewed most often from countries with Benin diaspora communities including Brazil and Réunion. However, the majority of the comments attached to this film are a discussion, at times heated, between viewers of Benin and Yoruba origin over each other's cultural origins. While most views are from South America, most comments come from *YouTube* users in the UK where there is perhaps a more vocal expression of an individual's cultural identity. In the case of another film about *Shango*[9], Esima Kpogho, also from Nigeria, the comments are of a different nature, questioning the accuracy of her comments based on perceptions of her own cultural origin, whether she is Bini, from Benin, or is Yoruba: "very poor of bini people to talk about Shango, they ont know nothing but to turn the history upside down... Binis should not tarnish the history for poor fame" (*YouTube* user Spongyb comment[10]). Andrew Keen (2008) has seen such comments as the death of culture, the rise of the cult of the amateur leading to a future where the acceptance of

knowledge is "a state of intellectual enervation and depletion hardly to be distinguished from massive ignorance" (Lewis Mumford quoted in Keen 2008, 45). However, this is to misunderstand the nature of the internet as a place to define, or re-define, one's identity.

While the Museum's intention had been to work with communities to examine the hidden histories of its collection, and the relationship between people and place, these films demonstrate how "groups or communities may in reality prove impossible as they often do not exist as a single homogenous mass" (Clayton 1999, 148). There are often conflicting and contradictory interests between separate communities with differences based on, for example, geographic origin, age, education, class or caste. Ivan Karp discusses the complex nature of individual identity, specifically the way "people perform their roles and express their individual feelings demonstrates that more than one identity enters into their actions" (1992, 20); the person being the "socially defined aspect of the self" while the individual is the "uniquely experienced side of the self" (1992, 21). Who is it, therefore, that a participant in the conversations is representing? The individual as they perceive it or the person as defined by one of their many communities? This dilemma is to Karp not so much "how people choose identities, but the checkered history of how those identities have been manifested" (1992, 23). A non-essentialist view of identity is that it is fluid, dependent on circumstance, or situation and that identity is a social concept allowing individuals to be grouped by socio-

economic class, ethnicity, gender, age, or sexuality (Newman & McLean 2002, 57). Hilda Hein notes that if museums attempt to expand their boundaries to include such outsiders, either self-selected or determined by socio-economic or cultural criteria, then this challenges the "parameters that made it a community of insiders in the first place" (Hein 2000, 39); that is, the museum ends up reflecting upon itself and its relationships with others.

The underlying rationale for the museum, "our guiding value, or moral compass, should be cultural democracy. Democracy is about debate, dialogue, deliberation... the challenge for museums is not simply broadening audiences, but enabling more people to become involved in what museums do: continuing the process of democratising collecting and interpretation, blending curatorial expertise with public participation in museum decision making, and enhancing the contribution of volunteers, so that museums can develop their own role as community spaces, as mediators between the past and the present, and as agents in a dialogue about who we are and what we might become or achieve." (David Lammy in DCMS 2006, 2).

Notes

1. *http://www.youtube.com/manchestermuseum*

2. *http://bit.ly/coffeepottraditions*

3. *http://bit.ly/armknife*

4. *http://bit.ly/collectiveconversations*

5. *http://www.revealinghistories.org.uk/*

6. *Between September 2007 and January 2010*

7. *http://bit.ly/shangothunder and http://bit.ly/shangoinitiation*

8. *http://bit.ly/shangostaff*

9. *http://bit.ly/shangostaff*

10. *http://bit.ly/shangostaff*

References

Anderson, B. 1983. *Imagined Communities*, Rev.ed. 1991. London and New York: Verso

Barnes, S. T. ed. 1989 *Africa's Ogun: Old World and New*. Bloomington and Indianapolis: Indiana University Press

Bascom, W. 1972. Shango in the New World. Austin: The African and Afro-American Research Institute, The University of Texas

Chun, S. et al 2006 'Steve.museum: An Ongoing Experiment in Social Tagging, Folksonomy, and Museums', in Trant and Bearman eds. *Museums and the Web 2006: proceedings*, Toronto: Archives & Museum Informatics. Available online. http://www.archimuse.com/mw2006/papers/wyman/wyman.html accessed 11 January 2010

Clayton, N. 1999. 'Folk devils in our midst? Collecting from 'deviant' groups' in Knell, S. 2004. ed. *Museums and the Future of Collecting*, 2nd edition. Aldershot: Ashgate, 146-154

Clifford, J. 1997. *Routes: Travel and Translation in the Late Twentieth Century*. Cambridge, Mass.: Harvard University Press.

Department for Culture, Media and Sport. 2006. *Understanding the Future: Priorities for England's Museums*

Hein, H. 2000. 'Museums and communities' in Hein, H. 2000.*The Museum in Transition*, Washington: Smithsonian Institution Press, 37-50.

Hooper-Greenhill, E. 1997. 'Towards Plural Perspectives' in Hooper-Greenhill, E. 1997. ed. *Cultural Diversity: Developing*

Museum Audiences in Britain London: Leicester University Press, 1-14

Karp, I. 1992. 'On Civil Society and Social Identity' in Karp, I., Lavine, S. & Kraemer, C. 1992. eds. *Museums and communities: the politics of public culture*. Washington: Smithsonian Institution Press, 19-33

Keen, A. 2008. *The Cult of the Amateur*. London: Nicholas Brealey

Kreps, C. 2003. *Liberating Culture: Cross-Cultural Perspectives on Museums*, Curation and Heritage Preservation. London and New York: Routledge

Lavine, S. 1992. 'Audience, Ownership, and Authority: Designing Relations between Museums and Communities' in Karp, I., Lavine, S. & Kraemer, C. 1992. eds. *Museums and communities: the politics of public culture*. Washington: Smithsonian Institution Press, 137-157

Lynch, B. 2002. 'If the Museum is the Gateway, Who is the Gatekeeper?'. *Engage Review* 11, Summer, 12-21

Manchester Museum 2009. *Community Engagement Strategy and Action Plan 2009-2010*. Available online: http://www.museum.manchester.ac.uk/community/ communityengagement/ accessed 12 January 2010

Museums Association. 2004. *Collections for the future*. Available online: http://www.museumsassociation.org/ download?id=11121 accessed 15 January 2010

Newman, A. & McLean, F. 2002. 'Architecture of Inclusion: Museums, Galleries and Inclusive Communities' in Sandell, R. 2002. ed. *Museums, society, inequality*, London

and New York: Routledge, 56-68

Resource. 2001. *Renaissance in the Regions: a new vision for England's museums*, London: Martin

Simpson, M. G. 2001. *Making Representations: Museums in the Post-Colonial Era*, rev.ed. London: Routledge

Witcomb, A. 2003. *Re-Imagining the Museum: Beyond the Mausoleum*, London: Routledge

Young, L. 2002. 'Rethinking Heritage: Cultural Policy and Inclusion' in Sandell, R. 2002. ed. *Museums, society, inequality*, London and New York: Routledge, 203-212

Social Media to Social Impact
Using the Network to Empower Change

GILLIAN THOMAS, TONY LIMA

& FERNANDO BRETOS

Miami Science Museum

While strong school use is a sign of good educational programs, a science institution without adult-focused programs and with low numbers of adult independent visitors is inherently in danger of being indistinguishable from a children's museum, with a restricted and increasingly young demographic. The Miami Science Museum has a strong track record of providing enjoyable school visits and excellent educational programs for the community as a whole. Its award-winning summer camp has remained a favorite and has provided happy memories to those who have attended it from around the community. The Museum is a rare phenomenon in Miami. Whereas, traditionally, museums are seen as spaces for the aristocratic and intellectuals, our Museum has expansive support and is used by all the different sectors of this very diverse community.

Nonetheless, this emphasis on services for schools and children had, by 2005, led to the Museum being increasingly regarded as an institution just for children. While Miami is one part of Florida where the population is not aging noticeably, ignoring a substantial proportion of the potential audience is not a viable strategy long-term. This was addressed as part of the Strategic Plan.

This plan, initially developed in 2005, had four goals:

- Visitor Experience: Provide a welcoming entry point to science and technology for all members of the community.
- Education: Inspire lifelong learning through creative experiences and open doors to new opportunities.

- Meeting Place: Develop the Museum as a meeting place, stimulating scientific and cultural exchange, at the local, national, and international level.
- Sustainability: Tap and enhance the abundant human, environmental and economic resources to create a sustainable Museum, and benefit the broader community.

The focus on acting as a meeting place for all the community and the overall sustainability goal led to a review of the Museum's position re adult visitors. Some small scale survey work with visitors regarding adults' use of exhibitions had also revealed comments such as "not much to look at for visitors".

To increase the numbers of adult visitors, two strategies were developed: select exhibition themes that are interesting for adults as well as for children; and increase the number of adult groups using the Museum.

In 2007, an expansion of temporary exhibition space enabled the Museum to present *Titanic* and resulted in a subsequent increase in the adult proportion of visitors. The following exhibition, *Science of Aliens*, also attracted independent adult visitors, with a slant toward young adults. The latter exhibition, however, while much enjoyed by young adults and with one aspect of the marketing campaign targeting them in particular, had also attracted some negative comment as unsuitable for small children because it was too frightening and inappropriate. This led to

some uncertainty as to whether adults and children could be accommodated comfortably together within a relatively small Museum. An additional approach of specific programming was also tested when a grant enabled some experimentation and activities to be developed specifically for older visitors. Even with this range of actions, the overall proportion of adult visitors remained relatively low, however, compared to similar museums. When school groups are included, the number of children visiting reached over 50% in some years, prior to *Titanic*. For the *Titanic* exhibition, this was reduced somewhat, to 42%, while *Science of Aliens* and *Dinosaurs of China* remained high. In 2007, children under 18 represented 49% and 48% respectively. Clearly, altering our exhibition policy alone would not effect a significant change.

Expanding and change

With the arrival of Tony Lima, VP of Communications and Marketing, to the senior management team in late 2007, and the advent of social media, these efforts moved into a different dimension and level of dynamism. It was decided to start a Young Professionals group, something the Museum had never had. For many years, the Museum had three support groups, consisting mainly of older adults. It also had a number of special interest affiliate groups, again mainly older adults, apart from one IT-related group.

For senior management, this was a somewhat cautiously accepted experiment and the constraint of making the group self-supporting from the start was imposed. Activities would

all be held out of regular opening hours, which avoided any conflict with young visitors and were, in fact, determinedly stated as being activities for adults without children. Providing after-hours activities and specific programming was a safe approach. The potential of social media had already been noted, as weekend workshops organized by an outside agency to teach people how to create Facebook profiles had been exceptionally well attended.

The Communications Team developed a plan for a monthly after-hours networking event, known as *@MiaSci: Happy Hour with Substance*, (the Museum logo and moniker are MiaSci). Deliberately expanding the activities included in the current Museum, the monthly @MiaSci events were dedicated to highlighting the science behind the arts. Historically, the arts have had more mass appeal, especially from this young professional demographic, so it was imperative that the angle for the events was artistic in nature. The audience was and continues to be described as: Young professionals, science aficionados, art enthusiasts and other 21-45 year-olds. With DJs, food and drinks, a $15 entrance fee provided a changing short program dedicated to an art form, from dance to poetry to the visual and culinary arts. The unusual venue (for this age group), the Science Museum, provided an additional attraction. For a number of attendees, returning to their "childhood" Museum for this innovative event concept was exciting and nostalgic.

The small and active Communications Team, all themselves in this age group, began an active search for sponsorship

and partnerships. They concentrated on brands for food and beverage support that skewed young and innovative, and green friendly, all buzz terms very attractive to the sought-after group. They also opted to forge media partnerships with SocialMiami.com and NewTimesMiami.com, both web-based portals as opposed to the more traditional media channels. Given the absence of a budget, social media was the necessary tool for communications. *@MiaSci: Happy Hour with Substance* first lived on the popular MySpace site, but when demographics for that site began to skew younger, the group was strategically moved to Facebook where it has had a growing presence for the past two years.

Tony Lima quickly recognized that to establish a strong presence within social media, specifically with the new sophistication that Facebook allowed, the Young Professionals group needed a "face" to immediately be credible and authentic. He created a "personal" Facebook page establishing himself as a "real" professional, living and working in Miami. He made sure to "friend" other Young Professionals organizations in South Florida, posted photos frequently of "desirable" events he attended and was involved in all dialogue involving Young Professional issues being discussed throughout Facebook. His positioning always came from the Museum's perspective, always mentioning that he was VP of the Museum. After some seeding, Tony began to endorse the @MiaSci events. Tony's recognizable affiliation to the Museum and his cyber networking activities (all during off/evening hours when the captive audience on Facebook is the greatest) helped grow the

group's fan base exponentially.

By the end of the first season, and with eight successful events to their credit, these activities were showing a small profit. Over 2,500 people had participated in events during the season's run and the group was awarded *Best Young Professional Mixer* by *The SunPost Miami* and *Miami New Times* and also received an honorable mention in *The Miami Herald*. Three media stories citing the popularity of the group were also published in *Miami Today* and in *The Miami Herald's Neighbors*.

Transforming into a support group

By the end of the first season, this was clearly an activity that was here to stay. The Museum, as a venue, had proved to be a great success, with many visitors reliving happy childhood moments or simply enjoying the exhibits. Different sections of the Museum: the exhibitions, planetarium and Wildlife Center provided a changing focus each month. A number of people had emerged as either key partners or as a focus for social activity. Selected and nurtured by Tony Lima, this now transformed into a Young Professionals Board of Directors of fourteen people, whose responsibilities included helping fundraise and garnering sponsorships to support the events, publicizing the events and serving as the movement's collective "face". The Board perfectly represented Young Professionals in South Florida with diverse cultures and professions visibly in the collective mix.

In parallel, two of the longer-term support groups were

now diminishing in numbers, as their members aged. It was decided that the Young Professionals would begin to take over the mantle of supporting the Museum and become the Young Patrons of the Museum.

With a full-fledged Board now helping guide the Young Patrons events, the second season of *@MiaSci* became richer in resources, gained more sponsors and grew in numbers substantially. Each of the Young Patrons Board members adopted the "credibility" model that Tony had originated by linking their personal Facebook profiles to the Young Patrons profile and also helping promote events on their respective pages.

In order to keep the programming fresh, the Young Patrons decided to host only five events at the Museum: four *Happy Hours with Substance* and a more elaborate culmination fundraiser, aptly titled *@MiaSci's BIG BANG*. The remaining events were taken "on the road" to different city lounges and restaurants. The science and art-programming piece was still intact, but technology-driven exchanges were added. For each of the away events, the team carried laptops where participants could easily get on Facebook and sign up to be fans of the Young Patrons profile. Participants were also encouraged to use their smart phones to connect from the event in exchange for sponsor-supported giveaways like gift certificates and movie tickets. The fan group grew from 400 to over 700 in a short three-month timespan.

Social action

With the economic downturn, the Museum increasingly used social media as its main vehicle for communications. However, the downturn had an unwanted impact. In Summer 2009, it became apparent that the Museum could be facing an unexpectedly large cut in its grant income from local government. The Museum had already had a substantial cut the previous year and if the further proposed cut had taken place, the Museum's grant income would have been 30% of the 2007 level. As one of the major cultural institutions in Miami, and due to historical reasons related to sources of support, the proportionate cut for the Museum was higher than anyone else.

The Communications Team immediately swung into action with a comprehensive media campaign inciting the community-at-large to take action. The objectives were simple: to inform the community about the proposed budget cut and its potential impact on the Museum; and to stimulate people to take action and give them the necessary quick-fire tools to do so. The campaign was based mostly on viral communications and social media, with a very aggressive messaging and tactical strategy that included letter-writing, development of collateral pamphlets, use of the Museum's website, Facebook and Twitter as central messaging portals, letter-writing parties, phone blasts (text and viral call drives) and speaking opportunities with media and at events. Although mostly viral, the campaign also countered with the placement of public service announcements and heavy media relations pitching from the Communications Team.

Other cultural organizations in the community hosted their own efforts to get the major part of the overall cultural budget restored. It was agreed that organizations across the sector would state the overall need first, and their own organization's second.

Our Communications Team had less than six weeks to develop and execute this call to action, and with a small team of three, it was imperative to quickly call on allies that could help strengthen the efforts. Our Young Patrons were asked to help lead the charge, positioned as "go to" representatives and spokespeople.

The process for finalizing the budget involved each of the thirteen Commissioners holding public meetings in their own constituencies. The Young Patrons Board now came out in active support of the Museum. At each of these meetings, individual Patrons from that constituency spoke out against the cut and about the importance of the Miami Science Museum to the community. Their presence was even stronger *en masse* at the final budget hearing with the County Commission, where our Communications Staff and Young Patrons stood in line for several hours to be able to gain access to the Chambers. The individual Patrons were eventually called to speak after a ten-hour wait. The overall result was a restoration of the budget for 2010.

None of this would have been possible without the long-term systematic use of social media to keep up the pressure, to create a community of support and to translate that sense of belonging into action. In addition, the sheer size and presence

of the Museum's campaign in social media raised the profile of the Museum in general, not just for its budget issues. The campaign garnered several print stories in *The Miami Herald* and *Miami Today*, over 100 public service announcements were placed, a total of seven interviews were completed on English and Spanish language radio stations, an estimated 200 calls were made to County Commissioners on our behalf and over 2,500 letters written.

The raised profile of this group has led to new opportunities for collaboration with several professional groups throughout the city. The Community Partnership for Homeless, a charity focused on enabling people to get out of homelessness, is currently expanding its young professionals support group and approached the Young Patrons for direction and to collaborate on activities. This both brings a wider group of people to assist in issues around homelessness, cementing the infrastructure within the community, and again raises awareness of the Miami Science Museum's programs and new developments – and its commitment to helping create a sustainable community.

Reclamation project

The Young Patrons and @MiaSci are two of several social networking tools the Museum has employed to impact social change while attracting new audiences. This commitment to go beyond the museum walls to engage the community has transcended to the Museum's permanent exhibits and education programs. One example is the *The Reclamation*

Project, a participatory eco-art project conceived by local Miami artist, Xavier Cortada, who was honored in 2007 by The Latin American Friends of the Museum, a support group, as one of their annual awardees of Notable Hispanics. Xavier Cortada is known for his social activism and his wide range of art installations reflect his practice of using art as a medium for social change. This Project explores our ability to co-exist with the natural world through a combination of visually evocative art exhibits and volunteer action that empowers participants to restore coastal habitats.

The *Reclamation Project* engages thousands of Miami residents every year. Volunteers collect Red Mangrove seedlings from Biscayne Bay in August and September. The seedlings are then exhibited in plastic water-filled cups along a modernist art grid where they germinate over the course of a year. These eco-art installations promote dialogue among visitors and encourage them to take action. Eventually, volunteers replant these seedlings in degraded areas that once were home to thriving coastal wetlands. By returning otherwise stagnant seedlings to areas cleared of invasive plants by Miami-Dade County, volunteers create new habitats and restore critical ecological services to a growing coastal urban area.

The project was launched in 2006 as a featured exhibit at Miami Beach's *Art Basel* art festival. In 2007, Gillian Thomas and Xavier Cortada converged on the idea to use the Museum as a home to the project and to inaugurate a permanent 1,100 mangrove seedling exhibit at the Museum's outdoor Wildlife

Center. Almost 100 feet long and 20 feet high, this living exhibit mimics a natural mangrove habitat. Currently in its third iteration, new seedlings replace germinated seedlings that are replanted in nature every year. As such the Museum's exhibit alone has returned almost two acres of mangrove habitat to Biscayne Bay since 2007.

The Museum exhibit is the epicenter for the project while also providing a base of operations for Project Director Fernando Bretos, who coordinates complementary programming in the community.

Inspired by the Museum installation, similar exhibits have been installed at local schools and retail stores. An additional 2,000 seedlings are maintained annually in eco-art installations at five local schools. Schoolchildren collect their own seedlings in groups, maintain their installations and return the seedlings to nature at the conclusion of the school year. Hundreds more seedlings are hosted by retail stores where they are seen by thousands of residents and tourists daily. These seedlings are intended as a symbolic "reclamation" where mangrove seedlings temporarily reclaim areas where they once thrived. Every year more schools and retail stores join a community effort that has expanded to other parts of the state. In 2009 mangrove-based eco-art programming was adopted in four additional Florida counties including Tampa Bay and Treasure Coast.

Volunteers are the beating heart of the project. Over 300 volunteers per year are connected through the project's popular website [www.reclamationproject.net], Twitter and

a Facebook fan page. Using these social media the Museum distributes educational literature, announces replanting and collection events and virtually links participants to one another who maintain a dialogue on how community change can restore the balance between humans and nature.

The *Reclamation Project* expanded in 2007 to regrow native habitats in urban areas. Through an initiative entitled *Native Flags*, participants are encouraged to plant a native tree sapling and a green flag designed by Xavier Cortada in their yards. These flags act as a catalyst of conversation and a call to action for neighbors to restore our native tree canopy. As the native trees grow, so does participants' interest in protecting the environment. Participants can post images of their trees and flags on the website, allowing the project to track progress in restoring Miami's urban canopy. In each of these activities, the use of social media has enabled a network of volunteers to emerge and convert their mutual interests into positive actions for change. The virtual links and communication strategies result in real-life social activities with positive impacts for the community.

Recent media such as Al Gore's film, *An Inconvenient Truth*, have given birth to a new environmental movement. This and other popular green media have seen immense popularity and alerted an entire nation to understand the threats which climate change and environmental degradation pose to our planet. The nation has since embarked on the critical second phase of the movement: to move away from simply identifying global environmental dilemmas towards a phase

of solutions and community empowerment to take action. The Reclamation Project exemplifies this important "next step" and embodies the mantra to *think globally and act locally*. Through a unique participatory eco-art platform, participants positively impact global change by taking collective action. Through the partnership with the Museum, the *Reclamation Project* has established a home, which has facilitated its expansion and increased its impact. Hosting by the Museum's website has increased its visibility. Events linked to the Young Professionals Group have benefited both groups and expanded participants' interests. Social media have provided the forum for action.

Conclusion

The Miami Science Museum is committed to empowering people and to facilitating the development of a sustainable community. Social media not only brings awareness to the Museum's programs but enables people to make a positive impact in the community and enhance the local environment, all while increasing their own personal well-being. Social media offer new opportunities to increase community focus and to bridge the gap between different sectors, or bring together different resources. While predominantly used by youth and younger adults, these can nonetheless bring into contact a wider age range and assist different groups within the overall community.

These groups are nurturing the future leadership within the community and strengthening links across interests

and sectors, as well as having a positive impact on the Miami Science Museum. Long term, this can only benefit the wider community as shared experiences facilitated via social media, lead to a shared goal of creating a great city for the future.

ABOVE AND BELOW: The Young Professionals' *Earth Hour* event, showing dresses made from recycled materials and the Reclamation Project mangrove installation.

Inclusive Without Knowing It

STEPHANIE WINTZERITH

Evaluation & Visitor Studies Consultant

Karlsruhe, Germany

Over the last two decades, most museums have become increasingly concerned with visitor orientation. Audiences, their expectations and needs, are ranking higher in the priority list. Is this enough to make museums inclusive? Do they care about inclusiveness in the first place? Visitor orientation is the first and probably most important step towards inclusiveness, but still does not account for all that might be implied in the concept. As a new notion in museology, inclusiveness needs to be thought about and will take time and effort to establish in practice. Without even knowing it, many museums are on their way to becoming genuinely inclusive institutions.

Though every museum is unique, one technique emerges being particularly productive in the field of inclusiveness: visitor research.

Visitor research is now an established discipline that has helped many museums grow closer to their audiences (Eidelmann et al. 2007, Dufresne-Tassé 2002). In speaking of *visitor research* I include visitor studies using descriptive methods, interdisciplinary research and even evaluation – measuring the achievement of set goals (Diamond 1999). It uses methods from empirical social sciences such as surveys, interviews and observation. The data gathered is mostly quantitative, but also includes qualitative elements. Visitor research can be carried out at different stages of the project development: before, during and after the planning of exhibitions for example (Screven 1990). Implementing the results and findings is, of course, crucial to the success and

usefulness of visitor research.

This paper starts with a brief outline of inclusiveness, as a first attempt to define what makes a museum inclusive. It will then focus on the case study of a medium-sized museum in Germany and the effects of its long tradition of visitor research. Tackling cross-cultural issues in exhibitions, opening up to predominantly museum-averse audiences, involving these communities in the planning process, developing long-term relationships and institutionalising international co-operation have been the key factors in implementing cultural inclusiveness. Local social issues have also been addressed by developing specific programmes. The whole strategy has been supported by information provided by surveys and visitor research. But let's first examine the concept of inclusiveness itself.

The inclusive museum: the three specifics

Inclusiveness is a highly complex notion, even more so when applied to museums. Far from any claim to comprehensiveness, this paper focuses on the visitor researcher's perspective, which results in focusing on three main characteristics of an inclusive museum: specific target audience(s), specific content with appropriate displays, and a specific purpose.

The term *inclusiveness* suggests that no one should be excluded from experiencing the benefits of the museum, in other words that the whole world – and every citizen in it – should be involved and able to see its exhibitions. In reality, of course, this remains a utopian view. It is simply

impossible for museums to serve all their potential audiences at the same time. Consequently, the museum has to set priorities and decide which audiences it wants to focus on and develop conscious efforts to serve. So an inclusive museum defines specific target groups, in terms of both visitors and communities to serve. Any museum's audience comprises several more-or-less specific groups which are overlap to some extent. What singles out an inclusive museum, then, is the attention given to a selected number of those audiences and maybe to groups who would not be typical visitors on the first place – without neglecting "traditional" audiences, of course. The museum needs to develop a profound knowledge of the specific groups if it is to respond to their needs and expectations and so take their interests, as well as its own aims, into account.

A second specific aspect of inclusiveness puts the emphasis on exhibition content and presentation. Far from the museum being an all-knowing repository of information and knowledge, the inclusive museum integrates the authority of involved communities and target groups into the making of the exhibition in terms of both the selection and interpretation of its contents. This ranges from the choice of exhibition themes and exhibits to the activities surrounding the exhibition. Clearly, it also has to adapt the display to the target groups: the same message needs to be communicated in different ways to different audiences.

A third aspect of the inclusive museum is its specific purpose. The choice of target group, of the themes and of the

means of integrating a community into the museum's work is linked to the concept of making a difference: for the museum itself and/or for the community. To give community members a voice, to present the exhibition in a way that matches their perception of themselves, or to enhance social integration, are examples of this specific purpose. Being inclusive for the sake of inclusiveness is much too vague and broad an approach. It needs to be narrowed down to tangible objectives – at least at first.

Having set the framework of inclusiveness, what is the link to visitor research? The key here is: getting to know the audience. Visitor research is the tool to gather and analyse information, and implementing inclusiveness is the aim. This information can be used to plan exhibitions or projects, or to evaluate their results and impact.

Case study: the Badisches Landesmuseum Karlsruhe
The following case study shows how a museum, using visitor research to enhance its quality in many different ways, became more and more inclusive long before the notion of inclusiveness appeared in the vocabulary of museologists. Rather than being *inclusive*, being *visitor-oriented* is of high importance for many museums. In Germany, one of the pioneers in this respect was – and still is – the Badisches Landesmuseum Karlsruhe (BLM). It is a regional museum, with eight museums and outstations under its umbrella. The BLM is located in the baroque castle of Karlsruhe, a town in the Rhine Valley at the edge of the French border and has

between 180,000 to 200,000 visitors a year.

The BLM defines itself as a universal museum. It is not a museum about the region of Baden, it is a museum for Baden, showing the whole world and its cultural roots to the people of the region (Wintzerith 2006). Over the last ten years, it has mounted a series of large and very successful special exhibitions focused mainly on archaeological topics.

Visitor orientation became a high priority when the current director, Prof. Dr. Harald Siebenmorgen, took over the BLM about 15 years ago. Since then, audiences have become the main focus of the museum's work. Visitor studies and evaluations have been regularly undertaken to get to know the museum's audiences, define their needs and expectations and gain their feedback on exhibitions, new ideas and education programmes. These visitor surveys and evaluations were first commissioned from the Institute of Sociology of the nearby Karlsruhe University. In 2003, ZEB – Centre for Evaluation and Visitor Research – was established jointly by BLM and the University, integrating visitor research into the organisation of the museum itself.

Just like any museum, the BLM has a proportion – probably the largest proportion – of its audience that we could call the "traditional museum-goers". They come to both permanent and temporary exhibitions as a result of mainstream museum work and public relations. Visitor-oriented, yes, but not inclusive yet. The museum wanted more: its plan was to become attractive to people who may not be so easily convinced that an exhibition could

be interesting, let alone of benefit to themselves. The BLM deliberately wanted to open itself up to new audiences and so began the process of becoming more inclusive, in terms of both cross-cultural issues and social inclusiveness.

Cross cultural issues: evaluation is the key

The process began with the phased refurbishment of the whole museum, with one department being converted every year over a period of about 15 years. It started with the so called *Türkenbeute*, a unique collection of objects brought to Baden as spoils of war after the defeat of the Ottoman army in the 17th century. As a sign of respect, it is now to be called *Türkensammlung*, a shift from *spoils* to *collection*. The carefully chosen exhibits were put into a new display, according to the then state-of-the-art standards of museology including hands-on elements, dioramas and attractive design. The exhibition proved very successful – as was the two-day Turkish Festival organised around the museum (in the park and gardens of the castle) for its launch.

For the first time, the Turkish community – one of Germany's largest immigrant groups, still struggling to integrate into German society – in Karlsruhe felt it was worthy of an exhibition. Even more so: a permanent exhibition. A piece of their past was in the museum, displayed in a dignified way despite the historical defeat. Their culture was celebrated in a festival in the very centre of the city, attended both by themselves and Germans for a period of real cultural exchange. They felt proud of who they are, and they felt accepted. It made

an immense difference. The event is still happily remembered by both the museum and the Turkish community.

The BLM hoped for success, but didn't expect that much. The question was: why did it work so well, what was the basis of this success? This clearly showed the need for evaluation. In the following years, many of the important exhibitions and events were analysed by a visitor survey. A systematic evaluation process was set up, helping improve the quality of the exhibitions and of museum work.

Another milestone of cross-cultural inclusiveness was achieved in 2001 with an exhibition on Ancient Crete and Minoan Culture. Here again, the exhibition – incorporating the findings of previous visitor surveys – accounted for a large part of the success. But there was more. What made this exhibition a good example of inclusiveness was the active involvement of the Greek community in the planning process as well as in the educational and event programme mounted around the exhibition. Greeks from Karlsruhe were invited to participate in the planning, organisation and implementation of activities around the exhibition. They created a link with contemporary Greece, setting up, for example, a very popular *kafenion* (Greek restaurant) inside the exhibition where visitors could have lunch. They also organised a traditional Easter celebration, and several workshops and conferences.

The summative evaluation (visitor survey) demonstrated a very high level of satisfaction with both the content and presentation of the exhibition. The hands-on elements, archaeological models and reconstructions proved especially

popular – elements now part of the BLM's exhibition style. Most of all, the huge success of the exhibition was rooted in the link with its visitors, many of them feeling a personal connection to Crete: they had been there for holidays, had Greek roots, or a strong interest in classical archaeology and had read books about Crete/Greece. All of them found something in the exhibition that connected them to Crete. A story, a smell, a sound or an image, it just felt familiar.

The next step towards inclusiveness was made in 2003 with an exhibition about the *Middle Ages in the Upper Rhine Valley*. On an institutional basis, the cooperation with several museums from neighbouring areas of France and Switzerland was particularly fruitful and well-organised. A front-end survey (Klein/Wintzerith 2001) was carried out to find out about the knowledge, the prejudices, ideas and expectations of potential visitors, as well as their interests and favourite topics. It was thus possible to identify the themes that needed particularly careful and attractive presentation to compensate for their relative lack of popularity. The whole exhibition aimed to show how interwoven the history and culture of the population along the Rhine was and still is. Translations and guided tours in French were the most obvious efforts to welcome French-speaking neighbours. The whole public relations and marketing campaign was designed to cross national boundaries and set up long-term contacts with the French region on the other side of the border. A summative evaluation (Klein/Wintzerith/Bock/Trinca 2002) of the exhibition showed how happy the visitors were to "rediscover"

the cultural connections with their neighbours, connections still strongly, albeit unconsciously, felt.

In an international context in which fear of Islam was growing, the BLM decided to challenge this and offer a frame for intercultural dialogue. Involving Islamic communities and creating long-term cooperation with them largely accounts for the success of the series of exhibitions organised in 2004-2005. The focus was on Tunisia with a main exhibition featuring Hannibal and the archaeological site of Cartago and two smaller art exhibitions, one with works of the Tunisian artist potter Khaled Ben Slimane and one showing traditional Sejnane pottery. That year's museum festival was a celebratory cultural encounter with many guests from Tunisia. *Club Carthage* was set up by Tunisians living in Karlsruhe and was very actively involved in the organisation of the programme mounted around the exhibitions. It is still very active today. Even though in this case visitor research has only been indirectly involved using the results of previous studies, this exhibition was a milestone in the development of the museums long-term international connections and as such was a palpable achievement of inclusiveness.

Another attempt to include the Turkish population was made in 2007 with an exhibition showing the latest archaeological excavations in Anatolia and what were probably the first man-built monuments 12,000 years ago. It was based on bilateral cooperation with the Turkish authorities and benefited from a strong commitment of the community in Karlsruhe. This time, large-scale visitor research was carried

out, showing that the reality did not entirely match the expectations in terms of audience structure. The public was mainly highly specialised – almost archaeological experts. As a consequence, the local audiences were underrepresented. An intensive information campaign was launched in the final phase of the exhibition to restore their balance. On the other hand, fewer Turks than expected came to the exhibition. They possibly felt that the time-gap of 12,000 years was too great to really connect with the exhibition's theme.

Social inclusion as a result of evaluation

Over the years, many visitor surveys have been carried out primarily to evaluate temporary exhibitions, programmes and festivals. A whole range of data (Klein 2003) has led to a broad understanding of visitors, their characteristics, needs and satisfaction levels. Even though an evaluation is usually a case study – meaning that its results apply to one single situation – the findings can be useful in other situations when applied with great care. The data gathered allowed for comparisons to show the differences between, for example, the audiences for the annual festivals and exhibitions as well as long-term trends in the structure of visitors. These trends influenced the BLM's strategy as much as individual evaluations did.

In addition to its broad audiences, the museum has defined certain specific target groups for whom it intends to develop particular initiatives. Children are, with or without their school-groups, one of the main target areas. An evaluation

of school visits has been carried out to determine their satisfaction and interest. There is of course also a range of guided tours for people with various disabilities. Here again, visitor research might generate useful information. As for socially disadvantaged people, there is a strong wish to involve them in the cultural life of the city and of the museum in particular. The surveys highlighted that these groups – as is the case with most museums – are not represented as much as the BLM would wish. The museum is still planning ways to enhance their participation but lacks the accurate data which non-visitor research could uncover, to identify the barriers to involvement.

Looking at the trends in the structure of the BLM's public, it is clear that younger generations are under-represented, especially among visitors to archaeological temporary exhibitions. The museum faces a certain aging of its visitor profile. Its greatest challenge will be to reverse this trend: to attract young people while not neglecting its older visitors.

How can visitor research help?

Above all, visitor research is about gathering the information a museum needs in order to become more and more inclusive. Visitor research is also the instrument to evaluate the results and measure the effect of/on inclusion and inclusiveness. The BLM case study demonstrates the range of possible research before, during and after the exhibition as a summative measurement of its impact. It provides valuable information about visitors, potential visitors and target groups in terms

of profile as well as in terms of expectations and needs.

Even though most museums don't consciously aim to be inclusive, they usually do want to open up their exhibitions to as many audiences as possible – and this is what inclusiveness is all about. The emphasis is, however, on quality rather than quantity. Sheer visitor numbers might be of greater interest to funding bodies than to museums themselves, but reaching a broad audience is a way of fulfilling the social function of the institution. Serving audiences, however they are defined, is one *raison d'être* of a museum, if not the main one. An inclusive museum defines its audiences in a particular way, that should be supported by the methods and results of visitor research.

Furthermore, visitor surveys are instruments to involve audiences directly in the museum's work, so enhancing its inclusiveness. Asking visitors for feedback in a systematic way gives them the well-founded impression that the museum cares about their opinions – cares for them – and that they can contribute in some way. The museum, meanwhile, obtains information it can process and use to inform decision making.

Feedback from the public is important, especially when demonstrating achievements and improvements. Most of all, it enables the museum to identify where room for improvement still remains. Using systematic and scientific methods of empirical research, visitor research gives a more or less objective result that goes beyond the purely subjective feedback a single person can get from observing and questioning the public. This methodology comes into its

own when the results of studies are shown to funding bodies, being seen as a trusted measurement of the outcomes and clear, fact-based statements of the achievement of goals and set targets.

References

Diamond, J. (1999) *Practical evaluation guide : tools for museums and other informal educational settings*, Walnut Creek: Altamira Press

Dufresne-Tassé, C. ed. (2002) *L'évaluation, recherche appliquée aux multiples usages / Evaluation : Multi-Purpose Applied Research / La evaluación : investigación aplicada a usos multiples*, ICOM-CECA, Montréal : Editions MultiMondes

Doering, Z. (1999) "Strangers, Gests or Clients? Visitor Experiences in Museums", *Curator*, 42:2 pp. 74-87

Eidelmann, J. Roustand, M. and Goldstein B. ed. (2007) *La place des publics – De l'usage des études et recherches par les musées*, Paris : La Documentation Française

Karp, I., Kraemer, C. and Lavine, S. ed. (1993) *Museums and communities: the politics of public culture.* Washington: Smithsonian Institution

Klein, H.J. and Wintzerith S. (2001) *Spätmittelalter am Oberrhein – eine Front-end Evaluation*, non published survey report, University of Karlsruhe (TH)

Klein, H.J. and Wintzerith, S., Bock J., Trinca M. (2002) *Gemischtes Doppel – Evaluation der Ausstellungen Stätmittelalter am Oberrhein in der Staatlichen Kunsthalle und im Badischen Landesmuseum, beide in Karlsruhe*, non published survey report, University of Karlsruhe (TH)

Klein, H.J., „Publikums-Barometer – Vom Nutzen kontinuierlicher Besucheranalysen" in Noschka-Roos, A. (2003) *Besucherforschung in Museen – Instrumentarien zur Verbesserung der Ausstellungskommunikation*, Public

Understanding of Science, pp. 110-143 Munich: Deutsches Museum

Macdonald S. ed. (2006) *A Companion to Museum Studies*, Oxford: Blackwell

Noschka-Roos, A. (2003) *Besucherforschung in Museen - Instrumentarien zur Verbesserung der Ausstellungskommunikation*, Public Understanding of Science, Munich: Deutsches Museum

Sandell, R. (1998) "Museums as Agents of Social Inclusion" in *Journal of Museum Management and Curatorship*, 17(4) p. 401-418

Sandell, R. (2003) "Social Inclusion, the Museum and the Dynamics of Sectoral Change", *Journal of Museum and Society* 1(1) pp. 45-62

Screven, C. (1990) "Uses of evaluation before, during and after exhibit design", in ILVS review: *A Journal of Visitor Behavior* Vol1, 1990 Nb 2 p. 36-66

Serell, B. (1998) *Paying attention: visitors and museum exhibitions*, Washington DC: AAM technical services.

Wintzerith, S. (2006) *Interkulturalität als Institutionalisierungsprozess dargestellt am Beispiel der internationalen Kooperation und der interkulturellen Verflechtungen der Museen in Mitteleuropa*, PhD Thesis, University of Karlsruhe (TH)

This paper was presented at "The Inclusive Museum" conference held in Leiden, Netherlands, 8th-11th June 2008.

Index

About the Authors

Nicola Abery is the Creative Director of www.looktolearn.co.uk, a museum education experience using Visual Thinking Strategies to create cross-curricular multi-dimensional programmes for schools and families. Nicola prepares, designs and delivers these programmes for the London Jewish Community Centre and the London School of Jewish Studies. In addition she also designs and creates primary school lesson modules on sustainable development issues for third sector organisations. Her formal training includes a degree in Education and Art, a Diploma in Museum Studies and recent study in the USA of Visual Thinking Strategies. She is currently developing an innovative museum/gallery education technique to enhance the study of Jewish texts and museum objects and art, making these exciting and approachable for children and families and empowering learners to unlock their artistic and critical skills through these methods. Nicola has worked in education for the past ten years in schools and museums in both London and Seattle, USA.

Lenore Adler is a Program Outreach Specialist at Carnegie Museum of Natural History in Pittsburgh, Pennsylvania. Lenore holds an MS Ed in Museum Education Leadership (Bank Street College, NY) and has volunteered and worked in the museum since 1985.

Anuradha Bhatia, PhD received her interdisciplinary doctoral degree from Colorado State University (CSU), USA. For her doctoral research, she studied a local history museum's

school programmes and its educators' relationship with the district's elementary school teachers. The dissertation was titled: *Museum and School Partnership for Learning on Field Trips*, and can be accessed at http://hdl.handle.net/10217/21298. She had received her master's in Apparel Design from CSU as well. Her other research interests are textile conservation, social-psychological aspects of clothing and historic textiles, costumes, and crafts.

Kate Bonansinga is director of the Stanlee and Gerald Rubin Center for the Visual Arts at The University of Texas at El Paso. Kate earned her MA in art history from the University of Illinois, Urbana-Champaign and her MBA from New Mexico State University. Her book *Centering the Periphery: Visual Artists Respond to the Border* is scheduled to be published by University of Texas Press in 2013.

Adam Bouse is currently an Experience Manager at Conner Prairie Interactive History Park. He is responsible for managing daily science and museum theater activities and presentations, as well as mentoring other staff and supporting programming in *1886 Liberty Corner*, *1836 Prairietown*, and *1859 Balloon Voyage*. He holds a BA in History from Ball State University, and is also certified as a pilot for one of the world's largest tethered, helium-filled passenger balloons. He can sometimes be found behind a plow on the 1886 farm, juggling baseballs as he auditions children to join a fictional circus, or conducting experiments with static electricity.

Fernando Bretos, a marine biologist and environmental educator, is Director of The Reclamation Project at Miami Science Museum [www.reclamationproject.net]. Fernando coordinates eco-art installations and associated educational outreach at museums, schools and retail areas throughout Miami. In his role he also organizes volunteer-based habitat coastal restoration efforts in Biscayne Bay. He is also a Research Associate at The Ocean Foundation, where he oversees a multinational program to restore coastal and marine resources shared by the three nations of the Gulf of Mexico: Cuba, Mexico and the United States. He previously worked at The Ocean Conservancy, and holds a Master's degree in Marine Affairs and Policy from the University of Miami's Rosenstiel School of Marine and Atmospheric Science and a Bachelor's degree in Biology from Oberlin College.

Vicky Cave, PhD is a specialist exhibition consultant with over 17 years' exhibition development experience, having created content, programmed educational events and written content for graphics, educational and follow-up materials for miniFROG at the music club, BlueFROG, Mumbai, India; The Science Museum, London; Eureka! The Museum for Children; The Children's City Project, Syria; Discover, London; and Sciencentre, Museum of Queensland, Australia. Vicky has also written books for children to accompany exhibitions, and has undertaken important research studies for strategic organisations including NESTA (National Endowment for Science, Technology and the Arts). She believes exhibition

experiences should be supported and extended into our everyday lives. [www.oujamaflip.com]

Malcolm Chapman has 20 years experience working with museum collections in both national and university museums. He has been Head of Collections Development and Registrar at The Manchester Museum since 2000. His role encompasses all aspects of collections management as well as improving and increasing user access to the collection, including new technologies. He is responsible for the development and implementation of digital and collection strategy and policy. Working regionally he sits on the Renaissance North West Collections Group. He has a Masters degree in Art Gallery and Museum Studies from the University of Manchester and regularly lectures on topics ranging from human remains, policy development, collections management and digital heritage. Before Manchester he worked on collections documentation systems at The British Museum for eleven years.

Sherice Clarke is a doctoral candidate at the University of Edinburgh's Moray House School of Education. She is currently a Visiting Researcher at the University of Pittsburgh's Learning Research and Development Center. Her research interests include learning in museums, adult ESOL, discourse in the learning context, and applying social theory to the understanding of language learning. She has been an ESOL practitioner for eight years and has received

AUDIENCES, CHALLENGES, BENEFITS

a MEd in Teaching English to Speakers of Other Languages from the University of Edinburgh, and a BA in Art History from Hunter College, City University of New York. She has held voluntary posts in the Museum of Modern Art New York's education department and in community-based ESOL.

Lucie Fitton is Inclusion Officer at the Museum of London, where she has managed the programme for over five years and has started working on the *London: World City* project, part of *Stories of the World*. Following a degree in ancient history and archaeology, Lucie worked in mentoring and youth work, and taught English as an additional language. Following this she worked for a number of years in the welfare-to-work sector with long-term unemployed people. Working on an MA in Museum Studies whilst in her current role allowed her to explore her interest in the impact of this kind of work using her projects and participants as case studies.

Alice Fox is the course leader for the new MA Inclusive Arts Practice at the University of Brighton in the School of Arts and Media, teaching and researching inclusive arts education. Recently Alice collaboratively directed and performed the *Smudged* inclusive performance at Tate Modern. Alice also coordinates the Arts Council-funded Rocket Artist group, for artists with learning disabilities. Currently she is developing a site-specific performance and exhibition with the Rocket Artists at the Medical Museum in Brussels called Measures of Bodies. Alice is also a Commercial Fellow working for the

ABOUT THE AUTHORS · 501

University in the field of social enterprise and communities of practice. Since the early 1990s Alice has worked with people with complex learning disabilities and challenging behaviour, both in the context of arts practice and the advocacy of human rights. To find out more about Alice's research go to: http://artsresearch.brighton.ac.uk/research/academic/fox_alice

Helen Graham is Research Associate at the International Centre for Cultural and Heritage Studies, Newcastle University. Helen has held learning and access roles at Museums Sheffield, Glasgow Museums and the National Maritime Museum and Royal Observatory, Greenwich. She has a developing publications record at the intersection of disability studies and museums studies and has had articles published in *Oral History, British Journal of Learning Disabilities* and *Cultural Trends.*

Heather Hollins has worked in the museum and education sectors for 16 years. After completing a MA in Museum Studies at the University of Leicester, she initially worked as a natural sciences curator before her interest turned to the potential role that museums can have to support learning and social inclusion. She has specialised in the strategic management of museum learning, access and community services and most recently worked for Museums Luton as Learning and Access Manager, instigating strategic reviews of the service's community, formal and informal learning programmes. Currently, she is writing up her PhD with her study focusing

on the use of emancipatory disability research principles with a group of young disabled people. She is also an Associate Tutor for the School of Museum Studies at the University of Leicester .

Yuha Jung holds a BFA in painting from Yeung Nam University in South Korea and a Master's degree in Museum Studies from Syracuse University. Yuha has worked at several museums, including the Everson Museum of Art, the Syracuse University Art Galleries, the Erie Canal Museum, and the American Museum of Natural History in New York. She is currently pursuing a doctoral degree in Art Education at the Pennsylvania State University, where she has taught a course on Museum Education and currently serves as the coordinator of the Edwin W. Zoller Gallery.

Jane Kalagher is a consultant and coach. She founded *Coaching Resources* and *Exhibits Matter* [www.exhibitsmatter.com] and works with individuals and leaders within organizations such as museums. For the past eighteen years, Jane has studied patterns in nature and psyche and applies pattern analysis to her work. She has been working on a museum project for the past three years that applies pattern recognition and analysis to the museum exhibit development process. She is a certified pattern analyst and is on the faculty of the Assisi Institute, Brattleboro, VT. Jane holds a BSN and MA in Counselling Psychology.

Tony Lima is Vice President of Marketing, Communications and Sales at the Miami Science Museum and will be leading communications and marketing efforts for the Museum's new building at Museum Park. Tony was previously Account Director for GolinHarris (IPG), one of the world's top marketing agencies, where he led the Miami office's consumer brands practice and the agency's Hispanic capabilities practice at a national level and for many years, developed and managed award-winning social marketing campaigns – including the national TRUTH campaign against teen tobacco use. Tony has a Bachelors of Arts degree in English from Florida State University and a Masters of Science degree in Integrated Communications from Florida International University.

Carole J. Makela, PhD is Professor of Education at Colorado State University. She serves as Program Chair for the Interdisciplinary Doctoral Specialization and as a research and methodology faculty member. In addition to a focus on graduate education, she has major roles in curricular development university-wide. With numerous publications on education and consumer issues, she has served as editor of *The Journal of Consumer Affairs* and is currently editor of the *Journal of Family & Consumer Sciences*.

Ailithir McGill is currently the Assistant General Manager for Guest Experience at Conner Prairie Interactive History Park. She oversees special projects and programs in three of the park's five major historic areas. She holds a BA in Museums

and Museum Management from Earlham College and an MA in Museum Studies from Indiana University. She started at Conner Prairie in 2001 as an historic interpreter and was promoted to become a project assistant on Conner Prairie's groundbreaking *Opening Doors to Great Guest Experiences* project. From there, she served as an interpretive team leader, the Museum Theater Coordinator, and the Experience Manager for Prairietown.

Camilla Rossi-Linnemann works in the Education and International Relations Department of the National Museum of Science and Technology Leonardo da Vinci (NMST) in Milan. Since 2006 Camilla has worked on several European Projects focusing on science communication and education, actively collaborating with numerous science centres and museums in Europe with the aim of improving access to scientific culture. Within NMST she also works on the development of strategies for engaging new audiences – young children, family groups and ethnic communities. She holds an MA in Museum Studies from Leicester University and a BA in Art History from the University of Milan and has specialised in Museum and Gallery Education at the Institute of Education in London and at the University of Ferrara.

Bryan Sitch has over 20 years' experience of working with archaeological collections in local authority and, more recently, university museums. He has been Curator of Archaeology and Head of Human Cultures at the Manchester

Museum since 2006. Bryan's role combines responsibility for the archaeology collection with management of staff and he leads a team of curators of Egyptology, Living Cultures, Numismatics and Archery. He has a Masters degree in Roman Archaeology from the University of Durham and a Masters degree in Museum Studies from the University of Leicester.

Gurdeep Thiara has been Curator of Community Engagement at The Manchester Museum since 2002. She has been responsible for the introduction of new approaches to community work within the Museum, in particular working with asylum seekers, refugees and other non-traditional audiences. She led the development of the Museum's Community Advisory Panel as well as Telling Our Lives and Collective Conversations projects. Prior to working in the Museum she worked for a number of years in community health work across Manchester.

Gillian Thomas is President and CEO of Miami Science Museum. She has over 20 years' experience in developing and directing major projects for science centers, museums and children's museums. As President/CEO of Miami Science Museum, she is leading the development of the new MiaSci Museum in Museum Park, a 250,000 square foot museum to open on a four acre site in 2014. Previously the CEO of at-Bristol, UK, she led the team developing of this award-winning $150m waterfront Millennium Project which opened in 2000. She was also the Director of Eureka! The Museum for

Children, in Halifax, UK, for its development and opening, and subsequently Assistant Director at the National Museum of Science and Industry, London, with responsibility for new building projects, galleries and facilities. Her first exhibition experience was a part of the development team for the Cite des Sciences and de L'Industrie, at la Villette, Paris, the largest science center in Europe. She has also acted as an international consultant on science center and museum projects for trusts, foundations and government agencies in Ireland, Egypt, Trinidad and Qatar as well as the US and the UK.

Stéphanie Wintzerith undertakes evaluations and visitor studies for museums and other cultural institutions. She graduated at the European Business School (Paris-Oxford-Berlin) and holds a masters in Ethnology (France). Her PhD topic covered the international cooperation of museums and the intercultural aspects linked to it. After completing her doctorate in 2006, she led the Centre for Evaluation and Visitor Research at the Badisches Landesmuseum in Karlsruhe, Germany for two years as its Scientific Director. She is now working freelance, with a strong focus on international projects and is a member of the board of ICOM Germany.

Also from MuseumsEtc

Inspiring Action: Museums and Social Change

Fifteen leading museum and gallery professionals contribute inspiring, practical essays on the ways in which their institutions are responding to the new social challenges of the twenty-first century.

Drawing on pioneering international experience from the UK, USA, Australia and Africa, these experienced professionals explore the theory and the practice of building social inclusion in museum and gallery programmes.

Contributors include: Ronna Tulgan-Ostheimer, Clarke Art Institute; Manon Parry, National Library of Medicine; Gabriela Salgado, Tate Modern; Katy Archer, NCCL Galleries of Justice; Peter Armstrong, Royal Armouries; Keith Cima, Tower of London; Olivia Guntarik, RMIT University; Elizabeth Wood, IUPUI School of Education; Gareth Knapman, Museum Victoria; Jennifer Scott, Weeksville Heritage; Susan Ghosh, Dulwich Picture Gallery; Jo Woolley, MLA; Marcia Zerivitz, Jewish Museum of Florida; Carol Brown, University of KwaZulu-Natal; Eithne Nightingale, V&A Museum.

ISBN: 978-0-9561943-1-2
Order online from www.museumsetc.com

New Thinking: Rules for the (R)evolution of Museums

This exciting new collection of essays by leading international museum practitioners focuses on the across-the-board innovations taking place in some of the world's most forward-thinking museums – and charts the new directions museums will need to take in today's increasingly challenging and competitive environment.

Among the twenty world-class organisations sharing their innovative experiences are:

- Canada Agriculture Museum
- Canadian Museum for Human Rights
- Conner Prairie Interactive History Park
- Cooper-Hewitt National Design Museum
- Imperial War Museum
- Liberty Science Center
- Miami Science Museum
- Museum of London
- National Museum of Denmark
- Royal Collection Enterprises
- Smithsonian American Art Museum
- Victoria & Albert Museum
- Wellcome Collection

ISBN: 978-0-9561943-9-8 (p/back) | 978-1-907697-04-3 (h/back)
Order online from www.museumsetc.com

Narratives of Community: Museums and Ethnicity

Edited by Dr Olivia Guntarik, RMIT University, Melbourne, Australia

In this groundbreaking book, cultural theorist and historian Olivia Guntarik brings together a collection of essays on the revolutionary roles museums across the world perform to represent communities. She highlights a fundamental shift taking place in 21st century museums: how they confront existing assumptions about people, and the pioneering ways they work with communities to narrate oral histories, tell ancestral stories and keep memories from the past alive.

The philosophical thread woven through each essay expresses a rejection of popular claims that minority people are necessarily silent, neglected and ignorant of the processes of representation. This book showcases new ways of thinking about contemporary museums as spaces of dialogue, collaboration and storytelling. It acknowledges the radical efforts many museums and communities make to actively engage with and overthrow existing misconceptions on the important subject of race and ethnicity.

ISBN: 978-1-907697-05-0 (paperback) | 978-1-907697-06-7 (hardback)
Order online from www.museumsetc.com

Creating Bonds: Marketing Museums

Marketing professionals working in and with museums and galleries throughout the UK, USA and beyond, share their latest insights and experiences of involving and speaking to a wide range of constituencies. Their practical, insightful essays span the development and management of the museum brand; successful marketing initiatives within both the small museum and the large national museum environment; and the ways in which specific market sectors - both young and old - can be effectively targeted.

Contributors include: Amy Nelson, University of Kentucky Art Museum; Aundrea Hollington, Historic Scotland; Adam Lumb, Museums Sheffield; Bruno Bahunek, Museum of Contemporary Art, Zagreb; Claire Ingham, London Transport Museum; Kate Knowles, Dulwich Picture Gallery; Danielle Chidlow, National Gallery; Margot Wallace, Columbia College; Rachel Collins, Wellcome Collection; Sian Walters, National Museum Wales; Gina Koutsika, Tate; Alex Gates, North Berrien Historical Museum.

ISBN: 978-0-9561943-1-2

Order online from www.museumsetc.com

Rethinking Learning: Museums and Young People

Practical, inspirational case studies from senior museum and gallery professionals from Europe and the USA clearly demonstrate the way in which imaginative, responsive services for children and young people can have a transformational effect on the museum and its visitor profile as a whole.

Authors recount how, for example – as a direct result of their focus on young people – attendance has increased by 60% in three years; membership has reached record levels; and repeat visits have grown from 30% to 50%. Many of the environments in which these services operate are particularly challenging: city areas where 160 different languages are spoken; a remote location whose typical visitor has to travel 80 miles; the museum which targets children with challenging physical, mental or behavioural needs.

This is an essential book not only for those working with children and young people, but for those in any way concerned with museum and gallery policy, strategy, marketing and growth.

ISBN: 978-0-9561943-0-5
Order online from www.museumsetc.com

The Power of the Object:
Museums and World War II

In this important new book, based on a conference held by the National Museum of Denmark, international museum professionals deal with the key issues affecting all history museums, using as the basis for their insights the interpretation by museums of World War II.

Among the many issues the contributors address are:

- How best can abstractions like cause, effect and other ideas be interpreted through objects?
- Just how is the role of objects within museums changing?
- How should we respond when increasingly visitors no longer accept the curator's choice of objects and their interpretation?
- How can museums deal effectively with controversial historical issues?

These essays explore how history museums can help explain and interpret the thinking of past generations, as well as their material culture.

ISBN: 978-0-9561943-4-3
Order online from www.museumsetc.com

Science Exhibitions: Curation and Design
Science Exhibitions: Communication and Evaluation

Edited by Dr Anastasia Filippoupoliti
Lecturer in Museum Education,
Democritus University of Thrace, Greece

These exciting new books examine how best to disseminate science to the public through a variety of new and traditional media. With over 40 essays from leading practitioners in the field, and over 1000 pages, they provide an authoritative, stimulating overview of new, innovative and successful initiatives.

The essays draw on cutting-edge experience throughout the world, and include contributions from Australia, Canada, Greece, Italy, Portugal and Mexico – as well as the UK and USA.

The authors examine the narratives generated in science exhibitions and tackle some of the challenges museums experience in transforming scientific concepts or events into three-dimensional exhibits.

ISBN: 978-0-9561943-5-0 and 978-0-9561943-8-1
Order online from www.museumsetc.com

Colophon

Published by
MuseumsEtc
8 Albany Street
Edinburgh EH1 3QB
www.museumsetc.com

Edition © MuseumsEtc 2010
Texts © the authors
All rights reserved

ISBN: 978-0-9561943-7-4
British Library Cataloguing in Publication information available.

Typeset in Underware Dolly and Adobe Myriad Pro

CPSIA information can be obtained at www.ICGtesting.com
Printed in the USA
LVOW121231010713

340765LV00005B/28/P